ART NOW

81 Artists at the Rise of the New Millennium
81 Künstler zu Beginn des 21. Jahrhunderts — 81 Artistes au commencement du 21ème siècle

Edited by Uta Grosenick & Burkhard Riemschneider

TASCHEN

KÖLN LONDON LOS ANGELES MADRID PARIS TOKYO

Contents — Inhalt — Sommaire

Preface — Vorwort — Préface

ART NOW, whose publication follows that of ART AT THE TURN OF THE MILLENNIUM, presents the work of young artists of the early 21st century.

The result is a comprehensive handbook for all art enthusiasts – both connoisseurs and laypersons alike – who are interested in the development of contemporary art over the past ten years. It contains more than 500 illustrations of the work of 81 artists from the fields of painting, photography, film and video, sculpture, performance art, and installation, which are accompanied by short, catchy texts. The artists presented here are by no means new discoveries or newcomers. They have all already had their work displayed in solo exhibitions at major art institutions and museums, have taken part in important group exhibitions, and are represented by commercial galleries. The "trends" that can be discerned from the following pages are therefore in no sense inventions of our own, but rather constitute an accurate observation of a lively scene featuring such varied figures as artists, exhibitors, curators, art critics, publicists, art dealers, gallery owners, art buyers, collectors, as well as their platforms, such as art academies, studios, art associations, museums, public collections, art magazines, catalogues, galleries, art fairs, and private collections.

Even though our attention continues to be focused on the Western (art) world, we do take account of the increasing internationalization of the art scene: Asian, African and South American artists in ART NOW embrace visions that are oriented towards European and North American art. At the same time, we cannot emphasize too much that our subjective selection is taken from a far larger number of young and promising, successful and exciting artists.

We devote four pages each to a total of 81 artists, with typical examples of their latest work. The informative elements – such as the alphabetical arrangement of the artists, brief descriptions of the works written by ten authors from the United States, Germany, Denmark, and Poland, illustrations of the artists' most important works, portraits of the artists, lists of their most important exhibitions and accompanying publications, along with statements by the artists themselves – provide insight, in compact form, into today's art scene. In addition, the glossary explains terms that frequently appear in the individual texts or in the discussion of contemporary art.

All this makes ART NOW not only an indispensable reference work, but also a stimulating illustrated volume and an interesting art guide; it is no less entertaining than it is informative for those who wish to confront the issues raised by young art.

Uta Grosenick and Burkhard Riemschneider

We would like to thank everyone who helped bring this book to fruition, first and foremost the artists, the galleries representing their work, and the photographers who have documented their work.
Thanks also to the authors of the texts and glossary: Kirsty Bell, Ariane Beyn, Frank Frangenberg, Barbara Hess, Gregor Jansen, Anke Kempkes, Lars Bang Larsen, Nina Möntmann, Raimar Stange, Rochelle Steiner and Adam Szymczyk.
We are grateful to associate editor Sabine Bleßmann, the designers Andy Disl and Birgit Reber, Ute Wachendorf of the production department, and Kathrin Murr for her support.
Our warmest thanks also go to the publisher Benedikt Taschen for his enormous enthusiasm throughout the whole creative process.

Preface — Vorwort — Préface

Mit ART NOW legen wir nach dem Erscheinen von ART AT THE TURN OF THE MILLENNIUM wieder ein Buch vor, in dem junge Künstlerinnen und Künstler zu Beginn des 21. Jahrhunderts präsentiert werden.

Herausgekommen ist ein umfangreiches Handbuch für jeden Kunstfreund – ob Kenner oder Einsteiger – der sich für die Entwicklung der zeitgenössischen Kunst der letzten zehn Jahre interessiert. Zu sehen sind über 500 Abbildungen von Arbeiten von 81 Künstlern aus den Bereichen Malerei, Fotografie sowie Film- und Videokunst, Bildhauerei, Performance- und Installationskunst, begleitet von kurzen eingängigen Texten. Bei den vorgestellten Künstlern handelt es sich keineswegs um „Neuentdeckungen" oder Newcomer. Alle Künstler sind bereits mit Einzelausstellungen an bedeutenden Kunstinstituten und Museen gezeigt worden, haben an großen wichtigen Gruppenausstellungen teilgenommen und werden von professionellen Galerien vertreten. Die „Trends", die man aus den folgenden Seiten herauslesen kann, sind also keinesfalls von uns kreiert, sondern stellen nur die genaue Beobachtung einer vitalen Szene dar, die sich aus so unterschiedlichen Personen wie Kunstschaffendem/Künstler, Kunstaussteller/Kurator, Kunstkritiker/Publizist, Kunstverkäufer/Galerist, Kunstkäufer/Sammler als auch ihren Plattformen wie Kunstakademie, Atelier, Kunstverein, Museum, öffentliche Sammlung, Kunstzeitschrift, Katalog, Galerie, Kunstmesse, Privatsammlung usw. zusammensetzt.

Auch wenn unser Hauptaugenmerk nach wie vor der westlichen (Kunst-)Welt gilt, tragen wir der zunehmenden Internationalisierung der Kunstszene Rechnung: Asiatische, afrikanische und südamerikanische Künstlerinnen und Künstler in ART NOW erweitern den oftmals auf Europa und Nordamerika fixierten Blickwinkel. Dabei können wir nicht aufhören zu betonen, dass unsere subjektive Auswahl aus einer weit größeren Anzahl von jungen und vielversprechenden, erfolgreichen und spannenden Künstlerinnen und Künstlern stammt.

Insgesamt stellen wir 81 Künstlerinnen und Künstler auf je vier Seiten mit exemplarischen Beispielen ihrer jüngsten Produktion vor. Die informativen Elemente – wie die alphabetische Reihenfolge der Künstlerinnen und Künstler, kurze Texte zum Werk, die von zehn Autorinnen und Autoren aus den Vereinigten Staaten, aus Deutschland, Dänemark und Polen verfasst wurden, Abbildungen der bedeutendsten Arbeiten der Künstlerinnen und Künstler sowie ihrer Porträts, Nennung ihrer wichtigsten Ausstellungen und der über sie erschienenen Publikationen sowie ein eigenes Statement – geben einen kompakten Einblick in die aktuelle Kunstszene. Das Glossar erklärt zusätzlich viele spezifische Begriffe, die in den Texten oder in der Diskussion um zeitgenössische Kunst immer wieder auftauchen.

Damit ist ART NOW unverzichtbares Nachschlagewerk, anregender Bildband und interessanter Kunstguide zugleich; ebenso unterhaltsam und informativ für alle, die sich mit junger Kunst auseinandersetzen wollen.

Uta Grosenick und Burkhard Riemschneider

Bedanken möchten wir uns bei allen, die am Zustandekommen dieses Buches mitgewirkt haben, zuallererst bei den Künstlerinnen und Künstlern, den Galerien, die ihr Werk repräsentieren, sowie den Fotografinnen und Fotografen, die diese Arbeiten dokumentiert haben. Bei den Autorinnen und Autoren der Texte und des Glossars Kirsty Bell, Ariane Beyn, Frank Frangenberg, Barbara Hess, Gregor Jansen, Anke Kempkes, Lars Bang Larsen, Nina Möntmann, Raimar Stange, Rochelle Steiner und Adam Szymczyk.
Außerdem sind wir der Ko-Lektorin Sabine Bleßmann, den Designern Andy Disl und Birgit Reber, der Herstellerin Ute Wachendorf sowie Kathrin Murr für ihre freundliche Unterstützung zu großem Dank verpflichtet.
Herzlichen Dank sagen möchten wir auch dem Verleger Benedikt Taschen, der das Entstehen der Publikation mit enormem Enthusiasmus begleitet hat.

Avec ART NOW, nous proposons, après la parution de ART AT THE TURN OF THE MILLENNIUM, un nouveau livre dans lequel sont présentés de jeunes artistes du début du 21ème siècle.

Cet ouvrage volumineux, destiné à tous les amateurs d'art – qu'il s'agisse d'experts ou de débutants en la matière – a été publié. Il traite de l'évolution de l'art contemporain sur les dix dernières années. On y trouve plus de 500 représentations de travaux réalisés par 81 artistes issus des domaines suivants : peinture, photographie ainsi qu'art cinématographique, vidéo, sculpture, performance et installation. Elles sont accompagnées de textes courts, faciles à comprendre. Les artistes présentés ne sont en aucun cas de « nouvelles révélations » ou Newcomer. Tous les artistes ont déjà été présentés à l'occasion d'expositions individuelles au sein d'instituts ou de musées d'art réputés ; ils ont participé à d'importantes expositions de groupe et sont représentés par des galeries professionnelles. Les tendances qui se dégagent de la lecture des pages suivantes ne sont de ce fait nullement les produits de notre création, mais découlent de l'observation approfondie de la scène artistique, qui se compose de personnes aussi diverses que le créateur d'art/l'artiste, l'exposant d'art/le curateur, le critique d'art/le publiciste, le vendeur d'art/le propriétaire de galerie d'art, l'acheteur/le collectionneur ainsi que leurs lieux d'exercices, tels que l'école des beaux-arts, l'atelier, la société d'amateurs d'art, le musée, les collections publiques, la revue d'art, le catalogue, la galerie, le salon, la collection privée.

Bien que notre attention principale se porte sur le monde (artistique) occidental, nous tenons compte de l'internationalisation croissante de ce secteur : des artistes asiatiques, africains et sud-américains de ART NOW élargissent le champ visuel souvent fixé sur l'Europe et l'Amérique du Nord. Ainsi, nous ne pouvons cesser de souligner que notre choix, subjectif, s'est fait à partir d'un bien plus grand nombre de jeunes artistes hommes et femmes, prometteurs, talentueux et captivants.

81 artistes sont présentés ici, chacun sur 4 pages avec des exemples significatifs de ses plus récentes productions. Les éléments d'information – comme l'ordre alphabétique des artistes, des textes succincts sur l'œuvre rédigés par 10 auteurs des États-Unis, d'Allemagne, du Danemark, de Pologne, des reproductions des principaux travaux des artistes, ainsi que leurs portraits, la mention de leurs principales expositions ainsi que les publications parues à leur sujet, et une déclaration de leur part – donnent un aperçu dense de la scène artistique actuelle. De plus, le glossaire clarifie un bon nombre de notions spécifiques que l'on retrouve souvent dans les textes ou les débats relatifs à l'art contemporain.

Ainsi, ART NOW constitue à la fois un ouvrage de référence indispensable, un livre album évocateur et un guide artistique passionnant. Pour tous ceux qui veulent aborder un art jeune tout aussi amusant qu'informatif.

Uta Grosenick et Burkhard Riemschneider

Nous souhaitons adresser ici nos remerciements à tous ceux qui ont contribué à la réalisation de ce livre, en tout premier lieu aux artistes, aux galeries qui défendent leurs œuvres et aux photographes qui les ont documentées.
Ensuite, aux auteurs des textes et du glossaire : Kirsty Bell, Ariane Beyn, Frank Frangenberg, Barbara Hess, Gregor Jansen, Anke Kempkes, Lars Bang Larsen, Nina Möntmann, Raimar Stange, Rochelle Steiner et Adam Szymczyk.
Nous tenons aussi à remercier particulièrement la co-lectrice Sabine Bleßmann, les designers Andy Disl et Birgit Reber, Ute Wachendorf pour la production des illustrations, ainsi que Kathrin Murr pour son aimable soutien.
Enfin, nous remercions chaleureusement l'éditeur Benedikt Taschen, qui a accompagné ce projet de son indéfectible enthousiasme.

ARTISTS

Franz Ackermann

1963 born in Neumarkt St. Veit, lives and works in Berlin, Germany

Franz Ackermann is more than just a painter. He is a tracker, map-reader, collector, code-breaker and constructor, a real roving observer. Location and connection are emotive words in an age when real spaces are being superseded by virtual ones. Ackermann transplants apparently firmly situated spaces, architectural structures, images and motifs to other, different and disorienting settings. He creates a new kind of cartography, in which the once-universal horizon becomes merely a part, one of the "tiles" – like tourism, colonialism, urbanisation, appropriation, movement and speed – that together form the mosaic of cultural identity. Ackermann is an arranger of heterotopias (as Foucault defined areas of social contact). He explores the surfaces that determine our perceptions of three-dimensionality. The eye of the artist eye moves restlessly, oscillating and looking for a foothold, caught up in the urge to deconstruct. His small sketches or "mental maps", his large-format "Evasions" and his vast panoramas are more than convincing, albeit interwoven now and then with a touch of utopianism. We the viewers are invited to explore these brave new worlds and see them through Ackermann's eyes, to embrace his intimate personal take on reality and understand how we, with our unsuspected ability to look forward and back, fit into the picture. Public space and private perception are brought atmospherically together, breaking down barriers and allowing the artist's intentions to shine through. Using photographs and mirrors – to symbolise the reality and non-reality of place – Ackermann creates a fusion of utopias and heterotopias, a platform for effective and wide-ranging debate on the issues of art and functionality.

Franz Ackermann ist mehr als nur Maler. Er ist Spurensucher, Kartenleser, Sammler, Dechiffrierer und Konstrukteur, eigentlich ein reisender Beobachter. Verortung und Vernetzung sind Reizworte in einer Zeit, in der reale Räume durch virtuelle ersetzt werden. Ackermann verpflanzt das scheinbar Verortete – Räume und Architekturen, Bilder und Motive – und schafft andere Bezugsfelder, in denen die Orientierung schwer fällt. So entstehen neue Kartografien, in denen der vormals universale Horizont in Teile zerlegt wird wie Tourismus, Kolonialismus, Urbanität, Aneignung, Bewegung, Geschwindigkeit, die gemeinsam das Mosaik der kulturellen Identität bilden. Ackermann ist ein Arrangeur von Heterotopien, wie Foucault die Räume sozialer Kontakte nannte. Er erforscht die Oberflächen, die unsere Wahrnehmung von Dreidimensionalität bestimmen. Der bewegte Blick ist unruhig, schwingt, sucht Halt und berauscht sich an dekonstruktiven Elementen. In seinen kleinen Skizzen, den „mental maps", den großflächigen „Evasionen" bis zu raumfüllenden Panoramen ist er mehr als überzeugend, obgleich manchmal ein wenig Utopismus aufscheint. Schöne neue Welt. Wir sollten sie mit den Augen Ackermanns abtasten, mit der innerbildlichen Realität verbinden und den eigenen Standort verstehen, der ungeahnte Rück- und Ausblicke ermöglicht. Der öffentliche Raum und die persönliche Wahrnehmung kommen atmosphärisch zusammen, riegeln sich nicht ab oder bilden eine Barriere, sondern lassen die Absichten des Künstlers durchscheinen. Insofern sind die verwendeten Fotografien und Spiegel, die die Realität und Nichtrealität des Ortes symbolisieren, eine Verschränkung der Utopien und Heterotopien, die eine Grundlage für eine vielfältige und weitreichende Debatte über die Probleme von Kunst und Funktionalität bildet.

Franz Ackermann est davantage que simplement un peintre. Il est fixeur de traces, lecteur de cartes, collectionneur, déchiffreur et constructeur : en fait, c'est un observateur-voyageur. La référence spatiale et la mise en réseau sont des notions tentantes à une époque où les espaces virtuels remplacent les espaces réels. Ackermann cultive les sites apparemment localisés – espaces et architectures, images et motifs – et les transforme en champs référentiels dans lesquels le repérage devient ardu. Il en résulte des cartographies nouvelles où l'horizon jadis horizontal devient enclave dans l'identification de soi : tourisme, colonialisme, urbanité, appropriation, mouvement, vitesse. Les hétérotopies, telles qu'elles ont été pensées par Foucault, sont des espaces de contact dont l'arrangeur Ackermann travaille l'espace iconique à l'instar des surfaces qui déterminent l'idée que nous nous faisons de la tridimensionnalité. Le regard s'inquiète, oscille, cherche un point d'appui et se grise d'éléments déconstructifs. Dans ses petits croquis, les « mental maps », ou dans les généreuses « évasions » jusqu'aux panoramas spatiaux, Ackermann devient largement crédible, avec une note occasionnelle d'utopie. Beauté d'un monde nouveau que nous devrions toucher avec les yeux d'Ackermann et combiner avec le monde de l'image, afin de comprendre notre propre emplacement comme un modèle iconique permettant des regards rétrospectifs et des ouvertures insoupçonnées. L'image et l'espace ouverts rapprochent leurs atmosphères, ne se ferment pas l'un à l'autre, ne dressent pas des barrières, mais font apparaître cet emplacement. Dans cette mesure, les photographies et les miroirs employés par Ackermann, qui transforment le lieu en non lieu, se situent à mi-chemin entre les utopies et les hétérotopies, en ceci que l'art et l'œuvre entretiennent un débat performatif et immensément diversifié.

G. J.

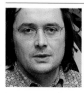

SELECTED EXHIBITIONS →
1999 *German Open*, Kunstmuseum Wolfsburg, Germany **2000** Castello di Rivoli, Turin, Italy; *Close Up*, Kunstverein Freiburg, Germany/ Kunsthaus Baselland, Basle, Switzerland **2001** Gavin Brown's enterprise, New York (NY), USA; Tomio Koyama, Tokyo, Japan; *Form Follows Fiction*, Castello di Rivoli, Turin, Italy; *hybrids*, Tate Gallery, Liverpool, UK; *Painting at the Edge of the World*, Walker Art Center, Minneapolis (MN), USA **2002** Kunsthalle Basel, Switzerland; Stedelijk Museum, Amsterdam, The Netherlands; Kunstmuseum Wolfsburg

SELECTED BIBLIOGRAPHY →
1997 *Atlas Mapping*, Offenes Kulturhaus Linz and Kunsthaus Bregenz; *Mental Maps*, Portikus, Frankfurt am Main **1999** *Mirror's Edge*, Bild Museet, Umeå **2000** *OFF*, Kasseler Kunstverein

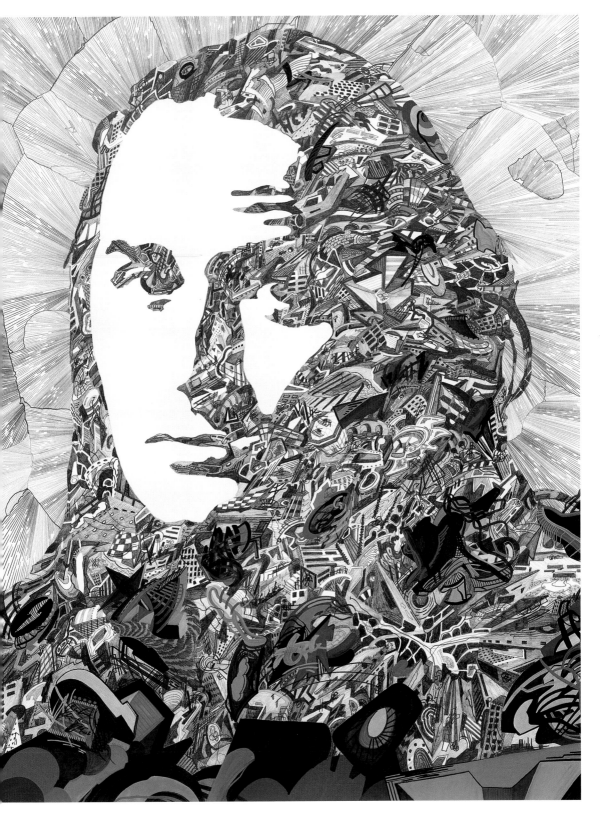

1 **Faceland,** 2001 (detail of white crossing), mixed media on paper, 85 x 65 cm
2 **B2 (Barbecue with the Duke),** 1999, oil on canvas, 240 x 400 cm
3 Installation views, *HausSchau – Das Haus in der Kunst,* Deichtorhallen, Hamburg, 2000
4 **Helicopter XV–...,** 2001, wall paintings, installation view, Walker Art Center, Minneapolis

„Wenn ich Kunst herstelle, überlappen sich gesellschaftliche und politische Fragestellungen mit meinem Interesse, bestimmte Erfahrungen zu vermitteln."

« Quand je fabrique de l'art, les questionnements sociaux et politiques se recouvrent avec l'intérêt que j'éprouve à transmettre certaines expériences. »

"When I make art, social and political questions overlap with my interest in communicating certain experiences."

2

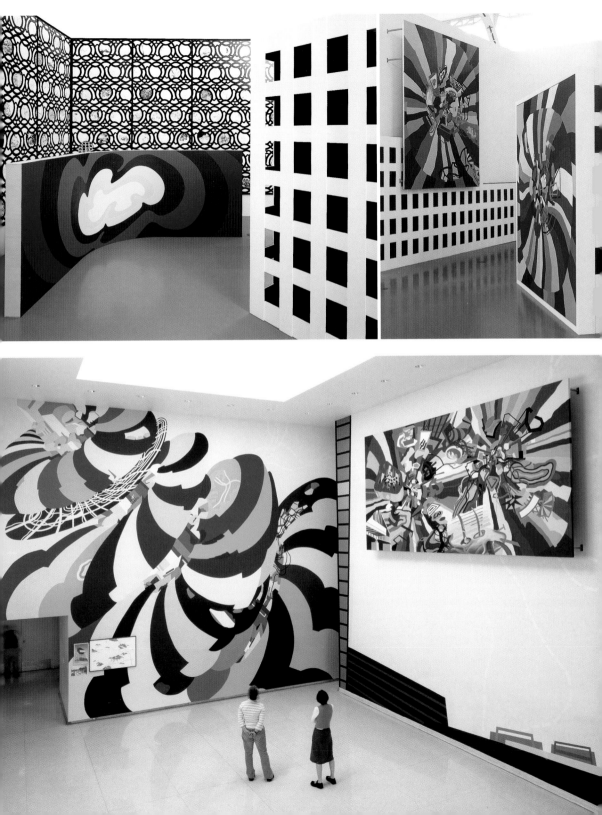

Doug Aitken

1968 born in Redondo Beach (CA), lives and works in Los Angeles (CA), USA

Doug Aitken's multi-screen video installations address the complex inter-relationships between man, media, industry and landscape. The viewer's experience of *Eraser*, 1998, an imposing seven-screen installation, is as much a process of discovery as the making of the piece was for Aitken. He draws us into a wild and hostile landscape with no sign of human life save a scattering of abandoned houses and disused machinery. Gradually it becomes apparent that this is all that remains of the settlements since the island's volcano erupted, destroying almost all traces of civilisation. The films' narratives reveal themselves in intricate spirals in which the viewer is forced to actively engage, both physically by passing through the exhibition space to see the various projections, and mentally as the multiple images prevent a single linear interpretation. The nature and perception of time itself become central in *Electric earth*, 1999. A solitary youth, like a pre-millennial everyman, strides across the urban wasteland in this sprawling eight-screen installation. The environment of blinking street lights, surveillance cameras, automatic car windows and neon signs around him begins to accelerate and he speeds up in turn, mimicking its jerky rhythms against a soundtrack of sampled ambient sound. Information overload is expressed through both the features of the man's external surroundings and his twitchy mental state as each affects the other, articulating the interdependency of man and his environment that informs all of Aitken's work.

Doug Aitken beschäftigt sich in seinen Videoinstallationen, in denen er mehrere Monitore einsetzt, mit der komplexen Wechselbeziehung zwischen Mensch, Medien, Industrie und Landschaft. Die Erfahrung des Betrachters der auf sieben Bildschirmen präsentierten, beeindruckenden Installation *Eraser*, 1998, ist eine ganz ähnliche Entdeckungsreise, wie sie die Arbeit an dem Werk für Aitken war. Er zieht uns gleichsam in eine wilde und abweisende Landschaft hinein, ohne ein Zeichen menschlichen Lebens bis auf eine Ansammlung verlassener Häuser und ausrangierter Maschinen. Allmählich tritt zutage, dass dies alles ist, was nach einem verheerenden Vulkanausbruch auf der Insel, der nahezu alle Spuren menschlicher Zivilisation zerstörte, von der Siedlung blieb. Die Geschichten, die in den Filmen erzählt werden, entfalten sich wie ineinander verschlungene Spiralen. Sie zwingen den Betrachter zu aktiver Teilnahme: physisch durch das Durchschreiten der Installation, um die verschiedenen Projektionen zu sehen; mental, weil die verschiedenen Bilderfolgen sich einer einheitlichen linearen Interpretation entziehen. Zentrale Frage von *Electric earth*, 1999, ist das Wesen und unsere Wahrnehmung der Zeit. Diese Installation mit acht Monitoren zeigt einen einsamen Jugendlichen – gewissermaßen ein Jedermann am Vorabend der Jahrtausendwende –, der durch eine Großstadtwüste wandert. Dabei beschleunigt sich allmählich der Rhythmus der blinkenden Ampeln, der Überwachungskameras, der Autofenster, die sich automatisch heben und senken, und der Neonzeichen um ihn herum. Auch der junge Mensch geht immer schneller und zeichnet die abgehackten visuellen Rhythmen – vor einem Klangteppich aus Hintergrundgeräuschen – gewissermaßen nach. Die Reizüberflutung findet ihren Ausdruck also zum einen in dem Trommelfeuer an Eindrücken, dem er ausgesetzt ist, zum anderen in seinen nervösen Reaktionen. Beide Aspekte beeinflussen sich wechselseitig, und genau diese reziproke Abhängigkeit von Mensch und Umgebung ist das Thema, mit dem sich Aitken in allen seinen Arbeiten beschäftigt.

Les installations vidéos à écrans multiples de Doug Aitken traitent des interactions complexes entre l'homme, les médias, l'industrie et le paysage. Dans *Eraser*, 1998, une imposante installation à sept écrans, l'expérience du spectateur est autant un processus de découverte que l'a été la réalisation de l'œuvre par Aitken. Il nous entraîne dans un paysage sauvage et hostile où il ne reste plus aucun signe de vie humaine hormis quelques maisons vides ici et là et des machines abandonnées. Il devient peu à peu évident que c'est là tout ce qu'il reste de la colonie de l'île depuis l'éruption d'un volcan qui a détruit pratiquement toute trace de civilisation. Les narrations du film se révèlent en spirales imbriquées dans lesquelles le spectateur est obligé de s'impliquer activement, tant physiquement en déambulant dans l'espace de l'exposition pour voir les différentes projections, que mentalement, car les images multiples empêchent une interprétation unique et linéaire. La nature et la perception du temps sont au cœur de *Electric earth*, 1999. Dans cette installation étendue, comptant huit écrans, un adolescent solitaire, tel un homme générique hors du temps, traverse un désert urbain. Autour de lui, un paysage de feux de croisement clignotants, de caméras de surveillance, de vitres de voitures automatiques et d'enseignes au néon semble s'accélérer à mesure qu'il hâte le pas, imitant leurs rythmes saccadés, sur un fond sonore réalisé avec un échantillonnage de bruits d'ambiance. La surcharge d'information s'exprime à la fois par les caractéristiques extérieures du décor et par l'agitation mentale du personnage, les deux s'affectant mutuellement, articulant l'interdépendance entre l'homme et son environnement, thème que l'on retrouve dans toute l'œuvre d'Aitken.

K. B.

SELECTED EXHIBITIONS →
1997 *Whitney Biennial*, The Whitney Museum of American Art, New York (NY), USA **1999** *Concentrations 33: Doug Aitken, Diamond Sea*, Dallas Museum of Art, Dallas (TX), USA; *APERTuttO, 48. Biennale di Venezia*, Venice, Italy **2000** *Glass Horizon*, Wiener Secession, Vienna, Austria; *Let's Entertain*, Walker Art Center, Minneapolis (MN), USA; *Biennale of Sydney*, Australia **2001** Serpentine Gallery, London, UK

SELECTED BIBLIOGRAPHY →
1998 *Metallic Sleep*, Taka Ishii Gallery, Tokyo **1999** *Concentrations 33: Doug Aitken, Diamond Sea*, Dallas Museum of Art, Dallas **2000** *I AM A BULLET*, London; *diamond sea*, Book works, London **2001** *sources for no religions, sources for new religions*, London

1 **Electric earth,** 1999, production stills

2 **I am in you,** 2000, 3 laser discs, 5 projections, installation views, Galerie Hauser & Wirth & Presenhuber, Zurich

„Für mich lautet die Frage: Wie kann ich die Zeit gewissermaßen zusammenbrechen oder expandieren lassen, das heißt ihre enge Form aufsprengen."

« La question que je me pose est : comment faire en sorte que le temps se replie sur lui-même ou s'élargisse, afin qu'il ne s'écoule plus sous cette forme étroite. »

"The question for me is how can I make time somehow collapse or expand, so it no longer unfolds in this one narrow form."

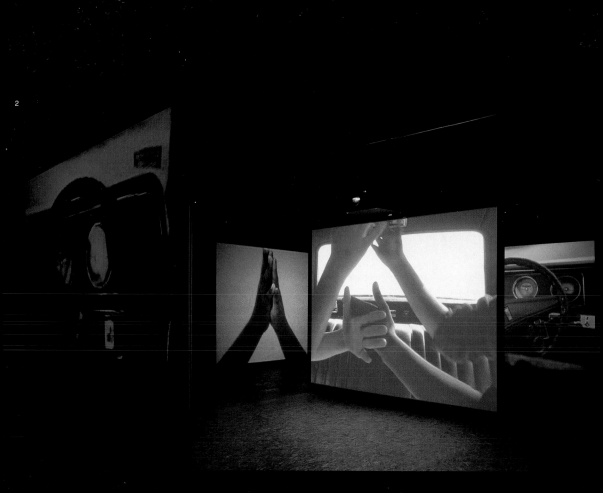

2

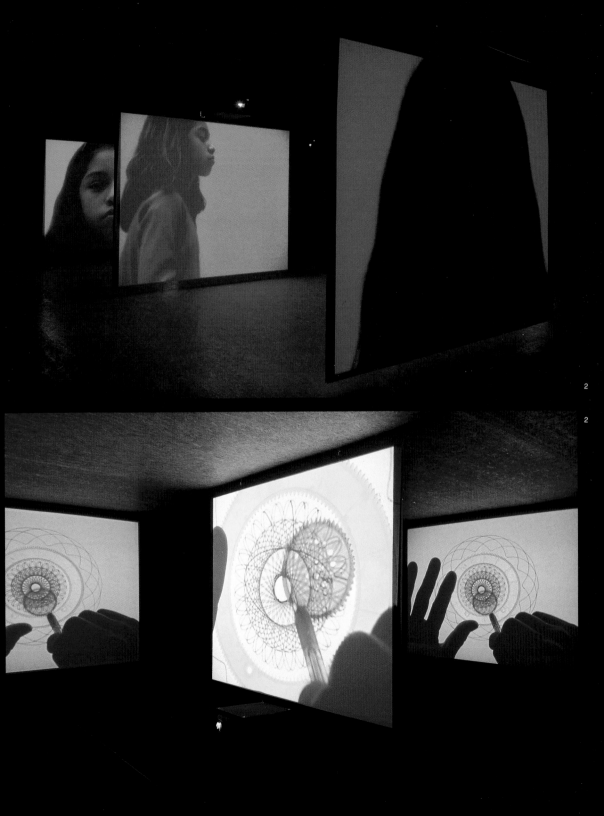

Darren Almond

1971 born in Wigan, lives and works in London, UK

Darren Almond's work focuses on the passage, duration and experience of time. He considers the paradox that a length of time passes slowly or quickly depending on the circumstances in which you find yourself. He is also interested in the differences between analogue and digital representations of time – or those that demonstrate measurable quantities versus those that are symbolic representations. In *A Real Time Piece*, 1996, Almond created a live video-link from his studio in West London to an alternative exhibition space and presented a 24-hour projection of his empty studio. The image portrayed the passage of time through the sound of a clock and changes in light quality in the room. Almond's *Tuesday (1440 Minutes)*, 1997, a grid of photographs documenting 24 hours on a particular Tuesday, developed out of *A Real Time Piece*. Shot in his studio, the photos reveal every minute of the day's duration. Also related is *H. M. P. Pentonville*, 1997, in which Almond set up a live video-link from an empty cell in London's Pentonville Prison to the Institute of Contemporary Arts in London. This piece emphasises the slow passage of time prisoners experience, and in turn it makes prisoners out of its viewers. The relationship between time and space is similarly in the forefront of *Meantime*, 2000, a giant LED clock constructed in a 12-metre shipping container. The artist sailed from London to New York with the container for six days, during which time it was connected to a global tracking satellite displaying Greenwich Mean Time. The piece serves as a representation of the passage of time and movement through space.

Darren Almond befasst sich in seiner Arbeit mit dem Verstreichen, der Dauer und der Erfahrung von Zeit. So interessiert ihn das Paradox, dass ein Zeitabschnitt je nach den Umständen schneller oder langsamer vergeht. Ferner faszinieren ihn die Unterschiede zwischen analogen und digitalen beziehungsweise quantitativen und symbolischen Repräsentationen der Zeit. So hat Almond für *A Real Time Piece*, 1996, zwischen seinem Atelier in West-London und einem alternativen Ausstellungsraum eine direkte Videoleitung geschaltet und 24 Stunden lang die Ansicht seines leeren Ateliers übertragen. Das Verstreichen der Zeit wurde durch das Ticken einer Uhr und die wechselnden Lichtverhältnisse in dem Raum spürbar gemacht. Aus *A Real Time Piece* ging im folgenden Jahr *Tuesday (1440 Minutes)*, 1997, hervor, ein Fotozyklus, der die 24 Stunden eines beliebigen Dienstags „widerspiegelt". Die in Almonds Atelier aufgenommenen Fotos dokumentieren die Dauer des Tages von Minute zu Minute. Ganz ähnlich strukturiert war auch *H. M. P. Pentonville*, 1997, für das Almond eine direkte Videoleitung zwischen einer leeren Zelle im Londoner Pentonville-Gefängnis und dem Institute of Contemporary Arts – ebenfalls in London – schaltete. In dieser Arbeit ist das langsame Verstreichen der Zeit dokumentiert, wie Gefängnisinsassen es empfinden mögen, zugleich fühlten sich die Zuschauer in die Situation von Häftlingen versetzt. Die Beziehung zwischen Zeit und Raum steht auch im Mittelpunkt der Arbeit *Meantime*, 2000. Dabei hat Almond eine riesige LED-Uhr in einen 12 Meter langen Container eingebaut. Danach ist er mit dem Container samt der Uhr, in die über Satellit permanent die Greenwich-Normalzeit eingespeist wurde, auf einem Schiff in sechs Tagen von London nach New York gereist. Die Arbeit dokumentiert somit das Verstreichen der Zeit und die Fortbewegung im Raum.

Darren Almond travaille sur le passage, la durée et l'expérience du temps. Il analyse le paradoxe qui veut qu'un moment passe lentement ou rapidement selon les circonstances dans lesquelles on se trouve. Il s'intéresse également aux différences entre les représentations analogiques et numériques du temps – ou encore, entre celles faisant état de quantités mesurables et celles qui consistent en représentations symboliques. Dans *A Real Time Piece*, 1996, Almond a établi une liaison vidéo en direct entre son atelier dans l'ouest de Londres et un espace d'exposition alternatif, présentant une projection de 24 heures de son atelier vide. L'image dépeignait l'écoulement du temps par le tic-tac d'une pendule et les changements de la qualité de la lumière dans la pièce. *A Real Time Piece* a ensuite débouché sur *Tuesday (1440 Minutes)*, 1997, un montage de photographies documentant 24 heures d'un certain mardi. Prises dans son atelier, les clichés montraient chaque minute du déroulement de la journée. Pour un autre projet apparenté, *H. M. P. Pentonville*, 1997, Almond a établi une liaison vidéo entre une cellule vide de la prison londonienne de Pentonville et l'Institute of Contemporary Arts de Londres. Cette œuvre mettait l'accent sur le lent passage des heures ressenti par les détenus et, en retour, faisait des spectateurs des prisonniers du temps. Cette relation entre temps et espace était au cœur de *Meantime*, 2000, une horloge géante à cristaux liquides construite dans un conteneur d'environ 12 mètres. L'artiste a ensuite fait le trajet en bateau avec le conteneur entre Londres et New York pendant six jours tout en étant relié à un satellite de surveillance mondiale réglé sur l'heure standard de Greenwich. Cette œuvre illustrait la représentation du passage du temps et du mouvement à travers l'espace.

Ro. S.

SELECTED EXHIBITIONS →
1997 Institute of Contemporary Arts, London, UK; *Sensation*, Royal Academy of Arts, London, UK **1999** The Renaissance Society, Chicago (IL), USA **2000** *Making Time: Considering Time as a Material in Contemporary Video and Film*, Palm Beach Institute of Contemporary Art, Palm Beach (FL), USA; *Apocalypse: Beauty and Horror in Contemporary Art*, Royal Academy of Arts, London, UK **2001** Tate Gallery, London, UK; Kunsthaus Zürich, Zurich, Switzerland

SELECTED BIBLIOGRAPHY →
2001 *Darren Almond*, Kunsthaus Zürich, Zurich

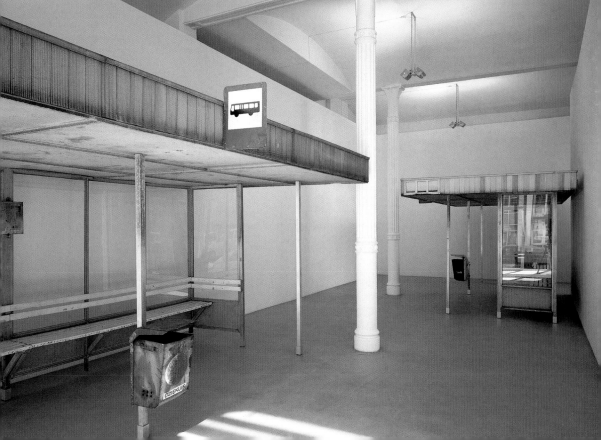

„Wir bedienen uns immer mehr einer binären Sprache des JA/NEIN, die Abstufungen nicht mehr kennt. Das schließt jedoch biologische oder organische Prozesse, also Gefühle aus."

« Nous avons adopté un langage binaire. Dans le binaire, il n'y a qu'un OUI et un NON, sans état intermédiaire. Cela exclue les processus biologiques et organiques : l'émotion. »

"We have adopted the language of binary terms. With binary there is only a YES and a NO and no inbetween state. This excludes biological and organic processes: emotion."

3

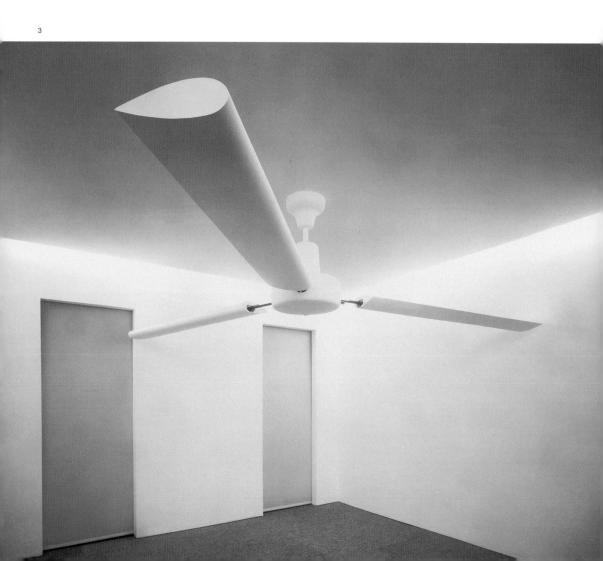

4

5

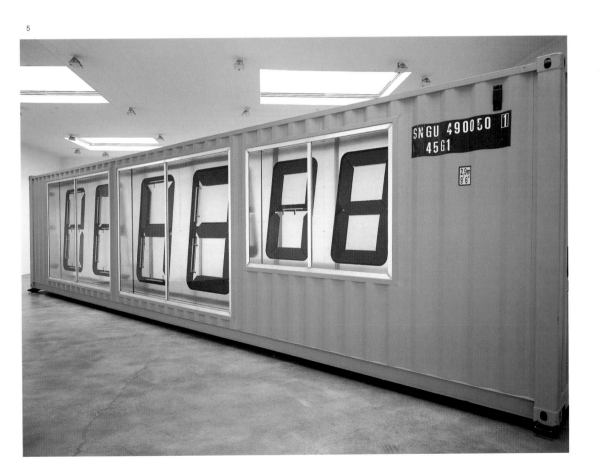

Kai Althoff

1966 born in Cologne, lives and works in Cologne, Germany

Kai Althoff is famous for his idiosyncratic, eccentric pictorial language. He moves, chameleon-like, between different media, from drawings and sculpture through music and photography to video, sometimes fusing them all in a complete installation that creates the illusion of a separate world. Althoff is engaged in a perpetual search for aesthetic variation. In projects with his band "Workshop", he tries to create a kind of pop utopia. His quest for evolved lifestyles harks back to the social change and alternative freedoms of the 1970s, and includes fantasies of breaking away from sexual convention. Althoff's style is often hermetic and not easily accessible. His installations feature characters from stories of the artist's own invention, with baffling titles like *Eulenkippstadt wird gesucht* (In Search of Eulenkippstadt) or *Hakelhug*. The artist himself assumes the role of a medium or "seer" who experiences the social situations and transforms them into art. Through Althoff's eyes, we see the world as a kaleidoscope of insubstantial, fragile meanings. Things we thought we knew, whose significance we took for granted, unexpectedly change and turn out to be the opposite of what we believed them to be. It is precisely from this penetrating view of the world that Althoff draws his hypersensitive creative perception, producing an array of absurd, grotesque figures, melancholy landscapes, sensual and spiritual experiences in garish colours, ominous scenarios and mazes.

Der Kölner Künstler Kai Althoff ist bekannt für seine eigenwillige, exzentrische Bildsprache. Wie ein Chamäleon bewegt er sich zwischen verschiedensten Medien von Zeichnung über Skulptur, Musik und Fotografie bis zu Video, fasst diese manchmal zu einer kompletten Raumerfindung zusammen, die er zur Illusion einer eigenständigen Welt verdichtet. Althoff macht sich immer wieder auf die Suche nach ästhetischer Veränderung, nach Pop-Utopien, wie etwa in den Projekten mit seiner Band „Workshop". Sein Interesse gilt einer Politik selbst erfundener Lebensformen, Lifestyles, die an Ideen von sozialer Veränderung und libertinär-alternative Entwürfe der siebziger Jahre anknüpfen, inklusive dem fantasievollen Bruch auch von sexuellen Konventionen. Dabei entwickelt er oftmals einen hermetischen Stil, der den Zugang zu seinen Arbeiten erschwert. In seinen Inszenierungen treten Fantasiewesen aus selbstersonnenen Geschichten auf, die rätselhafte Titel tragen wie *Eulenkippstadt wird gesucht* oder *Hakelhug*. Der Künstler selbst nimmt dabei die Rolle eines Mediums oder eines „Sehers" ein, der gesellschaftliche Gegebenheiten exemplarisch durchlebt und in Kunst überführt. Wir sehen durch Althoffs Augen die Welt als ein Kaleidoskop aus fragilen, brüchigen Bedeutungen. Dinge, die wir glauben zu kennen, deren Bedeutung wir als gegeben annehmen, verändern sich oft unerwartet und kippen in ihr Gegenteil um. Gerade aus dieser zugespitzten Wahrnehmung gewinnt Althoff sein hypersensibles, kreatives Potenzial: ein Kabinett skurriler und grotesker Figuren, elegische Landschaften, Erotik und Spirituelles in giftigen Farben, bedrohliche Szenarien und Irrgärten.

L'artiste colonais Kai Althoff est connu pour son langage artistique singulier et excentrique. Il évolue comme un caméléon à travers les médiums les plus divers – du dessin à la vidéo en passant par la sculpture, la photographie et la musique – qu'il réunit parfois dans des inventions spatiales totales développées jusqu'à créer l'illusion d'un monde particulier. Le travail d'Althoff est une quête permanente du changement par l'esthétique et les utopies pop, comme le montrent notamment les projets de son groupe musical « Workshop » ; il propose une politique de formes et de styles de vie inventés qui se rattachent aux idées de transformation sociale et aux projets libertaires alternatifs des années 70, de même qu'à la rupture créative des conventions sexuelles. Althoff élabore souvent pour cela un style hermétique qui rend plus ardu l'accès à ses œuvres. Dans ses mises en scène apparaissent des êtres fabuleux issus de contes inventés portant des titres aussi énigmatiques que *Eulenkippstadt wird gesucht*, qu'on peut traduire par *A la recherche de la ville à bascule aux chouettes*, ou *Hakelhug*, un nom propre fantaisiste. L'artiste lui-même adopte le rôle du médium ou du « voyant » qui vit les conditions sociales à titre d'exemple, et qui les transpose dans le domaine de l'art. A travers les yeux d'Althoff, le monde nous apparaît comme un kaléidoscope de significations fragiles et friables. Les choses que nous croyons connaître et dont le sens nous semble acquis, subissent souvent des mutations inopinées qui les inversent en leur contraire. C'est de cette perception exacerbée qu'Althoff tire précisément son potentiel hypersensible et créatif, dans un cabinet de figures bouffonnes et grotesques, de paysages élégiaques, d'érotisme et de spiritualité aux couleurs vénéneuses, aux décors et aux labyrinthes menaçants.

A. K.

SELECTED EXHIBITIONS →
1996 *Heetz, Nowak, Rehberger*, Städtisches Museum Abteiberg, Mönchengladbach, Germany; *Home Sweet Home*, Deichtorhallen Hamburg, Germany **1997** *Eulenkippstadt wird gesucht*, Robert Prime, London, UK **1999** *Ein noch zu weiches Gewese der Urian-Bündner*, Galerie Christian Nagel, Cologne, Germany; *oLdNEWtOWn*, Casey Kaplan, New York (NY), USA; *German Open*, Kunstmuseum Wolfsburg, Germany **2001** *Aus dir*, Galerie Daniel Buchholz, Cologne, Germany

SELECTED BIBLIOGRAPHY →
1996 *Heetz, Nowak, Rehberger*, Städtisches Museum Abteiberg, Mönchengladbach **1997** *Home Sweet Home*, Deichtorhallen, Hamburg **1999** *German Open*, Kunstmuseum Wolfsburg; Burkhard Riemschneider/Uta Grosenick (eds.), *Art at the Turn of the Millennium*, Cologne

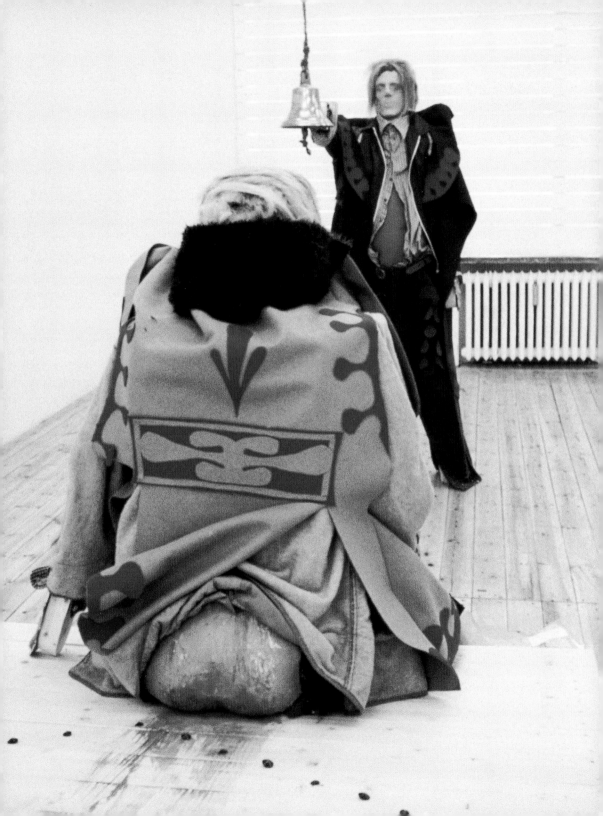

26

2

3

4

Matthew Barney

1967 born in San Francisco (CA), lives and works in New York (NY), USA

Every detail of Matthew Barney's lavish sculptures and films – from colour, form and material to costume, character and location – is part of a code that constitutes an intricately imagined parallel world. In his early work, Barney subjected himself to ordeals of physical endurance such as scaling the walls and ceiling of a gallery naked (*Blind Perineum,* 1991), exploring themes of gender identity and athleticism which remain central to his work. Since 1994 Barney has been absorbed in the *CREMASTER* series, a five-part drama of Wagnerian proportions. Each part comprises a film, a group of objects and a book of still images and has a specific symbolic setting which defines its atmosphere, formal appearance and content. Although there is little dialogue, the films have a narrative structure in which Barney plays the central protagonist with a supporting cast of ambiguously gendered fairies, Busby Berkeley-style chorus girls or horse-riding mounties. Each film is packed with obscure symbols and actions which suggest sexual reproduction while shrouding it in mystery. The work is named after the Cremaster muscle, which controls the raising and lowering of the testicles and is also responsible for the descent of the reproductive organs at fetal stage. As such, it can be read as an elaborate allegory about the process of sexual differentiation. But this reading is obscured by the vast accumulation of other references in each work, drawn from local culture, recent popular history or Barney's own personal history to create a multi-levelled mythological narrative with its own unique heroes, symbols and rituals.

Jedes Detail in den opulenten Skulpturen und Filmen von Matthew Barney – von Farbe, Form und Material bis zu den Kostümen, der Figurenzeichnung oder dem Schauplatz – ist Bestandteil eines Codes, der eine komplex angelegte Parallelwelt konstituiert. In seinem Frühwerk unterzog Barney sich der körperlichen Strapaze, die Wände und die Decke einer Galerie nackt zu erklettern (*Blind Perineum,* 1991), dabei die Themen der Geschlechteridentität und des Körperkults auslotend, die bis heute im Mittelpunkt seiner Arbeit stehen. Seit 1994 beschäftigt sich Barney vor allem mit seinem *CREMASTER*-Zyklus, einem fünfteiligen Drama von wagnerischen Dimensionen. Jede dieser Arbeiten besteht aus einem Film, einer Gruppe von Objekten sowie einem Buch mit Standfotos und hat ein bestimmtes symbolisch aufgeladenes Umfeld, das ihre Atmosphäre, ihr formales Erscheinungsbild und ihren Gehalt definiert. Auch wenn seine Filme kaum Dialoge haben, kommt Barney in ihrer narrativen Struktur die Hauptrolle zu; Nebenrollen spielen geschlechtsunspezifische Feen, in Busby-Berkeley-Manier agierende Chormädchen oder auch berittene Polizisten. Jeder der Filme verweist mit einer Vielzahl obskurer Symbole und Handlungen auf die sexuelle Fortpflanzung und umgibt sie zugleich mit einem Geheimnis. Benannt ist der Zyklus nach den Kremaster-Muskeln, die das Anheben und Absenken der Hoden ermöglichen, die aber auch den Austritt der männlichen Geschlechtsorgane beim Fötus bewirken. So gesehen lässt sich der Zyklus auch als subtile Allegorie auf den Prozess der sexuellen Differenzierung deuten. Diese Lesart wird in sämtlichen Filmen durch eine Vielzahl anderer Verweise relativiert, die Barney verschiedenen Kulturen, der neueren Populär-Geschichte und seiner persönlichen Biografie entnimmt. Auf diese Weise erschafft er eine vielschichtige mythologische Erzählung mit ganz eigenen Helden, Symbolen und Ritualen.

Les moindres détails des somptueux films et sculptures de Matthew Barney – de la couleur, des formes et des matériaux aux costumes, aux personnages et aux sites – font partie d'un code qui constitue un monde parallèle imaginaire et complexe. Dans ses premières œuvres, Barney se soumettait à des épreuves d'endurance physique, telle qu'escalader les murs et le plafond d'une galerie entièrement nu (*Blind Perineum,* 1991), explorant les thèmes de l'identité sexuelle et de l'athlétisme qui restent au cœur de son travail. Depuis 1994, Barney a été accaparé par sa série *CREMASTER,* une dramatique en cinq parties aux proportions wagnériennes. Chaque partie comprend un film, un groupe d'objets, un livre de photographies et dispose d'un décor symbolique spécifique qui définit son atmosphère, son aspect formel et son contenu. Bien qu'il y ait peu de dialogue, les films ont une structure narrative où Barney joue le rôle principal entouré d'une distribution de fées sexuellement ambiguës, de girls à la Busby Berkeley ou de membres de la police montée canadienne. Chaque film est rempli de symboles et d'actions obscures qui suggèrent la reproduction sexuelle tout en la nimbant de mystère. L'œuvre tient son nom du muscle cremaster, qui contrôle la levée et la descente des testicules et est également responsable de la descente des organes génitaux au stade fœtal. En tant que tel, on peut y voir une allégorie sophistiquée sur la différentiation sexuelle. Mais cette lecture est obscurcie par l'accumulation d'autres références dans chaque œuvre, puisées dans la culture locale, l'histoire populaire récente ou l'histoire personnelle de Barney lui-même, pour former un récit mythologique à couches multiples avec ses propres héros, symboles et rituels.

K. B.

SELECTED EXHIBITIONS →
1996 *CREMASTER 1* and *CREMASTER 4,* San Francisco Museum of Modern Art, San Francisco (CA), USA **1997** *CREMASTER 5,* Portikus, Frankfurt am Main, Germany **1998** *CREMASTER 5,* Fundació "la Caixa", Barcelona, Spain; *Wounds: Between Democracy and Redemption in Contemporary Art,* Moderna Museet, Stockholm, Sweden **1999** *CREMASTER 2,* Walker Art Center, Minneapolis (MN), USA **2001** *Public Offerings,* Los Angeles Museum of Contemporary Art (CA), USA **2002** The Cremaster Cycle, Museum Ludwig, Cologne, Germany

SELECTED BIBLIOGRAPHY →
1995 *MATTHEW BARNEY: CREMASTER 4,* Fondation Cartier pour l'Art Contemporain, Paris **1997** *MATTHEW BARNEY: CREMASTER 5,* Portikus, Frankfurt am Main; *MATTHEW BARNEY: CREMASTER 1,* Kunsthalle Wien, Vienna/Museum für Gegenwartskunst Basel, Basle **1999** *MATTHEW BARNEY: CREMASTER 2,* Walker Art Center, Minneapolis (MN); Burkhard Riemschneider/Uta Grosenick (eds.), *Art at the Turn of the Millennium,* Cologne

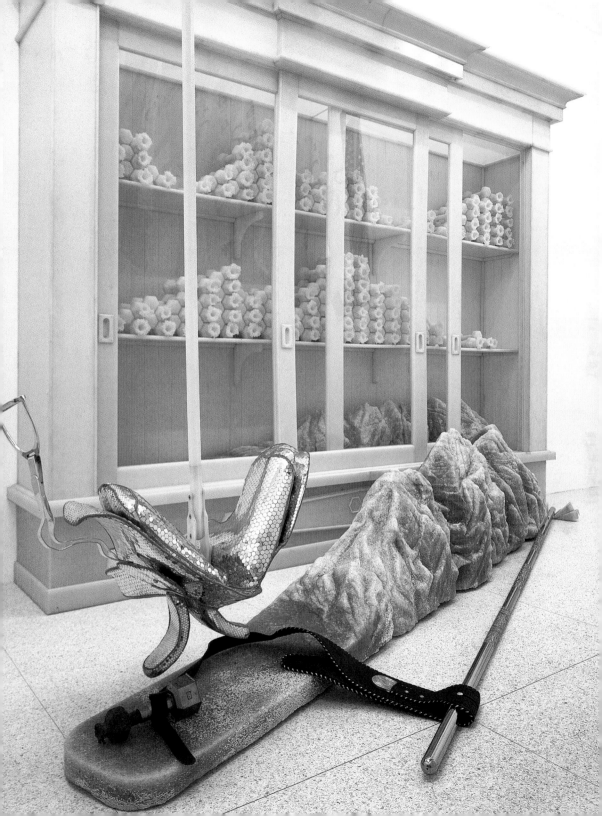

1 **CREMASTER 2: The Drone's Exposition,** 1999, mixed media sculpture installation including 35 mm film transferred from HDTV, 12 c-prints and 5 drawings in acrylic frames

2 **CREMASTER 1: Goodyear Field,** 1996, mixed media installation, overall 823 x 681 x 137 cm

3 **CREMASTER 4: The Isle of Man,** 1994/95, mixed media installation, overall 610 x 914 cm

4 **CREMASTER 2: Genealogy,** 1999, c-print in acrylic frame, 71 x 60 cm

5 **CREMASTER 1: Goodyear Chorus,** 1995, c-print in self-lubricating plastic frame, 111 x 137 cm

„Mir erscheint meine Arbeit nicht sonderlich merkwürdig. Entscheidend ist doch nur die Disziplin, eine Idee in all ihren Möglichkeiten auszuloten, ihre äußersten Grenzen zu erkunden."

« Je ne trouve pas que mon travail soit si étrange. L'important est d'avoir la discipline d'aller jusqu'au bout d'une idée, de l'étirer jusqu'au bout de ses limites. »

"I don't think my work is so strange. It's just a matter of having the discipline to go the whole way with an idea, to stretch it as far as it can go."

2

3

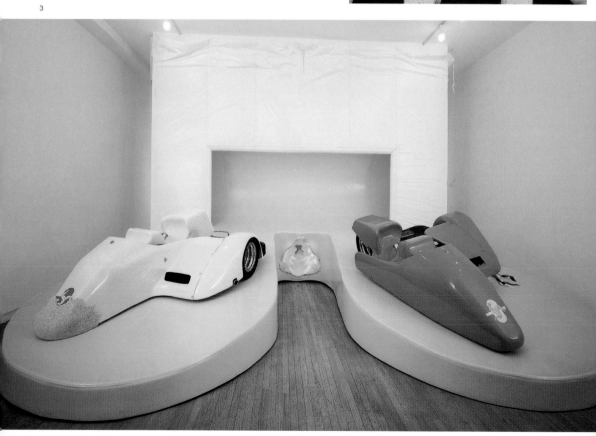

4

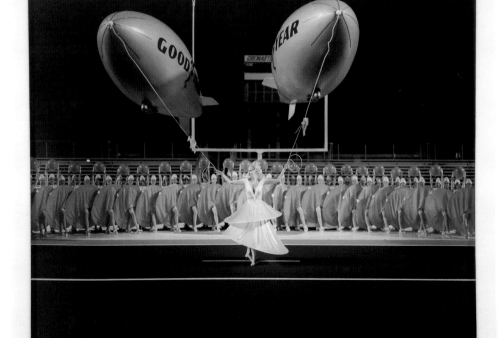

John Bock

1965 born in Gribbohm, lives and works in Berlin, Germany

John Bock is first and foremost a performance artist. He defines his comic, absurd, enigmatic performances as *Aktionen*, or "happenings". They cover a wide range of genres, from rustic buffoonery through complex didactic plays and multimedia psychodramas. Bock designs rough-and-ready costumes for himself and his troupe. The crude sets with simple props, many of them bits of junk, create the sometimes harmonious, sometimes totally incongruous backdrop to shows which, like a virus, run completely out of control. In these settings occupying large areas of space, the former student of economics reels off impenetrable formulae to explain the relationship between creativity and economics. For example, he soaps himself with unfeasibly generous quantities of shaving foam, or carries out deadly serious scientific experiments, some of them on himself. In the various performances staged throughout the duration of exhibitions of his work, he gives cryptic "lectures", plays schmaltzy records, and shows baffling videos. Crucial to these almost incomprehensible happenings is the fact that, as in the happenings of the 1960s and 1970s, there is no internal logic between the perplexing but seemingly autonomous subjects. Instead, we have a fanciful, sometimes manic analytical process in which the dogmatic Freudian view of the subconscious is placed under an aesthetic microscope. Bock does not perform dismal dramas of identity, but colourful burlesques like *ArtemisiaSogJod→Meechwimper lummering*, 2000, an incredible insight into the motivations that drive us.

John Bock ist vor allem ein Performancekünstler; er selbst bezeichnet seine so komisch-absurden wie hintergründigen Auftritte schlicht als „Aktionen". In diesen „Aktionen", die diverse Genres wie rustikalen Schwank, komplexes Lehrstück oder polymorph-perverses Psychodrama zitieren, treten der Künstler und seine Mitspieler in kruden, von Bock selbst entworfenen Kostümen auf. Aus einfachen, oftmals gefundenen Materialien gestaltete Bühnenbilder sorgen für den passend unpassenden Rahmen für die wie ein Virus wuchernden Schauspiele. In diesen raumgreifenden Settings erklärt der ehemalige Betriebswirtschaftsstudent mit für den Verstand unbegreiflichen Formeln den Zusammenhang von Kreativität und Ökonomie, lässt sich etwa mit einer Unmenge Rasierschaum einseifen oder führt todernst paradoxe wissenschaftliche Experimente und Selbstversuche durch. Kryptische Lesungen finden statt, sentimentale Schallplatten werden aufgelegt, und verwirrende Videos dokumentieren anschließend im Laufe der jeweiligen Ausstellung die ästhetischen Aktionen, die der Künstler während ihrer Eröffnung vorgeführt hat. Entscheidend an diesen kaum wirklich zu interpretierenden Aktionen ist, dass es bei ihnen nicht mehr – wie in vielen Performances vor allem in den sechziger und siebziger Jahren – um die psychische Logik von krisengeschüttelten, aber scheinbar autonomen Subjekten geht. Stattdessen steht hier die lustvolle, bisweilen manische Auflösung einer freudianisch vorgeschriebenen „diktatorischen Konzeption des Unterbewussten" auf dem ästhetischen Prüfstand. Nicht die Dramen trister Identität werden von Bock vorgespielt, sondern bunte Travestien, die wie ein *ArtemisiaSogJod→Meechwimper lummering*, so der Titel einer Aktion Bocks (*2000*), unglaubliche Einblicke in unseren Triebhaushalt erlauben.

John Bock est avant tout performer. Lui-même qualifie simplement d'« actions » ses interventions aussi profondes qu'absurdes et comiques. Dans ces actions, qui abordent des genres aussi différents que la farce paysanne, la pièce didactique complexe ou le psychodrame polymorphe et pervers, l'artiste et ses acolytes se présentent en costumes crus dessinés par Bock lui-même. Des décors réalisés à partir de matériaux simples, souvent trouvés par hasard, assurent un cadre aussi approprié qu'inapproprié pour ces pièces pullulantes comme une infection virale. Dans des compositions investissant tout l'espace, cet ancien étudiant en économie développe alors les liens entre créativité et économie en des formules qui échappent à l'entendement ; il se laisse ainsi enduire d'une énorme quantité de mousse à raser ou réalise avec un flegme imperturbable des expériences scientifiques paradoxales ou portant sur sa propre personne. Dans les expositions corollaires, des lectures sibyllines, des disques vinyles sentimentaux et des vidéos ahurissantes illustrent ensuite les actions esthétiques présentées pendant l'inauguration. Dans ces actions défiant toute interprétation, loin de la logique psychique de tant de performances des années 1960 et 1970, où des individus apparemment autonomes étaient secoués par une crise intérieure ou sociale, le facteur décisif est ici la dissolution ludique, voire obsessionnelle, des dogmes freudiens d'une « conception dictatoriale de l'inconscient » mis à l'épreuve de l'esthétique. Bock ne nous propose pas en effet les drames d'une tristesse identitaire, mais des travestissements hauts en couleurs qui, tel ce *ArtemisiaSogJod→Meechwimper lummering*, – titre d'une action (*2000*) –, ouvrent de stupéfiantes perspectives sur le jardin de nos pulsions. R. S.

SELECTED EXHIBITIONS →
1998 *1. berlin biennale*, Berlin, Germany **1999** Kunsthalle Basel, Basle Switzerland; Anton Kern Gallery, New York (NY), USA; *Home & Away*, Kunstverein, Hanover, Germany; *German Open*, Kunstmuseum Wolfsburg, Germany; *48. Biennale di Venezia*, Venice, Italy **2000** *Floß*, Gesellschaft für Aktuelle Kunst, Bremen, Germany; *Aller Anfang ist Merz*, Sprengel Museum, Hanover, Germany **2001** *Im Dilemma der ExistoEntropie*, Bonner Kunstverein, Bonn, Germany

SELECTED BIBLIOGRAPHY →
1999 *John Bock*, Kunsthalle Basel, Basle; *Home & Away*, Kunstverein, Hanover **2001** *Le Repubbliche dell'Arte Germania*, Siena; *John Bock. Gribbohm*, Bonner Kunstverein, Bonn/Gesellschaft für Aktuelle Kunst, Bremen

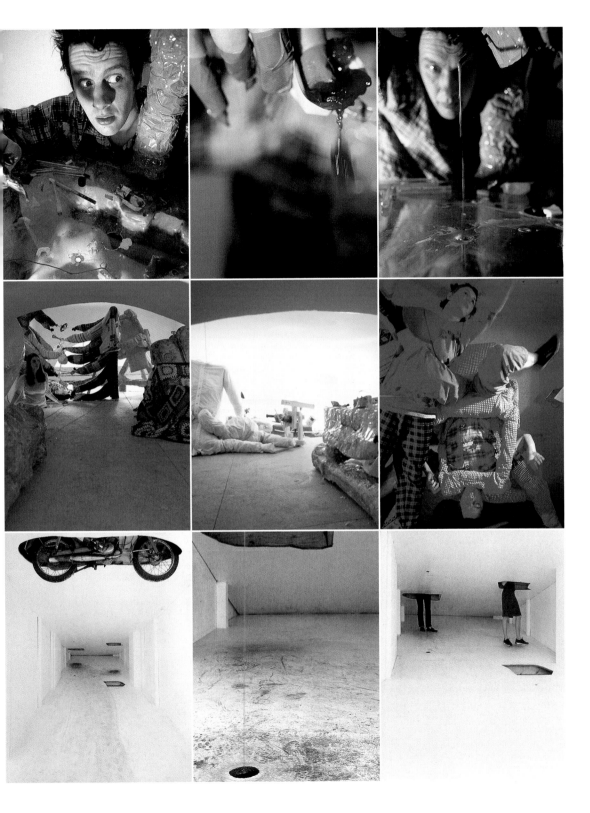

1 **ArtemisiaSogJod→Meechwimper lummering,** 2000, installation 2 **Lombardi Bängli,** 1999, installation and performance,
 and performance, Klosterfelde, Berlin Kunsthalle Basel

„NachschlageWERK schweige stille." « ŒUVRE de référence ne dis rien. »

"You won't find it in the dictionary."

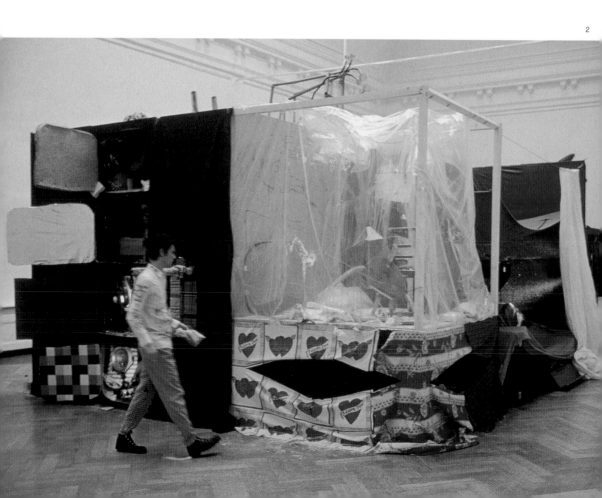

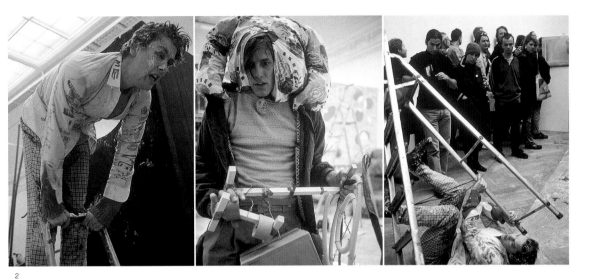

2

2

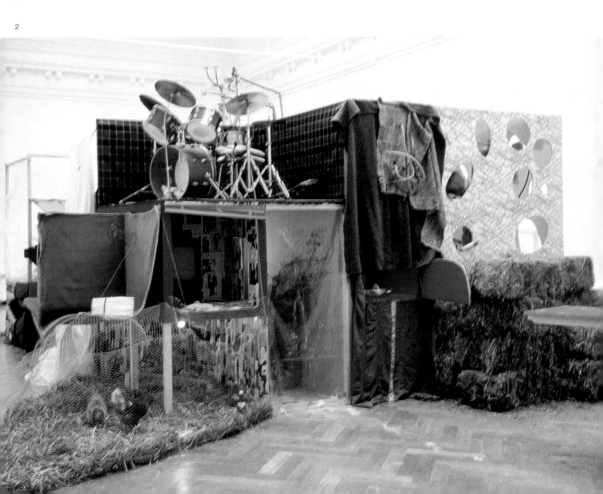

Cosima von Bonin

1962 born in Mombasa, Kenya, lives and works in Cologne, Germany

Cosima von Bonin is one of the most idiosyncratic players on the contemporary art scene. Since her début in the early 1990s, she has developed her own poetic language. Paintings, sculptures, installations, films and performances – her work is not confined to any single medium or material. Using textiles such as wool, cotton, linen, loden, felt, silk and velvet, she sews together or embroiders soft, delicate fabrics. Hers is art that has no need of a paintbrush. Cute, loden-covered mushrooms sprout from gallery floors; *Hermès*, 2000, presents surreally swollen Prada and Hermès handbags fashioned from felt. Her huge wall hangings made from stitched-together handkerchiefs are reminiscent of Sigmar Polke. Bonin puts materials together. She makes things and people work together. Her exhibitions repeatedly refer to artistic models which she integrates into her own work, which defies any stylistic or thematic classification. Bonin always invites other artists and friends to her exhibitions, turning them into family gatherings. Her work is all about communication and she places group interaction above the demands of art. Bonin's work not only fills space, it also extends over time, like a book whose pages are turned one by one. She tells stories and creates narrative stage sets, like her 1997 installation *Löwe im Bonsaiwald* (Lion in the Bonsai Forest). The viewer is led along a series of forking, corridor-like paths, pushing material aside in order to reach an ever more distant point. Those who are prepared to become completely involved gain the greatest pleasure from Bonin's art.

Zu den prägnantesten Protagonisten der Gegenwartskunst zählt Cosima von Bonin. Seit ihrem ersten Auftreten zu Beginn der neunziger Jahre hat sie ihre eigene poetische Sprache entwickelt. Bilder, Skulpturen, Installationen, Filme und Performances – auf kein Medium beschränkt sie ihr Werk, auf kein Material. Wir erleben Textilien wie Wolle, Baumwolle, Leinen, Loden, Filz, Seide oder Samt. Die schwachen, weichen Materialien werden vernäht und bestickt: Kunst, die auf den Pinsel verzichtet. Niedliche, mit Loden bespannte Pilze wuchern aus Galerieböden, Handtaschen von Prada und Hermès werden surreal vergrößert und in Filz ausgeführt (*Hermès*, 2000), große Wandarbeiten aus zusammengenähten Taschentüchern erinnern an Sigmar Polke. Bonin stellt Materialien zusammen. Sie lässt Dinge und Leute miteinander arbeiten; immer wieder finden sich in ihren Ausstellungen Verweise auf künstlerische Vorbilder, die in ihre eigenen Werke integriert werden. Sie selber entzieht sich einer stilistischen oder thematischen Einordnung. Bonin lädt immer wieder Künstler und Freunde zu ihren Ausstellungen ein, die dadurch zu Familienfesten werden. Diese Geste der Künstlerin, die den Gruppenbezug ihrer Arbeit über den Kunstanspruch stellt, macht die Kommunikation untereinander zum Gegenstand ihres Werkes. Bonin füllt mit ihren Arbeiten nicht allein den Raum, sie erstrecken sich in der Zeit, wie ein Buch im Nacheinander von Seite um Seite erschlossen wird. Geschichten, sprechende Kulissen: Ihre Installation *Löwe im Bonsaiwald* von 1997 ist eine Bühne; Wege führen wie Schneisen durch die Präsentation, schieben das Material beiseite, teilen sich vor dem Betrachter, der Bonin bis zu einem immer entfernter liegenden Punkt folgt. Das volle Vergnügen genießt, wer sich ganz auf ihre Objekte einlassen kann.

Cosima von Bonin compte parmi les protagonistes les plus marquants de l'art contemporain. Depuis sa première apparition au début des années 1990, elle n'a cessé de développer son propre langage poétique. Tableaux, sculptures, installations, films et performances – son travail ne se limite ni à aucun médium ni à aucun matériau particulier. Nous relevons la présence de toutes sortes de textiles : laine, coton, lin, loden, feutre, soie, velours. Ces matériaux souples et doux sont cousus et brodés : l'art de Bonin se passe volontiers du pinceau. De ravissants champignons tendus de loden jaillissent du sol des galeries, des sacs à main de chez Prada ou Hermès prennent des proportions surréalistes et sont exécutés en feutre (*Hermès*, 2000), de grandes œuvres murales faites de mouchoirs cousus ensemble rappellent certaines œuvres de Sigmar Polke. Bonin combine des matériaux. Elle fait collaborer les choses et les gens ; dans ses expositions, on trouve toujours des références à des modèles artistiques qu'elle intègre dans son propre travail. Elle-même échappe en revanche à toute classification stylistique ou thématique. Bonin lance toujours des invitations, à des artistes, à des amis. Cela transforme ses expositions en grandes fêtes familiales. La démarche de l'artiste, qui fait de la référence au groupe une priorité par rapport à sa revendication artistique personnelle, a pour objet la communication. Les œuvres de Bonin n'occupent pas seulement l'espace, elles s'étendent aussi dans le temps, comme on s'approprie un livre au fil des pages. Histoires, décors parlants : son installation *Löwe im Bonsaiwald* (Lion dans la forêt de bonsaïs, 1997) est une scène ; des parcours traversent cette présentation comme des layons et se fraient un chemin à travers le matériau qu'ils écartent, se séparent devant le spectateur, qui suit Bonin vers un point toujours plus éloigné. Tout le plaisir est pour le spectateur capable de s'investir pleinement dans ses objets. F. F.

SELECTED EXHIBITIONS →
1996 *Heetz, Nowak, Rehberger*, Städtisches Museum Abteiberg, Mönchengladbach, Germany; *Glockengeschrei nach Deutz*, Galerie Daniel Buchholz, Cologne, Germany **1998** *mai 98*, Josef-Haubrich-Kunsthalle, Cologne, Germany **1999** *Wyoming*, Kunsthalle St. Gallen, Switzerland; *German Open*, Kunstmuseum Wolfsburg, Germany **2000** *The Cousins*, Kunstverein Braunschweig, Germany **2001** *Bruder Poul sticht in See*, Kunstverein in Hamburg, Germany; Moderna Museet, Stockholm, Sweden; *Vom Eindruck zum Ausdruck – Grässlin*

Collection, Deichtorhallen Hamburg, Germany

SELECTED BIBLIOGRAPHY →
2000 *The Cousins*, Kunstverein Braunschweig; Dimitrios Georges Antonitsis (ed.), *Summer Camp - Camp Summer*, Hydra; *Rabbit at Rest*, Ursula-Blickle-Stiftung, Kraichtal

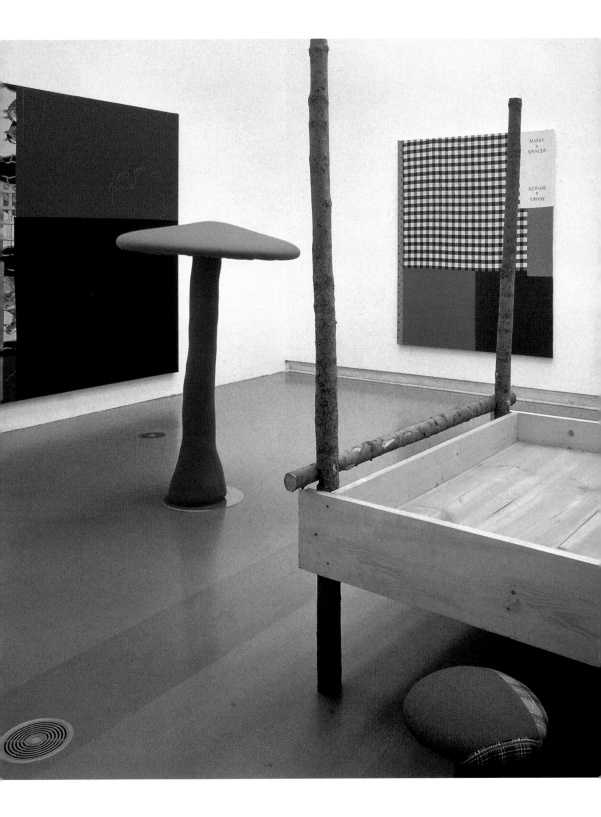

„Stets die Brautjungfer – niemals die Braut."

« Toujours la demoiselle d'honneur – jamais la mariée. »

"Always the bridesmaid – never the bride."

2

3

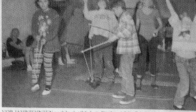

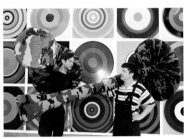

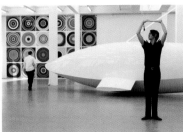

4

5

6

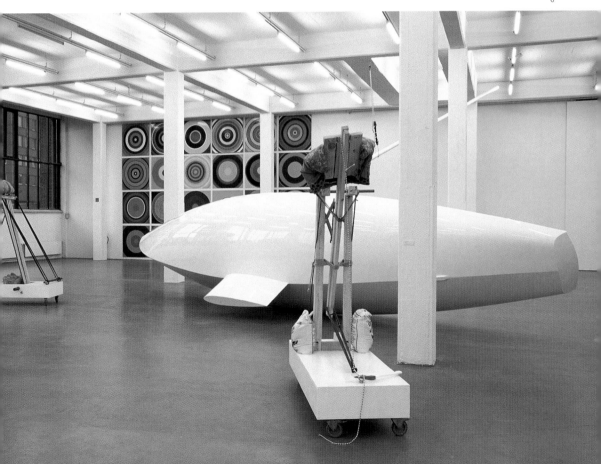

Candice Breitz

1972 born in Johannesburg, South Africa, lives and works in New York (NY), USA

In an age in which globalisation impinges on every aspect of our lives, photographic and video artist Candice Breitz uses her art to deal with themes of personal identity, cultural difference and ethnic variety. In her powerful montages, as politically committed as they are erratic, the white South African artist constantly draws disturbingly on the imagery of international pop culture. Typical of her strategy are photomontages like *Rainbow Series*, 1996. Here, Breitz follows the tradition of Surrealist collages, piecing together pornographic and ethnographic fragments to form images of the human body. For example, she fuses the upper body of a black woman with the pubic hair of a white porno-star to form a bewildering jigsaw, which is both a critique of the power of the exotic to arouse sexual desire and a comment on the impossibility of clearly delineated identity. Instead of showing the usual effect of globalisation, which is to obscure cultural differences, the artist here explicitly juxtaposes these differences to stress both their potential and their problems. In her video *Babel Series*, 1999, Breitz explores the tension between different languages. She recorded short sequences made up of a range of musical clips, in which artists like Madonna, Sting and Grace Jones sing brief sets of sounds like "da da da" or "pa pa pa" which she then spliced together into endless loops. A multilingual cacophony like something out of the Tower of Babel issues from seven monitors. The individual voices meld into a single one, underlining the total meaninglessness of what they are singing.

Die Foto- und Videokünstlerin Candice Breitz behandelt in ihrer Kunst vor allem Themen der subjektiven Identität, kulturellen Differenz und ethnografischen Vielfalt im Zeitalter einer in alle Lebensbereiche eingreifenden Globalisierung. In ihren eindringlichen, so engagierten wie erratischen Bildmontagen verfremdet die weiße Südafrikanerin immer wieder vorgefundenes Material aus der internationalen Welt der Populärkultur. Typisch für ihre künstlerische Strategie sind zum Beispiel die Fotomontagen aus *Rainbow Series*, 1996: Breitz hat hier in der Tradition surrealistischer Collagen pornografische und ethnografische Fragmente zu neuen körperähnlichen Gebilden zusammengesetzt. Schwarze Frauenoberkörper und die Schamhaare einer weißen Pornoakteurin etwa fügen sich zu einem verwirrenden Puzzle zusammen, das von der Erotisierung des Fremden genauso erzählt wie von der Unmöglichkeit einer ungebrochenen und stringenten Identität. Statt die Unterschiede verschiedener Kulturen, wie in der Globalisierung üblich, zu vertuschen, werden sie hier durch ihr direktes Aufeinandertreffen potenziert und zugleich problematisiert. Auch in ihrer Videoarbeit *Babel Series*, 1999, geht es Breitz um die Spannung zwischen unterschiedlichen Sprachen. Aus diversen Musikclips hat sie kurze Sequenzen entnommen, in denen zum Beispiel Madonna, Sting und Grace Jones kurze Lautfolgen wie "da da da" oder „pa pa pa" singen, und sie zu endlosen Loops zusammengeschnitten. Von sieben Monitoren erklingt ein babylonisches Sprachgewirr, dessen einzelne Stimmen nur eines verbindet: die absolute Sinnlosigkeit ihrer Aussage.

Dans son travail, la photographe et vidéaste Candice Breitz traite les thèmes de l'identité subjective, de la différence culturelle et de la diversité ethnographique à l'ère d'une mondialisation intervenant dans tous les domaines de la vie. Dans ses montages photographiques saisissants, aussi engagés qu'erratiques, l'Africaine du Sud de race blanche détourne sans cesse des matériaux trouvés issus de l'univers de la culture populaire à l'échelle planétaire. Un aspect caractéristique de sa stratégie apparaît notamment dans les photomontages des *Rainbow Series*, 1996, qui recomposent, à partir de fragments pornographiques et ethnographiques, des figures plus ou moins corporelles traitées dans la tradition surréaliste. Des torses de femmes noires et les poils pubiens d'une actrice porno noire y composent un puzzle troublant qui parle aussi bien de l'érotisation de l'étranger que de l'impossibilité de créer une identité homogène valide. Ici, plutôt que de gommer les différences entre les cultures, comme le fait constamment la globalisation, celles-ci sont au contraire accentuées et problématisées par leur collision. Dans une vidéo comme *Babel Series*, 1999, Breitz travaille sur la tension entre différentes langues. L'artiste a extrait de plusieurs clips vidéo de brèves séquences dans lesquelles Madonna, Sting ou Grace Jones chantent de courtes suites de sons comme « da da da » ou « pa pa pa », puis les a mises en boucle. Sept moniteurs diffusent dès lors un brouhaha proprement babylonien des langues, dans lequel les voix isolées sont uniquement liées par l'insignifiance absolue de leur message.

R. S.

SELECTED EXHIBITIONS →
1997 *2nd Johannesburg Biennale*, Cape Town, South Africa
1999 Rüdiger Schöttle Galerie, Munich, Germany; *Global Art 2000*, Museum Ludwig, Cologne, Germany **2000** Chicago Project Room, Chicago (IL), USA; Art & Public, Geneva, Switzerland; *Taipeh Biennale 2000*, Taipeh, Taiwan; *Kwangju Biennale*, Kwangju, South Korea **2001** Henry Urbach Gallery, New York (NY), USA; Kunstmuseum St. Gallen, Switzerland; *Tele(Visions)*, Kunsthalle Wien, Vienna, Austria

SELECTED BIBLIOGRAPHY →
2000 *Die verletzte Diva*, Munich **2001** *Candice Breitz Cuttings*, Offenes Kulturhaus/Centrum für Gegenwartskunst Oberösterreich, Linz; *Monet – Ordnung und Obsession*, Hamburg

42

„Der Ausdruck der Unterschiede, die an den Grenzen der Dinge wirksam werden, findet sein ästhetisches Gegenstück in der Fotomontage."

« L'expression de la différence que révèle la limite a son pendant esthétique dans le photomontage. »

"The expression of the differences created on the boundaries between things finds its aesthetic counterpart in photomontage."

2

3

4

Glenn Brown

1966 born in Hexham, lives and works in London, UK

Some contemporary artists recognise an attitude in the art of the Surrealist movement that seems completely relevant today, and this is an opinion that Glenn Brown presumably agrees with. Frank Auerbach meets Salvador Dalí in his canvases, since Brown has appropriated their works indiscriminately from photographs. Brown "presents" painting, he gives new life to a historic practice, and at the same time he infiltrates it when he paints what look like photographic replicas of the works of other artists. He takes his references from the élite sphere of high art as well as the user-friendly mainstream and easily blends sources from different centuries in his paintings. His smooth, flat representations of works by famous colleagues raise the issues of authorship, authenticity and originality. His works are not exact replicas of famous paintings by Fragonard, Rembrandt, van Gogh or de Kooning. He carefully manipulates them: colours are heightened, certain details added or subtracted, and crucially, any texture is wiped away in favour of a closed surface that is as unremittingly flat as a photograph. Brown eliminates any trace of his own hand and cites contexts beyond the pictures themselves. His version of a Fragonard, for example, is called *Disco*, 1997/98; a Rembrandt portrait is entitled *I Lost my Heart to a Star Ship Trooper*, 1996. Science fiction livens up many of his paintings. Floating asteroids and futuristic cities are enlarged to an epic scale and found in paintings such as *The Tragic Conversion of Salvador Dalí (after John Martin)*, 1998. Here, Brown re-works the style of 19th-century painter John Martin with elements of Chris Foss, a popular sci-fi illustrator. And the message the viewer takes away is that great visions require great gestures.

In der Kunst des Surrealismus erkennen manche Zeitgenossen eine der Jetztzeit verwandte Geisteshaltung – eine Sichtweise, der der englische Maler Glenn Brown vermutlich zustimmen würde. Auf seinen Leinwänden treffen Frank Auerbach und Salvador Dalí aufeinander, deren Werke sich Brown unterschiedslos nach fotografischen Vorlagen aneignet. Brown präsentiert Malerei: Er belebt die historische Praxis und unterwandert sie zugleich, wenn er fotorealistische Bilder nach den Vorlagen anderer Künstler malt. Er findet seine Referenzen in der elitären Hochkunst wie im publikumsnahen Mainstream und mixt mühelos Jahrhunderte. Seine glatten, flachen Darstellungen von Arbeiten berühmter Kollegen stellen die Frage nach Autorschaft, Authentizität und Originalität. Seine Arbeiten sind keine exakten Kopien der berühmten Arbeiten von Fragonard, Rembrandt, van Gogh oder de Kooning. Er hat sie sorgfältig manipuliert: Farben wurden aufgehellt, bestimmte Details hinzugefügt oder entfernt, und vor allem ist jede Textur weggewischt zugunsten einer geschlossenen Oberfläche, gleichförmig wie eine Fotografie. Brown eliminiert jede Spur einer eigenen Handschrift und verweist auf Zusammenhänge, die den Rahmen des Bildes verlassen. Seine Version eines Fragonard heißt beispielsweise *Disco*, 1997/98, ein Rembrandt-Porträt *I Lost my Heart to a Star Ship Trooper*, 1996. Sciencefiction belebt einen Großteil seiner Gemälde. Flottierende Asteroide und futuristische Städte sind in einem epischen Maß aufgeblasen in Bildern wie *The Tragic Conversion of Salvador Dalí (after John Martin)* von 1998, in dem Brown den Stil des Malers John Martin aus dem 19. Jahrhundert mit dem des aktuell populären Sciencefiction-Illustrators Chris Foss mischt. Große Visionen brauchen große Gesten, sagen die Bilder von Brown.

Certains contemporains identifient dans l'art surréaliste une attitude apparentée à celle de notre époque – un regard auquel le peintre anglais Glenn Brown ne manquerait sans doute pas de souscrire. Dans ses toiles, on assiste à la rencontre entre Frank Auerbach et Salvador Dalí, dont Brown s'approprie les œuvres inchangées à partir de photographies. Brown présente de la peinture. En peignant des tableaux photoréalistes d'après les modèles proposés par d'autres artistes, il donne vie à la pratique historique tout en la minant. Il puise ses références aussi bien dans un art élitiste que dans le courant populaire dominant et mélange les siècles avec aisance. Ses représentations planes et léchées des œuvres de collègues célèbres reposent la question de l'auteur, de l'authenticité et de l'originalité. Ses œuvres ne sont pas les copies exactes de peintures célèbres de Fragonard, de Rembrandt, de van Gogh ou de de Kooning. Elles sont soigneusement manipulées par l'artiste : les couleurs ont été rehaussées, certains détails ont été ajoutés ou supprimés, et surtout, toute texture a été supprimée au profit d'une surface hermétique, uniforme comme une photographie. Brown fait disparaître toute trace d'écriture personnelle et fait référence à des contextes extra-picturaux. Ainsi, sa version d'un Fragonard s'appelle *Disco*, 1997/98, un portrait de Rembrandt est intitulé *I Lost my Heart to a Star Ship Trooper*, 1996. La science-fiction anime une grande partie de ses peintures. Des astéroïdes flottants et des villes futuristes sont amplifiées jusqu'à l'épique dans des tableaux comme *The Tragic Conversion of Salvador Dalí (after John Martin)*, 1998, dans lequel Brown mélange le style de John Martin, un peintre du 19ème siècle, avec celui de l'illustrateur de science-fiction contemporain Chris Foss. Comme le disent les tableaux de Brown, les grandes visions requièrent de grandes poses.

F. F.

SELECTED EXHIBITIONS →
1994 *Here and Now*, Serpentine Gallery, London, UK **1995** *Brilliant!*, Walker Art Center, Minneapolis (MN), USA **1997** *Sensation*, Royal Academy of Arts, London, UK **1998** Patrick Painter Inc., Los Angeles (CA), USA **1999** *Examining Pictures: Exhibiting Paintings*, Whitechapel Art Gallery, London, UK; **2000** *The British Art Show 5*, Hayward Gallery, London, UK; *Hypermental*, Hamburger Kunsthalle, Hamburg, Germany **2001** Patrick Painter Inc., Los Angeles; Galerie Max Hetzler, Berlin, Germany **2002** *Biennale of Sydney*, Australia

SELECTED BIBLIOGRAPHY →
1997 *Glenn Brown*, Queens Hall Arts Centre, Hexham **2000** *Glenn Brown*, Centre d'Art Contemporain du Domaine de Kerguéhennec, Bignan

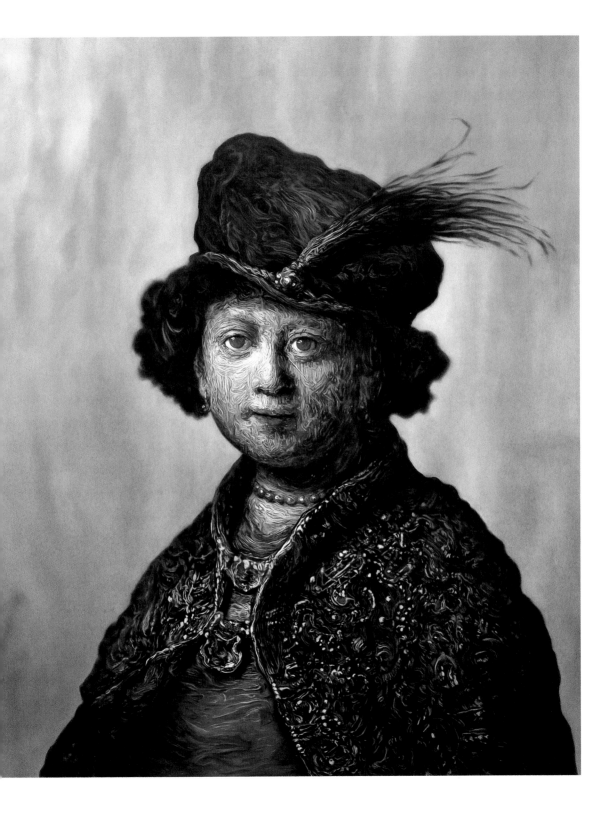

1 **Joseph Beuys,** 2001, oil on panel, 96 x 80 cm
2 Installation view, Domaine de Kerguéhennec, France, 2000;
 left to right: **Jesus; The Living Dead (after Adolf Schaller),** 1998, oil on
 canvas; **The Andromeda Strain,** 2000, oil and acrylic paint on plaster;
 Böcklin's Tomb (after Chris Foss), 1998, oil on canvas

3 **Little Deaths,** 2000, oil on panel, 68 x 54 cm
4 **Life without Comedy,** 2001, oil on panel, 69 x 53 cm
5 **It's a Curse It's a Burden,** 2001, oil on panel, 105 x 75 cm

„Ich wähle Künstler aus, die mir gefallen und meiner Ansicht nach nicht
genügend Anerkennung finden."

« Je choisis des artistes que j'aime et ceux que je considère sous-estimés. »

"I pick artists I like and those that I feel aren't given enough credit."

2

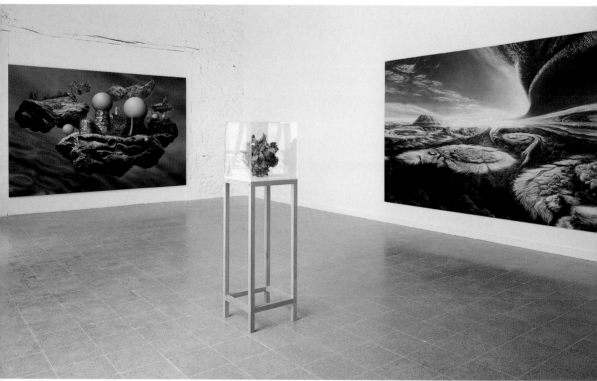

3

4

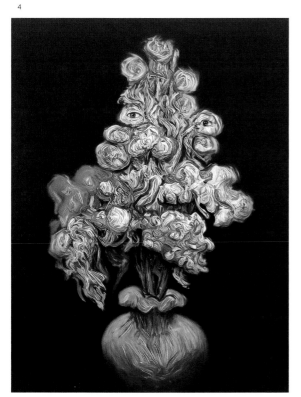

5

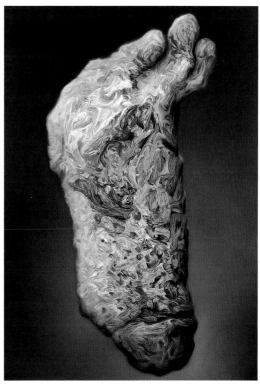

Angela Bulloch

1966 born in Fort Frances, Canada, lives and works in London, UK, and Berlin, Germany

Angela Bulloch creates binary systems in space, which operate on the "on-off" principle. For example, with *Video Sound Systems*, 1997, when the viewer sits on the "sound clash bench" to watch the monitor, the pressure on the seat turns the sound on. In *Betaville*, 1994, a "drawing machine" tracing vertical lines switches to horizontal ones, while the viewer is seated in front of it. Bulloch's understanding of participation is based on the perception of the viewer as a social being, who radiates physical impulses, and on the behaviourist concept of stimulus and response. In her *Rules Series* – sets of rules of how to behave in specific situations which are mounted on the wall or on display panels – she is also exploring patterns of social behaviour in the context of institutional power structures. The new complex of pixel works uses digitally controlled light boxes to probe the interactive relations between the production and reception of visual images. In her *Prototypes* series, she stacks specially created pixel monitors in 50 x 50 x 50 cm format, which light up in the 16 million colours of an 8-bit monitor. Some of Bulloch's work reflects her interest in theories of how the electronic media affect ways of seeing. For example, for *BLOW UP T. V.*, 2000, she uses a brief still from Michelangelo Antonioni's film "Blow Up", reducing the resolution to 17 pixels. The scenes that appear on the monitors become completely unrecognisable. Here, she is referring to the possibilities of changing perception through technological means and the way in which the act of enlarging an image can both reveal and conceal its content.

Angela Bulloch schafft binäre Systeme im Raum, die nach dem Prinzip von „on" und „off" funktionieren. So schaltet sich beim Setzen auf die „sound clash benches" der Ton zu dem auf einem Monitor gezeigten Video ein (*Video Sound Systems*, 1997), oder eine „drawing machine" wird in Gang gesetzt, deren sonst senkrechte Linienführung während der Sitzdauer waagerecht verläuft (*Betaville*, 1994). Bullochs Verständnis von Partizipation beruht darauf, dass der Betrachter ein soziales Subjekt ist. Er gibt physische Impulse, die dem aus der Verhaltenspsychologie bekannten behavioristischen Muster von Reiz und Reaktion folgen. In ihren *Rules Series* – ortsbezogenen Verhaltensregeln, die auf der Wand oder auf Displays angebracht sind – untersucht Bulloch soziale Verhaltensmuster auch im Hinblick auf institutionelle Machtstrukturen. Der neue Werkkomplex der Pixel-Arbeiten untersucht die Wechselwirkung von Bildproduktion und Bildrezeption anhand digital gesteuerter Lichtkästen. In der *Prototypes* betitelten Serie stapelt sie eigens entwickelte Pixel-Boxen im Format 50 x 50 x 50 cm, die in 16 Millionen Farben eines 8-Bit-Monitors aufleuchten. Darüber hinaus lassen einige Arbeiten durch ein theoretisches Interesse am Einfluss elektronischer Medien auf das Sehen schließen. So reduziert Bulloch in *BLOW UP T. V.*, 2000, eine kurze Einstellung aus dem Film „Blow Up" von Michelangelo Antonioni auf 17 Pixel. Von der ursprünglichen Szene ist auf den Monitoren nichts mehr zu erkennen. Damit bezieht sie sich auf die technischen Möglichkeiten des Erkennens, die durch Vergrößerung sowohl aufdecken als auch verschleiern können.

Angela Bulloch crée dans l'espace des systèmes binaires qui fonctionnent sur le principe « Marche/Arrêt ». Le fait de s'asseoir sur un de ses bancs appelés « sound clash benches », déclenche le son de la vidéo qu'on voit passer sur un moniteur (*Video Sound Systems*, 1997) ; ou bien une « drawing machine » qui dessinait des lignes horizontales, se met à dessiner des traits verticaux tout le temps que le spectateur reste assis devant elle (*Betaville*, 1994). La manière dont Bulloch conçoit la participation du spectateur repose sur le fait que le spectateur est conçu avant tout comme un sujet social. Celui-ci fournit des impulsions physiques qui suivent le schéma « stimulus/réponse » tel qu'on le connaît de la psychologie behaviouriste. La nouvelle série des travaux à pixels explore l'interaction de la production de l'image et de sa réception à l'aide de caissons lumineux à commande numérique. Dans sa série *Prototypes*, Bulloch empile des moniteurs à pixels conçus par ses soins, de format 50 x 50 x 50 cm, qui s'allument dans les 16 millions de couleurs d'un moniteur de 8-Bit. Dans certaines œuvres, l'intérêt théorique porté sur l'influence des médias électroniques renvoie au regard. Pour *BLOW UP T. V.*, 2000, Bulloch se sert d'un bref passage du film « Blow up » de Michelangelo Antonioni, dont la résolution a été réduite à 17 pixels. La scène initiale n'est plus identifiable à l'écran. Bulloch se réfère ainsi aux possibilités technologiques de la connaissance, où l'agrandissement peut aussi bien révéler que voiler. N. M.

SELECTED EXHIBITIONS →
1993 *Aperto, 45. Biennale di Venezia*, Venice, Italy **1996** *Traffic*, capcMusée d'Art Contemporain, Bordeaux, France **1997** *Vehicles*, Le Consortium, Centre d'Art Contemporain, Dijon, France **1998** *Superstructure*, Museum für Gegenwartskunst Zürich, Zurich, Switzerland **2000** *Sonic Boom – The Art of Sound*, Hayward Gallery, London, UK **2002** *Claude Monet ...bis zum digitalen Impressionismus*, Fondation Beyeler, Basle, Switzerland; *Ann Lee*, Kunsthalle Zürich, Zurich, Switzerland

SELECTED BIBLIOGRAPHY →
1994 *Angela Bulloch*, Fonds régional d'art contemporain Languedoc-Roussillon, Montpellier/Kunstverein in Hamburg **1998** *Satellite – Angela Bulloch*, Museum für Gegenwartskunst, Zurich **2000** *Angela Bulloch – Rule Book*, London **2001** Uta Grosenick (ed.), *Women Artists*, Cologne; *Angela Bulloch – Z Point*, Kunsthaus Glarus

EARTH FIRST

1. Learn how to agitate – successful movements like the Civil Rights movement, trade unions etc., spent lots of time out in communities talking to people and offering solutions

2. Remember 'the earth is not dying, it is being murdered and the people murdering it have names and addresses

3. Create a movement that people want to join and stay in We need to create a system that reduces our dependency on capitalism and destabilises it. By working closer with LETS schemes etc., we could create a parallel economy that would make the capitalist one irrelevant

4. Counteract the media backlash by pointing out our successes more.

5. Criminal damage must be talked about! You don't have to say you do it, but always say that it is understandable, given people's frustrations Sometimes it is inappropriate and we have to have the intelligence to know when this is.

6. Learn from current 'successful' organisations like The Land is Ours and Friends of the Earth, who score by being well connected, wealthy and strategic. But let's not allow them to set the agenda – use their networks and work with them on local issues

7. Should EF! develop itself? A difficult one this. We are, by nature and necessity, shy of centralised structures, but could we do with a little more centralisation for fund-raising, resource gathering, concentrated outreach, access to expertise, etc?....

Think About It!

50

1 **Earth First,** 2000, installation view, Kokerei Zollverein, Essen, 2001
2 **Prototypes,** 2000, installation view, Galerie Hauser & Wirth & Presenhuber, Zurich

3 **Codes,** 1998, installation view, Schipper & Krome, Berlin

„Manche Werke hören auch nach ihrer Realisierung nicht auf, sich weiterzuentwickeln, weil in ihnen bereits ein Element der Veränderung angelegt ist beziehungsweise ein Potenzial, das solche Prozesse ermöglicht."

« Les travaux continuent souvent à évoluer après avoir été réalisés pour la simple raison qu'ils sont conçus avec un élément de changement ou un potentiel inhérent de modifications qui peuvent survenir. »

"The works often continue to evolve after they have been realised, simply by the fact that they are conceived with an element of change, or an inherent potential for some kind of shift to occur."

2

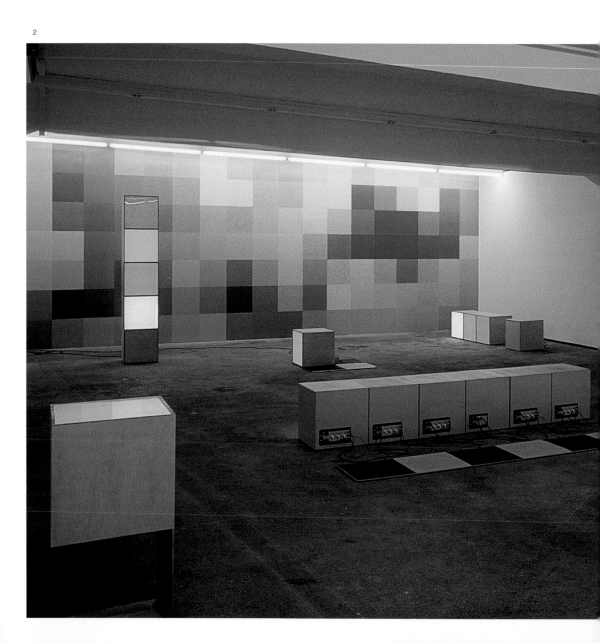

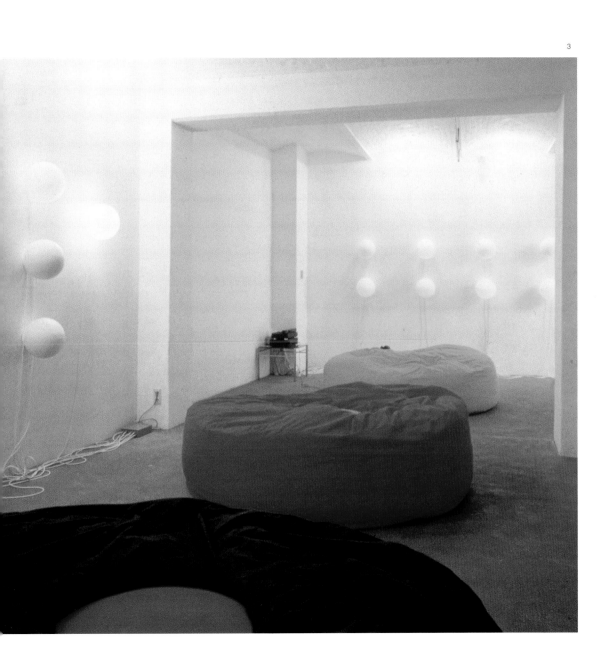

Janet Cardiff

1957 born in Brussels, Canada, lives and works in Berlin, Germany

Janet Cardiff uses sound to heighten and alter individuals' experiences of space and time. She is interested in the ways our surroundings are perceived and memories are represented. In her site-specific *Walks* she layers recordings of her voice and audio effects, simultaneously delivering a narrative and guiding visitors on a predetermined path. Using binaural recording, Cardiff creates lifelike representations of sounds that can be perceived three-dimensionally. These pieces, which play on personal CD players, benefit from the portable technology of Discmans, which allows listeners to be enveloped by sound and block out their surroundings while walking around, thus existing in a self-contained realm. Cardiff integrated images into the sound work in her *Walk* for the 1999/2000 *Carnegie International*. She used handheld digital video recorders to enable individuals to view the piece's route and take part in the story on miniature screens. In *The Paradise Institute*, 2001, a collaboration with George Bures Miller for the *Venice Biennale*, she constructed a small-scale theatre fitted with seats and a screen on which their film played. The soundtrack, which was recorded using the binaural technique and played through individual headphones, mixed multiple story lines: the realms of the filmic space, constructed theatre space, and actual real-time experiences converge. The power of Cardiff's work lies in the intersection of various realities as well as her ability to build and deliver multi-layered and provocative narratives.

Janet Cardiff verwendet Klangmaterial, um unsere Raum- und Zeiterfahrung zu verändern und zu vertiefen. Sie interessiert sich dafür, wie wir unsere Umgebung wahrnehmen und unsere Erinnerungen wiedergeben. In ihren standortspezifischen *Walks* schneidet sie Aufnahmen ihrer Stimme und andere Audioeffekte übereinander. So erzählt sie zugleich eine Geschichte und leitet den Besucher auf einen festgelegten Pfad. Dank zweikanaliger Aufnahmeverfahren gelingt es Cardiff, lebensnahe Tonaufzeichnungen zu machen, die sich dreidimensional wahrnehmen lassen. Die Arbeiten sind auf CD festgehalten und werden über tragbare Discmans abgespielt, so dass der „Zuhörer" sich – durch Umgebungsgeräusche ungestört – in einer Klangwolke fortbewegen kann und sich in eine selbstgenügsame kleine Welt versetzt fühlt. Cardiff hat in ihre Klangwerke auch Bilder integriert, so in der Arbeit *Walk*, die sie für die Ausstellung *Carnegie International* 1999/2000 geschaffen hat. Dabei hat sie digitale Videorekorder verwendet, damit der Betrachter sich einen Eindruck von der Route verschaffen und die Geschichte auf Minibildschirmen verfolgen konnte. Für die Arbeit *The Paradise Institute*, 2001, entstanden in Zusammenarbeit mit George Bures Miller für die *Biennale* in Venedig, hat sie ein mit Sitzen und einer Leinwand ausgestattetes kleinformatiges (Film-)Theater entworfen. Der Zweikanalton des hier aufgeführten Films wurde den Zuschauern per Kopfhörer individuell zugespielt. Auf der Tonspur waren verschiedene Vorgänge zugleich gespeichert: So verschmolzen der filmische Raum, der künstlich konstruierte Theaterraum und konkrete Echtzeiterfahrungen zu einer unauflöslichen Einheit. Die Kraft von Cardiffs Arbeiten liegt zum einen in der Überschneidung ganz unterschiedlicher Realitäten, zum anderen in ihrer Fähigkeit, vielschichtige und provozierende Erzählungen zu entwickeln und vorzuführen.

Janet Cardiff se sert des sons pour renforcer et altérer les expériences individuelles d'espace et de temps. Elle s'intéresse aux manières dont nous percevons notre environnement et dont les souvenirs sont représentés. Sur ses *Walks* (Promenades) créées en fonction de chaque site, elle associe des enregistrements de sa voix et des effets sonores, racontant une histoire tout en guidant les visiteurs sur un chemin prédéterminé. Utilisant un enregistrement binaural, Cardiff crée des représentations réalistes qui peuvent être perçues de manière tridimensionnelle. Ces pièces, qui s'écoutent sur des lecteurs de CD personnels, bénéficient de la technologie portable Discmans, qui permet à chacun d'être enveloppé par le son tout en se déplaçant, oubliant son environnement en étant plongé dans une sphère autonome. Dans son *Walk* pour 1999/2000 *Carnegie International*, Cardiff a intégré des images dans son travail sonore : elle a utilisé de petits caméscopes numériques qui permettent aux visiteurs de voir l'itinéraire de l'œuvre et de participer à l'histoire par l'intermédiaire d'écrans miniatures. Dans *The Paradise Institute*, 2001, une collaboration avec George Bures Miller pour la *Biennale* de Venise, elle a construit un petit théâtre équipé de sièges et d'un écran sur lequel était projeté leur film. La bande son, enregistrée avec la technique binaurale et diffusée dans des casques individuels, mélangeait plusieurs trames narratives : les domaines de l'espace filmique, l'espace théâtral construit et les expériences vécues en temps réel convergeaient. La puissance du travail de Cardiff se situe à l'intersection des différentes réalités ainsi que dans sa capacité à construire et présenter des narrations multicouches et provocantes.

Ro. S.

SELECTED EXHIBITIONS →
1997 *Skulptur. Projekte*, Münster, Germany **1998** *XXIV Bienal de São Paulo*, Brazil **1999** *London Walk*, Artangel, London, UK; *The Museum as Muse: Artists Reflect*, The Museum of Modern Art, New York (NY), USA; *Carnegie International*, Carnegie Museum of Art, Pittsburgh (PA), USA **2000** *Sleep Talking*, Kunstraum München, Munich, Germany; *Wonderland*, Saint Louis Art Museum, St. Louis (MS), USA **2001** Canadian Pavilion, *49. Biennale di Venezia*, Venice, Italy **2001** *010101*, San Francisco Museum of Modern Art (CA), USA

SELECTED BIBLIOGRAPHY →
1996 *NowHere*, Louisiana Museum of Modern Art, Humlebaek **1997** *Present Tense: Nine Artists in the Nineties*, San Francisco Museum of Modern Art (CA); Klaus Bußmann/Kasper König/Florian Matzner (eds.), *Skulptur. Projekte*, Münster **1999** *Carnegie International*, Carnegie Museum of Art, Pittsburgh (PA) **2000** Janet Cardiff/Kitty Scott, *Janet Cardiff: The Missing Voice (Case Study B)*, Artangel, London

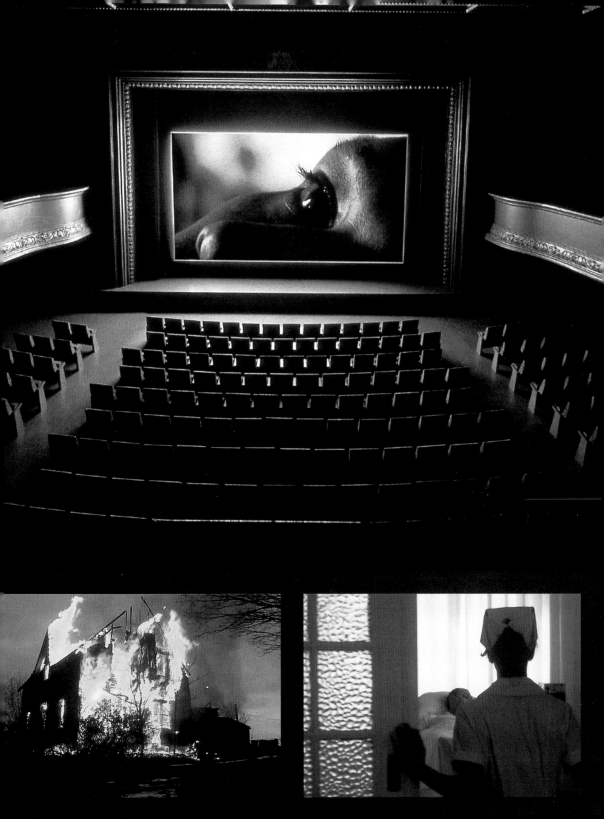

1 In collaboration with George Bures Miller:
 The Paradise Institute, 2001, audio, video, mixed media
2 **Forest Walk,** 1991, site-specific audio
3 **Louisiana Walk #14,** 1996, mixed media

4 In collaboration with George Bures Miller:
 The Dark Pool, 1996, wooden tables, chairs, loudspeakers, electronic equipment, various components and objects

„Ständig erreichen Klänge und Geräusche unser Ohr,
und wir lassen uns davon viel stärker beeinflussen, als uns bewusst ist."

« Le son nous affecte constamment et nous dépendons de lui beaucoup plus qu'on ne le pense. »

"Sound affects us constantly and we rely on it much more than we realise."

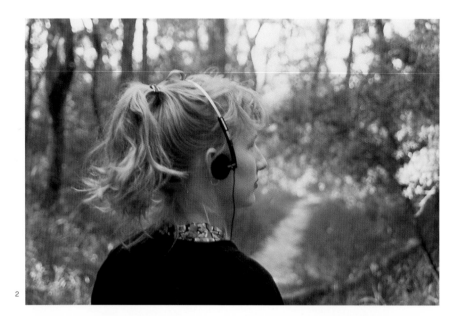

2

3

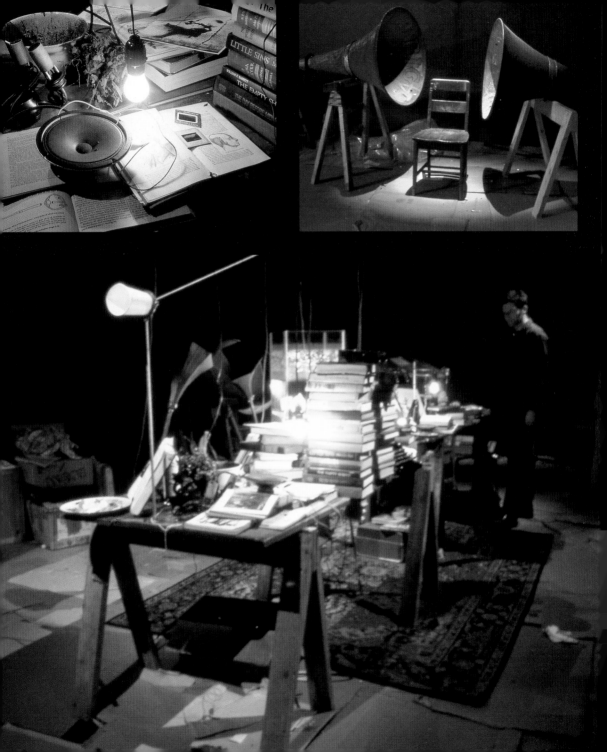

Merlin Carpenter

1967 born in Pembury, lives in London, UK, and Berlin, Germany

Merlin Carpenter's approach to the medium of painting is deeply ambivalent. On the one hand, he produces meaningless paintings, alluding to the style of artists like Jackson Pollock and Julian Schnabel. On the other, he promotes what he calls the "de-subjectivisation of the brush stroke", with his hand-painted imitations of the aesthetics of computer graphics. In his exploration of what he has called "overdetermined imagery" and his quotations from everyday visual culture, such as fashion photography, Carpenter also reveals his own fascination with concepts like "beauty" and "perfection". In his exhibition *As a Painter I Call Myself the Estate Of*, 2000, he marked out the parallels and differences between art and non-artistic luxury items, by displaying a motor boat next to his pictures. Alongside his work as an artist, Carpenter is engaged in a range of other activities, all reflecting the social context in which art is created and his own position as an artist. These include writing texts, such as articles on painting for the periodical "Texte zur Kunst" and contributing to a catalogue for Michael Krebber – as well as taking part in joint ventures. In the 1990s Carpenter, Dan Mitchell, Nils Norman and others set up the experimental "Poster Studio" in London. From the outset it was only intended as a short-term initiative, in order to avoid monopolisation by any single medium. Its aims were to produce a critical analysis of the contemporary London art world and to encourage informal networking among artists.

Die Herangehensweise von Merlin Carpenter an das Medium Malerei zeugt von einer grundlegenden Ambivalenz: So verweisen seine Bilder in entleerender Absicht auf die Malstile von Künstlern wie Jackson Pollock oder Julian Schnabel. Dabei propagiert Carpenter eine „Entsubjektivierung des Pinselstrichs" (M. C.), etwa indem er manuell die Ästhetik von Computermalprogrammen imitiert. In seiner Auseinandersetzung mit überdeterminierten Positionen der Malerei, aber auch in seinen Zitaten der visuellen Alltagskultur wie Modefotografie, manifestiert Carpenter allerdings zugleich seine eigene Faszinertheit von Wertbegriffen wie „Schönheit" und „Gelungenheit". Auf Differenzen und Parallelen zwischen Kunst und anderen, nicht-künstlerischen Luxusgütern spielte er in seiner Ausstellung *As a Painter I Call Myself the Estate Of*, 2000, an, indem er neben seinen Bildern auch ein Motorboot präsentierte. Seine künstlerische Produktion flankiert Carpenter mit einer Reihe paralleler Aktivitäten, die die gesellschaftlichen Voraussetzungen und Rahmenbedingungen von Kunst sowie seine eigene Position als Künstler reflektieren: Dazu gehört das Schreiben von Texten – zum Beispiel über Malerei in der Zeitschrift „Texte zur Kunst" oder ein Katalogbeitrag für Michael Krebber – ebenso wie seine Beteiligung an kollektiven Projekten. So gründete Carpenter Mitte der neunziger Jahre zusammen mit Dan Mitchell, Nils Norman und anderen den experimentellen Londoner Projektraum „Poster Studio": eine Initiative, die von vornherein als zeitlich befristet konzipiert war, um sie einer medialen Vereinnahmung möglichst zu entziehen. Ihre Ziele waren die kritische Analyse der damaligen Londoner Kunstwelt und die Förderung informeller Netzwerke.

La manière dont Merlin Carpenter approche le médium « peinture » ressort d'une ambiguïté fondamentale. Sous le signe de l'évidement sémantique, ses tableaux renvoient aux styles picturaux d'artistes comme Jackson Pollock ou Julian Schnabel. En même temps, Carpenter pratique une « désubjectivation du trait de pinceau » (M. C.), comme lorsqu'il imite l'esthétique « fait main » de certains programmes informatiques de peinture. Cela dit, dans son travail sur les positions surdéterminées de la peinture comme dans ses citations de la culture visuelle quotidienne – notamment de la photographie de mode –, Carpenter montre aussi sa propre fascination à l'égard de jugements de valeur comme « beau » et « réussi ». Dans l'exposition *As a Painter I Call Myself the Estate Of*, 2000, l'artiste mettait ainsi en évidence les différences et les similitudes entre l'art et les articles de luxe, présentant entre autres un canot à moteur à côté de ses peintures. La production artistique de Carpenter s'accompagne d'une série d'activités parallèles qui veulent donner un reflet des conditions sociales et du contexte de l'art, mais aussi de la propre position de l'artiste, activités parmi lesquelles on compte l'écriture de textes – comme celui sur la peinture paru dans la revue « Texte zur Kunst » ou sa contribution à un catalogue de Michael Krebber –, mais aussi la participation à des projets collectifs. Au milieu des années 90, avec Dan Mitchell, Nils Norman et quelques autres, Carpenter créait ainsi à Londres l'espace expérimental « Poster Studio » – une initiative conçue dès le départ comme limitée dans le temps afin de la soustraire autant que possible à toute récupération médiatique. Les buts de ce collectif étaient l'analyse critique de la scène londonienne de l'époque et la revendication de réseaux informels. B. H.

SELECTED EXHIBITIONS →
1994 Friedrich Petzel/Nina Borgmann, New York (NY), USA; *Untitled Group Show*, Metro Pictures, New York (NY), USA **1998** *Chant No 1*, Galerie Max Hetzler, Berlin, Germany **1999** *Malerei*, INIT Kunsthalle, Berlin **2000** *As a Painter I Call Myself the Estate Of*, Wiener Secession, Vienna, Austria; *Girlfriend* (curated by Sarah Morris), Galerie für Zeitgenössische Kunst, Leipzig, Germany **2001** *My Father, the Castaway*, WhiteCube, Kunstakademi Bergen, Norway; *Jewels-in-Art*, Galerie Bleich-Rossi, Graz, Austria

SELECTED BIBLIOGRAPHY →
1993 Merlin Carpenter/Nils Norman, *Meet You by the Strange Twisted Old Oak Tree on the Secluded Knoll at Dawn in Your Swimming Trunks and I'll Tell You Something Secret (Don't Be Late)*, Galerie Z, Göttingen **1995** *Voluntary Effort*, Tom Solomon's Garage, Los Angeles (CA) **2000** *Merlin Carpenter. As a Painter I Call Myself the Estate Of*, Wiener Secession, Vienna

1 **When There's Nothing Inside But You,** 1999, oil on canvas, 183 x 140 cm
2 Installation view, Galerie Max Hetzler, Berlin, 2000

3 **The 14th Floor,** 1999, oil on canvas, 130 x 183 cm

„Für mich ist es so: Wenn eine Information handelbar ist,
ist sie es nicht wert, gehandelt zu werden."

« Pour moi, si une information est commerciable,
elle ne vaut pas la peine d'être commercialisée. »

"For me, if a piece of information can be traded then it's not worth trading."

2

Maurizio Cattelan

1960 born in Padova, Italy, lives and works in New York (NY), USA

Art is separate from reality, and it's possible to get away with more within its boundaries. This common opinion is challenged by artists who raise questions about the limits of artistic freedom and try to shake the rules that keep reality safe. One of Pier Paolo Pasolini's short films shows The Passion being shot by a mad film crew. An extra playing one of the criminals actually dies on the cross by accident; he starves to death when the rest of the crew forget to get him down from the cross because they are busy stuffing themselves. Maurizio Cattelan, the jester of the art world, makes a radical attempt to ridicule the principles on which the artist's smooth functioning in society is based. He selects the privileged – but also ambiguous – position of a notorious provocateur, in order to show the hypocritical customs that facilitate the soporific, steady flow of ideas and cash in the contemporary art world. A gallery owner fastened to a wall with adhesive tape (*A Perfect Day*, 1999); the Pope struck down by a meteorite (*La Nona Ora*, 1999); a praying little Hitler (*Him*, 2001); a squirrel that shoots itself with a gun (*Bidibidobidiboo*, 1996): the characters created by Cattelan are at the same time caricatured and tragic. Playing with the great icons of history and the heroes of everyday life, Cattelan follows a path once trodden by villains, conjurors and charlatans. Artists have too often sought refuge in the nimbus of their own art, lecturing and proclaiming like prophets.

Die Kunst ist von der Wirklichkeit verschieden und lässt innerhalb ihrer Grenzen größere Freiheiten zu. Dieser gängigen Meinung treten jene Künstler entgegen, die Fragen über die Grenzen der künstlerischen Freiheit aufwerfen und gegen die Abschottung zwischen Kunst und Realität rebellieren. In einem von Pier Paolo Pasolinis Kurzfilmen ist ein verrücktes Filmteam zu sehen, das die Passion Christi verfilmt. Dabei kommt versehentlich ein Statist zu Tode, der einen der beiden Schächer darstellt. Der Mann verhungert, weil die übrigen Mitarbeiter des Teams ihn versehentlich am Kreuz hängen lassen, während sie sich den Bauch vollschlagen. Ganz ähnlich unternimmt auch Maurizio Cattelan, der Spaßvogel der Kunstszene, den radikalen Versuch, die Prinzipien, von denen das reibungslose Funktionieren des Künstlers in der Gesellschaft abhängt, der Lächerlichkeit preiszugeben. Er stellt sich auf den ebenso privilegierten – wie ambivalenten – Standpunkt des notorischen Provokateurs und versucht die heuchlerischen Mechanismen sichtbar zu machen, die in der heutigen Kunstszene einen ebenso gleichmäßigen wie einschläfernden Fluss der Ideen gewährleisten. Ein Galerist, der mit Klebeband an einer Wand fixiert ist (*A Perfect Day*, 1999); der von einem Meteoriten getroffene Papst (*La Nona Ora*, 1999), ein betender kleiner Hitler (*Him*, 2001), ein Eichhörnchen (*Bidibidobidiboo*, 1996), das sich selbst erschießt: Die Figuren, die Cattelan kreiert, sind zugleich karikaturistisch überzeichnet und tragisch. Er spielt mit den großen Ikonen der Geschichte und den Heroen des Alltagslebens und verfolgt dabei einen Weg, auf dem früher nur Schurken, Verschwörer und Scharlatane anzutreffen waren. Nach seiner Auffassung haben sich die Künstler bisher zu häufig hinter dem Nimbus ihrer Kunst verborgen und sich in der Pose des Propheten und des Predigers gefallen.

L'art est séparé de la réalité. A l'intérieur de ses frontières, on peut aller plus loin. Cette opinion très répandue est contestée par des artistes qui remettent en question les limites de la liberté artistique et tentent de dépoussiérer les règles qui préservent la réalité du danger. Dans un court métrage, Pier Paolo Pasolini montre La Passion filmée par une équipe de fous. Un figurant jouant un des larrons meurt sur la croix pendant le tournage: l'équipe l'a oublié et l'a laissé littéralement mourir d'inanition pendant qu'elle s'empiffrait. Maurizio Cattelan, le bouffon du monde de l'art, fait une tentative radicale pour ridiculiser les principes sur lesquels l'artiste opère sans heurts dans la société. Il a choisi la position privilégiée – mais également ambiguë – de provocateur notoire afin de dénoncer les mœurs hypocrites qui facilitent le flux soporifique et régulier d'idées et de liquidités dans le monde de l'art contemporain. Un propriétaire de galerie scotché à un mur (*A Perfect Day*, 1999); le Pape écrasé par un météorite (*La Nona Ora*, 1999); un petit Hitler en prière (*Him*, 2001) ; un écureuil qui se suicide d'une balle dans la tête (*Bidibidobidiboo*, 1996) : les personnages créés par Cattelan sont à la fois caricaturaux et tragiques. En jouant avec des personnalités historiques et nos héros de tous les jours, Cattelan suit un chemin déjà tracé autrefois par les mécréants, les conjurateurs et les charlatans. Les artistes ont souvent cherché refuge dans les nimbes de leur propre art, se prenant pour des prophètes en sermonnant et proclamant.

A. S.

SELECTED EXHIBITIONS →
1993 *Aperto, 45. Biennale di Venezia*, Venice, Italy **1997** *Italian Pavilion* (with Enzo Cucchi, Ettore Spalletti), *45. Biennale di Venezia*, Venice, Italy; *Skulptur. Projekte*, Münster, Germany **1998** *Manifesta 2*, Luxembourg **2000** Museum für Gegenwartskunst, Zurich, Switzerland; *Let's Entertain*, Walker Art Center, Minneapolis (MN), USA; In Between, EXPO 2000, Hanover, Germany **2001** *Hollywood*, special project in the *49. Biennale di Venezia*, Venice, Italy; *Dévoiler*, Institut d'Art Contemporain, Villeurbanne, France

SELECTED BIBLIOGRAPHY →
1997 Klaus Bußmann/Kasper König/Florian Matzner (eds.), *Skulptur. Projekte*, Münster; *Maurizio Cattelan*, Castello di Rivoli, Turin; *Dynamo Secession*, Wiener Secession, Vienna **1998** *Projects 65: Maurizio Cattelan*, The Museum of Modern Art, New York **1999** *Maurizio Cattelan*, Kunsthalle Basel, Basle **2000** Francesco Bonami/Barbara Vanderlinden/Nancy Spector, *Maurizio Cattelan*, London

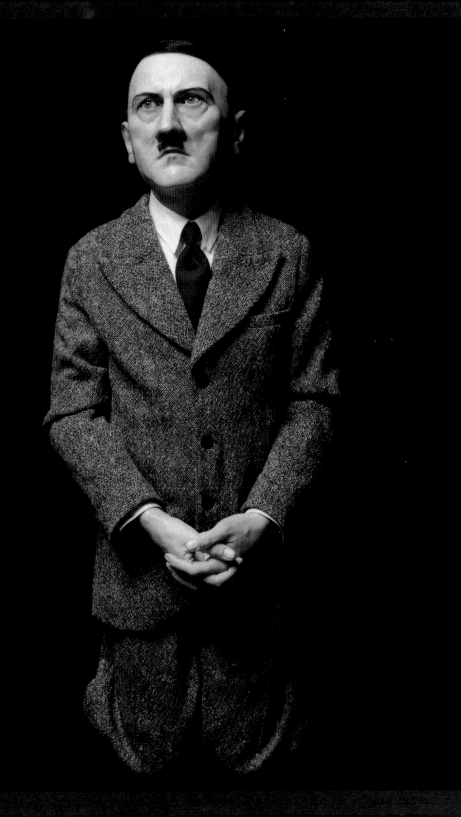

1 **Him,** 2001, wax, human hair, suit, polyester resin, 101 x 41 x 53 cm,
 installation view, Fargfabriken, Stockholm
2 **Hollywood,** 2001, nine giant letters, 23 x 170 m, special project for the

49. Biennale di Venezia, Venice, 2001, with the Patronage of the City
of Palermo, Sicily
3 **La Nona Ora,** 1999, mixed media, installation view, Kunsthalle Basel, Basle

„Wer die Macht besiegen will, muss sich ihr stellen,
sie sich zu Eigen machen und sie unablässig wiederholen."

« Pour être vaincu, le pouvoir doit être abordé, récupéré et reproduit à l'infini. »

"To be defeated, power must be approached, reappropriated and endlessly replicated."

2

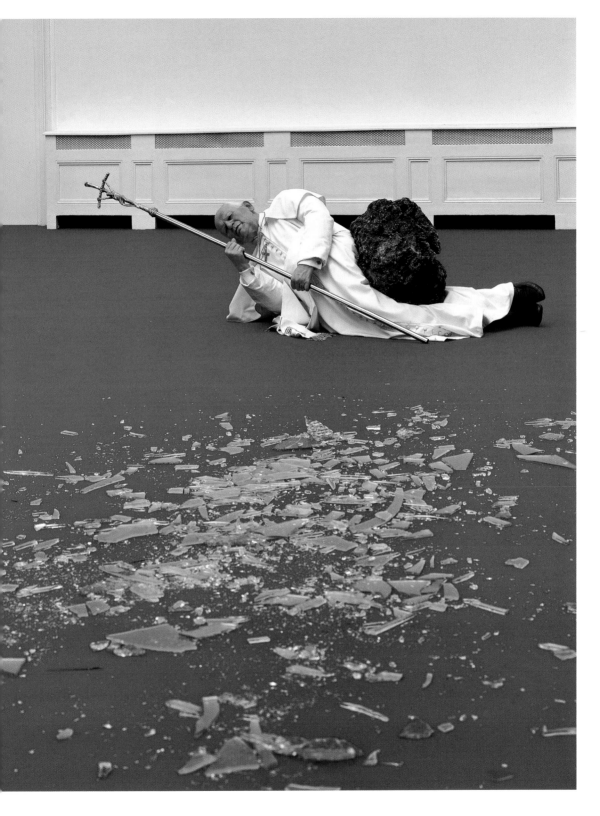

Jake & Dinos Chapman

Jake Chapman, 1966 born in Cheltenham, and Dinos Chapman, 1962 born in London; live and work in London, UK

Jake and Dinos Chapman are fascinated with horror, from grisly physical violence to grotesque deformity and visions of hell. In *The Disasters of War*, 1993, based on Goya's famous series of etchings, they recreated each scene of death and mutilation in three dimensions using remodelled plastic figurines. In *Tragic Anatomies*, 1996, groups of variously cojoined and mutated child mannequins with obscene genitalia sprouting from their bodies revel in an ironic pastoral setting of plastic plants and Astroturf, suggesting the nightmarish results of a malevolent genetic experiment. The Chapmans' sculptures, drawings and prints recall the physical and sexual aggression typical of adolescent school-boys' doodles, while exposing the voyeuristic attraction to disaster that remains in adulthood. Their most elaborate sculpture to date, *Hell*, 2000, is a huge swastika-shaped diorama in which 5,000 figurines, each hand-painted to represent either Nazi soldiers or mutants, engage in minute acts of torture and punishment. This orgy of self-consuming violence appears to be a plastic illustration of Dante's Inferno with added elements of Hieronymus Bosch, all transported to the 20th-century Western world where the Holocaust is our most painfully immediate conception of hell. While the Chapmans clearly delight in shock tactics and obscenity, they also examine ways in which questions of morality can be squeezed from acts of sin. This is attested by the fundamental moral questions which have arisen in the controversial debates over their work.

Jake und Dinos Chapman sind fasziniert vom Horror, ob in Gestalt grässlicher physischer Gewalt, grotesker Deformationen oder von Höllenvisionen. In der Arbeit *The Disasters of War*, 1993, inspiriert durch Goyas berühmte Radierfolge, haben sie jede einzelne Todes- und Ver-stümmelungsszene dreidimensional mit Hilfe von umgestalteten Plastikfigurinen dargestellt. *Tragic Anatomies*, 1996, besteht aus Gruppen ganz unterschiedlich miteinander verschmolzener und mutierter Kinder-Puppen, aus deren Leibern obszöne Genitalien hervorsprießen – in einem pseudo-pastoralen Ambiente aus Plastikpflanzen und Kunstrasen, als seien sie die albtraumhaften Ergebnisse eines böswilligen gentechnischen Experiments. Die Skulpturen, Zeichnungen und grafischen Arbeiten der Chapman-Brüder erinnern an die physische und sexuelle Aggressivität, wie man sie in den Kritzeleien pubertierender Schuljungen antrifft, während sie zugleich die voyeuristische Faszination spürbar machen, die das Grauen auch für den Erwachsenen bereithält. Die bislang komplexeste plastische Arbeit *Hell*, 2000, ist ein riesiges swastikaförmiges Diorama, in dem 5000 handbemalte Figurinen, die entweder Nazisoldaten oder Mutanten darstellen, an detailliert wiedergegebenen Folter- und Bestrafungshandlungen teilnehmen. Dieser alles verzehrende Gewaltexzess erscheint wie eine plastische Illustration zu Dantes Inferno mitsamt Anklängen an Hieronymus Bosch. Dies alles übertragen in die abendländische Welt des 20. Jahrhunderts, in der bislang der Holocaust als unsere schmerzlichste unmittelbare Höllenerfahrung gilt. Mögen die Chapman-Brüder auch Freude an Schocktaktiken und Obszönitäten haben, suchen sie gleichwohl nach Wegen, in immer neuen Akten des Sündenfalls die Frage nach der Moral aufzuwerfen. Bezeugt wird dies auch durch die fundamentalen moralischen Fragen, die in den kontroversen Debatten um ihre Arbeit aufgeworfen werden.

Jake et Dinos Chapman sont fascinés par l'horreur, de la violence physique macabre aux déformations et aux visions grotesques de l'enfer. Dans *The Disasters of War*, 1993, basé sur la célèbre série de gravures de Goya, ils ont récréé chaque scène de mort et de mutilation en trois dimensions avec des poupées en plastique remodelé. Dans *Tragic Anatomies*, 1996, des groupes de mannequins enfants diversement accouplés et mutilés, avec des organes génitaux obscènes jaillissant de leur corps, jouent dans un décor pastoral ironique fait de plantes en plastique et de pelouse synthétique, suggérant les résultats cauchemardesques d'une expérience génétique malveillante. Les sculptures, dessins et gravures des Chapman rappellent les agressions physiques et sexuelles typiques des gribouillis de collégiens, tout en révélant une attirance voyeuriste pour la catastrophe qui perdure à l'âge adulte. Leur sculpture la plus élaborée à ce jour, *Hell*, 2000, est un immense diorama en forme de croix gammée où 5,000 personnages, chacun peint à la main pour représenter soit un soldat nazi soit un mutant, effectuent des actes infimes de torture et de châtiment. Cette orgie de violence autodestructrice évoque une illustration en plastique de l'Enfer de Dante à laquelle viendraient s'ajouter des éléments empruntés à Jérôme Bosch, le tout transposé dans le monde occidental du 20ème siècle, où l'Holocauste représente notre conception la plus douloureusement immédiate de l'enfer. Si les Chapman prennent un plaisir évident à choquer par leur violence et leur obscénité, ils examinent également les façons dont le péché peut être détourné en questions de moralité. En témoignent aussi les questions morales fondamentales soulevées dans les controverses autour de son travail.

K. B.

SELECTED EXHIBITIONS →
1993 *The Disasters of War*, Victoria Miro Gallery, London, UK **1995** *Brilliant!*, Walker Art Center, Minneapolis (MN), USA **1996** *Chapman-world*, Institute of Contemporary Arts, London, UK **1997** *Six Feet Under*, Gagosian Gallery, New York (NY), USA; *Sensation*, Royal Academy of Arts, London, UK **1999** *The Disasters of War*, Jay Jopling/White Cube, London, UK; *Heaven*, Kunsthalle Düsseldorf, Germany **2000** Kunst-Werke, Berlin, Germany; *Apocalypse: Beauty and Horror in Contemporary Art*, Royal Academy of Arts, London, UK

SELECTED BIBLIOGRAPHY →
1996 *Chapmanworld*, Institute of Contemporary Arts, London **1997** *Unholy Libel*, Gagosian Gallery, New York (NY) **1999** Burkhard Riemschneider/Uta Grosenick (eds.), *Art at the Turn of the Millennium*, Cologne

1 **Arbeit McFries,** 2001, mixed media, 122 x 122 x 122 cm
2 **Hell,** 1999/2000, glass-fibre, plastic and mixed media, 9 parts,
 8 parts: 244 x 122 x 122 cm, 1 part: 122 x 122 x 122 cm
3 **Hell** (detail)

4,5 **Exquisite Corpse I,** 2000, set of 20 etchings, handcoloured,
 watercolour, each 47 x 38 cm
6 **The tragik konsequekes of Driving Karele//ly,** 2000, mixed media,
 36 x 99 x 99 cm

„Unser Ziel ist es, die Erinnerung an sämtliche Formen des Terrorismus wach zu halten und dem Betrachter das Vergnügen bestimmter Horrorempfindungen zu verschaffen, ihn in den Zustand einer gewissen bourgeoisen Erschütterung zu versetzen."

« Nous cherchons à récupérer toutes les formes de terrorisme afin d'offrir au spectateur le plaisir d'un certain type d'horreur, d'un certain type de convulsion bourgeoise. »

"We are interested in recuperating every form of terrorism in order to offer the viewer the pleasure of a certain kind of horror, a certain kind of bourgeois convulsion."

2

3

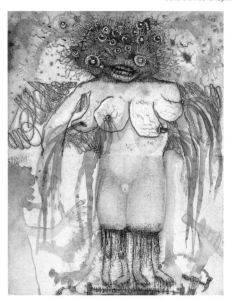

4

5

6

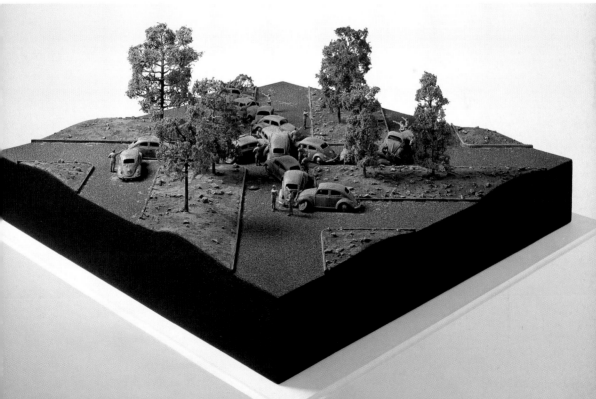

Martin Creed

1968 born in Wakefield, UK, lives and works in Alicudi, Italy

Martin Creed's exhibitions are often closely attuned to the architectural nature of gallery space. His best-known works are balloon-filled rooms realised in several versions, utilising the exhibition space as container and unit of measurement. A prime example is *Work No. 201: Half the air in a given space*, 1998, with multicoloured balloons. Since 1987, Creed has numbered his works, thereby acknowledging the principle of series as a leitmotif for his artistic activity. For *Work No. 228: All of the sculpture in a collection*, 2000, he gathered together all Southampton City Art Gallery's sculptures, from Rodin to Whiteread, in one room. In contrast to the overcrowded feel of this project, *Work No. 227: The lights in a room going on and off*, 2000, is an empty room in which the usual gallery lighting is replaced by lights operated by a time switch, turning on and off at five-second intervals. It is precisely through these minimalist interventions that Creed focuses the viewer's attention on the physical environment. For his outdoor projects, Creed often uses neon signs, like the vague but optimistic declaration that "Everything is going to be alright", which works both as an ironic message above New York's Times Square, and on the abandoned portico of a former orphanage in the London Borough of Hackney. Singing and playing guitar and keyboards with the three-piece band "Owada", Creed clearly demonstrates the association between minimalist reductionism and self-expression. His emotionally charged singing style is accompanied by the repetitive rhythms of the instruments: "from none take one, add one, make none".

Die Ausstellungen von Martin Creed beschäftigen sich häufig mit der architektonischen Situation des Galerieraums. In seinen bekanntesten Arbeiten, den mit Luftballons gefüllten Räumen, die er in unterschiedlichen Variationen realisierte, benutzte er den Ausstellungs-raum als Container und Maßeinheit (zum Beispiel *Work No. 201: Half the air in a given space*, 1998, mit farbigen Ballons). Seit 1987 nummeriert er seine Arbeiten durch, wobei sich das sukzessive Prinzip der Serie als Leitmotiv seiner Vorgehensweise bereits in den Titeln vermittelt. Für *Work No. 228: All of the sculpture in a collection*, 2000, stellte er alle verfügbaren Skulpturen der Southampton City Art Gallery, von Rodin bis Whiteread, in einem Raum zusammen. Im Kontrast zur Fülle dieser Arbeiten steht der leere Raum in *Work No. 227: The lights in a room going on and off*, 2000, wobei lediglich die übliche Galeriebeleuchtung mit einer Zeitschaltuhr im 5-Sekunden-Takt ein- und ausgeschaltet wird. Gerade diese minimalen Eingriffe lenken die Wahrnehmung auf die physische Umgebung. Für Arbeiten im Außenraum verwendet Creed häufig Neonschriftzüge, wie den unspezifischen Hoffnungsmacher „Everything is going to be alright", der sowohl die Situation am Times Square in New York ironisch beleuchten kann wie auch den verlassenen Portikus eines ehemaligen Waisenhauses im Londoner Stadtteil Hackney. Bei seiner dreiköpfigen Band „Owada", in der Creed als Sänger und Bassist agiert, wird besonders deutlich, wie er minimalistische Reduktion mit einem Selbstausdruck verbindet. Sein emotional aufgeladener Gesang begleitet den repetitiven Rhythmus der Instrumente: „from none take one, add one, make none".

Les expositions de Martin Creed sont souvent liées à la configuration architecturale de l'espace d'exposition. Dans ses œuvres les plus célèbres, des salles remplies de ballons, dont il a réalisé différentes versions, Creed se sert de l'espace d'exposition comme container et comme unité de mesure (par exemple *Work No. 201: Half the air in a given space*, 1998, avec des ballons de couleur). Depuis 1987, Creed assigne à ses œuvres un numéro d'ordre. Le principe de succession de la série, leitmotiv de sa démarche, est donc déjà présent dans les titres. Pour *Work No. 228: All of the sculpture in a collection*, 2000, il rassemblait toutes les sculptures disponibles de la Southampton City Art Gallery, de Rodin à Whiteread, dans une seule salle. Contrastant avec la profusion de ce travail, on trouve l'espace vide de *Work No. 227: The lights in a room going on and off*, 2000, une œuvre pour laquelle un minuteur allume et éteint toutes les 5 secondes l'éclairage ordinaire de la galerie. Ce sont ces interventions minimalistes qui concentrent la perception de l'environnement physique. Pour ses œuvres dans l'espace public, Creed se sert souvent d'écritures au néon, figurant par exemple l'espoir artificiel et anonyme d'une phrase comme « Everything is goin to be alright », qui éclaire de son ironie la situation de Times Square, à New York, ou le portail d'un orphelinat désaffecté situé au bout d'une petite voie à sens unique de Hackney, à Londres. Dans son groupe « Owada » composé de trois membres, et dont il est chanteur et bassiste, on voit clairement comment Creed associe la réduction minimaliste et l'expression de soi. La forte charge émotionnelle de son chant accompagne le rythme répétitif des instruments : « from none take one, add one, make none ».

N. M.

SELECTED EXHIBITIONS →
1995 Camden Arts Centre, London, UK **1997** *Lovecraft*, Centre for Contemporary Arts, Glasgow, UK **1998** *Biennale of Sydney*, Australia; *Crossings*, Kunsthalle Wien, Vienna, Austria **1999** *Nerve*, Institute of Contemporary Arts, London, UK; *Work No. 203*, The Portico, London, UK **2000** *The British Art Show 5*, Hayward Gallery, London, UK **2001** *Work No. 265*, Micromuseum for Contemporary Art, Palermo, Italy; *The Turner Prize Exhibition*, Tate Britain, London (UK)

SELECTED BIBLIOGRAPHY →
1996 *Life/Live*, Musée d'Art Moderne de la Ville de Paris **2000** *Martin Creed works*, Southampton City Art Gallery, Southampton

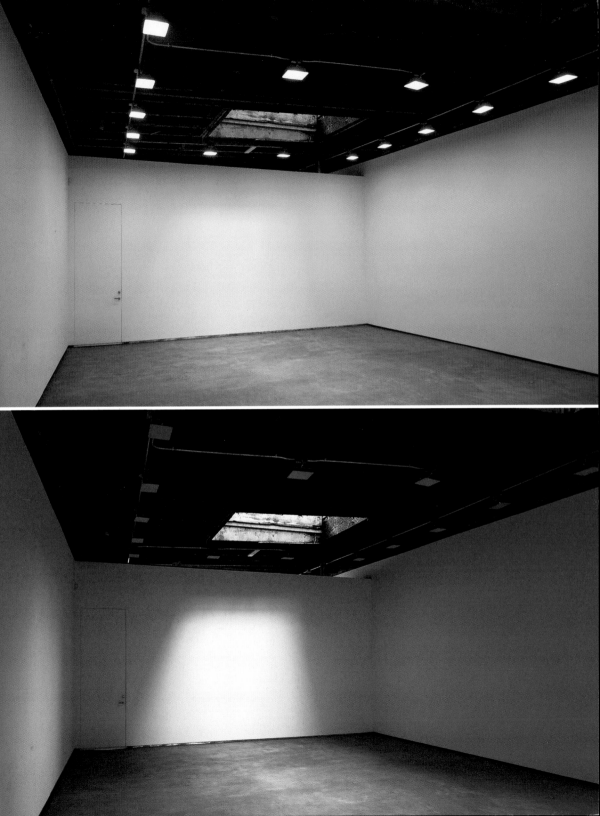

1 **Work No. 227: The lights in a room going on and off,** 2000, frequency 5 seconds on, 5 seconds off, materials variable, dimensions variable
2 **Work No. 201: Half the air in a given space,** 3rd March, 1998, balloons in assorted colours, dimensions variable, installation view, Gavin Brown's enterprise, New York (NY)

3 **Work No. 247: Sorge Dich Nicht,** 2000, neon, installation, St. Peter's tower, Cologne
4 **Work No. 203: Everything is going to be alright,** 1999, neon, installation, Clapton, London, 60 x 1220 cm

„In vielen meiner Werke versuche ich, zugleich etwas zu schaffen und un-geschehen zu machen …, also ein Nichts zu kreieren, das zugleich etwas ist."

« Dans un long processus, je tente de faire et de défaire à la fois … ce qui produit en quelque sorte du rien tout en étant quelque chose. »

"In a lot of work I try to make it and unmake it at the same time, ... which sort of adds up to nothing but at the same time is something too."

2

John Currin

1962 born in Boulder (CO), lives and works in New York (NY), USA

John Currin is a painter whose work requires a second look. At first view, his pictures, or at least his portraits, recall Renaissance painting and early Mannerism. In the style of the Old Masters, Currin's engaging creations question the traditions of painting and how they influence contemporary ways of seeing. On second look, the viewer realises that the American artist has loaded his appealing images with modern-day notions of beauty and morality. The standards set by fashion and gossip magazines, with their kitsch clichés, are clearly exposed and gloriously caricatured in the manner of "great art". Outsized busts, super-slim and super-fit beauties and the joys of family life, even in old age, are constantly recurring motifs. He paints nudes, sometimes classical, sometimes pornographic, and banal scenes of daily life straight out of the TV soaps. But beneath the seemingly smooth surface of upper middle class aesthetics, we soon discover extreme ugliness. Hysterical laughter, grotesquely overblown physical proportions, tasteless humour and bodily decay, which elegant attire can barely hide, subtly spoil the sensual pleasure of Currin's paintings. Glamorous and cynical at the same time, the paintings create a tension, which viewers are invited to break by laughing at what they see. A typical example is *Park City Grill*, 2000, in which a couple are seen flirting with each other. But their tensely casual attitude and clichéd beauty betray the artificiality and hollowness of the world in which they live.

John Currin ist ein Maler für den zweiten Blick. Auf den ersten Blick erinnern seine Bilder, zumeist handelt es sich um Porträts, an die Malerei der Renaissance und des frühen Manierismus. Im „altmeisterlichen" Stil befragen Currins sinnenfreudige Werke die Tradition der Kunst und ihre Rolle in der zeitgenössischen Bildrezeption. Auf den zweiten Blick erkennt der Betrachter nämlich, dass der amerikanische Künstler seine ansprechenden Motive mit aktuellen Vorstellungen von Schönheit und Moral aufgeladen hat. Kitschige Klischees und normative Regeln, wie wir sie aus Modemagazinen oder aus der Regenbogenpresse kennen, finden sich hier entlarvend deutlich im Glanz „großer Malerei" karikiert: Übergroße Busen, sportlich-schlanke Beauties und alte Menschen in einer Familienidylle zählen zu den immer wieder-kehrenden Sujets des Künstlers – genau wie mal eher klassisch, mal eher pornografisch anmutende Akte oder banale Alltagsszenen, die direkt einer TV-Seifenoper entnommen sein könnten. Aber auch übertriebene Hässlichkeiten entdeckt man schnell unter der glatten Oberfläche dieser scheinbar durch und durch großbürgerlichen Ästhetik. Hysterisches Lachen, grotesk überdehnte Körperproportionen, peinliche Possenspiele und körperlicher Verfall, der kaum von edler Kleidung verdeckt wird, verderben klammheimlich das sinnliche Vergnügen an den Bildern von Currin. Glamourös und zynisch zugleich bauen die Gemälde einen Spannungsbogen auf, der sich in einem befreienden Lachen über das Dargestellte entlädt. Typisch dafür ist zum Beispiel das Bild *Park City Grill*, 2000, das ein flirtendes Paar zeigt – beide Protagonisten verraten mit ihrer angespannten Lässigkeit und klischeehaften Schönheit die Künstlichkeit und Hohlheit ihrer Welt.

John Currin est un peintre dont le travail s'adresse au deuxième regard. Au premier regard en effet, ses tableaux – le plus souvent des portraits – rappellent les peintures de la Renaissance et des débuts du Maniérisme. Dans le style des « anciens », ses œuvres hautes en couleurs interrogent la tradition de la peinture et son rôle dans la perception contemporaine de l'image. Au deuxième regard, le spectateur s'aperçoit que l'artiste américain investit ses motifs séduisants des conceptions de beauté et de morale qui sont aujourd'hui monnaie courante. Les clichés kitsch et les règles normatives connues des magazines de mode ou de la presse à sensations sont clairement démasqués et caricaturés sous le signe de la « grande peinture » : poitrines opulentes, beautés sportives hyper-sveltes, bonheur familial authentique même au troisième âge, comptent parmi les sujets de prédilection de l'artiste. Aussi bien que les nus de tendance tantôt classique, tantôt pornographique, ou les scènes de la vie quotidienne qui pourraient être tirées directement d'un feuilleton télévisé. Mais sous la surface de cette esthétique en apparence entièrement bourgeoise, on découvre aussi des laideurs exagérées. Rires hystériques, étirement grotesque des proportions corporelles, blagues de mauvais goût, déchéance physique transparaissant sous le vêtement distingué gâchent secrètement le plaisir sensuel des images proposées par l'artiste. De manière mi glamoureuse, mi cynique, ces peintures créent un champ de tension dont l'énergie se décharge dans une dérision libératrice de la représentation. Un exemple caractéristique en est le tableau *Park City Grill*, 2000, qui montre un couple en train de flirter : la décontraction contrainte et la beauté convenue des deux protagonistes trahissent l'artifice et l'inanité de leur univers.

R. S.

SELECTED EXHIBITIONS →
1995 *Aperto, 45. Biennale di Venezia*, Venice, Italy **1995** Institute of Contemporary Arts, London, UK **1998** *Young Americans 2*, Saatchi Gallery, London, UK **1999** Regen Projects, Los Angeles (CA), USA; *Malerei*, INIT Kunsthalle, Berlin, Germany **2000** Monika Sprüth Galerie, Cologne, Germany; Sadie Coles HQ, London, UK; *Whitney Biennial*, The Whitney Museum of American Art, New York (NY), USA **2001** Andrea Rosen Gallery, New York (NY), USA; *Works on Paper*, Victoria Miro Gallery, London, UK; *About Faces*, C & M Arts, New York (NY), USA

SELECTED BIBLIOGRAPHY →
1998 *Young Americans 2*, London; *Pop Surrealism*, The Aldrich Museum of Contemporary Art, Ridgefield (CT) **1999** *Carnegie International*, Carnegie Museum of Art, Pittsburgh (PA); Burkhard Riemschneider/Uta Grosenick (eds.), *Art at the Turn of the Millennium*, Cologne

1 **The Old Fence,** 1999, oil on canvas, 193 x 102 cm
2 **The Lobster,** 2001, oil on canvas, 102 x 81 cm
3 **The Cuddler,** 2000, oil on canvas, 97 x 62 x 4 cm

4 **Park City Grill,** 2000, oil on canvas, 97 x 76 x 4 cm
5 **Homemade Pasta,** 1999, oil on canvas, 127 x 107 cm
6 **Gold Chains and Dirty Rags,** 2000, oil on canvas, 122 x 81 cm

„Es ist am besten, sich Gesichter als Spiegel vorzustellen."

« Le mieux est de recevoir ces visages comme des miroirs. »

"It is best to think of the faces as mirrors."

2

3

4

5

6

Tacita Dean

1965 born in Canterbury, UK, lives and works in Berlin, Germany

If cartographers represent space by drawing it in two dimensions, and archaeologists draw the axis of historical time by studying human artefacts, it must be possible to find a more complete method of referring to the totality of the human experience of space and time. *Totality*, 2000, is the title of one of Tacita Dean's works. In her art, films, photographs and chalk drawings, the artist wanders through regions that have traditionally been divided by science. She is interested in strange and unique phenomena, private utopias and interrupted narratives, in which culture is reflected and human longings find their place. In her *Disappearance at Sea* cycle, 1996/97, the protagonist slowly loses himself in the sea, convinced that has succeeded in going beyond the boundaries of ordinary time and cognizable space. The ocean is the last residuum of not-knowing in a world that is perfectly transparent and measured. With the common theme of entropy and disintegration in almost all contemporary human creations, Dean makes reference to Robert Smithson's work in her sound piece entitled *Trying to Find the Spiral Jetty*, 1997. Dean combines in her work a thirst for emotion and the sensitivity of a romantic wanderer with the analytical passion of an enlightened vivisectionist. She blends diagrams, strange objects and visual substitutes for sensations experienced by the other senses, along with film images. These are constructed with the precision of a classical sonnet, as calm and beautiful as the moon before Man first set foot on it.

Auch wenn die Kartografen und die Archäologen sich darauf beschränken mögen, den Raum als zweidimensionale Fläche darzustellen beziehungsweise die Achse der historischen Entwicklung durch das Studium menschlicher Artefakte sichtbar zu machen, muss es dennoch möglich sein, die Totalität der menschlichen Raum- und Zeiterfahrung in umfassenderer Weise erlebbar zu machen. Wohl deshalb hat Tacita Dean einem ihrer Werke den programmatischen Titel *Totality*, 2000, gegeben. In ihren Arbeiten, Filmen, Fotografien und Kreidezeichnungen durchwandert die Künstlerin Regionen, die üblicherweise als Gegenstandsbereiche verschiedener Wissenschaften gelten. Sie interessiert sich vor allem für sonderbare oder einzigartige Phänomene, private Utopien und unterbrochene Erzählungen, in denen sich die Kultur spiegelt und menschliche Sehnsüchte ihren Ausdruck finden. In ihrem Zyklus *Disappearance at Sea*, 1996/97, versinkt der Protagonist allmählich in der See und scheint davon überzeugt, die Grenzen der gewöhnlichen Zeit und des wahrnehmbaren Raumes überschritten zu haben. Der Ozean ist in unserer Welt die letzte Sphäre des Nicht-Wissens, zugleich vollkommen transparent und begrenzt. In ihrem Sound-Stück *Trying to Find the Spiral Jetty*, 1997, das auf Robert Smithsons Arbeit Bezug nimmt, befasst sich mit dem Thema der Entropie und der Auflösung, das heute in zahllosen künstlerischen Äußerungen eine so zentrale Rolle spielt. In Deans Arbeiten fließen die Sehnsucht nach Gefühlen, die Sensibilität der romantischen Wanderin und die analytische Passion der aufgeklärten Vivisektionistin zusammen. Sie kombiniert Diagramme, merkwürdige Objekte und visuelle Zeichen, die für die Empfindungen der übrigen Sinnesorgane stehen, mit Filmbildern. Diese Arbeiten sind mit der Präzision eines klassischen Sonetts komponiert und präsentieren sich in solcher Ruhe und Schönheit wie der noch von keines Menschen Fuß betretene Mond.

Si les cartographes représentent l'espace en deux dimensions et que les archéologues reconstituent l'axe du temps historique en étudiant les objets fabriqués par l'homme, il doit être possible de trouver une méthode plus complète de se référer à la totalité de l'expérience humaine de l'espace et du temps. L'une des œuvres de Tacita Dean s'intitule *Totality*, 2000. Dans son art, ses films, ses photographies et ses dessins à la craie, elle se promène dans des régions qui, traditionnellement, ont été divisées par la science. Elle s'intéresse aux phénomènes étranges et uniques, aux utopies privées et aux récits interrompus, où la culture se reflète et les aspirations humaines trouvent leur place. Dans son cycle *Disappearance at Sea*, 1996/97, le protagoniste se perd lentement en mer en étant convaincu d'être parvenu à dépasser les limites du temps ordinaire et de l'espace connu. L'océan est le dernier bastion du non-connu dans un monde parfaitement transparent et mesuré. Les thèmes de l'entropie et de la désintégration étant communs à presque toutes les créations humaines contemporaines, Dean fait référence au travail de Robert Smithson dans sa pièce sonore intitulée *Trying to Find the Spiral Jetty*, 1997. Dans son travail, Dean associe un désir d'émotion et la sensibilité d'une promeneuse romantique à la passion analytique d'une vivisectionniste éclairée. Elle mêle diagrammes, objets étranges, substituts visuels de sensations perçues par les autres sens à des images filmées. Le tout est construit avec la précision d'un sonnet classique, aussi calme et beau que la lune avant que le premier homme ne marche dessus.

A. S.

SELECTED EXHIBITIONS →
1997 Frith Street Gallery, London, UK **1998** Institute of Contemporary Art, University of Pennsylvania, Philadelphia (PA), USA **1999** *Tacita Dean, Lee Ranaldo, Robert Smithson*, Dia Center for the Arts, New York (NY), USA **2000** Museum für Gegenwartskunst, Basle, Switzerland; *Intelligence*, Tate Britain, London, UK; *Mixing Memory and Desire*, Neues Kunstmuseum, Lucerne, Switzerland **2001** *Arcadia*, National Gallery of Canada, Ottawa, Canada; Tate Britain, London, UK

SELECTED BIBLIOGRAPHY →
1997 *Missing Narratives*, Witte de With Centre for Contemporary Art, Rotterdam **1998** *Tacita Dean*, Institute of Contemporary Art, University of Pennsylvania, Philadelphia (PA) **2000** *Tacita Dean*, Museum für Gegenwartskunst, Basle **2001** *Tacita Dean*, Tate Britain, London

1 **Teignmouth Electron,** Cayman Brac, 1999, black and white photograph, 103 x 69 cm
2 **Bubble House (Exterior),** 1999, colour photograph, 148 x 173 cm
3 **Bubble House (Seaview),** 1999, colour photograph, 110 x 143 cm
4 **Fernsehturm,** 2001, 16 mm colour anamorphic film, optical sound, 44 min

„Ich möchte, dass die Menschen sich mit Zeit geradezu überflutet fühlen." « Je désire que les gens se sentent inondés de temps. »

"I want people to feel drenched in time."

2

3

4

Thomas Demand

1964 born in Munich, lives and works in Berlin, Germany, and London, UK

The artist Thomas Demand is a photographer and he is also a sculptor, for everything he photographs has been painstakingly and precisely created by him. His subjects range from single interiors to whole buildings, even entire streets. On second glance these locations, most of which remain deserted, are revealed to be models, and the questions arise: what is the original, which is the fabrication and at what point are the boundaries of simulation reached? The pictures have a symbolic effect, designed to jog memories of "fundamentality": the convincing solemnity of a study in *Büro* (Office), 1995; the vertiginous height of *Sprungturm* (Diving Board), 1994, at the swimming baths; or the technical smoothness of *Rolltreppe* (Escalator), 2000. Demand does not shy away from politically explosive and emotionally charged locations in his works. The bathtub in which a German politician was found dead in mysterious circumstances in a hotel room in Geneva is recreated and photographed by the artist in *Badezimmer* (Bathroom), 1997, as is the prototype of the exhibition hall designed by the Nazi architect Albert Speer for the 1937 Paris World Fair, in *Modell* (Model), 2000. For these two works, Demand used pre-existing photographs to construct his models, which were in turn translated back into photographs. Via the detour of his reconstructed models, Demand succeeds in claiming that social reality can be interpreted as fiction.

Der Künstler Thomas Demand ist Fotograf und im selben Moment ein Bildhauer, denn alles was er fotografiert, hat er zuvor in penibler und präsizer Arbeit selber hergestellt. Das Spektrum seiner konstruierten Sujets reicht von einzelnen Innenräumen über komplette Gebäude bis hin zu ganzen Straßen. Orte, meist bleiben sie menschenleer, werden zum Modell ihrer selbst, entlarven sich auf den zweiten Blick als Täuschung und stellen so die Frage nach Original und Fälschung sowie die nach den Grenzen der Simulation. Zudem behaupten die Bilder auch eine zeichenhafte Wirkung, die Erinnerungen an „Wesentliches" in Gang setzen soll: Die akkurate Tristesse eines Arbeitsraums in *Büro*, 1995, die Schwindel erregende Höhe vom *Sprungturm*, 1994, im Schwimmbad, oder die technische Glätte der *Rolltreppe*, 2000, erzählen genau davon. Aber auch politisch brisante und emotional aufgeladene Orte finden sich in Demands Werk. Die Badewanne, in der ein deutscher Politiker unter mysteriösen Umständen in einem Genfer Hotelzimmer tot aufgefunden worden war, stellt der Künstler ebenso nach und fotografiert sie in *Badezimmer*, 1997, wie den Prototyp der Ausstellungshalle in *Modell*, 2000, die der nationalsozialistische Architekt Albert Speer für die Weltausstellung 1937 in Paris entworfen hatte. Bei diesen beiden Arbeiten basieren die Vorlagen für das von ihm gebaute Modell auf Fotografien, die also gleichsam zurückübersetzt werden in neue Fotografien. Durch den Umweg, den Demand dabei über seine nachgebauten Modelle geht, gelingt es ihm, gesellschaftliche Realität als interpretierbare Fiktion zu behaupten.

L'artiste Thomas Demand est à la fois photographe et sculpteur. Tout ce qu'il photographie a été réalisé par ses soins dans un travail pénible et précis. L'étendue de ses sujets construits de toutes pièces va d'espaces intérieurs spécifiques à des rues entières en passant par des immeubles. Le plus souvent exempts de toute présence humaine, des lieux deviennent le modèle d'eux-mêmes et n'apparaissent comme un leurre qu'au second regard, posant ainsi le problème de l'original et de la copie, mais aussi des limites de la simulation. De plus, les photographies font l'effet d'un signe qui évoque le souvenir de quelque chose d'« essentiel » : comme l'évoquent avec une éloquente précision la tristesse poignante d'un espace de travail dans *Büro* (Bureau), 1995, le vertige des hauteurs dans *Sprungturm* (Plongeoir), 1994, dans une piscine ou la perfection technique d'un *Rolltreppe* (Escalator), 2000. La baignoire d'une chambre d'hôtel de Genève, dans laquelle un politicien allemand fut retrouvé mort dans des conditions mystérieuses, a été reconstituée par l'artiste et photographiée dans *Badezimmer* (Salle de bains), 1997, aussi bien que le prototype de la halle d'exposition que l'architecte nazi Albert Speer conçut pour l'Exposition universelle de Paris en 1937 (*Modell*/Maquette, 2000). Dans ces deux œuvres, les modèles des maquettes construites par Demand s'appuient sur des photographies, qui sont donc en quelque sorte reconverties en de nouvelles photographies. Par le détour qu'il emprunte à travers ses reconstitutions, Demand parvient à affirmer la réalité sociale comme une fiction interprétable.

R. S.

SELECTED EXHIBITIONS →
1999 *Tunnel, Art Now 16*, Tate Gallery, London, UK; *Große Illusionen*, Museum of Contemporary Art, North Miami (FL), USA **2000** Fondation Cartier pour l'Art Contemporain, Paris, France **2001** *Report*, Sprengel Museum, Hanover, Germany; *Discovery*, pitti immagine, Palazzo Pitti, Florence, Italy; Stichting De Appel, Amsterdam, The Netherlands **2000** *Age of Influence*, Museum of Contemporary Art, Chicago (IL), USA; *Dinge in der Kunst des XX. Jahrhunderts*, Haus der Kunst, Munich, Germany **2001** *6ème Biennale de Lyon*, France

SELECTED BIBLIOGRAPHY →
1999 Burkhard Riemschneider/Uta Grosenick (ed.), *Art at the Turn of the Millennium*, Cologne **2000** *Thomas Demand*, Fondation Cartier pour l'Art Contemporain, Paris; *Small World*, Museum of Contemporary Art, San Diego (CA) **2001** *Big Nothing. Die jenseitigen Ebenbilder des Menschen*, Staatliche Kunsthalle Baden-Baden; *Thomas Demand. Report*, Sprengel Museum, Hanover; *Thomas Demand*, Aspen Art Museum, Aspen (CO)/Stichting De Appel, Amsterdam

1 **Podium,** 2000, c-print/Diasec, 296 x 178 cm
2 **Poll,** 2001, c-print/Diasec, 180 x 260 cm
3 **Stapel/Pile,** 2001, c-print/Diasec, 5 parts, 53 x 84 cm

4 **Stapel/Pile,** 2001, c-print/Diasec, 5 parts, 42 x 54 cm
5 **Copyshop,** 1999, c-print/Diasec, 184 x 300 cm

„Ich habe den Eindruck, dass sich Fotografie nicht mehr sehr auf symbolische Strategien verlassen kann und sie stattdessen psychologische Erzählstränge innerhalb des Mediums erkundet."

« J'ai l'impression que la photographie ne peut plus compter beaucoup sur des stratégies symboliques et qu'au lieu de cela elle explore des fils narratifs psychologiques à l'intérieur du médium. »

"I have the impression that photography can no longer rely much on symbolic strategies and has to probe psychological narrative elements within the medium instead."

2

3

4

5

Rineke Dijkstra

1959 born in Sittard, lives and works in Amsterdam, The Netherlands

Portraits are central to the work of Dutch photographer Rineke Dijkstra. The artist generally creates her documentary projects by approaching children and young people in public spaces such as beaches, parks and nightclubs. This results in intense collaborations and, although her models are lifted out of their everyday contexts, they are given leeway to choose the manner in which they express themselves. This endows the photographs with a poignancy and humour that belies their sociological coolness. In the late 1990s the artist turned to the medium of video. In *The Buzzclub, Liverpool, UK/Mysteryworld, Zaandam, NL*, 1996/97, young clubbers were positioned facing a static video camera in a bare, dimly lit studio. Dressed for clubbing, the adolescents dance to "their" music, but now they must do so without the protection of a crowd. Using a variety of settings, Dijkstra repeatedly reveals the discrepancy between norm, uniformity and individual identity. This is evident once more in her latest cycle of photographs, *Israel Portraits*, 2001. Prompted by an invitation from the Herzliya Museum of Art she was inspired to take portraits of Israelis on military service, an important period in the lives of young Israelis, who are expected to serve irrespective of their gender. Dijkstra photographed the recruits dressed in both uniform and civilian clothes on their first day, and in full gear after a military exercise in the Golan Heights. The faces of the young soldiers speak of pride and insecurity, adventurousness and vulnerability. These photographs document individual transitions that are marked by the rites of social initiation and political and personal ambivalence.

In den Arbeiten der niederländischen Fotografin Rineke Dijkstra spielt das menschliche Porträt die zentrale Rolle. Für ihre dokumentarischen Projekte spricht die Künstlerin zumeist Kinder und Jugendliche im öffentlichen Raum an – etwa am Strand, im Park oder in einer Diskothek. Es entsteht eine intensive Zusammenarbeit, bei der die Modelle zwar aus ihrem alltäglichen Kontext herausgelöst werden, aber gleichzeitig Raum für einen selbst gewählten Ausdruck erhalten. Dadurch haben die Fotografien, bei aller soziologischen Kühle, rührende und humorvolle Momente. Ende der neunziger Jahre wandte sich die Künstlerin dem Medium Video zu. In *The Buzzclub, Liverpool, UK/Mysteryworld, Zaandam, NL*, 1996/97, filmte sie junge Diskobesucher, die sie in einem leeren Studio bei fahler Beleuchtung frontal vor eine statische Kamera stellte. Die Jugendlichen in ihrem nächtlichen Outfit beginnen zu „ihrer" Musik zu tanzen, allerdings ohne den Schutz der Masse. Es ist immer wieder diese Diskrepanz zwischen Norm, Uniformiertheit und individueller Identität, die Dijkstra in verschiedenen Milieus zum Vorschein bringt – so auch in ihrem neuesten Fotozyklus, den *Israel Portraits*, 2001. Angeregt durch eine Einladung des Herzliya Museum of Art, wuchs die Idee, Porträts von Israelis während ihres Militärdienstes zu machen, der eine wichtige Rolle im Leben israelischer Jugendlicher spielt, zumal Männer und Frauen gleichermaßen eingezogen werden. Dijkstra fotografierte die Rekruten in ihren Uniformen und in ihrer Zivilkleidung, am ersten Tag ihres Dienstes und in voller militärischer Montur nach einer Waffenübung auf den Golan-Höhen. In den Gesichtern der jungen Soldaten steht der Ausdruck von Stolz neben Verunsicherung, Abenteuergeist neben Verletzlichkeit. Es sind Dokumente eines Übergangs, gezeichnet von den Riten gesellschaftlicher Initiation und von politischer und persönlicher Ambivalenz.

Dans les œuvres de la photographe néerlandaise Rineke Dijkstra, le portrait occupe une place centrale. Pour ses projets documentaires, l'artiste fait le plus souvent appel à des enfants et à des jeunes dans l'espace public – à la plage, dans les parcs ou dans les discothèques. Il en résulte une intense collaboration qui fait certes sortir les modèles de leur environnement quotidien tout en leur donnant du champ pour un mode d'expression librement choisi. De ce fait, malgré une froideur toute sociologique, ces photographies contiennent des moments émouvants et pleins d'humour. A la fin des années 90, l'artiste se tourne vers la vidéo. Dans *The Buzzclub, Liverpool, UK/Mysteryworld, Zaandam, NL*, 1996/97, elle s'attache à filmer de jeunes danseurs de discothèque – frontalement, devant une caméra fixe, dans un studio vide baignant dans un éclairage glauque. Vêtus de leur accoutrement nocturne, les jeunes commencent à danser sur « leur » musique, sans bénéficier il est vrai de la protection de la foule. C'est toujours ce décalage entre norme, uniformité et identité individuelle que Dijkstra met en évidence dans différents milieux. Ceci vaut également pour son dernier cycle de photographies, les *Israel Portraits*, 2001. Sur une invitation du Herzliya Museum of Art, Dijkstra conçut l'idée de photographier des Israéliens pendant leur service militaire, qui joue un rôle important dans la vie des jeunes Israéliens, notamment au regard du fait qu'hommes et femmes sont également appelés sous les drapeaux. Dijkstra a photographié les jeunes recrues dans leurs uniformes et dans leurs habits civils, le premier jour de leur service, en équipement militaire complet, après un exercice de tir sur les hauteurs du Golan. Dans leurs visages, l'expression de fierté côtoie celle de l'insécurisation, l'esprit d'aventure la vulnérabilité. Ces documents sont ceux d'une transition signée par les rites de l'initiation sociale et de l'ambivalence politique et individuelle.

A. K.

SELECTED EXHIBITIONS →
1997 *47. Biennale di Venezia*, Venice, Italy **1998** Museum Boijmans Van Beuningen, Rotterdam, The Netherlands; *XXIV Bienal Internacional de São Paulo*, Brazil **1999** *The Buzzclub, Liverpool, UK/Mysteryworld, Zaandam, NL*, Museu d'Art Contemporàni de Barcelona, Spain **2001** *Israel portraits*, The Herzliya Museum of Art, Herzliya, Israel; *Focus: Rineke Dijkstra*, The Art Institute of Chicago (IL), USA

SELECTED BIBLIOGRAPHY →
1996 *Prospekt 96. Photographie in der Gegenwart*, Schirn Kunsthalle, Frankfurt am Main **1998** *Rineke Dijkstra, Über die Welt*, Sprengel Museum, Hanover; *Menschenbilder*, Museum Folkwang, Essen **2001** *Israel portraits*, The Herzliya Museum of Art, Herzliya; *Rineke Dijkstra and Bart Domburg: Die Berliner Zeit*, DAAD Galerie, Berlin

1, 2, 4 **Induction Center,** Tel Hashomer, Israel, April 12, 1999, c-prints, each 126 x 107 cm
3 **Abigael,** Herzliya, Israel, April 10, 1999, c-print, 126 x 107 cm

5 **The Buzzclub, Liverpool, UK/Mysteryworld, Zaandam, NL,** 1996/97, two screen video installation, duration 26:40 min
6 **Golani Brigade,** Eyakim, Israel 26, 1999, c-prints, each 180 x 150 cm

„Mich interessiert vor allem die paradoxe Beziehung zwischen der Identität und der Uniformität, der Macht und der Verletzlichkeit jedes Individuums und jeder Gruppe. Dieses Paradox versuche ich sichtbar zu machen, indem ich das Augenmerk auf Posen, Einstellungen, Gesten und Blicke richte."

« Je m'intéresse au paradoxe entre l'identité et l'uniformité, au pouvoir et à la vulnérabilité de chaque individu et de chaque groupe. C'est ce paradoxe que je tente de visualiser en me concentrant sur des poses, des attitudes, des gestes et des regards. »

"I am interested in the paradox between identity and uniformity, in the power and vulnerabiltity of each individual and each group. It is this paradox that I try to visualise by concentrating on poses, attitudes, gestures and gazes."

5

Peter Doig

1959 born Edinburgh, lives and works in London, UK

Peter Doig paints picturesque landscapes inspired by images in photographs, films, books and other popular media. In *Night Fishing*, 1993, he started with an image found in an advertisement for a fishing holiday in Canada, from which he created a scene set on a lake at dusk. *Daytime Astronomy*, 1997/98, was inspired by a photograph of Jackson Pollock taken by Hans Namuth, in which Pollock lies on his back gazing upwards. Doig does not paint nature scenes from within the landscape itself, and his use of reproductions is also indirect: he works from photocopies and sketches that are generations removed from the originals by his repeated reworking of the images. Doig has created multiple versions of similar scenes as paintings and as intimate drawings and studies. Inspired by a scene in the horror movie "Friday the 13th", he painted several images of a lake with a figure slumped over a canoe. A related group of works entitled *Echo-Lake*, in which a figure cups his hands to shout out across the lake, is inspired by the same movie. In addition to sources in popular culture, Doig is interested in the use of intense colour by Impressionist and Post-impressionist painters, as well as the effect of the camera on the way artists have visualised the natural world for more than a century. While his work has been compared to that of Gerhard Richter because of the strong relationship between painting and photography, Doig looks more towards the tradition of painting and the ways artists such as Friedrich, Constable and Monet interpreted and abstracted the landscape.

Peter Doig malt pittoreske Landschaften und lässt sich dabei von Fotos, Filmen, Büchern und sonstigen populären Medien inspirieren. So liegt etwa der Arbeit *Night Fishing*, 1993, ein Bild zugrunde, das er in einer Werbung für einen Angelurlaub in Kanada entdeckt hat. Ausgehend von diesem Bild hat Doig eine Szene in der Abenddämmerung auf einem See gestaltet. Auch zu dem Werk *Daytime Astronomy*, 1997/98, hat Doig sich von einem Foto anregen lassen, das Hans Namuth von dem auf dem Rücken liegenden Jackson Pollock gemacht hat. Aber Doig verzichtet bei seiner Landschaftsmalerei nicht nur auf die unmittelbare Anschauung der Natur, er ist sogar auf möglichst große Distanz zu seinen Motiven bedacht: So arbeitet er zum Beispiel nach Fotokopien und Skizzen, die durch wiederholte Überarbeitungen gleich um mehrere „Generationen" von den Originalen entfernt sind. Doig hat zahllose Versionen ganz ähnlicher Motive mal als Gemälde, dann wieder als intime Zeichnungen oder als Studien gestaltet. So ist etwa eine Szene aus dem Horrorfilm „Freitag der 13." Ausgangspunkt etlicher verschiedener Versionen eines Sees mit einer Figur, die über einem Kanu zusammengebrochen ist. In einer weiteren – *Echo-Lake* betitelten – Werkgruppe ist eine Figur mit erhobenen Händen zu sehen, die etwas über einen See brüllt. Auch hier hat wieder derselbe Film als Inspirationsquelle gedient. Doig entnimmt seine Motive aber nicht nur aus Vorlagen der Pop-Kultur, er beschäftigt sich auch mit den intensiven Farben der impressionistischen und postimpressionistischen Malerei. Außerdem befasst er sich mit der Frage, wie die Erfindung der Kamera den Blick der Künstler auf die Natur in den letzten 150 Jahren verändert hat. Wegen der engen Beziehung zwischen Malerei und Fotografie hat man Doig immer wieder mit Gerhard Richter verglichen. Doch gilt sein Interesse vor allem jener malerischen Tradition und jenen Interpretations- und Abstraktionsverfahren, von denen sich Landschaftsmaler wie Friedrich, Constable und Monet haben leiten lassen.

Peter Doig peint des paysages pittoresques inspirés par des images trouvées dans des photographies, des films, des livres et d'autres médias populaires. Dans *Night Fishing*, 1993, il est parti d'une image trouvée dans une publicité pour un séjour de pêche au Canada, avec laquelle il a créé une scène située sur un lac au crépuscule. De même, *Daytime Astronomy* 1997/98, s'inspire d'une photographie de Jackson Pollock prise par Hans Namuth, où Pollock est allongé sur le dos, fixant le ciel. Doig ne peint pas les paysages d'après nature. Son recours aux reproductions est tout aussi indirect : il travaille à partir de photocopies et de croquis qui, à force d'être retravaillés, finissent par être à des générations de l'original. Doig a créé des versions multiples de scènes similaires sous forme de peintures, de dessins et d'études. Inspiré par une scène du film d'horreur « Vendredi 13 », il a peint plusieurs images d'un lac avec un silhouette affalée dans un canoë. Une série d'œuvres apparentées, *Echo-Lake*, où une silhouette met ses mains en porte-voix pour appeler quelqu'un de l'autre côté du lac, renvoie au même film. Outre la culture populaire, Doig s'inspire des couleurs intenses des impressionnistes et postimpressionnistes. Il s'intéresse également à l'influence de l'appareil photo sur la manière dont les artistes visualisent la nature depuis plus d'un siècle. Son travail a souvent été comparé à celui de Gerhard Richter du fait de ses liens étroits entre la peinture et la photographie, mais Doig s'oriente davantage vers la tradition picturale et la façon dont des artistes tels que Friedrich, Constable et Monet ont interprété et traduit le paysage de manière abstraite. Ro. S.

SELECTED EXHIBITIONS →
1994 *The Turner Prize Exhibition*, Tate Gallery, London, UK **1996** *Homely*, Gesellschaft für Aktuelle Kunst, Bremen, Germany **1998** *Blizzard seventy-seven*, Kunsthalle Nürnberg, Nuremberg, Germany **1999** *Version*, Kunsthaus Glarus, Switzerland; *Examining Pictures*, Museum of Contemporary Art, Chicago (IL), USA **2000** *Currents 83: Peter Doig*, Saint Louis Art Museum, St. Louis (MS), USA; *Twisted*, Stedelijk Van Abbe Museum, Eindhoven, The Netherlands **2002** Santa Monica Museum of Art, Santa Monica (CA), USA

SELECTED BIBLIOGRAPHY →
1996 *Homely*, Gesellschaft für Aktuelle Kunst, Bremen **1998** *Peter Doig: Blizzard seventy-seven*, Kunsthalle Nürnberg, Nuremberg/ Kunsthalle zu Kiel/Whitechapel Art Gallery, London **1999** *Peter Doig: Version*, Kunsthaus Glarus **2000** *MATRIX 183: Peter Doig, Echo-Lake*, University Art Museum, Berkeley (CA); *Currents 83: Peter Doig*, St. Louis Art Museum (MS)

1 **The heart of Old San Juan,** 1999, oil on canvas, 250 x 196 cm
2 **Untitled (Pond Painting),** 2000, oil on canvas, 200 x 250 cm

3 **Echo-Lake,** 1998, oil on linen, 229 x 359 cm
4 **100 Years Ago,** 2000, oil on canvas, 200 x 296 cm

„Ich betrachte meine Bilder durchaus nicht als realistisch. Ich glaube vielmehr, dass sie vornehmlich im Kopf entstehen und nicht allzu viel mit dem zu tun haben, was wir da draußen vor uns sehen."

« Je ne considère pas du tout mes peintures comme réalistes. Je les conçois comme découlant de ce qu'on a dans la tête plutôt que de ce qu'on a sous les yeux. »

"I don't think of my paintings as being at all realistic. I think of them as being derived more from within the head than from what's out there in front of you."

2

3

4

Keith Edmier

1967 born in Chicago (IL), lives and works in New York (NY), USA

Keith Edmier's highly detailed representational sculptures refer to memories of his childhood in 1970s Midwestern America and have been described as "Sentimental Realism". Conflating personal history with collective memory, he relieves the autobiographical content of his work by adding details which refer to icons of recent history. *Beverley Edmier, 1967*, 1998, is a life-size rendering of his heavily pregnant mother wearing the same Chanel suit as Jackie Kennedy wore on the day of the president's assassination while *Jill Peters*, 1997/98, is a waxy portrait of his first love, sporting the infamous feather-flick hairstyle of Farah Fawcett, who was the first love of countless American teenagers of Edmier's generation. A sense of vulnerability is implied by cartoonish exaggerations of scale, lurid primary colours or suggestively phallic structures that recall the ungainly awkwardness and sexual discomfort of adolescence. Edmier's fascination with childhood heroes led to a collaboration with Evel Knievel and a small-scale bronze monument (*Evel Knievel, American Daredevil*, 1996) and inspired a recent project which returns to his teenage fascination with Farah Fawcett. When he discovered that Fawcett is a practising artist as well as a famous actress, Edmier contacted her and suggested they collaborate on a work. Their first collaborative sculpture, *Untitled (Hands)*, 2000, is a marble carving of his and her hands. With a touching sincerity, Edmier conveys the gap between the intensity of childhood and its recollection in maturity and the transformation of a boy's unqualified hero-worship into a mutual adult affiliation.

Die ungemein detailliert herausgearbeiteten Skulpturen von Keith Edmier, bisweilen als „sentimentaler Realismus" beschrieben, beziehen sich auf seine Kindheit im Mittleren Westen der siebziger Jahre. Durch Verschmelzung persönlicher Erfahrungen und kollektiver Erinnerung relativiert Edmier den autobiografischen Bezug seiner Arbeiten: Er fügt ihnen Details hinzu, die auf die Ikonen der jüngeren Vergangenheit verweisen. *Beverley Edmier, 1967*, 1998, ist eine lebensgroße Skulptur, die Edmiers hochschwangere Mutter in demselben Chanel-Kostüm zeigt, das Jackie Kennedy am Tag der Ermordung des Präsidenten trug. *Jill Peters*, 1997/98, wiederum ist ein Wachsbildnis seiner ersten Liebe, dargestellt mit der berüchtigten Frisur jener Farah Fawcett, die die erste Liebe zahlloser männlicher Teenager aus Edmiers Generation war. Einen Eindruck von Verletzlichkeit vermitteln karikaturistisch überzeichnete Größenverhältnisse, gespenstisch wirkende Primärfarben sowie suggestive phallische Elemente, die an die ersten linkischen Annäherungsversuche und das sexuelle Unbehagen der Pubertät erinnern. Edmiers Faszination für die Heroen seiner Kindheit führte zur Zusammenarbeit mit Evel Knievel, die eine kleinformatige Bronzeskulptur (*Evel Knievel, American Daredevil*, 1996) ergab, sowie ein neueres Werk, das einmal mehr auf seine jugendliche Begeisterung für Farah Fawcett zurückgeht. Als Edmier herausfand, dass Fawcett nicht allein eine berühmte Schauspielerin, sondern zudem praktizierende Künstlerin ist, nahm er Kontakt zu ihr auf und regte eine Zusammenarbeit an. Die erste gemeinsam geschaffene Skulptur *Untitled (Hands)*, 2000, ist eine in Marmor gemeißelte Nachbildung seiner und ihrer Hände. Mit anrührender Aufrichtigkeit verweist Edmier auf die Kluft zwischen intensiver Kindheitserfahrung und der Erinnerung des Herangewachsenen, zwischen der unqualifizierten Heldenverehrung des Jungen und der gegenseitigen Verbundenheit Erwachsener.

Qualifiées de « Réalisme sentimental », les sculptures figuratives très détaillées de Keith Edmier renvoient à des souvenirs de son enfance dans le Midwest américain des années 1970. Associant son histoire personnelle à la mémoire collective, il dilue le contenu autobiographique de ses œuvres en y ajoutant des détails liés à des personnalités symboliques de l'histoire récente. *Beverley Edmier, 1967*, 1998, est une reconstitution grandeur nature de sa mère enceinte portant le même tailleur Chanel que Jackie Kennedy le jour de l'assassinat de son mari. *Jill Peters*, 1997/98, est un portrait en cire de son premier amour coiffée à la lionne avec la fameuse crinière à la Farah Fawcett, elle-même premier amour d'innombrables adolescents américains de la génération d'Edmier. Il se dégage une impression de vulnérabilité de ses distorsions d'échelles, très bande dessinée, de ses couleurs primaires criardes ou de ses structures phalliques suggestives qui évoquent la gaucherie et la gêne sexuelle de l'adolescence. La fascination d'Edmier pour les héros de son enfance a débouché sur sa collaboration avec Evel Knievel et un petit monument en bronze (*Evel Knievel, American Daredevil*, 1996). Elle lui a également inspiré un autre projet lié à sa passion adolescente pour Farah Fawcett. Lorsqu'il a découvert que la célèbre actrice était également une artiste plasticienne, il l'a contactée et lui a proposé une collaboration. Leur première œuvre commune, *Untitled (Hands)*, 2000, est une sculpture en marbre de leurs mains. Avec une sincérité touchante, Edmier traduit l'écart entre l'intensité de l'enfance et son souvenir à l'âge adulte, ainsi que la transformation de la vénération inconditionnelle d'un héros par un garçon en une affiliation réciproque entre adultes.

K. B.

SELECTED EXHIBITIONS →
1995 *Human/Nature*, The New Museum of Contemporary Art, New York (NY), USA **1997** University of South Florida Art Museum, Tampa (FL), USA; *Gothic*, Institute of Contemporary Art, Boston (MA), USA **1998** Sadie Coles HQ, London, UK **1999** *Abracadabra*, Tate Gallery, London, UK **2000** *Greater New York*, P.S.1, Long Island City (NY), USA; *Age of Influence: Reflections in the Mirror of American Culture*, Museum of Contemporary Art, Chicago (IL), USA **2002** *Whitney Biennial*, The Whitney Museum of American Art, New York (NY), USA

SELECTED BIBLIOGRAPHY →
1997 *Gothic*, Institute of Contemporary Art, Boston (MA); *Keith Edmier*, University of South Florida Art Museum, Tampa (FL) **1998** *Keith Edmier*, Douglas Hyde Gallery, Dublin **1999** *Abracadabra*, Tate Gallery, London; Burkhard Riemschneider/Uta Grosenick (eds.), *Art at the Turn of the Millennium*, Cologne **2000** *Greater New York*, P.S.1, Long Island City (NY)

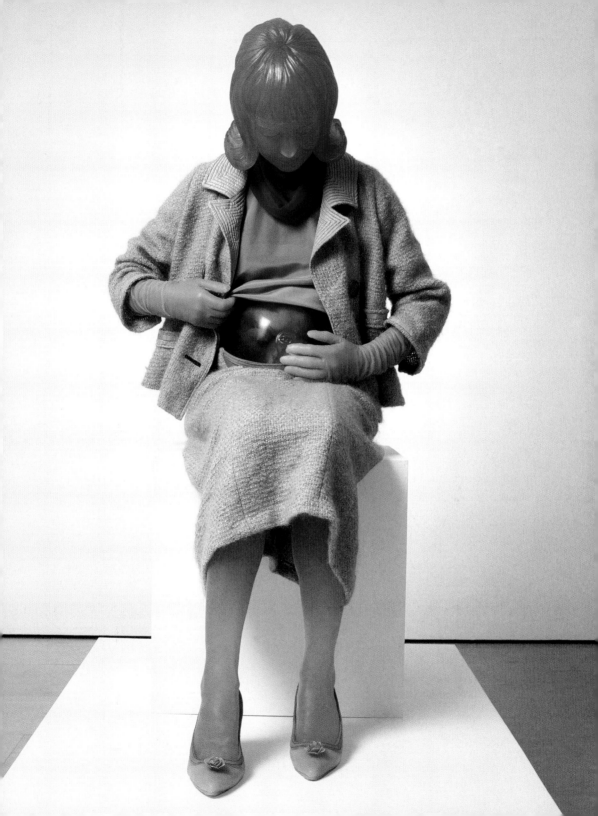

1 **Beverley Edmier, 1967,** 1998, cast resin, silicone, acrylic paint, fabric, 129 x 80 x 57 cm
2 **KE:EK,** 1997, installation view, University of South Florida Art Museum, Tampa (FL)
3 In collaboration with Farah Fawcett: **Untitled (Hands),** 2000, alabaster, wood pedestal, 36 x 18 x 17 cm
4 **Emil Dobbelstein and Henry J. Drope, 1944 – Presidential Wreath,** 2000, installation view, neugerriemschneider, Berlin

„An der Vorstellung festhalten, dass in der Kunst alles möglich ist, aber auch die Konsequenzen dieser Freiheit zu akzeptieren."

« S'en tenir à l'idée que tout est possible en art mais accepter les conséquences de cette liberté. »

"To hold on to the idea that anything is possible in art, but to accept the consequences of that freedom."

2

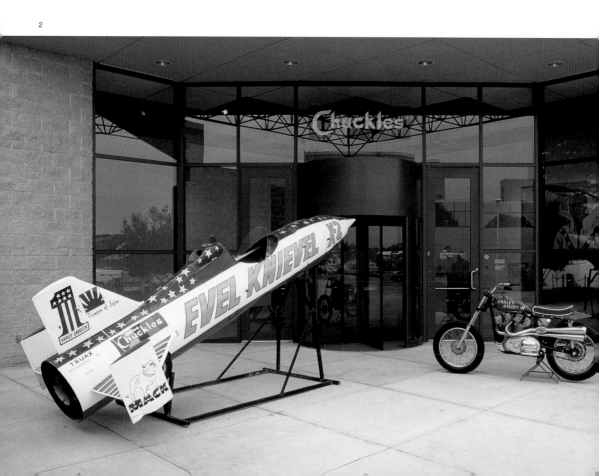

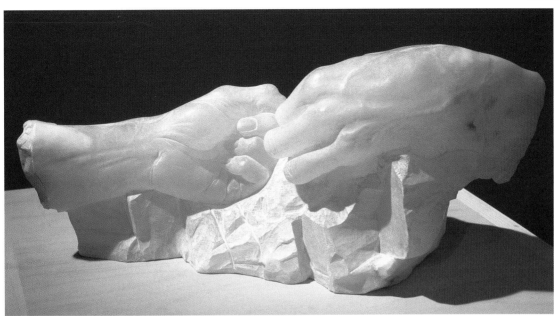

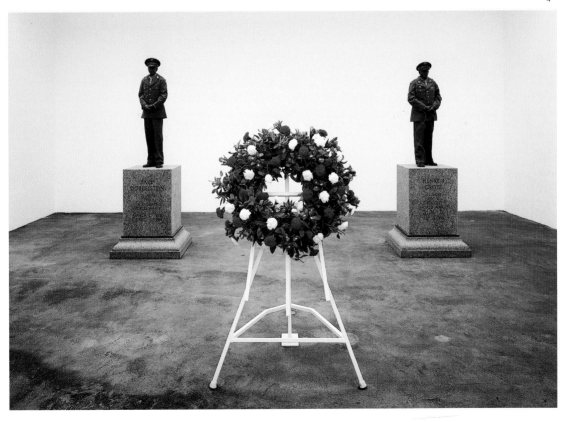

Olafur Eliasson

1967 born in Copenhagen, Denmark, lives and works in Berlin, Germany

Olafur Eliasson's work is focused on natural elements and the conditions under which they are experienced. Water, light, moss, ice, steam and rainbows are among the phenomena that have been central to his sculptural installations. In *Your strange certainty still kept*, 1996, he created an indoor waterfall and used strobe lights to make the flowing liquid appear to be suspended in mid-air. He created a similar effect in *The drop factory. A short story on your self-ref and rep*, 2000, at the Saint Louis Art Museum, in which he enclosed his water-and-strobe effects inside a dome resembling the utopian architecture of R. Buckminster Fuller as well as the igloo-shaped structures prevalent in Iceland. Mirrored panels covered the interior and exterior of Eliasson's dome, and viewers became part of its kaleidoscopic reflections. While his work is often compared to the seamless installations by Light and Space artists James Turrell and Robert Irwin, Eliasson lets viewers see the ordinary lamps, hoses, pumps and valves used to create extraordinary effects. In *Your repetitive view*, 2000, and *Your now is my surroundings*, 2000, both at a gallery in New York, Eliasson also employed mirrors to create kaleidoscopic effects. For these pieces he opened up the gallery's walls and ceiling and brought the outdoors into the space in the form of reflections of the sky and urban elements. The use of mirrors is just one of the ways Eliasson underscores the human subjectivity and individual perception at the basis of his work. Viewers are integral participants in Eliasson's sensory environments, with their roles often signaled by the word "your" in his titles.

Das Werk von Olafur Eliasson kreist um die Natur und die Bedingungen, unter denen wir sie erfahren. Wasser, Licht, Moos, Eis, Dampf und Regenbögen sind nur einige der zentralen Phänomene in seinen skulpturalen Installationen. Für *Your strange certainty still kept*, 1996, hat er einen Innenraum-Wasserfall geschaffen und Stroboskoplampen installiert, deren Licht die herabstürzende Flüssigkeit in der Luft optisch gefrieren ließ. Mit ganz ähnlichen Effekten hat er auch bei *The drop factory. A short story on your self-ref and rep*, 2000, für das Saint Louis Art Museum gearbeitet. Diesmal hat er den Wasserfall in eine Kuppel verlegt, die zugleich an die utopische Architektur eines R. Buckminster Fuller und die traditionelle isländische Iglubauweise erinnert. Eliassons Kuppel war innen und außen mit Spiegeln verkleidet, so dass der Betrachter selbst zum Bestandteil dieser kaleidoskopartigen Reflexionen wurde. Eliassons Arbeiten werden immer wieder mit den makellosen Installationen der Licht-und-Raum-Künstler James Turrell und Robert Irwin verglichen. Doch zeigt Eliasson ganz offen die profanen Lampen, Schläuche, Pumpen und Ventile, die die ungewöhnlichen Effekte erzeugen. In *Your repetitive view*, 2000, und *Your now is my surroundings*, 2000, beide ausgestellt in einer New Yorker Galerie, hat Eliasson Spiegel verwendet, um eine kaleidoskopartige Wirkung zu erzielen. Er hat für diese Werke sogar die Wände und die Decke der Galerie geöffnet und das Außen als Spiegelung der Sonne und des städtischen Umraums in den Raum hineingelenkt. Die Spiegelelemente, mit denen Eliasson arbeitet, unterstreichen die subjektive und individuelle Rezeption seiner Werke. In Eliassons sinnlichen Installationen ist der Betrachter ein unverzichtbarer Mitspieler, der in den Werktiteln durch Verwendung des Wortes „your" direkt angesprochen wird.

Le travail d'Olafur Eliasson se concentre sur les éléments naturels et les conditions sous lesquelles ils sont vécus. L'eau, la lumière, la mousse, la vapeur et les arcs-en-ciel comptent parmi les phénomènes ayant fait l'objet de ses installations sculpturales. Dans *Your strange certainty still kept*, 1996, il a créé une cascade en salle et a utilisé des lumières stroboscopiques pour donner l'illusion que le liquide était suspendu dans l'air. Il a créé un effet similaire dans *The drop factory. A short story on your self-ref and rep*, 2000, au Saint Louis Art Museum. Il a enfermé ses effets d'eau et de lumière stroboscopique sous un dôme rappelant l'architecture utopique de R. Buckminster Fuller ainsi que les structures en forme d'igloo d'Islande. Des panneaux en miroirs tapissaient l'intérieur et l'extérieur du dôme, si bien que les spectateurs devenaient partie intégrante de ses reflets kaléidoscopiques. On compare souvent son travail aux installations des artistes de la lumière et de l'espace, James Turrell et Robert Irwin, si ce n'est qu'Eliasson montre les outils ordinaires – lampes, tuyaux, pompes et valves – qu'il utilise pour créer des effets extraordinaires. Dans *Your repetitive view*, 2000, et *Your now is my surroundings*, 2000, tous deux à une galerie new-yorkaise, Eliasson emploie à nouveau des miroirs pour créer des effets kaléidoscopiques. Pour ces œuvres, il a ouvert les murs et le plafond de la galerie et amené l'extérieur à l'intérieur par l'intermédiaire des reflets du ciel et des éléments urbains. Le recours aux miroirs n'est qu'un des moyens dont il se sert pour souligner la subjectivité et la perception individuelle à la base de son travail. Les spectateurs participent intégralement à ses environnements sensoriels, leur rôle étant souvent indiqué par l'emploi du possessif « your » (le votre) dans ses titres.

Ro. S.

SELECTED EXHIBITIONS →
1998 *XXIV Bienal Internacional de São Paulo*, Brazil; *1. berlin biennale*, Berlin, Germany **1999** Dundee Contemporary Arts, Dundee, UK; Stichting De Appel, Amsterdam, The Netherlands; Kunstverein Wolfsburg, Germany; *Carnegie International*, Carnegie Museum of Art, Pittsburgh (PA), USA; *dAPERTuttO, 48. Biennale di Venezia*, Venice, Italy **2000** *Your surrounded intuition versus your intuitive surroundings*, The Art Institute of Chicago, Chicago (IL), USA; *Wonderland*, Saint Louis Art Museum, St. Louis (MS), USA

SELECTED BIBLIOGRAPHY →
1997 *Olafur Eliasson, The Curious Garden*, Kunsthalle Basel
1998 Olafur Eliasson, *USERS*, Copenhagen/Berlin **1999** *Carnegie International*, Carnegie Museum of Art, Pittsburgh (PA)
2000 *Wonderland*, Saint Louis Art Museum, St. Louis (MS)

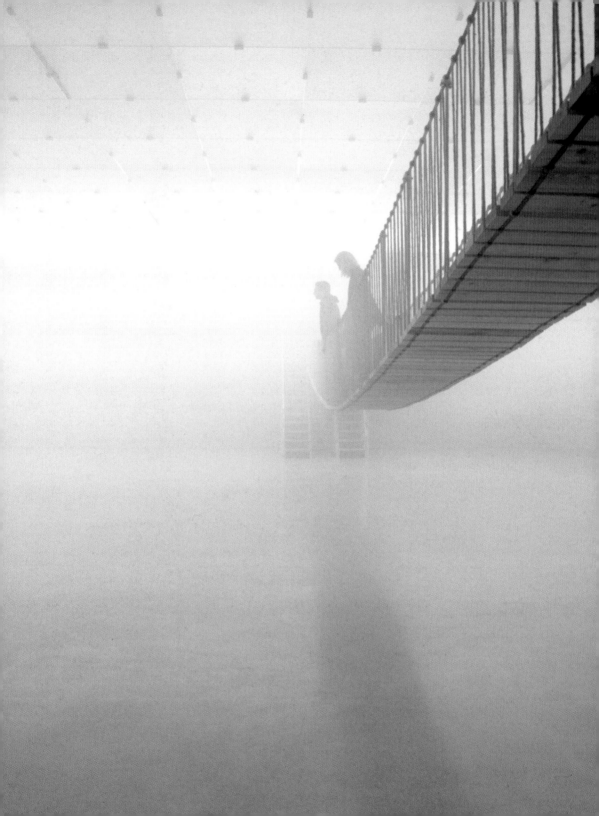

1 **The mediated motion,** 2001, installation view, Kunsthaus Bregenz
2 **Orientation lights,** 1999, stainless steel, glass, striplights, colour filters, 200 x 70 x 70 cm, installation view, Zentrum für Kunst und Medien-technologie, Karlsruhe
3 **The double sunset,** 1999, Utrecht
4 **Waterfall,** 1998, installation view, *Biennale of Sydney*, Botanical Garden

„Ich glaube, mein Begriff von Raum und Bewusstsein lässt sich nur vor dem Hintergrund meiner skandinavischen Herkunft verstehen, und ganz sicher würde die Natur für mich eine andere Rolle spielen, wenn ich zum Beispiel in New York aufgewachsen wäre."

« Je tiens sans doute ma notion de l'espace et de la conscience de mes origines scandinaves. Elle est différente du rôle que la nature jouerait dans ma vie si je venais de New York, par exemple. »

"I believe my notion of space and consciousness is derived from my Scandinavian background, and it is different from the role nature would play in my life if I were from New York, for example."

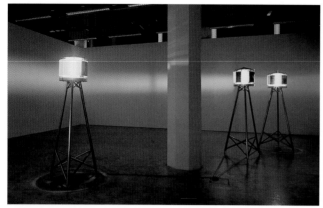

2

3

Tracey Emin

1963 born in London, lives and works in London, UK

Provocation and scandal seem predetermined wherever she turns up. Yet in recent years Tracey Emin's appearances, frequently dressed in her friend Vivienne Westwood's designs, have been so diverse that her range can only be described as wide and impressive. For the Turner Prize nomination in 1999 she exhibited *My Bed*, malodorous and rumpled after a week's illness, with all the paraphernalia she had used in it – books, bottles, cigarette butts, condoms and handkerchiefs – making a direct emotional communication with the observer. Feelings are important to her, and a desire that nobody is left unmoved by her art. Her life as a ready-made object, her private universe, her excesses, her failures and her loves are relentlessly spread out, exhibited and examined. Emin takes as her theme statements about herself and her relationships, her life, body and feelings in such an open and shocking manner that the public, faced with this excess of exhibitionism, generally reacts with unease, shame, anger or grief. Nevertheless, the honesty and authenticity with which Emin confronts her everyday traumas can hardly be described as exaggerated; rather, they issue from a remarkable sensitivity and sense of the aesthetic – rare virtues in our era of endemic superficiality. *Helter fucking skelter*, 2001, is a stage for her emotions, adrift on a never-ending ride in the funfair of life: her joys and heartbreaks, her fate both as a celebrity in the art world and in her private relationships. Emin's skill at illustrating the undepictable with her installations, stories, drawings, sculptures, embroideries and films is continually accompanied by sentimentality and passion. However, she truly believes that there is a powerful dimension to art, which pukes at all that is profane and uncertain.

Wo immer sie auftaucht, scheinen Provokation und Skandal vorprogrammiert. Dabei ist Tracey Emin in den letzten Jahren derart unterschiedlich aufgetreten, bisweilen ausstaffiert von ihrer Freundin Vivienne Westwood, dass ihr enormes Spektrum als schillernd bezeichnet werden muss. Bei der Turner-Prize-Nominierung 1999 stellte sie *My Bed*, ihr nach einer Woche Krankheit übel riechendes und zerwühltes Bett samt aller darin benutzten Utensilien wie Bücher, Flaschen, Zigarettenkippen, Kondome, Taschentücher aus – eine unmittelbare Übertragung ihrer Gefühle auf den Betrachter. Emotionen sind ihr wichtig, denn kalt lässt diese Kunst niemanden. Es sind ihr Leben als Ready-Made, ihre Privatsphäre, ihre Exzesse, ihr Scheitern und ihre Liebe, die ständig ausgebreitet, vorgeführt und überprüft werden. Emin thematisiert Stellungnahmen zu ihrer Person und ihren Beziehungen, ihrem Leben, Körper und ihren Gefühlen derart offen und schockierend, dass das Publikum vor soviel Exhibitionismus zumeist nur Beklemmung, Scham oder Wut und Trauer befällt. Gleichwohl sind ihre Ehrlichkeit und Authentizität gegenüber den Traumata ihres Alltags kaum überzogen zu nennen, sondern vielmehr ästhetisch und erstaunlich sensibel– seltene Qualitäten in einer von Oberflächlichkeiten geprägten Zeit. Mit *Helter fucking skelter*, 2001, inszeniert sie ihre Affekte als endlose Rutsche auf dem Rummelplatz des Lebens: ihre Freude und Tragik, ihr Schicksal als öffentliche Berühmtheit der Kunstwelt und ihre privaten Beziehungen. Emins Fähigkeit, das Nichtabbildbare in Installationen, Erzählungen, Zeichnungen, Skulpturen, Stickereien oder Filmen zu zeigen, wird permanent von ihrer eigenen Sentimentalität und Leidenschaft unterlaufen. Aber sie glaubt an eine kraftvolle Dimension in der Kunst, die jede profane Beliebigkeit absolut zum Kotzen findet.

Partout où elle passe, la provocation et le scandale semblent programmés d'avance. Il reste que les apparitions de Tracey Emin – parfois habillée par son amie Vivienne Westwood – ont été ces dernières années si diverses que l'immense éventail de ses possibilités doit être qualifié de stupéfiant. Lors de la remise du Prix Turner en 1999, elle expose *My Bed*, son lit défait, malodorant suite à une semaine d'alitement, y compris tous les objets utilisés pendant la maladie – livres, bouteilles, mégots, préservatifs, mouchoirs –, transmission directe de ses sentiments au spectateur. Les émotions jouent un rôle capital pour elle. L'artiste ne laisse personne indifférent : ce sont sa vie comme ready-made, sa sphère privée, ses excès, ses échecs et ses amours, qui sont sans cesse exhibés, présentés, vérifiés. Emin dépeint des prises de positions sur sa propre personne ; ses relations, sa vie, son corps et ses sentiments sont mis à nu de manière si ouverte et choquante que le public n'en ressent souvent que gêne, honte, rage ou tristesse. Cependant, sa sincérité et l'authenticité dont elle fait preuve face aux traumas de sa vie quotidienne ne peuvent guère être qualifiés d'inflationnistes, ils sont plutôt esthétiques et d'une sensibilité frappante – qualités rares à une époque empreinte de superficialité. Avec *Helter fucking skelter*, 2001, elle met en scène ses affects perdus comme un interminable toboggan sur la foire d'empoigne de la vie : ses joies, sa tragédie, son destin comme célébrité du monde de l'art et dans ses relations privées. La capacité d'Emin à montrer l'irreprésentable dans ses installations, ses récits, dessins, sculpture, broderies ou ses films, est sans cesse sapée par sa sentimentalité et sa passion. Elle croit cependant à une dimension puissante dans l'art, qui vomit tout arbitraire profane. G. J.

SELECTED EXHIBITIONS →
1998 *Sobasex (My Cunt is Wet with Fear)*, Sagacho Exhibition Space, Tokyo, Japan **1999** *Every Part of Me's Bleeding*, Lehmann Maupin, New York (NY), USA; *Hundstage*, Gesellschaft für Aktuelle Kunst, Bremen, Germany; *The Turner Prize Exhibition*, Tate Gallery, London, UK **2000** *Nurture and Desire*, Hayward Gallery, London, UK; *Diary*, Cornerhouse, Manchester, UK; *The British Art Show 5*, Hayward Gallery, London, UK **2001** *You forgot to kiss my soul*, White Cube, London, UK; *Century City*, Tate Modern, London, UK

SELECTED BIBLIOGRAPHY →
1994 *Exploration of the Soul*, London **1997** *Always Glad to See You*, London **1998** *Tracey Emin. Holiday Inn*, Gesellschaft für Aktuelle Kunst, Bremen **2000** *Diary*, Cornerhouse Manchester **2001** *Century City*, Tate Modern, London; Uta Grosenick (ed.), *Women Artists*, Cologne

1 **The Perfect Place to Grow,** 2001, wooden birdhouse, DVD, monitor, trestle, plants, wooden ladder, 261 x 83 x 162 cm
2 Installation view, *The Turner Prize Exhibition*, Tate Gallery, London, 1999
3 **Sometimes ..,** 2001, c-type print mounted on foam board, 101 x 168 cm
4 Installation view, *You forgot to kiss my soul*, White Cube², London, 2001; foreground: **Upgrade,** 2001, papier-maché concorde, wood and metal stand, 160 x 110 x 75 cm

„Zeitlebens habe ich eine schwere Last mit mir herumgetragen. Auch wenn sie heute immer noch da ist, bedrückt sie mich nicht mehr so sehr."

« J'ai eu toute ma vie une grosse puce électronique sur les épaules. Je l'ai encore aujourd'hui, mais elle ne m'écrase plus. »

"I've had a big chip on my shoulder all my life. I've still got it but now it's not weighing me down."

2

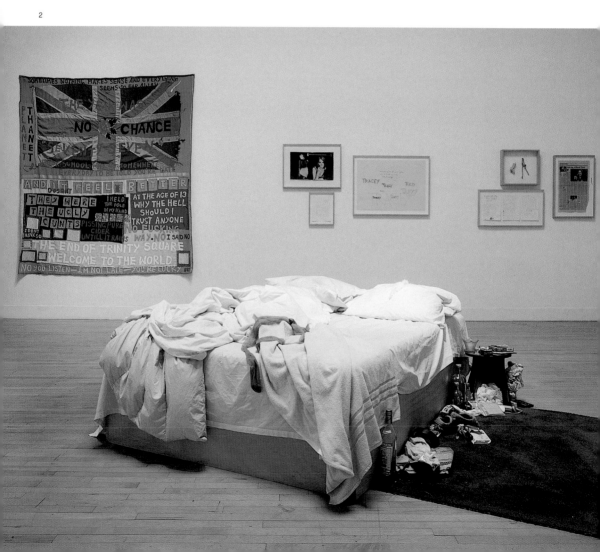

3

4

Sylvie Fleury

1961 born in Geneva, lives and works in Geneva, Switzerland

The overture to Sylvie Fleury's work in the early 1990s consisted of careful arrangements of designer label shopping bags or expensive cosmetics packaging. Some early critics interpreted this as a commentary on our consumer society's merchandising fetish. The presentation of these early works already seemed to suggest a profound sympathy with the aesthetics of Pop Art and Minimalism. Fleury moved on rapidly, appropriating the well-known works of male artists by producing obvious copies on which she applied fake fur, which endowed her imitations with a dash of visual and tactile seductiveness. By the late 1990s Fleury had extended the scope of her multi-layered imagery to encompass disparate, sometimes typically "masculine" domains, like motor sports and customised limousines. The increasing complexity of her work, in which various aesthetic sensibilities and fields of reference overlap, makes it difficult to predict Fleury's future artistic development. With her latest works and exhibition projects Fleury gives the impression that she no longer desires to be identified with the cliché of the photogenic "Material Girl". The letters S. F. – which could either be read as the artist's initials or the abbreviation for Science Fiction – form the title of her first major exhibition this century, in which she articulates her fascination with Zen, New Age and other spiritual systems. In interviews, Fleury has often emphasised the term "vehicle" to describe her works. Beginning with the body, which serves as a vehicle for the soul, Fleury today also considers shoes, cars and space rockets as instruments of propulsion, both spiritual and physical.

Arrangements aus glamourösen Designer-Einkaufstüten oder Verpackungen von Luxus-Kosmetika bildeten Anfang der neunziger Jahre den Auftakt zum Werk von Sylvie Fleury, das einigen Kritikern zunächst als Kommentar zum Warenfetischismus einer Konsumgesellschaft erschien. Schon in den Präsentationen dieser frühen Arbeiten schwang immer auch ein genaues Wissen um die künstlerischen Ästhetiken von Pop- und Minimal-Art mit. Wenig später ging Fleury dazu über, sich bekannte Werke männlicher Künstlerkollegen durch offenkundige Imitationen anzueignen, und verlieh diesen durch die Verwendung von Kunstfell einen nicht nur visuell, sondern auch haptisch verführerischen "Touch". Ende der neunziger Jahre griff Fleury mit ihren vielschichtigen Bildwelten in unterschiedliche, teils klassisch "männliche" Domänen, wie etwa die des Motorsports und des "Customising" von Straßenkreuzern, über. Die zunehmende Komplexität ihres Werkes, in dem sich verschiedene Ästhetiken und Bezugsfelder überlagern, macht Fleurys künstlerische Entwicklung schwer vorhersehbar. Ihre jüngsten Arbeiten und Ausstellungsprojekte erwecken den Eindruck, dass Fleury nicht (mehr) auf das Klischee eines fotogenen "Material Girl" festgelegt werden möchte. S. F. – lesbar als Initialen der Künstlerin, aber auch als Abkürzung für Sciencefiction – lautet der Titel ihrer ersten großen Ausstellung im neuen Jahrhundert, in der sich ihr Interesse für Zen, Newage und andere spirituelle Techniken artikuliert. In Interviews hob Fleury mehrfach die Bedeutung des Begriffs "Vehikel" für ihre Arbeiten hervor: Angefangen beim Körper, der als Vehikel für den Geist dient, sieht Fleury heute auch Schuhe, Autos und Raketen als Instrumente einer nicht allein physischen, sondern auch spirituellen Fortbewegung.

Les arrangements de sacs glamoureux ou d'emballages de cosmétiques de luxe ont marqué le coup d'envoi de l'œuvre de Sylvie Fleury au début des années 90, un coup d'envoi que certains critiques ont d'abord lu comme un commentaire sur le caractère fétichiste de la société de consommation. La présentation de ces premières œuvres procédait toujours d'une connaissance approfondie des esthétiques du Pop Art et du Minimal Art. Un peu plus tard, par des imitations évidentes, Fleury s'attache à s'approprier les œuvres célèbres de collègues masculins et leur confère un « touch » de séduction visuelle, mais aussi tactile, avec l'utilisation de fourrure synthétique. A la fin des années 90, Fleury étend ses mondes iconiques polysémiques à différents domaines considérés comme classiquement « masculins », notamment ceux du sport automobile et de la « personnalisation » des voitures de luxe. La complexité croissante d'un travail où se superposent différentes esthétiques et champs référentiels, rend aujourd'hui l'évolution artistique de Fleury moins prévisible. Ses œuvres et projets d'expositions les plus récents éveillent le sentiment que l'artiste ne veut pas (ou plus) être identifiée au cliché de la photogénique « material girl ». S. F., qu'on peut lire comme les initiales de l'artiste, mais aussi comme l'abréviation de « science fiction », est le titre de la première grande exposition de l'artiste en ce nouveau siècle. Fleury y articule sa fascination pour le zen, le New Age et d'autres techniques spirituelles. Dans ses interviews, Fleury a souligné à plusieurs reprises l'importance de la notion de « véhicule » pour ses œuvres : à commencer par le corps, véhicule de l'esprit. Fleury considère aussi les chaussures, les voitures et les fusées comme les instruments d'un mouvement de nature non seulement physique, mais aussi spirituelle.

B. H.

SELECTED EXHIBITIONS →
1998 XXIV Bienal Internacional de São Paulo, Brazil **1999** Galerie Art & Public, Geneva, Switzerland; Ace Gallery, New York (NY), USA; oh cet écho! (duchampiana), Musée d'Art Moderne et Contemporain, Geneva, Switzerland; Heaven, Kunsthalle Düsseldorf, Germany **2000** John Armleder & Sylvie Fleury, Kunstmuseum St. Gallen, Switzerland; What if, Moderna Museet, Stockholm, Sweden **2001** Museum für neue Kunst, Zentrum für Kunst und Medientechnologie, Karlsruhe, Germany

SELECTED BIBLIOGRAPHY →
1998 Sylvie Fleury. First Spaceship On Venus And Other Vehicles, XXIV Bienal Internacional de São Paulo; Close Encounters/Contacts Intimes, The Ottawa Art Gallery, Ottawa **1999** Sylvie Fleury, Ostfildern-Ruit **2001** S. F., Museum für neue Kunst, Zentrum für Kunst und Medientechnologie, Karlsruhe

1 **Razor Blade,** 2001, aluminium, stainless steel, 8 parts, each
290 x 145 x 1 cm, installation view, Museum für neue Kunst, Zentrum
für Kunst und Medientechnologie, Karlsruhe
2 *Sylvie Fleury/John Armleder*, installation view, Kunstmuseum St. Gallen,
2000

3 **Dog Toy 4 (Gnome),** 2000, styrofoam, paint, 190 x 170 x 150 cm
4 **Ford Cosworth DFV,** 2000, verchromte Bronze, 60 x 65 x 50 cm
5 Installation view, *Sylvie Fleury/John Armleder*, Kunstmuseum St. Gallen,
2000; foreground: **Spring Summer 2000 (blue),** 2000; **Spring Summer
2000 (orange),** 2000; background, **Skin Crime 2 (Givenchy 601),** 1997

„Ich zwinge die Betrachter zu genießen!
Was auch immer sie tun müssen, um ihre Kicks zu kriegen."

« J'oblige le spectateur à prendre du plaisir !
Quoi qu'il doive faire pour prendre son pied. »

"I urge the audience to enjoy!
Whatever they must do to get their kicks."

2

3

4

5

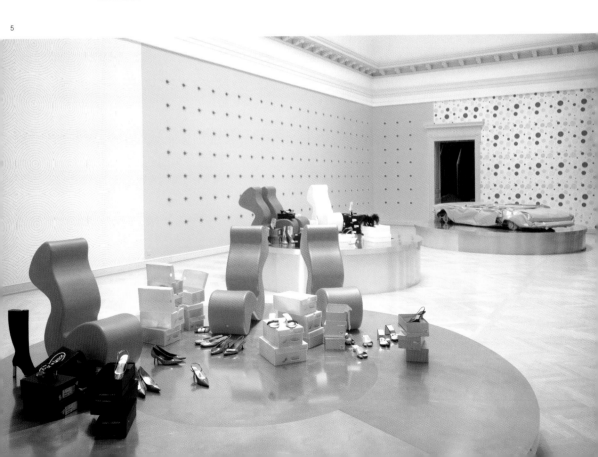

Ellen Gallagher

1965 born in Providence (RI), lives and works in Provincetown (MA) and New York (NY), USA

"If people want to understand my art they must be ready to step into my world," Ellen Gallagher said enticingly in an interview. She seduces the viewer with the beauty of her images and even more with their hidden meanings. The daughter of a Black African father and a white Irish mother, the artist sensuously balances the abstract and the figurative. Against the carefully crafted backdrop of her canvases, she stages an on-going minstrel show, echoing the 19th-century caricature of African-American creativity in which "blacked-up" white artists performed and sang. Since her début at the 1995 *Whitney Biennial,* Gallagher has created a parallel world in which no complete black bodies appear. All that the viewer sees are the rolling eyes and big lips, as in *Host,* 1996, which draws on the grotesque imagery of American minstrels. Gallagher is heir to a world that treats the African-American culture with disdain. She expresses in painting what rap artists do in music when they call themselves "niggers" and draw strength from emulating those who mock them. Gallagher perpetuates the gross stereotypes in the same way, without attempting any critique. The central motif of her work is the absence of bodies. The artist recalls how, since childhood, she has felt that, while there were possibilities for black individuals, there was no redemption for blacks as a family. Through her work she has seductively made that loss our gain.

„Wenn sie meine Kunst verstehen wollen, sollten sie bereit sein, meine Welt zu betreten", lockte Ellen Gallagher in einem Interview. Sie verführt den Betrachter mit der Schönheit ihrer Bilder und der Andeutung, dass noch mehr dahinter stecken könnte. Als Tochter eines schwarzafrikanischen Vaters und einer weißen, irischen Mutter, balanciert die Amerikanerin in ihrer Kunst abstrakte und figurative Momente auf sinnliche Weise aus. In den minimalistisch gesteppten Hintergründen ihrer Leinwände hat sich eine permanente Minstrelshow eingenistet, die Karikatur afro-amerikanischer Kreativität im 19. Jahrhundert, in der schwarz geschminkte Weiße Schwarze spielten und sangen. Seit ihrem ersten Auftreten auf der *Whitney Biennial* 1995 kreiert Gallagher eine parallele Welt, in der der vollständige schwarze Körper fehlt. Was übrig bleibt – die rollenden Augen und bleckenden Münder, wie in ihrer 1996 entstandenen Arbeit *Host* –, entnimmt Gallagher der grotesken Bildwelt der amerikanischen Minstrelsänger. Wenn Gallagher diese Welt mit ihrer Afro-Amerikaner herabsetzenden Perspektive aufnimmt, vollzieht sie in der Malerei, was Rapper im Sprechgesang zelebrieren, wenn sie sich Nigger nennen und Stärke aus der Besetzung der anderen Position ziehen. Ebenso wiederholt Gallagher groteske Stereotypen der Afro-Amerikaner, ohne an einer Kritik interessiert zu sein. Die Abwesenheit des Körpers in Gallaghers Arbeit ist das zentrale Motiv. Sie hätte es gefühlt, führt die Künstlerin aus, schon als Kind, dass es keine Erlösung für die Familie der Schwarzen gibt, nur Chancen für das schwarze Individuum. Der Verlust wirkt bei ihr verführerisch.

« Si vous voulez comprendre mon travail, vous devez être prêt à entrer dans mon univers ». Tel était l'accroche qu'Ellen Gallagher proposait dans une interview. Gallagher séduit le spectateur en laissant entendre que quelque chose de plus se cache derrière la beauté de ses images. Fille d'un père noir africain et d'une mère blanche irlandaise, l'artiste américaine équilibre de manière sensuelle éléments abstraits et figuratifs. Dans les fonds de ses toiles aux piqûres minimalistes s'est installé un minstrel show permanent, référence aux spectacles du 19ème siècle dans lesquels des blancs fardés de noir jouaient les noirs et chantaient en caricaturant la créativité afro-américaine. Depuis sa première apparition à la *Whitney Biennial* en 1995, Gallagher continue de créer un monde parallèle d'où le corps noir entier est toujours absent. Ce qui en reste, ce sont des yeux qui roulent et des bouches montrant les dents, éléments que Gallagher emprunte au monde d'images grotesque des minstrel singers américains, tels qu'on a pu les voir dans *Host,* 1996. En investissant ce monde de sa perspective humiliante pour les noirs américains, Gallagher réalise en peinture ce que les rappeurs célèbrent dans leurs textes scandés, lorsqu'ils se qualifient eux-mêmes de nègres et qu'ils puisent leur force dans la projection négative de l'autre. Gallagher reproduit les stéréotypes grotesques des Afro-américains sans être intéressée par une critique. L'absence du corps est le motif central de son œuvre. L'artiste explique qu'enfant déjà, elle avait perçu que la situation des noirs était sans issue collectivement, et que leurs chances étaient purement individuelles. Chez elle, l'absence est d'un effet séduisant.

F. F.

SELECTED EXHIBITIONS →
1995 *Whitney Biennial,* The Whitney Museum of American Art, New York (NY), USA **1996** Mary Boone Gallery, New York (NY), USA **1998** Gagosian Gallery, New York (NY), USA; *Piecing together the puzzle,* Museum of Modern Art, New York (NY), USA **1999** Galerie Max Hetzler, Berlin, Germany **2000** Anthony d'Offay Gallery, London, UK; *Greater New York: New Art in New York Now,* P.S.1, Long Island City (NY), USA **2001** Des Moines Art Center, Des Moines (IA), USA; *The Americans,* Barbican Art Gallery, London, UK

SELECTED BIBLIOGRAPHY →
1996 *The Astonishing Nose,* Anthony d'Offay Gallery, London **1998** *Ellen Gallagher,* Gagosian Gallery, New York (NY) **2000** *Ellen Gallagher: Pickling,* Galerie Max Hetzler, Berlin **2001** *Ellen Gallagher: Blubber,* Gagosian Gallery, New York (NY)

110

1 **Host,** 1996, oil, pencil and paper on canvas, 175 x 27 cm
2 **Falls and Flips,** 2001, painting, 305 x 488 cm

„Ich werde deine Membran nicht durch ein erregendes Bild zum Platzen bringen."

« Je ne vais pas vous faire éclater la membrane avec une image affriolante. »

"I'm not going to pop your membrane with a titillating image."

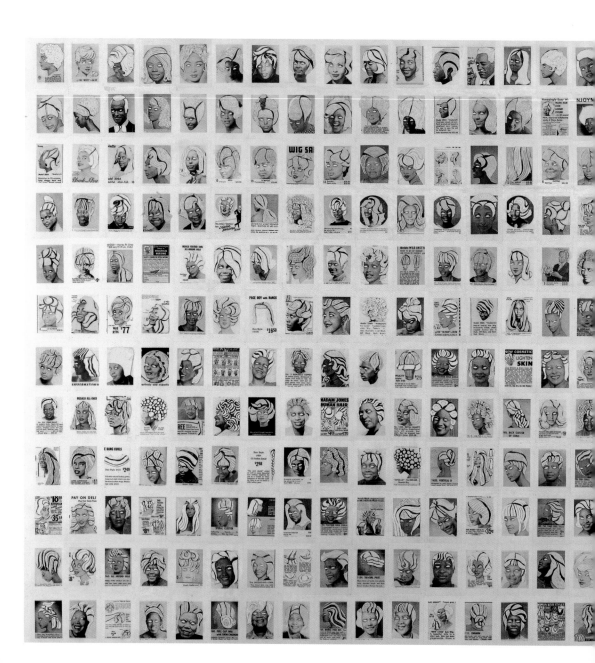

Liam Gillick

1964 born in Aylesbury, lives and works in London, UK, and New York (NY), USA

Liam Gillick works in a whole range of different media. His art does not simply consist of spacious installations, graphically complex texts and minimalist objects. He also publishes full-length books, composes film music, arranges exhibitions and produces architectural designs. The "parallelism" of his work is crucial. On the one hand his projects are "free artistic expression"; on the other, they are "applied art", apparently with a clearly defined practical purpose. Between the two spheres of activity, he creates for himself a space for discourse on a wide variety of subjects. Gillick's aesthetic philosophy transcends the separation between pure theory and simple practicality, and that between poetic fiction and empirical fact. Gillick's *Prototype design for conference room (with joke by Matthew Modine arranged by Markus Weisbeck)*, 1999, is a complete design for a conference room. The strictly geometric furniture and the configuration of the walls, inspired by the words of a joke, were executed during an exhibition of the artist's work. A real symposium was held in the room, but the work also stands as an autonomous post-minimalist environment. The joke on the wall is about the American director Stanley Kubrick and the science-fiction film he never made. Entitled "David", the movie provided the theme and the title of the exhibition. This was a complex meditation on many different levels about possible forms of presentation and action, a seamless combination of reflection, memory and imagination.

Die Kunst von Liam Gillick ereignet sich in den unterschiedlichsten Medien, denn Gillick präsentiert nicht nur raumfüllende Installationen, grafisch aufwendige Textarbeiten oder eher minimalistische Objekte, sondern publiziert zudem ganze Bücher, schreibt Filmmusik, arrangiert Ausstellungen und entwirft architektonische Studien. Wichtig ist dabei der „parallele" Charakter seiner Arbeiten: Gillicks konzeptionelle Gestaltungen funktionieren einerseits als „freie" Kunst, parallel dazu aber immer auch als „angewandtes Handwerk", das sich klar definierten Zwecken zu unterwerfen scheint. Zwischen diesen beiden Sphären entwickelt sich ein diskursiver Raum, der ein Verhandeln verschiedenster Themen erlaubt. Dieses ästhetische Denken findet jenseits der Trennungen von reiner Theorie und bloßer Praxis sowie von poetischer Fiktion und empirischem Faktum statt. Gillicks *Prototype design for conference room (with joke by Matthew Modine arranged by Markus Weisbeck)*, 1999, stellt das komplette Design für einen Konferenzraum dar. Die streng geometrischen Möbel und die Wandgestaltung, die aus dem Text eines Witzes bestand, wurden während einer Ausstellung des Künstlers geschaffen. Hier wurde zwar tatsächlich ein Symposium abgehalten, die Arbeit behauptete sich aber auch als autonomes postminimalistisches Environment. Zudem spielte der an der Wand zu lesende Witz auf den amerikanischen Regisseur Stanley Kubrick an, dessen unrealisiert gebliebener Sciencefictionfilm „David" Thema und Titel der Ausstellung war. So verschränkten sich hier unterschiedliche Ebenen zu einem komplexen Nachdenken über mögliche Formen von Präsentation und Aktion. Reflexion, Erinnerung und Imagination gehen dabei nahtlos ineinander über.

L'art de Liam Gillick se déploie dans les médiums les plus divers. En effet, Gillick ne se borne pas à présenter des installations complètes, des œuvres faites d'écritures au graphisme extrêmement élaboré ou des objets plutôt minimalistes, il publie aussi des livres, écrit des musiques de films, arrange des expositions et réalise des études architecturales. Dans son travail, le caractère « parallèle » de ses œuvres joue un rôle important : ses réalisations conceptuelles fonctionnent d'une part comme de l'art « libre », mais aussi et toujours comme un art « appliqué » qui semble être au service de buts clairement définis. Entre ces deux univers se déploie un espace discursif qui permet une intégration des thèmes les plus divers. Cette pensée esthétique se déploie au-delà des distinctions entre théorie pure et simple pratique, entre fiction poétique et fait empirique. Le *Prototype design for conference room (with joke by Matthew Modine arranged by Markus Weisbeck)*, 1999, se présente comme le design intégral d'une salle de conférences. Les meubles rigoureusement géométriques et le décor mural constitué du texte d'une blague, ont été réalisés pendant une exposition de l'artiste. C'est dans ce contexte que s'est réellement tenu un symposium, tandis que l'œuvre s'affirmait tout aussi bien comme un environnement postminimaliste à part entière. De plus, la blague figurant au mur faisait allusion au metteur en scène de cinéma américain Stanley Kubrick, dont le film « David », une œuvre de science-fiction restée à l'état de projet, était le thème et le titre de l'exposition. Différents niveaux s'imbriquaient donc ici en une réflexion complexe sur les formes de présentation et d'action possibles. Les limites entre réflexion, mémoire et imagination y étaient dans une large mesure abolies.

R. S.

SELECTED EXHIBITIONS →
1997 *documenta X*, Kassel, Germany **1999** *David*, Frankfurter Kunstverein, Frankfurt am Main, Germany **2000** *Consultation Filter*, Westfälischer Kunstverein, Münster, Germany; *What if*, Moderna Museet, Stockholm, Sweden; *Intelligence*, Tate Britain, London, UK; *Continuum 001*, Centre for Contemporary Arts, Glasgow, UK; *The British Art Show 5*, Hayward Gallery, London, UK **2001** *2. berlin biennale*, Berlin, Germany **2002** *Wood Way*, Whitechapel Art Gallery, London, UK; *Ann Lee*, Kunsthalle Zürich, Zurich, Switzerland

SELECTED BIBLIOGRAPHY →
1997 *Big Conference center, Liam Gillick*, Ludwigsburg **1998** *Cream*, London **1999** *5 or 6, Liam Gillick*, New York (NY) **2000** *Liam Gillick*, Frankfurter Kunstverein, Frankfurt am Main/Westfälischer Kunstverein, Münster **2002** *Liam Gillick, Literally No Place*, London

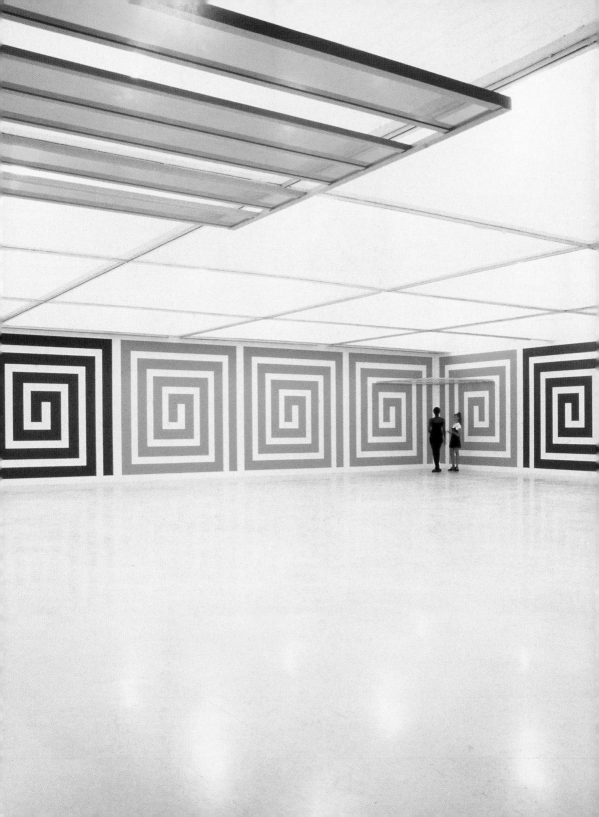

1 **Revision/22nd Floor Wall Design,** 1998, installation view, *Revision,*
 Villa Arson, Nice
2 Installation view, Galerie Hauser & Wirth & Presenhuber, Zurich, 2001;
 foreground: **Filtration,** 2001; background: **Waldish Screen #1 and #2,** 2000
3 **The factory where my father worked at the time that he supplied the
 materials for the construction of the space-station in the film 2001,** 2001,
 Lambda print, 42 x 59 cm

4 **Multiple Event Graphic #3,** 2000, Lambda print, 42 x 59 cm
5 **Prototype design for conference room (with joke by Matthew Modine
 arranged by Markus Weisbeck),** 1999, installation view, *DAVID,*
 Frankfurter Kunstverein, Frankfurt am Main

„… Denken angewandt auf einen speziellen Ort oder eine spezielle Gruppe
von Konzepten."

« … La pensée appliquée à un lieu précis ou à un ensemble particulier
de concepts. »

"… thought applied to a special place or a special set of concepts."

2

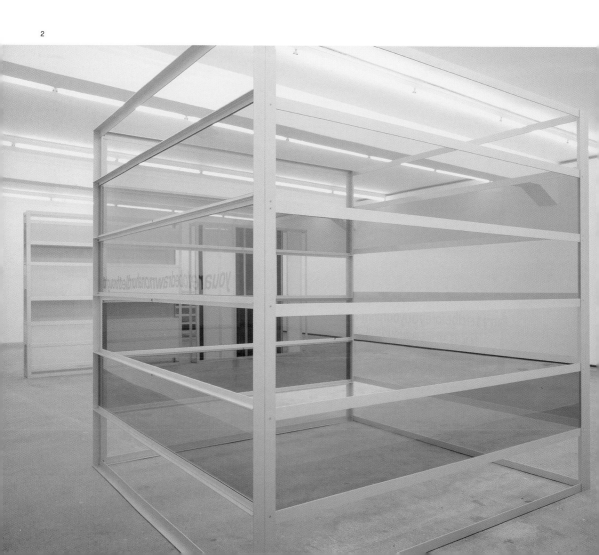

3

4

5

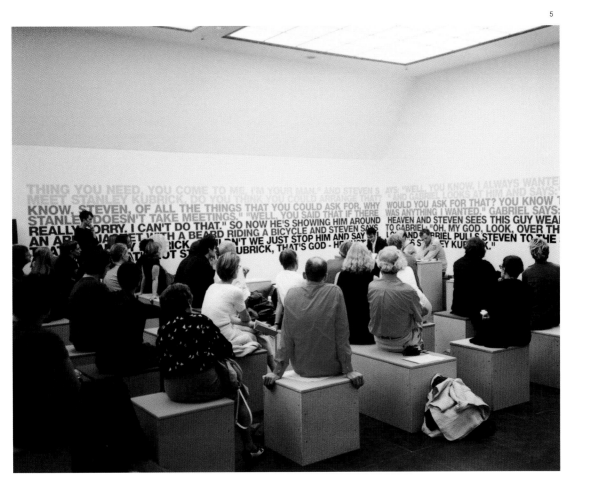

Felix Gonzalez-Torres

1957 born in Güaimaro, Cuba, 1996 died in Miami (FL), USA

Felix Gonzalez-Torres' works invest the most mundane materials (candy, clocks, lightbulbs) and common-place processes (off-set printing, photography) with a preciousness and poetry to convey both the rational value of life and its inevitable transience. His large stacks of sheets of paper printed with a text or image, or lines and carpets of glittering gold-wrapped candies, resemble the stable structures of minimalism, but are in a state of constant transformation as the audience is invited to take a piece of paper or candy away and the piles gradually shrink. There are discrete references to his personal history in titles, or in details such as the weight of the golden candy in *Untitled (Placebo)*, 1991, which equals the combined weight of the artist and his lover; or more overt political references in works such as *Untitled*, 1989, a billboard with text highlighting key moments in the struggle for gay rights, but no didactic explanation is given and the audience is free to bring its own personal associations into play in the construction of meaning. In *Untitled*, 1991, a tender and intimate image of a recently slept in bed is displayed in the most public manner on huge billboards across New York City. This personal elegy to the death of his lover from AIDS becomes an eloquent and universal expression of love, beauty, tragedy and loss. The elusive quality of images such as this, or of a bird flying alone through a cloudy sky in a "stack" piece, is all the more poignant in the light of the artist's own premature death from AIDS in 1996.

Die Arbeiten von Felix Gonzalez-Torres entstehen aus den banalsten Materialien (Bonbons, Uhren, Glühbirnen) und Verfahren (Offset-Druck, Fotografie) und wirken so kostbar und poetisch, dass sie zugleich ein Gefühl für den rationalen Wert des Lebens und dessen unvermeidliche Vergänglichkeit wecken. Seine hohen Stapel mit Texten oder Bildern bedruckter Papierblätter oder seine in Goldpapier gewickelten – in Reihen oder zu ganzen Teppichen angeordneten – glitzernden Bonbons erinnern zwar an die unverrückbaren Strukturen des Minimalismus, befinden sich jedoch in einem Zustand der permanenten Veränderung, da das Publikum eingeladen ist, ein Blatt Papier oder ein Bonbon mitzunehmen, so dass die Materialhaufen allmählich schmelzen. Versteckte Hinweise auf den persönlichen Werdegang des Künstlers finden sich etwa in den Werktiteln, oder aber sie sind in Arbeiten wie dem goldenen Riesenbonbon *Untitled* (Placebo), 1991, enthalten, das genauso viele Kilo auf die Waage bringt wie der Künstler selbst und sein Geliebter zusammen. Explizit politische Verweise finden sich in Werken wie *Untitled*, 1989, einem Plakat mit Texten, die auf die entscheidenden Etappen des schwulen Kampfes um Gleichberechtigung verweisen. Dabei verzichtet der Künstler vollständig auf didaktische Erklärungen, so dass es dem Betrachter freigestellt ist, seine eigenen Assoziationen ins Spiel zu bringen. In der Arbeit *Untitled*, 1991, wurde das zärtliche und intime Bild eines Bettes, in dem noch kurz zuvor jemand geschlafen hatte, in der denkbar öffentlichsten Manier auf riesigen Plakatwänden überall in New York gezeigt. Dabei erweist sich diese persönliche Bekundung der Trauer über den Tod seines an den Folgen von AIDS gestorbenen Geliebten als ebenso beredter wie universell gültiger Ausdruck der Liebe, der Schönheit, der Tragik und des Verlusts. Der fast unwirkliche Charakter solcher Bildmotive, etwa auch des Vogels, der auf den Blättern einer Papierstapel-Arbeit durch einen wolkenverhangenen Himmel fliegt, gewinnt noch eine zusätzliche Prägnanz durch den vorzeitigen Tod des Künstlers, der 1996 ebenfalls an den Folgen von AIDS gestorben ist.

Le travail de Gonzalez-Torres investit avec délicatesse et poésie les matériaux les plus quotidiens (bonbons, pendules, ampoules électriques) et les techniques les plus communes (impression offset, photographie) pour traduire à la fois la valeur rationnelle de la vie et son inévitable nature éphémère. Ses installations – de hautes piles de papiers imprimés avec un texte ou une image, des lignes ou des tapis de bonbons enveloppés dans de la Cellophane dorée – rappellent les structures stables du Minimalisme mais sont dans un état de transformation permanente car le public est invité à prendre une feuille ou une friandise, faisant ainsi progressivement diminuer les tas. On retrouve de discrètes allusions autobiographiques dans ses titres ou des détails, tels que le poids des bonbons dorés dans *Untitled (Placebo)*, 1991, qui correspond à la somme exacte des poids de l'artiste et de son compagnon, ou des références politiques plus directes dans des œuvres telles que *Untitled*, 1989 : un panneau publicitaire avec un texte énonçant les moments importants dans la lutte pour les droits des homosexuels. Néanmoins, ses œuvres ne s'accompagnent d'aucune explication didactique, chacun étant libre de faire participer ses associations personnelles à la construction du sens. Pour *Untitled*, 1991, l'image tendre et intime d'un lit défait était placardée sur d'immenses panneaux publicitaires un peu partout dans New York. Cette élégie à la mort de son compagnon, décédé du Sida, constitue une expression éloquente et universelle d'amour, de beauté, de tragédie et de deuil. La qualité fugace d'images telles que celle d'un oiseau isolé volant dans un ciel nuageux, dans une de ses « piles », est d'autant plus émouvante à la lumière de la mort prématurée de l'artiste, emporté lui aussi par le Sida en 1996. K. B.

SELECTED BIBLIOGRAPHY →
1993 *Felix Gonzalez-Torres*, Los Angeles (CA) **1994** *Felix Gonzalez-Torres*, Museum of Contemporary Art, Los Angeles (CA) **1997** *Felix Gonzalez-Torres, Catalogue Raisonné*, Ostfildern-Ruit **2000** *Felix Gonzalez-Torres*, Serpentine Gallery, London

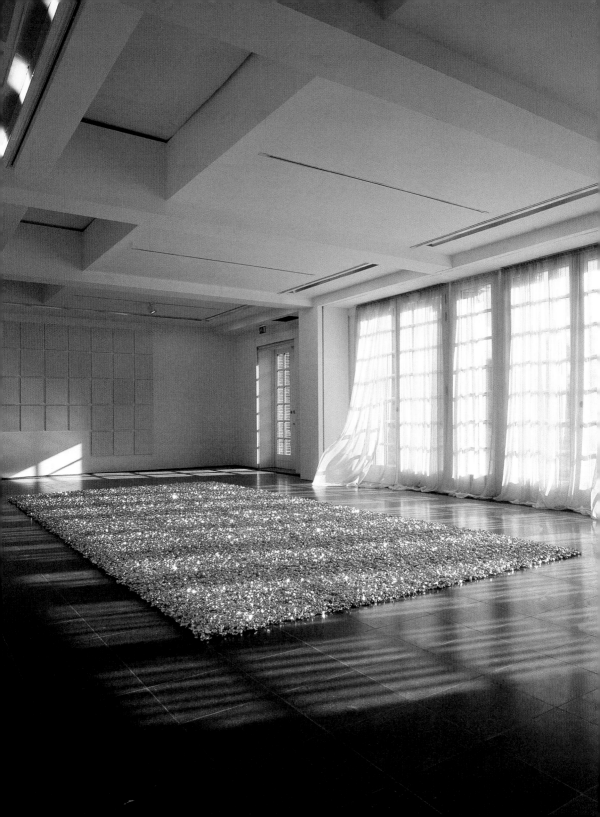

1 Installation view, *Felix Gonzalez-Torres*, Serpentine Gallery, London, 2000; foreground: **Untitled (Placebo)**, 1991, candies, individually wrapped in silver cellophane, endless supply, ideal weight: 500 – 600 kg, background left: **Untitled (Loverboy)**, 1989, blue fabric, metal rod; background right: **Untitled (31 Days of Bloodworks)**, 1991, acrylic, gesso, graphite, photographs, paper on canvas, 31 parts, each 51 x 41 cm

2 **Untitled (Beginning)**, 1994, plastic beads, metal rod, installation view, Andrea Rosen Gallery, New York, 1997
3 **Untitled**, 1995, billboard, as installed for *Felix Gonzalez-Torres*, Andrea Rosen Gallery, New York, 2000, in 24 outdoor locations throughout New York City, location: Atlantic and Washington Avenues, Brooklyn

„Mir geht es vor allem darum, ein Zeichen zu hinterlassen, dass es mich gegeben hat: Ich war hier. Ich war hungrig. Ich habe Niederlagen erlitten. Ich war glücklich. Ich war traurig. Ich war verliebt. Ich habe Angst gehabt. Ich war voll Hoffnung. Ich habe eine Idee gehabt und einen guten Zweck verfolgt, und deswegen mache ich Kunst."

« Il s'agit par-dessus tout de laisser une trace de mon existence. J'ai été ici. J'ai eu faim. J'ai été vaincu. J'ai été heureux. J'ai été triste. J'ai aimé. J'ai eu peur. J'ai espéré. J'ai eu une idée qui m'a paru utile, c'est pourquoi j'ai créé des œuvres d'art. »

"Above all else, it is about leaving a mark that I existed: I was here. I was hungry. I was defeated. I was happy. I was sad. I was in love. I was afraid. I was hopeful. I had an idea and I had a good purpose and that's why I made works of art."

2

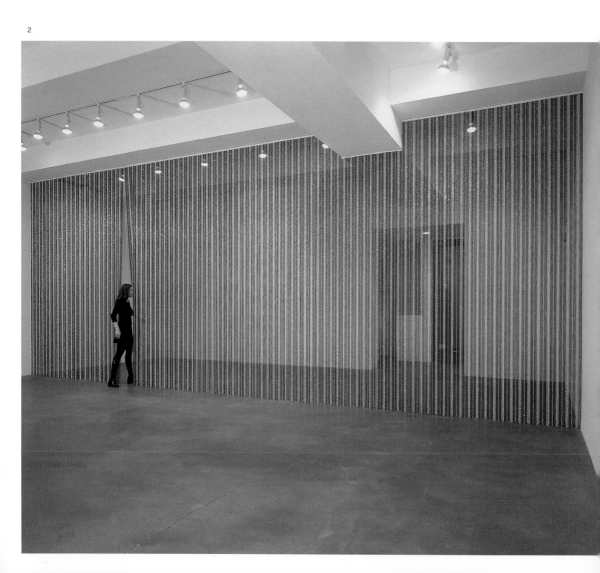

Douglas Gordon

1966 born in Glasgow, lives and works in Glasgow, UK, and New York (NY), USA

The work of Douglas Gordon, one of the most successful international artists of recent years, confronts existential themes such as guilt and fear, love and death, and the problems of memory and vision. Mainly using film, video and photography, he pinpoints these issues and explores them through repetition, enlargement and slow motion. These "ultimate questions" are transformed into succinct statements, which can be read in new ways and re-examined. For his installation *Feature Film*, 1999, Gordon filmed the maestro James Conlon conducting a performance of Bernard Herrmann's music for Alfred Hitchcock's 1957 film, "Vertigo". On the screen the conductor's movements and gestures synchronise with the soundtrack. Feelings such as fear, tenderness or aggression are made visible and engage in constant interplay with the music. At the same time, memories of the film classic sweep the spectator into a turmoil of sensations akin to the dizziness portrayed in "Vertigo". *Hand with Spot*, 2000, is a series of photographs in which Gordon plays with a theme from Robert Louis Stevenson's adventure story "Treasure Island", in which a black spot on the hand was the mark of death. The artist painted a black spot on his own left hand and photographed it with his right. He then enlarged 13 Polaroids and hung them on the wall as an ominous self-portrait. Once again, Gordon stresses the dark, bizarre aspects of life and tries to explore them through visual imagery.

Douglas Gordon, einer der international erfolgreichsten Künstler der letzten Jahre, beschäftigt sich in seiner künstlerischen Arbeit mit existenziellen Themen wie Schuld und Angst, Liebe und Tod sowie mit den Problemen von Erinnerung und Vision. Vor allem in den Medien Film, Video und Fotografie rückt er diese Fragestellungen in den Blickpunkt und überhöht sie eindrucksvoll mit den Mitteln der Wiederholung, Vergrößerung und Verlangsamung. So gerinnen vermeintlich „letzte Fragen" zu prägnanten Gesten, die neu gelesen und in Frage gestellt werden können. Für seine Installation *Feature Film*, 1999, hat Gordon den Dirigenten James Conlon bei der Einspielung der von Bernard Herrmann komponierten Musik zu Alfred Hitchcocks Film „Vertigo" von 1957 gefilmt. Auf der Leinwand ist zu sehen, wie sich die im selben Moment zu hörende Musik in den Bewegungen und der Mimik des Dirigenten spiegelt. Gefühle wie Angst, Zärtlichkeit oder Aggression werden sichtbar und verschränken sich gleichsam mit der Filmmusik. Zudem versetzt die Erinnerung an den Filmklassiker den Rezipienten in einen Strudel von Empfindungen, der dem in „Vertigo" thematisierten Schwindel vergleichbar ist. Gordons Fotoserie *Hand with Spot*, 2000, spielt an auf ein Motiv des Abenteuerromans „Die Schatzinsel" von Robert Louis Stevenson: ein schwarzer Fleck auf der Hand als Todesahnung. Gordon hat sich einen solchen Fleck auf die eigene linke Hand gemalt und dann mit der rechten Hand diesen Fleck fotografiert. Anschließend wurden 13 dieser Polaroids vergrößert und quasi als Unheil verkündendes Selbstporträt an die Wand gehängt. Einmal mehr also betont Gordon hier die dunklen, abgründigen Seiten des Lebens und versucht ihnen mit einer visuellen Inszenierung auf die Spur zu kommen.

Dans son œuvre, Douglas Gordon, l'un des artistes les plus en vue sur le plan international ces dernières années, se penche sur des thèmes existentiels tels que l'angoisse, la culpabilité, l'amour et la mort, ainsi que sur les problèmes de la mémoire et de la vision. Ces problématiques sont surtout traitées et présentées dans des médias comme le cinéma, la vidéo et la photo, dans lesquels Gordon les met en exergue de manière frappante par la répétition, l'agrandissement et le ralenti. Ainsi, des questions touchant aux choses prétendument « dernières » sont figées dans des gestes frappants qui peuvent ainsi être soumis à une nouvelle lecture et à de nouveaux questionnements. Pour son installation *Feature Film*, 1999, Gordon a filmé le chef d'orchestre James Conlon lors de son enregistrement de la musique de Bernard Herrmann composée pour le film d'Alfred Hitchcock « Vertigo », 1957. A l'écran, on peut voir la musique se refléter dans les gestes et les mimiques du chef d'orchestre. Des sentiments tels que la peur, la tendresse ou l'agression deviennent visibles tout en se fondant à la musique du film. En même temps, le souvenir de ce classique du cinéma replace le spectateur dans un tourbillon de sentiments comparable au vertige illustré par le film « Vertigo ». La série photographique *Hand with Spot*, réalisée en 2000, fait allusion à un motif du roman d'aventures de Robert Louis Stevenson, « L'île au trésor », dans lequel une tache noire sur la main figure un présage de mort. Gordon a peint une telle tache sur sa main gauche et l'a ensuite photographiée de la main droite. 13 de ces polaroïds étaient ensuite agrandis et accrochés au mur en guise d'autoportrait funeste. Soulignant une fois de plus les aspects obscurs et abyssaux de la vie, Gordon tente de les appréhender par l'intermédiaire de leur mise en scène visuelle.

R. S.

SELECTED EXHIBITIONS →
1998 *Emotion*, Deichtorhallen Hamburg, Germany **1999** Neue Nationalgalerie, Berlin, Germany; Galeria Foksal, Warsaw, Poland; *Feature Film*, Kölnischer Kunstverein, Cologne, Germany; *peace*, Migros Museum für Gegenwartskunst, Zurich, Switzerland; *Notorious*, Museum of Modern Art, Oxford, UK **2000** Musee d'Art Moderne de la Ville de Paris, France **2001** Museum of Contemporary Art, Los Angeles (CA), USA; Galleri Nicolai Wallner, Copenhagen, Denmark **2002** Kunsthaus Bregenz, Austria

SELECTED BIBLIOGRAPHY →
1998 *Kidnapping*, Rotterdam; *Douglas Gordon*, Kunstverein Hannover, Hanover **1999** *Feature Film*, Cologne **2000** *Douglas Gordon, Black Spot*, Tate Gallery, London **2002** *Douglas Gordon*, Kunsthaus Bregenz

1 **Feature Film,** 1999, 35 mm film, film still
2 **Hand with spot A–M,** 2001, digital c-type prints, each 147 x 122 cm, installation view, Lisson Gallery, London
3 **Monument for X,** 1998, video installation on monitor or projection on wall with semi tuned radio broadcast
4 In collaboration with Jonathan Monk: **The end uncovered,** 2001, slide projection, slide number one of 80

„Ich möchte meine Arbeit nicht unnötig festlegen, indem ich sie als persönlich, autobiografisch oder bekenntnishaft charakterisiere."

« Je ne veux pas définir l'œuvre en disant qu'elle est personnelle, autobiographique ou tenue à la manière d'un journal intime. »

"I don't want to pin the work down by saying it's personal, autobiographical, or diaristic."

2

3

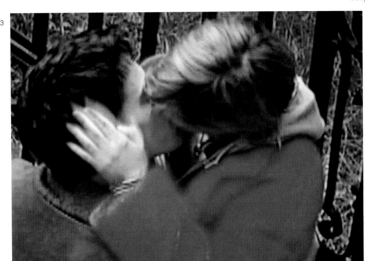

4

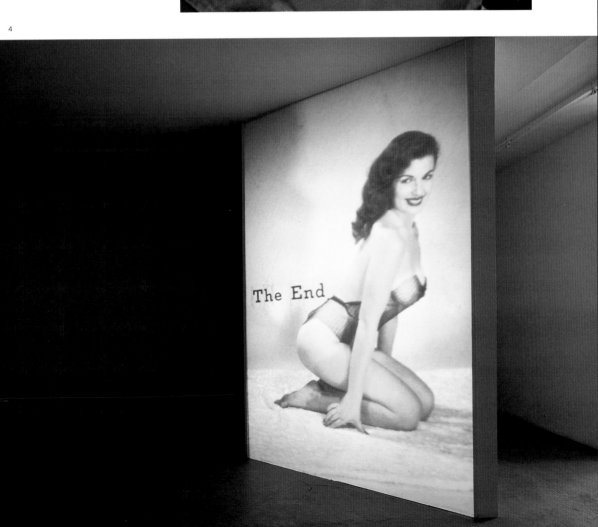

Andreas Gursky

1955 born in Leipzig, lives and works in Düsseldorf, Germany

Andreas Gursky is a photographer in an age of globalisation: since the mid 1980s his subjects have included ports and airports, the interiors of stock markets and the factory floors of "global players", as well as showcases of fetish items produced by international fashion labels. The extent of his production is limited to some ten pictures a year. Gursky concentrates on individual pictures which can be combined into groups of works related by subject matter. His photographs seem to raise the question of the role allocated to the individual in a world-wide economic and cultural integration. He frequently illustrates human beings as a mass in the form of ornamental abstractions: at raves, rock concerts or boxing matches. Gursky's photographs also seem to want to draw attention to the camera itself, which is still able to capture the individual while the bare eye has long failed to do so. In 1984 when Gursky took a picture of the Klausen Pass he was unaware of the presence of a group of hikers, who only appeared in the final print. In the catalogue of his retrospective at the New York Museum of Modern Art, the great variety of extreme close-ups of faces and gestures blend together into what looks like a homogenous mass from a distance. Since the 1990s, Gursky has been creating extremely large-format works using digital processing and taking full advantage of all the technical means available to this medium. As a result, his pictures appear to be in deliberate competition with the large-format pictures of everyday culture as well as the monumental formats of high art. At the same time they extend the spectrum of how things are viewed – from close-up, highly detailed readings to structural analysis.

Andreas Gursky ist Fotograf im Zeitalter der Globalisierung: Seit Mitte der achtziger Jahre gehören Häfen und Flughäfen, Interieurs von Börsen und von Fabrikationshallen der „global player" sowie in Schaukästen inszenierte Warenfetische internationaler Modemarken zu seinen Sujets. Der Umfang seiner Produktion ist auf etwa zehn Bilder pro Jahr begrenzt; Gursky konzentriert sich auf Einzelbilder, die sich zu motivisch verwandten Werkgruppen zusammenschließen lassen. Dabei scheinen die Fotografien auch die Frage aufzuwerfen, welche Rolle dem Individuum innerhalb von weltweiten ökonomischen und kulturellen Verflechtungen zufällt. Häufig werden Menschen im Aggregatzustand der Masse, als ornamentale Abstraktionen sichtbar: bei Ravepartys, Rockkonzerten oder Boxkämpfen. Doch Gurskys Fotografien scheinen zugleich darauf aufmerksam machen zu wollen, dass die Kamera das Individuum auch dort noch registriert, wo das bloße Auge längst versagt. Als Gursky 1984 eine Aufnahme des Klausenpasses machte, entging seinem Blick die Präsenz einiger Wanderer, die erst auf dem Abzug zum Vorschein kamen. Auch die Detailvergrößerungen im Katalog seiner Retrospektive im New Yorker Museum of Modern Art betonen die Vielfalt von Gesichtern und Gesten, die sich nur aus der Distanz zur scheinbar homogenen Masse zusammenfügen. Seit den neunziger Jahren verwendet Gursky – unter Einsatz der digitalen Bildbearbeitung – extreme Großformate, die die technischen Möglichkeiten des Mediums restlos ausschöpfen. Damit treten seine Fotografien in bewusste Konkurrenz zu Großbildern der Alltagskultur wie auch zu Monumentalformaten der Hochkunst. Sie erweitern zugleich das Spektrum der Betrachtungsweisen – von einer nahsichtigen, detailverliebten Lektüre bis zur strukturellen Analyse.

Andreas Gursky est photographe à l'ère de la mondialisation : depuis le milieu des années 80, les ports et les aéroports, les salles des bourses et les halles de fabrication des « global players », mais aussi les fétiches commerciaux mis en scène dans les vitrines des grandes marques de la mode, font partie de ses sujets. Sa production est limitée à une dizaine de photographies par an. Gursky se concentre sur des images uniques que leur parenté thématique permet de regrouper en séries. En même temps, ses photographies semblent poser la question du rôle de l'individu au sein des réseaux économiques et culturels mondiaux. Souvent, les êtres sont montrés à l'état grégaire de la masse ou comme des abstractions ornementales : rave-parties, concerts de rock ou combats de boxe. Mais les photographies de Gursky semblent aussi vouloir faire remarquer que l'appareil photo consigne l'existence de l'individu même lorsque l'œil en est devenu depuis longtemps incapable. En 1984, alors qu'il prend une photographie des Alpes autrichiennes, quelques randonneurs dont il ne relèvera la présence qu'au tirage, échappent à son regard. Dans le catalogue de la rétrospective organisée par le Museum of Modern Art de New York, les agrandissements de certains détails soulignent la diversité des visages et des gestes que seul l'éloignement fondait en une masse homogène. Depuis les années 90, Gursky s'appuie sur le traitement informatique de l'image pour générer des formats extrêmes qui épuisent toutes les possibilités techniques du médium. Ses œuvres entrent ainsi délibérément en concurrence avec les images de la culture quotidienne comme avec les formats de l'art monumental. Elles élargissent en même temps le spectre des modes de contemplation – de la lecture indulgente, amoureuse du détail, à l'analyse purement structurelle.

B. H.

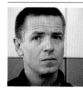

SELECTED EXHIBITIONS →
1998 *Currents 27*, Milwaukee Art Museum, Milwaukee (WI), USA; *Foto-grafien 1984–1998*, Kunstmuseum Wolfsburg, Germany; *Fotografien 1984 bis heute*, Kunsthalle Düsseldorf, Germany; *Das Versprechen der Fotografie: Die Sammlung der DG Bank*, Hara Museum of Contemporary Art, Tokyo, Japan **1999** Van Abbemuseum, Eindhoven, The Netherlands **2000** *Architecture Hot and Cold*, The Museum of Modern Art, New York **2001** Museum of Modern Art, New York (NY), USA; *Let's Entertain*, Walker Art Center, Minneapolis (MN), USA

SELECTED BIBLIOGRAPHY →
1998 *Andreas Gursky: Fotografien 1984–1998*, Kunstmuseum Wolfsburg; *Andreas Gursky: Fotografien 1984 bis heute*, Kunsthalle Düsseldorf **2001** *Andreas Gursky*, Museum of Modern Art, New York (NY)

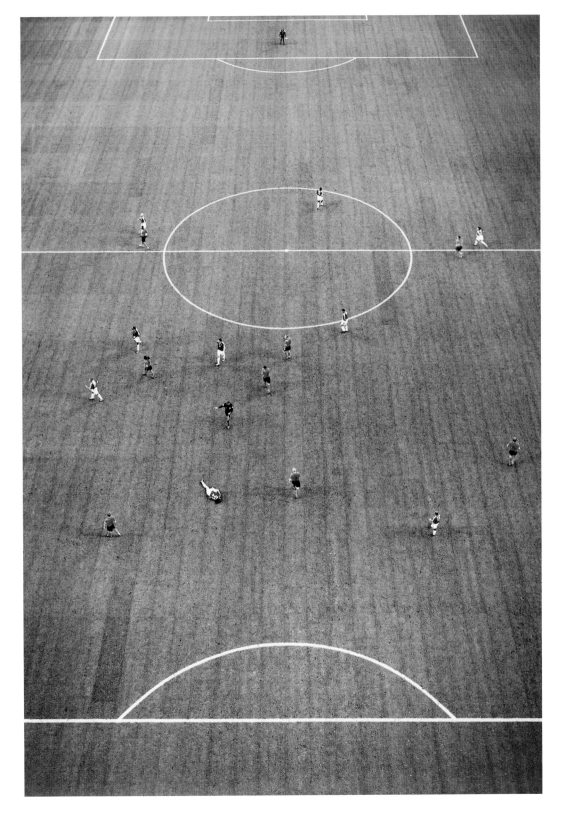

1 **EM Arena, Amsterdam I,** 2000, c-print, 275 x 205 cm
2 **99 cent,** 1999, c-print, 207 x 337 cm

3 **Chicago Board of Trade II,** 1999, c-print, 207 x 337 cm

„Im Rückblick sehe ich, dass mein Wunsch zur Abstraktion immer
radikaler wird. Kunst sollte nicht einen Rapport von Wirklichkeit liefern,
sondern sollte hinter die Dinge blicken."

« Rétrospectivement, je vois que mon désir d'abstraction devient de
plus en plus radical. Plutôt que de proposer un rapport au réel, l'art devrait
regarder derrière les choses. »

"In retrospect I can see that my desire to create abstractions has become more and more radical. Art should not be delivering a report on reality, but should be looking at what's behind something."

2

Thomas Hirschhorn

1957 born in Berne, Switzerland, lives and works in Paris, France

Thomas Hirschhorn's works are epic and detailed displays. He favours disposable materials such as cardboard, tape and tin foil, with which he mimics and parodies subjects and creates umbilical chords between them. His works could be called small cosmologies, where everything is shown to be connected to everything else. The crude, home-grown character of Hirschhorn's work is underlined by a caricatured resonance with authoritative forms of display; the historical monument or the didactics of the museum display where text and image are mixed. Hirschhorn's environments are archival – meant to be read as well as experienced – and they intervene in the public arena. *Deleuze Monument*, 2000, was a tribute to the philosopher Gilles Deleuze in the form of a public sculpture, which Hirschhorn realised in a Paris suburb in collaboration with local youth. The monument created a sculptural space that wasn't purely plastic. It also consisted of a seminar on Deleuze's thinking, a conversation involving the local public. Hirschhorn's projects embody an interface between realism and utopia. They are interzones that lie in an extension of sensory perceptions offered by everyday life, and in the realm of macro-political movements. If by their scale alone Hirschhorn's large works demonstrate an ambition to recreate the world, their inferior and impermanent forms and materials metaphorically show the fragility of the position from which he is critically challenging power formations. In his art, Hirschhorn uses what he himself calls cheap tricks and stupid things in order to humorously undermine power.

Die Arbeiten von Thomas Hirschhorn sind episch angelegte und detailreiche Werke. Er bevorzugt Wegwerfmaterialien wie Karton, Klebeband und Alufolie, mit deren Hilfe er Motive nachempfindet und parodiert und zwischen ihnen nabelschnurartige Verbindungen herstellt. Man könnte seine Arbeiten als kleine Kosmologien bezeichnen, in denen alles mit allem zusammenhängt. Der für Hirschhorns Arbeiten typische ungeschönte Bastelcharakter wird durch die karikaturistische Einbettung in seriöse Präsentationskontexte hervorgehoben – sei es ein historisches Monument oder die Didaktik der Museumsdarbietung, in der Bild und Text miteinander vermischt sind. Hirschhorns Environments präsentieren sich gewissermaßen als Archive – sie wollen gelesen und erfahren werden – und intervenieren zugleich in die Öffentlichkeit. Mit *Deleuze Monument*, 2000, zollt Hirschhorn dem Philosophen Gilles Deleuze Tribut, in Gestalt einer öffentlichen Skulptur, die er in einem Pariser Vorort mit dort heimischen Jugendlichen realisiert hat. Das Monument bedingt einen skulpturalen – allerdings nicht ausschließlich plastischen – Raum. So war darin ein Seminar über Deleuze' Denken inbegriffen – ein Gespräch, an dem sich auch die Bewohner des Viertels beteiligen konnten. Hirschhorns Projekte bilden eine Schnittstelle zwischen Realismus und Utopie. Sie sind Fortschreibungen des Sinneswahrnehmungen, die wir aus unserem Alltagsleben kennen, und verknüpfen diese mit makro-politischen Vorgängen. Mag allein schon das große Format seiner Arbeiten Hirschhorns Ehrgeiz bekunden, die Welt neu zu erschaffen, so bezeugen ihre ebenso unspektakulären wie kurzlebigen Formen und Materialien zugleich auch die Fragilität der Position, von der aus er die vorgegebenen Machtstrukturen kritisch in Frage stellt. Im Übrigen arbeitet Hirschhorn in seiner Kunst mit – wie er selbst es nennt – billigen Tricks und dummen Sachen, um mit humoristischen Mitteln die Fundamente der Macht zu untergraben.

Les œuvres de Thomas Hirschhorn sont épiques et détaillées. Il privilégie les matériaux jetables tels que le carton, le ruban adhésif et la feuille d'aluminium, avec lesquels il imite et parodie des sujets, puis les relie par des cordons ombilicaux qu'il crée. Ses œuvres pourraient être qualifiées de « petites cosmologies », où tout est montré comme étant lié à tout le reste. La nature brute, improvisée, du travail d'Hirschhorn est soulignée par la résonance caricaturale des formes autoritaires de présentation : le monument historique ou le didactisme de l'exposition du musée où les textes et les images se mêlent. Ses environnements sont comme des archives – censés être lus aussi bien que vécus – et interviennent dans la sphère publique. *Deleuze Monument*, 2000, est un hommage au philosophe Gilles Deleuze sous la forme d'une sculpture publique réalisée dans une banlieue parisienne avec la collaboration de la jeunesse locale. Ce monument créait un espace sculptural qui n'était pas purement plastique. Il consistait également en un séminaire sur la pensée de Deleuze, une conversation impliquant le public local. Les projets de Hirschhorn incarnent une interface entre réalisme et utopie. Ce sont des interzones qui résident dans une extension des perceptions sensorielles offertes par la vie quotidienne ainsi que dans le domaine des mouvements macropolitiques. Si, par leur simple échelle, ses grandes œuvres trahissent une ambition de recréer le monde, leur formes et leurs matériaux inférieurs et éphémères démontrent métaphoriquement la fragilité de la position depuis laquelle il défie par sa critique les formations de la puissance. Dans son art, Hirschhorn utilise ce qu'il appelle lui-même des trucs faciles et des idioties pour saper le pouvoir avec humour.

L. B. L.

SELECTED EXHIBITIONS →
1998 *Premises*, Guggenheim Museum, New York (NY), USA
1999 *World Corners*, Musée d'Art Moderne de Saint-Etienne, France; *Unfinished History*, Museum of Contemporary Art, Chicago (IL), USA; *Mirror's Edge*, Bild Museet, Umeå, Sweden **2000** *World Airport*, The Renaissance Society, Chicago (IL), USA; *Protest & Survive*, Whitechapel Art Gallery, London, UK **2001** *Archaeology of Engagement*, Museu d'Art Contemporani, Barcelona, Spain; *Vivre sa vie*, The Tramway, Glasgow, UK

SELECTED BIBLIOGRAPHY →
1995 Künstlerhaus Bethanien, Berlin **1996** Kunstmuseum Luzern, Lucerne **1998** *Ein Kunstwerk, ein Problem*, Portikus, Frankfurt am Main **2000** *Jumbo Spoons and Big Cake*, The Art Institute of Chicago

„Ich mache keine politische Kunst, sondern mache Kunst politisch."

« Je ne fais pas de l'art politique, je fais de l'art politiquement. »

"I don't make political art, I make art politically."

2

Damien Hirst

1965 born in Bristol, lives and works in Devon, UK

Damien Hirst's profile is as much that of showman, entrepreneur and self-promoter as artist. His exhibitions are elaborate large-scale spectacles more familiar to a science museum or theme park than a gallery. A 2000 show entitled *Theories, Models, Methods, Approaches, Assumptions, Results, and Findings* presented an ensemble of 31 sculptures, installations and wall pieces. Alternately grandiose and tongue-in-cheek, they deal with the unwieldy themes of life and death, sickness and science, chaos and order as first seen in 1991 with his infamous preservation of a dead shark in a tank of formaldehyde. Industrially constructed steel and glass cases, hybrids of the minimalist cube and the forensic vitrine, are a signature style of Hirst's. The enormity of scale and ambition of production characteristic of Hirst's work is here in works such as *Hymn*, 2000, a twenty foot high painted bronze human torso, its skin partially removed to reveal its internal organs, an exaggerated version of an educational anatomy model. Huge shiny medicine cabinets containing rows of evenly spaced, multicoloured pills express the world's infinite variety of sickness as well as man's attempts to regulate it (through medicine). A sculpture with the same long title as the show itself, in which dozens of ping pong balls jiggle in two vitrines, held aloft by gusts of air from two ventilators, is a light hearted meditation on the chaos and repetition of life. Hirst's is an existentialism for everyman, expressed with a schoolboy's sense of humour and a surrealist's sense of the absurd.

Damien Hirst gilt ebenso als Showmaster, Unternehmer und Selbstvermarkter wie als Künstler. Seine Ausstellungen sind ausge-klügelte großformatige Spektakel, die man eher in einem Wissenschaftsmuseum oder Themenpark erwarten würde als in einer Galerie. Hirsts im Jahr 2000 gezeigte Schau *Theories, Models, Methods, Approaches, Assumptions, Results, and Findings*, präsentierte ein Ensemble von 31 Skulpturen, Installationen und Wandarbeiten. Mal in grandioser, dann in ironischer Manier befasst er sich hier mit so sperrigen Themen wie Leben und Tod, Krankheit und Wissenschaft, Chaos und Ordnung. Ein erstes Beispiel für diese Vorgehensweise ist der berüchtigte Hai, den er 1991 in einem mit Formaldehyd gefüllten Aquarium konserviert hat. Hirsts Stil ist vor allem duch industriell gefertigte Stahl- und Glasbehälter – Mischformen aus minimalistischen Würfelkonstrukten und gerichtsmedizinischen Vitrinen – charakterisiert. Für die Dimension und die Ambition des Hirstschen Kunstschaffens typisch sind auch Werke wie *Hymn*, 2000, ein knapp sieben Meter hoher bemalter menschlicher Bronzetorso, dessen äußere Hülle stellenweise abgelöst ist und – als gigantisch vergrößertes Anatomiemodell – einen Blick auf die inneren Organe gestattet. Riesige spiegelblanke Medizinschränke, in denen in genau bemessenen Abständen Batterien bunter Pillen arrangiert sind stehen beispielhaft für die unendliche Vielfalt der Krankheiten und für das Streben des Menschen, ihrer mit Hilfe der Medizin Herr zu werden. Eine Skulptur, deren langer Titel gleichlautend mit dem der Ausstellung ist, besteht aus zwei Vitrinen, in denen Ventilatoren Dutzende von Pingpong-bällen in Bewegung halten und ist damit eine beschwingte Überlegung über das Chaos und das ewige Einerlei des Daseins. Hirst praktiziert einen Existentialismus für jedermann, ausgedrückt mit zugleich jungenhaftem Humor und einem surrealistischen Sinn für das Absurde.

Le C. V. de Damien Hirst pourrait tout autant être celui d'une bête de scène, d'un homme d'affaires et d'un spécialiste de l'auto-promotion que celui d'un artiste. Ses expositions sont de grands spectacles sophistiqués qui tiennent davantage du musée des sciences ou du parc d'attraction que de la galerie d'art. En 2000, une exposition intitulée *Theories, Models, Methods, Approaches, Assumptions, Results, and Findings,* présentait un ensemble de 31 sculptures, installations et œuvres murales. Tantôt grandioses, tantôt ironiques, elles traitaient des thèmes plutôt encombrants de la vie et de la mort, de la maladie et de la science, du chaos et de l'ordre, comme cela avait déjà été le cas en 1991 lorsqu'il fit scandale avec sa présentation d'un requin mort conservé dans un aquarium rempli de formol. Ses boîtes industrielles en verre et acier, croisement du cube minimaliste et de la vitrine de criminalistique, sont devenues son signe de reconnaissance. L'énormité de l'échelle et de l'ambition des réalisations de Hirst s'illustre dans des œuvres telles que *Hymn*, 2000 : un torse humain en bronze peint de six mètres de haut, dont la peau en partie ôtée révèle ses organes internes – version exagérée d'un écorché de salle de classe. D'immenses armoires à pharmacie étincelantes, contenant des rangées de pilules multicolores minutieusement espacées, expriment l'infinie variété de la maladie comme dans les espèces) ainsi que les tentatives de l'homme pour la contrôler (par la médecine). Une sculpture portant le même long titre que l'exposition, où des dizaines de balles de ping-pong maintenues en l'air par deux ventilateurs se trémoussent dans deux vitrines, constitue une méditation amusée sur le chaos et la répétition de la vie. L'existentialisme de Hirst s'adresse à tout le monde, s'exprimant avec un humour d'écolier et un sens de l'absurde surréaliste.

K. B.

SELECTED EXHIBITIONS →
1997 *The Beautiful Afterlife*, Bruno Bischofberger, Zurich, Switzerland **1998** *Damien Hirst*, Southampton City Art Gallery, Southampton, UK **1999** *Pharmacy*, Tate Gallery, London, UK **2000** *Sadler's Wells*, London, UK; *Theories, Models, Methods, Approaches, Assumptions, Results, and Findings*, Gagosian Gallery, New York (NY), USA; *Hyper Mental*, Kunsthaus Zürich, Zurich, Switzerland; Hamburger Kunsthalle, Hamburg, Germany; *Ant Noises*, Saatchi Gallery, London, UK **2001** *Double Vision*, Galerie für Zeitgenössische Kunst, Leipzig, Germany; *Public Offerings*, Museum of Contemporary Art, Los Angeles (CA), USA; *Century City*, Tate Modern, London, UK

SELECTED BIBLIOGRAPHY →
1995 *Some Went Mad, Some Ran Away*, Serpentine Gallery, London **1997** *Want to Spend the Rest of My Life Everywhere with Everyone, One to One, Always, Forever, Now*, London **2000** *Theories, Models, Methods, Approaches, Assumptions, Results, and Findings*, Gagosian Gallery, New York (NY)

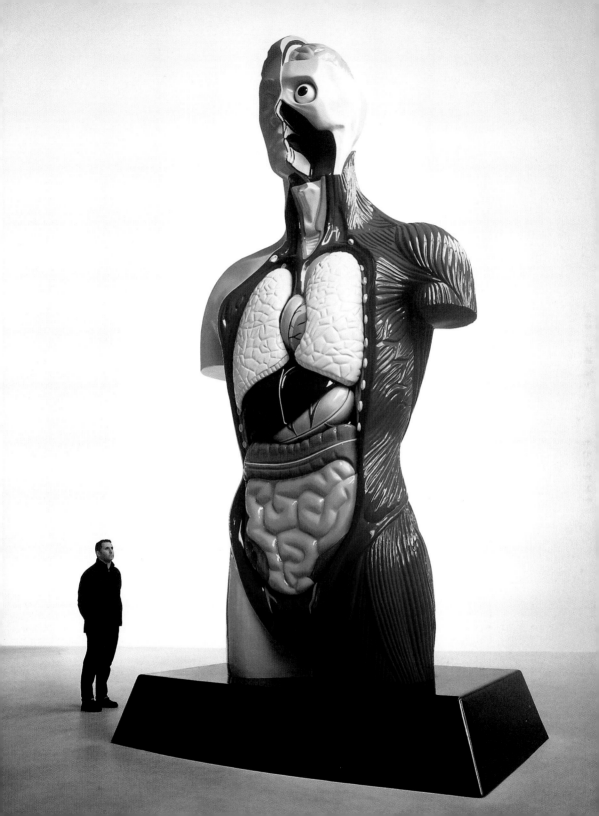

1 **Hymn,** 2000, painted bronze, 610 x 274 x 122 cm
2 **Lost Love,** 2000, vitrine with African river fish, 366 x 213 x 213 cm
3 **Concentrating on a Self-Portrait as a Pharmacist,** 2000, vitrine, portrait,

objects, 244 x 274 x 305 cm
4 **Adam & Eve (Banished from the Garden),** 2000, steel and glass vitrine, 221 x 427 x 122 cm

„Letztendlich handelt es sich um den Wunsch, ewig zu leben. Darum geht es ja schließlich in der Kunst."

« Tout se résume au désir de vivre à jamais. C'est de cela qu'il s'agit en art. »

"It all boils down to the desire to live forever. This is what art's all about."

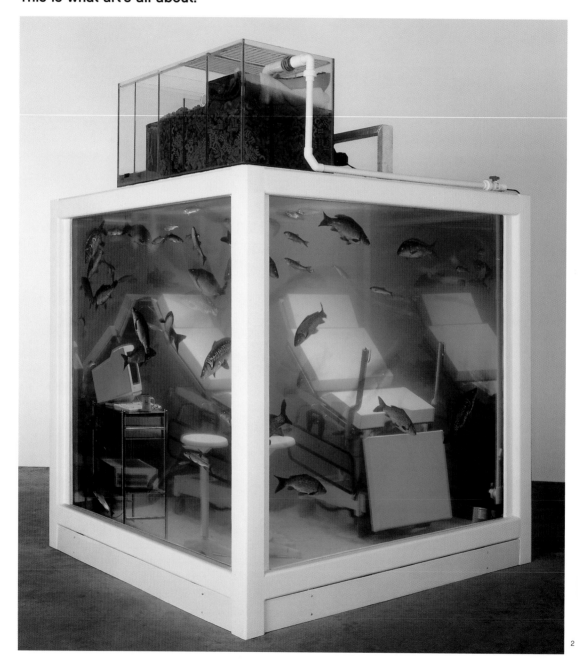

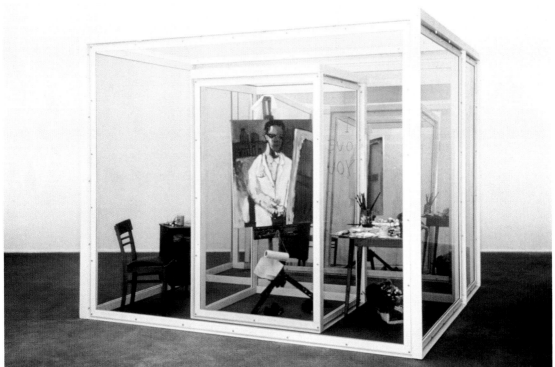

3

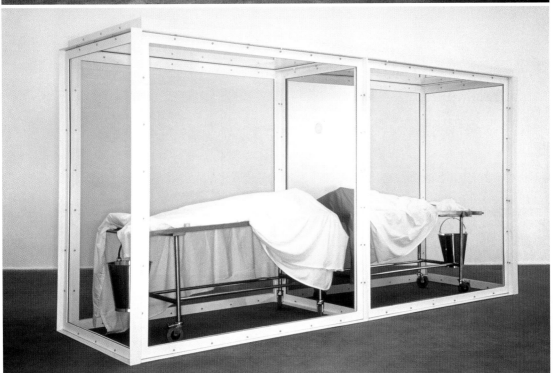

4

Carsten Höller

1961 born in Brussels, Belgium, lives and works in Stockholm, Sweden

Carsten Höller creates a happy combination of art and science. His aim is to extend the boundaries of human perception or, to be more precise, to manipulate it and release it from its most primitive parameters in its search for physiological sensations. If we want to broaden our perceptual horizons, we must abandon our habits and certainties. Since 1999 Höller's white Daimler has been hurtling around the art market and along ordinary streets, covered with stickers in various languages advertising *The Laboratory of Doubt*. Contradicting Adorno's dictum that art acquires meaning in proportion to its lack of function, Höller provides a service. He produces positive effects. His art objects function in the same way as the human body. They give us answers to our questions, like "Who am I? Where am I going? What can I think?" By focussing on physiological sensation and providing physical experiences, he breaks down the barriers between art and behaviour which tend to trivialise art and rob it of meaning and relevance. In 2001 in *Instrumente aus dem Kiruna Psycholabor* (Instruments from the Kiruna Psycholaboratory) Höller used flickering lights to show the synchronisation of brain activity and the visual phenomena experienced by the closed eye, behind the retina and under the eyelids. In his *Light Wall*, 2000, 1,920 light bulbs emit light and heat, rhythmically flashing at a Hertz frequency of 7.8. Even with eyes closed, the viewer cannot escape the light, which creates a multicoloured negative. The brain is compared to an electrical system, synchronising external impulses. The exhibition space is a machine whose task is to synchronise itself with visitors and provide them with a shared experience.

Carsten Höller ist als Künstler ein glücklicher Wissenschaftler. Er arbeitet an der Ausdehnung der menschlichen Wahrnehmung, oder genauer gesagt, daran, dass diese manipulierbar ist, abhängig von primitivsten Parametern, süchtig nach physiologischen Sensationen. Will man seine Wahrnehmung erweitern, muss man Gewissheit und Gewöhnung fahren lassen. Seit 1999 rauscht Höllers weißer Daimler durch den Kunstmarkt und über gewöhnliche Straßen und kündigt mit Aufklebern in diversen Sprachen *The Laboratory of Doubt* an. Ein paar Meilen entfernt von Adornos Diktum, Kunst gewinne in der Funktionslosigkeit ihren Sinn, ist Höller ein Dienstleister, er produziert positive Effekte. Seine Objekte funktionieren ähnlich wie unser Körper, sie antworten auf unsere Fragen: „Wer bin ich, wohin gehe ich, was kann ich denken?" Da er die Aufmerksamkeit auf physiologische Sensationen lenkt und Erfahrungen vermittelt, durchbricht er die Barriere zwischen Kunst und Handeln, die die Kunst trivialisiert und sie der Wirkung einer tatsächlichen Praxis beraubt. Im Jahre 2001 erzählt Höller in *Instrumente aus dem Kiruna Psycholabor* von der Synchronisation der Gehirnaktivitäten durch flackernde Lichter, die bei geschlossenen Augen visuelle Phänomene zaubern, hinter der Retina, unter den Augenlidern. In seiner Arbeit *Light Wall*, 2000, verströmen 1920 Glühbirnen ihr Licht und ihre Wärme, blitzen im Rhythmus des Taktes einer 7,8 Hertz Frequenz. Selbst hinter den Augenlidern hat man keine Ruhe und sieht ein vielfarbiges Negativ. Das Gehirn gleicht einem elektrischen System, dass Impulse von außen synchronisiert. Der Ausstellungsraum ist eine Maschine, deren Aufgabe es ist, sich mit den Besuchern zu synchronisieren, um mit ihnen zusammen etwas zu erleben.

Comme artiste, Carsten Höller est un scientifique comblé. Il travaille sur le développement de la perception humaine, plus précisément sur le fait qu'elle est manipulable, dépendante de paramètres infiniment primitifs, avide de sensations physiologiques. Lorsqu'on se propose d'étendre le champ de sa perception, on doit laisser de côté les certitudes et les habitudes. Depuis 1999, la Daimler blanche de Höller sillonne le marché de l'art et les sentiers battus, répandant la bonne parole du *Laboratory of doubt* à coup d'autocollants en plusieurs langues. A bien des lieues de l'affirmation d'Adorno, selon laquelle l'art prend son sens dans l'absence de fonction, Höller est un prestataire de service. Il produit des effets positifs. Ses objets fonctionnent un peu comme notre propre corps, ils répondent à nos questions : « qui suis-je ? où vais-je ? que puis-je penser ? » En dirigeant l'attention vers les sensations physiologiques et en faisant part de ses expériences, Höller abat la barrière entre l'art et l'action, qui trivialise l'art et le soustrait aux effets d'une pratique concrète. En 2001, dans *Instrumente aus dem Kiruna Psycholabor* (Outils du psycholaboratoire Kiruna), Höller évoque la synchronisation des activités cérébrales à l'aide de lumières clignotantes qui, derrière les paupières baissées, font apparaître des phénomènes visuels sur la rétine. Dans son *Light Wall* (Mur de lumière, 2000), 1,920 ampoules électriques dispensent leur lumière et leur chaleur, flashent au rythme de 7,8 hertz. Même derrière les paupières baissées, l'œil est bombardé de stimuli, et l'on voit un négatif multicolore. Le cerveau est comme un système électrique qui synchronise des impulsions extérieures. La salle d'exposition est une machine dont la fonction est de se caler sur le rythme du spectateur, et de vivre quelque chose avec lui. F. F.

SELECTED EXHIBITIONS →
1997 documenta X (with Rosemarie Trockel), Kassel, Germany **2000** *Liukuratoja – Slides, Tuotanto – Production*, Kiasma, Studio K, Helsinki, Finland; *Synchro System*, Fondazione Prada, Milan, Italy; *Over the Edges*, S.M.A.K., Stedelijk Museum voor Actuele Kunst, Ghent, Belgium; *An Active Life*, The Contemporary Arts Center, Cincinnati (OH), USA; *In Between* (with Rosemarie Trockel), EXPO 2000, Hanover, Germany **2001** *Instrumente aus dem Kiruna Psycholabor*, Schipper & Krome, Berlin, Germany; *Yokohama Triennale*, Yokohama, Japan

2002 *Light Corner*, Museum Boijmans Van Beuningen, Rotterdam, The Netherlands

SELECTED BIBLIOGRAPHY →
1999 *Neue Welt*, Museum für Gegenwartskunst Basel, Basle **2000** *Registro*, Fondazione Prada, Milan; Daniel Birnbaum/Patrik Nyberg (eds.), *Tuotanto/Production*, Helsinki **2001** Hans Ulrich Obrist/Barbara Vanderlinden (eds.), *Laboratorium*, Cologne

1 **Light Wall,** 2000, installation view, Fondazione Prada, Milan
2 **Valerio I,** 1998, installation view, Kunst-Werke, Berlin
3 **Frisbeehaus,** 2000, installation view, *HausSchau – Das Haus in der Kunst,*
 Deichtorhallen, Hamburg

4 **Ballhaus** (detail), 1999, installation view, *Sanatorium,* Kunst-Werke, Berlin
5 **Upside Down Mushroom Room,** 2000, installation view, Fondazione Prada,
 Milan

„Zweifel ist schön."

« Le doute est beau. »

"Doubt is beautiful."

2

4

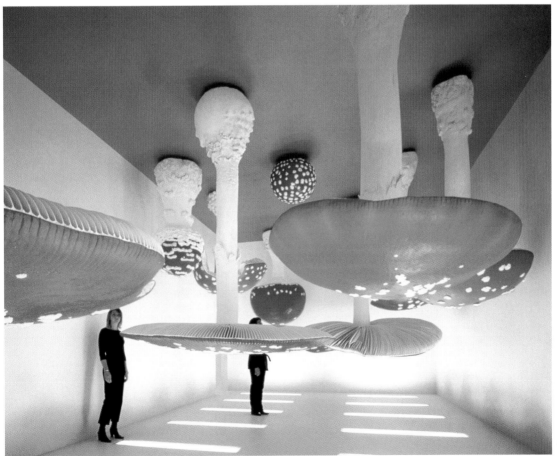

5

Gary Hume

1962 born in Kent, lives and works in London, UK

Gary Hume came to public attention in the late 1990s with his *Doors* series of full-scale paintings depicting hospital swing doors. Although they tend to be interpreted as allegorical descriptions of the despair he felt at the time, associated with loss, ending, death or fearful loneliness, he himself regards them as perfect works of art, which counteract the vileness of reality. In the years since then he has remained faithful to this principle. The covers of gossip and pornographic magazines, popular icons of fashion and music, hands, flowers and old master-pieces from the world's museums provide him with templates whose forms and colours he radically abstracts, thereby seeming to negate any real engagement with the original subject. Thus Pop Art meets Rorschach, Art Deco encounters Jan Vermeer, Kate Moss runs into the Renaissance painter Petrus Christus. Nevertheless, the paintings resist all arbitrariness and are a testimony to his interest in exploring the difference between archetype and copy, sign and signified; these are probed by Hume in defiance of the onslaught of decoration, kitsch and bad design. The optical trickery of his pictures is based on the aesthetic use of spaces in which his images move back and forth between gaze and memory ("Being seen"). Different sections are subjected to a variety of treatments, ranging from high gloss to matt hatching, thereby supporting perception and effect, as his signature and brush strokes disappear in favour of the smoothly devised, empty surface. The gaps reflect painting's qualitative advantage in showing empty spaces – regardless of whether the motivation is to be found within or outside the image. One thing is certain, however: Hume enjoys the viewer's irritation to the full and does not shrink from pathos.

Bekannt wurde Gary Hume Ende der neunziger Jahre durch die Serie *Doors*, lebensgroße Gemälde von Schwing-Flügeltüren in Krankenhäusern. Häufig als allegorische Beschreibung seines damaligen, trostlosen Zustands interpretiert, assoziiert mit Verlust, Ende, Tod oder angstvoller Einsamkeit, sind sie seiner Meinung nach perfekte Kunstwerke, die der scheußlichen Realität ein Gegenbild eröffnen. Diesem Prinzip ist er in den Folgejahren treu geblieben. Die Cover von Boulevard- oder Porno-Magazinen, die Pop-Ikonen aus Mode und Musik, Hände, Blumen oder die alten Meisterwerke aus den Museen der Welt liefern ihm die Umrisse, die formal und farblich stark abstrahiert eine Auseinandersetzung mit dem Vorbild scheinbar negieren. So trifft Pop-Art auf Rorschach, Art déco auf Jan Vermeer, Kate Moss auf den Renaissancemaler Petrus Christus. Die Gemälde wehren sich jedoch gegen jede Beliebigkeit und bezeugen das Interesse an der Differenz von Urbild und Abbild, von Zeichen und Bezeichnetem, welches Hume gegen die Phalanx von Dekoration, Kitsch und schlechtem Design auslotet. Der optische Trick seiner Bilder beruht auf der ästhetischen Nutzung der Zwischenräume, in denen das Bild zwischen Sehen und Erinnern („Gesehen werden") oszilliert. Hierbei unterstützt die unterschiedliche Behandlung der von hoch glänzend bis matt schraffiert reichenden Partien die Wahrnehmung und Wirkung, da seine Signatur und Pinselspur zugunsten der glatt designten, leeren Oberflächen verschwindet. In den Leerstellen liegt der Qualitätsvorsprung der Malerei, Freiräume zur Erscheinung zu bringen – seien sie inner- oder außerbildlich motiviert. Eines aber ist sicher: Unsere wohlige Irritation kostet Hume weidlich aus und scheut sich nicht, pathetisch zu werden.

Gary Hume s'est fait connaître à la fin des années 90 avec sa série *Doors*, des peintures grandeur nature de portes d'hôpitaux à double battant. Souvent interprétées comme une description allégorique de son sentiment de désespérance à cette époque, associées aux idées de perte, de fin, de mort ou d'angoisse devant la solitude, elles sont selon lui des œuvres d'art parfaites qui proposent une image à contre-courant de l'horreur de la réalité. Dans les années qui ont suivi, Hume est resté fidèle à ce principe. Les couvertures de revues pornographiques ou de la presse du cœur, les icônes populaires de la mode et de la musique, les mains, les fleurs ou les anciens chefs-d'œuvre des grands musées fournissent des silhouettes dont la forte abstraction semble nier formellement toute confrontation avec le modèle. Le Pop Art rejoint le test de Rorschach, l'Art nouveau Vermeer, Kate Moss le peintre de la Renaissance Petrus Christus. Mais ces peintures se défendent de tout arbitraire et attestent un intérêt certain pour l'écart entre le modèle et sa représentation, entre le signe et le signifié, intérêt que Hume sonde en le comparant aux légions de décorations, d'images kitsch et de mauvais designs. La virtuosité visuelle de ses tableaux repose sur l'utilisation esthétique des espaces interstitiels dans lesquels le tableau oscille entre contemplation et réminiscence (« être vu »). Les différences de traitement des parties superbrillantes, mates ou hachurées, mettent alors l'accent sur la perception, sur l'effet, d'autant que toute facture personnelle et toute trace de pinceau disparaissent au profit d'une surface vide et lissée comme un design. C'est dans ces intervalles que réside l'avance qualitative de la peinture, qui sait visualiser les espaces vides – que ceux-ci soient motivés par des considérations extérieures ou inhérentes au fait pictural. Une certitude demeure : notre douce irritation fait la délectation de Hume, une délectation qui ne recule pas devant le pathos. G. J.

SELECTED EXHIBITIONS →
1996 Bonnefanten Museum, Maastricht, The Netherlands; *The Turner Prize Exhibition*, Tate Gallery, London **1999** Whitechapel Art Gallery, London, UK; British Pavilion, *48. Biennale di Venezia*, Venice, Italy **2000** Fundació "la caixa", Barcelona, Spain; *Painting the Century*, National Portrait Gallery, London, UK; *Ant Noises*, Saatchi Gallery, London, UK; *Sincerely Yours*, Astrup Fearnley Museum, Oslo, Norway **2001** *Century City*, Tate Modern, London, UK; *Heads and Hands*, Decatur House Museum, Washington D.C., USA

SELECTED BIBLIOGRAPHY →
1995 *Gary Hume*, Institute of Contemporary Arts, London; *Gary Hume*, Kunsthalle Bern, Berne **1996** Bonnefanten Museum, Maastricht **1998** *Real/Life: New British Art*, Tochigi Prefectural Museum of Fine Arts, Tochigi **1999** *Gary Hume*, British Council, London; Matthew Collings, *This is Modern Art*, London; Richard Cork et al., *Young British Art: The Saatchi Decade*, London; *Gary Hume*, Fundació "la Caixa", Barcelona

1 **Daffodils,** 2000, enamel paint on aluminium panel, 250 x 200 cm
2 **Snowman,** 2000, c-print, 158 x 122 cm

3 Installation views, *New Paintings,* Matthew Marks Gallery, New York (NY), 2001
4 **Spring Angels,** 2000, series of 8 screenprints, each 127 x 102 cm

„Ich möchte etwas Großartiges malen, etwas Vollkommenes –
etwas voller Traurigkeit."

« Je veux peindre quelque chose de splendide, de parfait,
qui soit donc plein de tristesse. »

"I want to paint something that's gorgeous, something that's perfect, so that it's full of sadness."

2

3

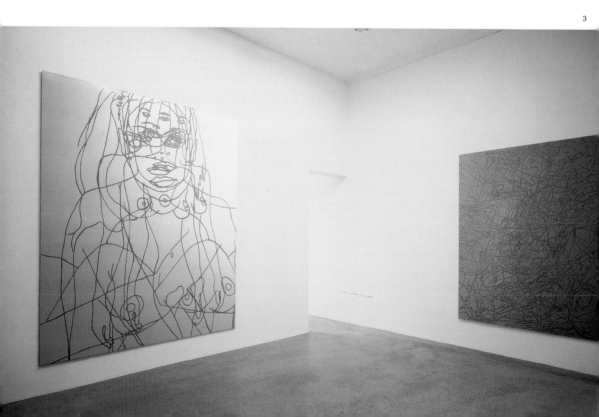

4

3

Mike Kelley

1954 born in Detroit (MI), lives and works in Los Angeles (CA), USA

Mike Kelley, who has been around for some thirty years as an artist, performer and musician, is one of the best-known representatives of Californian Post-Conceptualism. He was deeply influenced by the radical political upheavals of the early 1970s and the artistic changes brought about simultaneously by a new generation of artists in the USA and Europe. Los Angeles' emerging performance scene proved to be an important field for experimentation. Kelley is interested in the unconscious, in the darker side of American society and the parts of human nature repressed by the modern world. His work is a synthesis of punk themes, bits of trash, cartoons, folk art and teenage culture. In his numerous happenings, theatre pieces, videos and installations, Kelley presents a surreal world full of strange creatures and taboo-breaking motifs. His opulent space installations are rich in cultural references, while he also sets up absurd experiments using the arsenal of the subculture and the everyday horror vacui – the fear of empty space – to create an art of "cultural exorcism". Kelley has been involved in many collaborations, the most important of which include his enduring partnership with Paul McCarthy. Their performances together are full of recurring allusions to the radical rituals of Viennese Actionism, an aesthetic which they interweave with home-grown American iconography. Kelley's complex, labyrinthine works have made him one of the leading exponents of "crossover art", a genre that knows no boundaries between high and low culture, nor between visual art, music and theatrical forms.

Mike Kelley, seit rund dreißig Jahren als Künstler, Performer und Musiker aktiv, ist einer der bekanntesten Vertreter des kalifornischen Postkonzeptualismus. Er war maßgeblich von den politischen und künstlerischen Umbrüchen geprägt, die Anfang der siebziger Jahre von einer jungen Generation in den USA und in Europa durchgesetzt wurden. Besonders die sich damals formierende Performance-Szene in Los Angeles war ein entscheidendes Experimentierfeld für Kelley. Sein Interesse gilt dem Unbewussten, der dunklen Kehrseite der amerikanischen Gesellschaft ebenso wie dem Verdrängten der Moderne. In seine Kunst integriert er Motive des Punk, Trash-Elemente, Cartoons, Folk-Art und Produkte der Teenage-Culture. In zahlreichen Aktionen, Bühnenstücken, Videos und Installationen zeigt Kelley surreale Welten mit tabubrechenden Motiven, voller bizarrer Kreaturen. Seine opulenten Räume stattet er mit einer Fülle von kulturellen Referenzen aus. Dabei durchkreuzt er immer wieder seine absurden Versuchsanordnungen zur Kunstgeschichte mit den Arsenalen der Subkultur und dem Horror vacui des Alltags. Es entsteht eine Kunst des „kulturellen Exorzismus". Kelley ist viele Kooperationen eingegangen, unter denen besonders die langjährige Zusammmenarbeit mit Paul McCarthy hervorzuheben ist. In ihren gemeinsamen Performances haben die Künstler sich immer wieder auf die radikalen Riten des Wiener Aktionismus bezogen und diese Ästhetik mit Motiven ihrer eigenen amerikanischen Ikonografie durchwoben. Kelley ist mit seinem komplexen labyrinthischen Werk längst zu einem der wichtigsten Vertreter eines Crossover geworden, das weder Grenzen von High und Low noch zwischen Kunst, Musik und theatralischen Formen anerkennt.

Mike Kelley, qui travaille comme plasticien, performer et musicien depuis quelque trente ans, est un des représentants majeurs du postconceptualisme californien. Marqué par les transformations politiques et artistiques que la jeune génération imposait au début des années 70 en Europe et aux Etats-Unis, il voit s'ouvrir devant lui un champ d'expériences avec l'émergence de la scène de la performance à Los Angeles. Son intérêt porte en premier lieu sur l'inconscient, sur la face cachée et sombre de la société américaine et sur les refoulements de la modernité. Dans son art, il intègre des motifs de la scène punk, des éléments trash, des dessins animés, des aspects du Folk Art et les produits de la culture des teen-agers. Ses nombreuses actions, pièces théâtrales, vidéos et installations présentent des mondes surréels emplis de créatures bizarres et de motifs qui brisent les tabous. Dans la perspective d'un art de « l'exorcisme culturel », leurs espaces opulents débordent de références culturelles au sein desquelles l'artiste cherche constamment à faire cohabiter les tentatives de classement absurdes de l'histoire de l'art et l'arsenal de la subculture et de l'horreur du vide quotidiens. Kelley a souvent travaillé en coopération. Dans ce contexte, il convient de souligner les nombreuses années de sa collaboration avec Paul McCarthy. Dans leurs performances communes, les deux artistes se sont inspirés des rituels radicaux de l'actionnisme viennois tout en faisant entrer dans cette esthétique les motifs de leur propre iconographie américaine. Avec son œuvre complexe et labyrinthique, Kelley est depuis longtemps devenu le grand adepte d'un crossover qui fait fi des frontières entre haute et basse culture, entre les arts plastiques, la musique et les formes d'art scéniques. A. K.

SELECTED EXHIBITIONS →
1997 *documenta X* (with Tony Oursler), Kassel, Germany **1999** *On the Sublime*, Rooseum, Center for Contemporary Art, Malmö, *Sweden; The American Century: Art and Culture 1950–2000*, The Whitney Museum of American Art, New York (NY), USA **2000** *The Poetics Project: 1977–1997 (Documenta Version)*, Centre Georges Pompidou, Paris, France (with Tony Oursler); *Sublevel, Framed and Frame, Test Room*, Migros Museum für Gegenwartskunst, Zurich, Switzerland; *Apocalypse: Beauty and Horror in Contemporary Art*, Royal Academy of Arts, London, UK; *Art in the 80's*, P.S.1, Long Island City (NY), USA **2001** *Painting at the Edge of the World*, Walker Art Center, Minneapolis (MN), USA **2002** *Sonic Process*, Centre Georges Pompidou, Paris, France

SELECTED BIBLIOGRAPHY →
1992 Thomas Kellein (ed.), *Mike Kelley*, Basel/Frankfurt/London **1999** *Mike Kelley: Two Projects*, Kunstverein Braunschweig; *Mike Kelley*, London

1 Extracurricular Activity, protective Reconstruction #1 (Domestic Scene), (detail), 2000, installation and video, installation view, *Apocalypse*, Royal Academy of Arts, London
2 Framed & Frame (Miniature Reproduction *China Town Wishing Well* built by Mike Kelley after Miniature Reproduction *Seven Star Cavern* built by Prof. H. K. Lu) Part 1, 1999, mixed media, 287 x 485 x 409 cm (one of two parts)
3 Framed & Frame (Miniature Reproduction China Town Wishing Well built by Mike Kelley after Miniature Reproduction Seven Star Cavern built by Prof. H. K. Lu) Part 2, 1999, mixed media, 287 x 485 x 409 cm (one of two parts)
4 Arena #10 (Dogs), 1990, stuffed animals on afghan, 29 x 312 x 81 cm

„Mir scheint, dass Kunst rituell vom Leben getrennt werden muss, um Kunst zu sein. Sieht man in ihr mehr als einen Spiegel, erscheint das problematisch."

« Il me semble que l'art doit être rituellement séparé de la vie pour être de l'art, ainsi voir en lui plus qu'un miroir semble problématiques. »

"It seems to me that art has to be ritually separated from life in order to be art, so to talk about it as anything more than a mirror seems problematic."

2

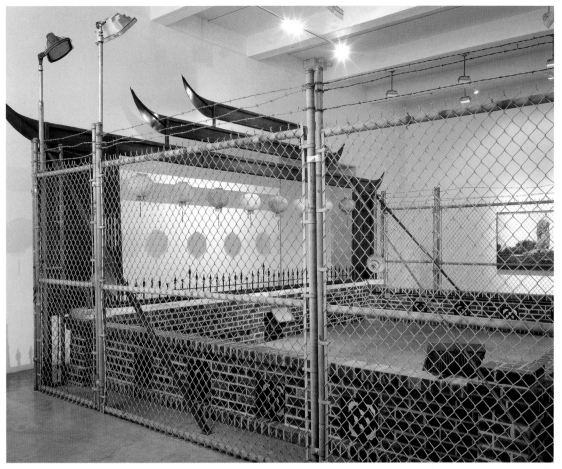

Rachel Khedoori

1964 born in Sydney, Australia, lives and works in Los Angeles (CA), USA

Rachel Khedoori is a sculptress: it would be hard to find anyone else who creates images in such a complex, spatially expansive form as she does in her film installations. Sculpture and film are combined for viewers in such a dynamic way that it is as if they are in motion, and their perception is in motion. Khedoori breaks open the kineastic arrangement engaging the static and passive observer. We see not only the devices of image creation – the projectors and spools – but also the observer as he or she tries to find their way within the complicated, spatially interlocking and fragmented settings, like excerpts of claustrophobic situations from the realm of dreams. Khedoori reaches into the medium of film and its illusionist character using artistic techniques, and she thus makes film a physical experience. The installation *Untitled (Blue Room),* 1999, is a 35mm film showing a reconstructed room in a house in Pasadena, that takes up an entire room in the gallery. The projection hits two adjoining mirrored surfaces arranged on the gallery wall and gallery floor, and from there it is thrown back, distorted, returned. Unsure where their attention should be focussing, viewers are constantly forced to change their perception. They see a film: an endless loop. They see the technique: the spools, the projector. They see the projected room, while the gallery room itself is in darkness. The observer is obliged to take part in this highly complicated game, assimilating the reflected illusion of the film, the reality of its apparatus, and the sculptural quality of the room which is the scene of the projection. This multi-layered iridescent moment transmitted to the viewer is representative of the complexity of Khedoori's installations.

Rachel Khedoori ist eine Bildhauerin: Kaum jemand bearbeitet Bilder auf so komplexe raumgreifende Weise wie sie in ihren Film-installationen, in denen sie Skulptur und Film in dynamischer Weise für den Betrachter verbindet. Wir sind in Bewegung, unsere Wahrnehmung ist in Bewegung. Khedoori bricht die cineastische Anordnung auf, die den statischen und passiven Betrachter vorsieht. Nicht nur die Apparate der Bilderzeugung, die Projektoren und Spulen werden vorgeführt, der Betrachter ebenso, wenn er sich in komplizierten, räumlich ineinander verschachtelten und verspiegelten Settings zurechtfinden muss, die sich ausnehmen wie klaustrophobische Situationen aus dem Reich der Träume. Khedoori greift mit künstlerischen Techniken in das Medium Film und seinen illusionistischen Charakter ein, damit Film wieder zur gelebten Körpererfahrung wird. Die raumfüllende Installation *Untitled (Blue Room)* von 1999 besteht aus einem 35-mm-Film, der ihr rekonstruiertes Zimmer in einem Haus in Pasadena zeigt. Die Projektion trifft auf zwei an Galeriewand und -boden zusammengefügte Spiegelflächen und wird von diesen verzerrt zurückgeworfen. Unsicher, worauf sich die Aufmerksamkeit richten soll, sind wir zu einem permanenten Wechsel der Einstellungen gezwungen. Wir sehen einen Film: einen bruchlosen Loop; wir sehen die Technik: die Spulen, den Projektor; wir sehen den Raum der Projektion, der Galerieraum selbst ist verdunkelt. Der Betrachter muss teilnehmen an dem höchst komplizierten Spiel, der in sich selbst gespiegelten Illusion des Filmes, der Realität seiner Apparaturen, der skulpturalen Qualität des Raumes, in den gleichzeitig projiziert wird. Das ihm dabei vermittelte, vielschichtig irisierende Moment steht in einem offenbaren Zusammenhang zur Komplexität von Khedooris Installationen.

Rachel Kheedori est une sculptrice : presque personne ne travaille les images de manière aussi spatiale qu'elle le fait dans ses installations cinématographiques, qui procèdent à l'intégration dynamique du spectateur dans la sculpture et le film. Le spectateur est en mouvement, et sa perception est ce mouvement. Kheedori reformule une répartition des rôles qui assigne au spectateur une place statique et passive. Les éléments concrets générateurs de l'image – projecteurs et bobines – ne sont pas seuls à être montrés, le spectateur est lui aussi représenté dans son effort pour se repérer au sein de ces arrangements compliqués dont les imbrications spatiales et les jeux de miroir complexes s'apparentent à des situations claustrophobiques issues de l'univers des rêves. Par des moyens artistiques, Kheedori travaille sur le médium « film » et sur son caractère illusionniste afin que le cinéma devienne une expérience corporelle vécue. L'installation spatiale intégrale *Untitled (Blue Room),* 1999, consiste en un film en 35 mm montrant la reconstitution de la chambre de l'artiste dans une maison de Pasadena. La projection est dirigée vers deux pans de miroir fixés au mur et au plafond, d'où elle est reflétée, déformée. Hésitant sur l'endroit où il doit diriger son attention, le spectateur se voit obligé à un constant changement de mise au point. Il voit un film : une séquence passée en boucle sans rupture ; il en voit les aspects techniques : les bobines, le projecteur ; il voit l'espace de la projection, l'espace d'exposition étant plongé dans l'obscurité. Le spectateur doit prendre part à ce jeu hautement complexe, à l'illusion cinématographique reflétée en elle-même, à la réalité des appareillages, à la qualité sculpturale de l'espace dans lequel se déroule en même temps la projection. Les différents niveaux de cette déstructuration qui lui sont communiqués sont en rapport direct avec la complexité des installations de Khedoori. F. F.

SELECTED EXHIBITIONS →
1995 Association of the Museum van Hedendaagse Kunst, Ghent, Belgium **1996** *Inklusion : Exklusion,* Steirischer Herbst, Graz, Austria **1998** Suermondt-Ludwig-Museum, Aachen, Germany **1999** David Zwirner, New York (NY), USA; *Vergiss den Ball und spiel weiter,* Kunsthalle Nürnberg, Nuremberg, Germany **2000** Galerie Gisela Capitain, Cologne, Germany; Museum of Contemporary Art, Los Angeles (CA), USA; Sammlung Hauser und Wirth, St. Gallen, Switzerland **2001** Kunsthalle Basel, Basle, Switzerland

SELECTED BIBLIOGRAPHY →
1999 *Vergiss den Ball und spiel weiter – Das Bild des Kindes in zeitgenössischer Kunst und Wissenschaft,* Kunsthalle Nürnberg, Nuremberg **2000** Kunsthalle Basel, Basle; *Flight Patterns,* Museum of Contemporary Art Los Angeles, (CA) **2001** Kunstverein Braunschweig

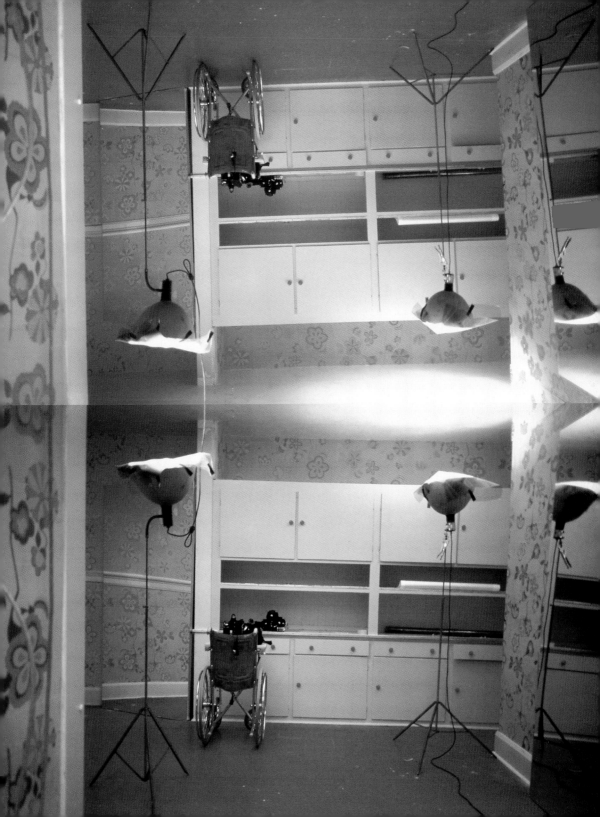

1 **Untitled (Pink Room #5),** 2001, Ilfochrome print, 71 x 53 cm
2 **Untitled (Model),** 2000, multiplex, wood, polycarbonate, 51 x 274 x 152 cm
3 **Untitled (Wanas),** 1997, 16 mm colour film (endless loop, 7 min), looping device, projector, installation view, Kunsthalle Basel, Basle, 2001

4 **Untitled (Blue Room),** 1999, 35 mm colour film (endless loop, 8:15 min), film projector, looper, wooden room, two way mirror, installation view, Kunsthalle Basel, Basle, 2001
5 **Untitled,** 2001, 6 fake tree stumps, photographs, DVD, 2 monitors, wooden room, installation view, Kunsthalle Basel, Basle

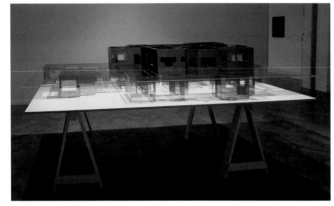

2

3

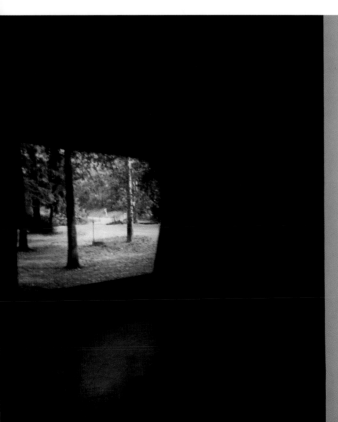

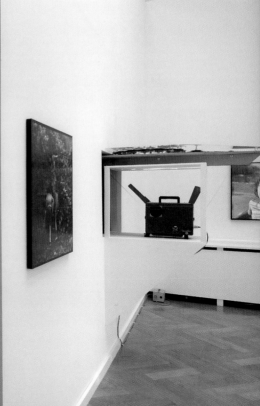

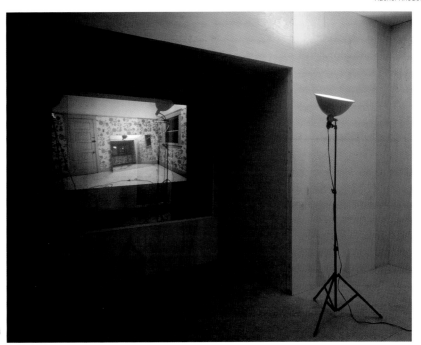

4

5

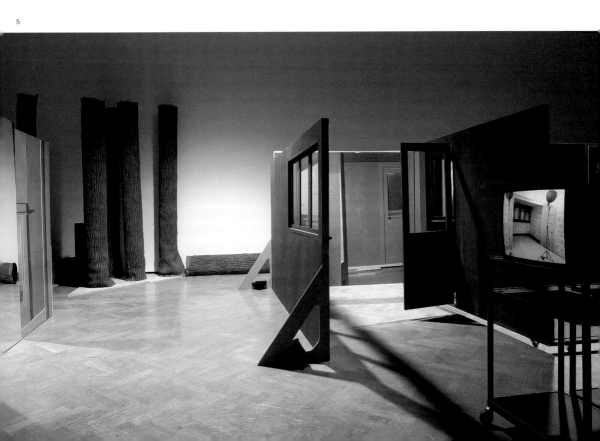

Martin Kippenberger

1953 born in Dortmund, Germany, 1997 died in Vienna, Austria

Hardly anyone else has injected the contemporary image of the artist with so much life as Martin Kippenberger. His early death once again leads us to question the apparent link between creative genius and premature demise. Shrewdly contriving to be born in 1953, he always had a slight advantage over those who would later become his rivals: Werner Büttner and Albert Oehlen, both born in 1954. Always one step ahead, Kippenberger managed to create the impression that he had access to some kind of code, more important than art, artists or art critics. He kept the upper hand in a game that he made his own. Over the course of two decades, starting with "Kippenberger's Büro" in Berlin in the 1970s and ending with his posthumous contributions to *documenta X* in 1997, he achieved an artistic output, one of whose main aims was to spread good humour. Kippenberger's world revolved with fantastic lightness and speed. He loved to tell stories and maintained an ongoing dialogue with art, its history and the aura surrounding it. Thus he was able to bring surprising new perspectives to panel painting, introduce timeless innovations to sculpture, and influence the thinking and behaviour of the present generation of artists. Kippenberger's unique sense of humour, which took the art market as a model of reality, made many people doubt the seriousness of his work. Even so, they were still eager to hear what he had to say. The title of a 1990 installation – *Jetzt geh ich in den Birkenwald, denn meine Pillen wirken bald* (Now I'm going into the birch forest as my pills will take effect soon) – showed the oracular insight we had come to expect of a man like Kippenberger.

Kaum jemand hat das zeitgenössische Bild des Künstlers mit mehr Leben gefüllt als Martin Kippenberger, 1997 in Wien gestorben, 1953 in Dortmund geboren. Sein früher Tod lässt uns einmal mehr den sinnvollen Zusammenhang suchen zwischen genialischer Kreativität und vorzeitigem Ableben. Geschickt ausgesucht sein Geburtsdatum 1953, gab es ihm den kleinen Vorsprung gegenüber seinen späteren Kombattanten aus dem 54er Jahrgang Werner Büttner und Albert Oehlen. Immer einen Schritt vorneweg, konnte Martin Kippenberger den Eindruck erwecken, über eine Vorgabe zu verfügen: vor der Kunst, den Künstlern, der Kritik. Vorteil Kippenberger: ein Spiel, dass der Künstler persönlich nahm. Von den Anfängen im Berliner Büro Kippenberger der siebziger Jahre bis zu den posthum realisierten Beiträgen für die *documenta* 1997 in Kassel – zwei Jahrzehnte künstlerischer Produktion voller Zeichen guter Laune. Kippenbergers Welt drehte sich mit fabelhafter Leichtigkeit und Geschwindigkeit im permanenten, erzählfreudigen Dialog des Künstlers mit der Kunst und ihrer Geschichte, ihrer Aura. Auf diese Weise hat er dem Tafelbild überraschende Perspektiven abringen, dem Skulpturalen zeitlose Neuerungen hinzufügen können und das Denken und Handeln der heutigen Künstlergeneration beeinflusst. Kippenbergers spezifischer Humor, der den Kunstmarkt als Modell der Wirklichkeit akzeptierte, ließ manchen am Ernst seines Werks zweifeln und ihm trotzdem gerne zuhören. *Jetzt geh ich in den Birkenwald, denn meine Pillen wirken bald* – der Titel der Arbeit von 1990 hatte die orakelhafte Weisheit, die man von einem Kippenberger erwarten konnte.

Aucun autre artiste ou presque n'a autant donné vie à l'image de l'artiste contemporain que Martin Kippenberger, mort en 1997 à Vienne, né en 1953 à Dortmund. Son départ dans la force de l'âge nous incite une fois de plus à chercher un lien recevable entre la créativité du génie et une mort prématurée. Une année de naissance habilement choisie lui confère une légère avance sur ses futurs compagnons d'armes du millésime 54, Werner Büttner et Albert Oehlen. Toujours un pas en avant, Kippenberger pouvait donner le sentiment de disposer d'un avantage : sur l'art, sur les artistes, sur la critique. Avantage Kippenberger : un jeu que l'artiste prenait très personnellement. Des débuts au « Büro Kippenberger » à Berlin dans les années 70 jusqu'aux contributions posthumes réalisées pour la *documenta* de 1997 à Cassel – deux décennies de production artistique pleines de signes de bonne humeur. Le monde de Kippenberger virevoltait avec une légèreté et une vitesse fabuleuses dans le dialogue constant, affable de l'artiste avec l'art, son histoire et son aura. C'est ainsi qu'il a su tirer du tableau des perspectives inattendues et enrichi la sculpture d'innovations intemporelles, influençant la pensée et l'action de la génération d'artistes actuelle. L'humour très particulier de Kippenberger, qui acceptait le marché de l'art comme modèle de la réalité, a fait douter du sérieux de son œuvre plus d'un artiste qui néanmoins a eu plaisir à l'écouter. Maintenant, *Jetzt geh ich in den Birkenwald, denn meine Pillen wirken bald* (Je m'en vais dans la forêt de bouleaux, car mes cachets ne tarderont pas à faire effet) – ce titre d'une œuvre de 1990 avait la sagesse prophétique qu'on pouvait attendre d'un Kippenberger.

F. F.

SELECTED EXHIBITIONS →
1997 *Skulptur. Projekte*, Münster, Germany; *documenta X*, Kassel, Germany **1998** Kunsthalle Basel, Basle, Switzerland; Kunsthaus Zürich, Zurich **1999** Deichtorhallen, Hamburg, Germany **2000** Renaissance Society, Chicago (IL), USA **2001** *Let's Entertain*, Kunstmuseum Wolfsburg, Germany; *Vom Eindruck zum Ausdruck – Grässlin Collection*, Deichtorhallen Hamburg, Germany **2002** Zwirner & Wirth, New York (NY), USA; *Lieber Maler, male mir*, Centre Georges Pompidou, Paris, France

SELECTED BIBLIOGRAPHY →
1997 Burkhard Riemschneider, *KIPPENBERGER*, Cologne **1998** *Martin Kippenberger*, Kunsthalle Basel, Basle; *Martin Kippenberger, Die gesamten Plakate 1977–1997*, Kunsthaus Zürich, Zurich **1999** *The Happy End of Franz Kafka's Amerika*, Deichtorhallen, Hamburg **2002** *Kommentiertes Werkverzeichnis der Bücher*, Cologne

1 **Ohne Titel (Jacqueline The Paintings Pablo Picasso Couldn't Paint Anymore),** 1996, oil on canvas, 180 x 150 cm
2 Installation view, *Zero Gravity*, Kunstverein für die Rheinlande und Westfalen, 2001; left: **Tankstelle Martin Bormann,** 1986, right: **Brasilien aktuéll,** 1986

3 **Ohne Titel (Durchgenudelt),** 1996, mixed media on paper, 28 x 22 cm
4 **Ohne Titel,** 1996, mixed media on paper, 28 x 22 cm
5 **Ohne Titel,** 1994, mixed media on paper, 30 x 21 cm
6 **Ohne Titel,** 1995, mixed media on paper, 30 x 21 cm

„Dieses Leben kann nicht die Ausrede für das nächste sein." « Cette vie-ci ne peut servir d'excuse pour la prochaine. »

"This life cannot be the excuse for the next."

2

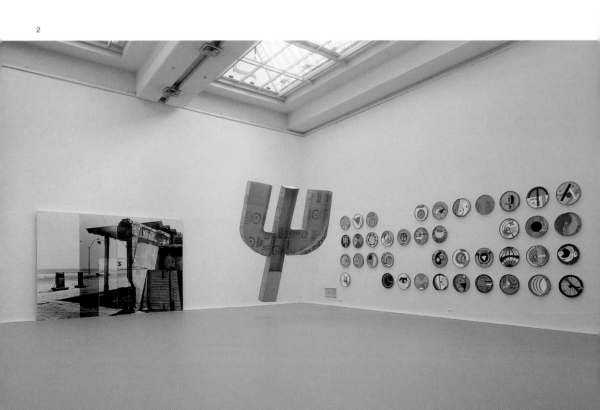

3

4

5

6

Jeff Koons

1955 born in York (PA), lives and works in New York (NY), USA

Jeff Koons can rightly be called the one of the most spectacular art-world icons of recent decades. As a self-made man, who used to finance his complex projects in New York by playing the stock market, he has become the promoter par excellence of his own provocative work. From an early age, Koons was attracted by American folk art and Surrealism. Later, he combined these influences with the strategies of pop art. His glamorous sculptures were inspired by the world of advertising, cheap kitsch and everyday objects. Nor did he flinch, in his 1991 *Made in Heaven* series, at appearing in flagrante with his then wife, the Italian porn star Ilona Staller, also known as "Cicciolina". What some saw as sabotage of the art business, others regarded as an expression of the optimism that prevailed during the economic boom of the 1980s. Despite all the scandals, Koons continued to be a great moralist, whose declared aim was to exploit the accessibility and popularity of his work to bring art to the masses. During the 1990s not a great deal was heard of Koons. But in autumn 1999 he returned to the scene with *Easyfun*, a series of large-format paintings and coloured mirrors shaped like the heads of cartoon animals. The *Easyfun* paintings are impressive and exuberant collages of advertising images and references to popular culture, like the bits of breakfast cereal swirling around in a waterfall of milk in *Cut Out*, 1999. He cuts pieces out of certain motifs and underlays them with outlandish images to create an eerie, surreal, psychedelic effect. Koons himself has defined *Easyfun's* ecstatic but calculated imagery as "barococo".

Jeff Koons kann wohl als eine der spektakulärsten Künstler-Ikonen der letzten zwanzig Jahre bezeichnet werden. Als Selfmademan, der seine aufwendigen Projekte in New York mit Börsenspekulationen finanzierte, ist er im großen Stil zum Manager seines eigenen provo-kanten Werks geworden. Koons' Interesse galt schon früh der amerikanischen Volkskunst und dem Surrealismus. Später verband er diese Einflüsse mit den Strategien der Pop-Art. Er benutzte Anzeigen aus der Werbung und nahm billige Kitschfiguren und Alltagsgegenstände zum Vorbild für seine glamourösen Skulpturen. Auch vor pornografischen Selbstinszenierungen mit seiner damaligen Lebensgefährtin, dem italie-nischen Pornostar Ilona Staller, genannt „Cicciolina", macht er nicht Halt (*Made in Heaven*, 1991). Was die einen als Sabotage des Kunstbetriebs ansahen, wurde von anderen als Ausdruck eines zeitgemäßen Optimismus der konjunkturverwöhnten achtziger Jahre betrachtet. Allen Skandalen zum Trotz blieb Koons immer ein großer Moralist, dessen erklärtes Ziel es war, durch die allgemeine Verständlichkeit und Popularität seiner Objekte die Kunst zu demokratisieren. Im Verlauf der neunziger Jahre war es ruhig um Koons geworden. Im Herbst 1999 jedoch kehrte er mit der Werkgruppe *Easyfun* in die Kunstszene zurück, einer Reihe von großformatigen Bildern und farbigen Spiegeln in den Umrissen cartoon-artiger Tierköpfe. Die *Easyfun*-Gemälde sind eindrucksvolle, farbenfrohe Collagen aus Reklamebildern und Elementen der Alltagskultur, wie im Fall der in einem Sturzbach von Milch wirbelnden Frühstücksflocken in *Cut Out*, 1999. Bestimmte Motive höhlt er gespenstisch aus und unter-legt sie mit artfremdem Bildmaterial, wodurch ein surrealer, psychedelischer Eindruck entsteht. Diese kalkulierte malerische Ekstase von *Easyfun* hat Koons selbst als „Barokoko" bezeichnet.

Jeff Koons peut sans doute être décrit comme l'une des icônes artistiques les plus spectaculaires des vingt dernières années. Self-made-man, il a d'abord financé ses projets onéreux au moyen de spéculations boursières réalisées à New York, avant de devenir le grand manager de son œuvre provocant. Dès le début, Koons s'est intéressé à l'art populaire américain et au surréalisme. Plus tard, il associe ces influences aux stratégies du Pop Art, se servant d'annonces publicitaires et prenant pour modèle de ses sculptures glamoureuses des figures kitsch et des objets quotidiens. Koons n'a pas reculé devant les mises en scène pornographiques de sa propre personne avec sa compagne de l'époque, la star du porno Ilona Staller, dite « Cicciolina » (*Made in Heaven*, 1991). Ce que certains ont décrié comme une opération de sabo-tage du marché de l'art, a été considéré par d'autres comme l'expression de l'optimisme conjoncturel des années 80 « dorées ». Défiant tous les scandales, Koons est toujours resté un grand moraliste dont le but déclaré a été de démocratiser l'art par l'intelligibilité universelle et la popularité de ses objets. Dans le courant des années 90, un certain silence s'est fait autour de l'artiste. Mais à l'automne 1999, Koons est revenu sur la scène artistique avec *Easyfun*, une série de tableaux grand format et de miroirs de couleur inscrits dans la silhouette de têtes d'ani-maux qui rappellent des dessins animés. Les peintures de la série *Easyfun* sont d'impressionnants collages bigarrés associant des images publicitaires et des éléments de la culture quotidienne. Dans *Cut Out*, 1999, c'est un déversement de flocons de petit déjeuner virevoltant dans une cascade de lait. Certains motifs sont évidés de manière fantomatique et sous-tendus de matériaux étrangers au genre, ce qui produit une impression surréelle et psychédélique. Koons a décrit l'extase picturale calculée d'*Easyfun* comme du « Barococo ». A. K.

SELECTED EXHIBITIONS →
1992 *Retrospective*, San Francisco Museum of Modern Art, San Francisco (CA), USA **1994** *A Survey 1981–1994*, Anthony d'Offay Gallery, London, UK **2000** *Easyfun – Ethereal*, Deutsche Guggenheim, Berlin, Germany; *Hypermental*, Kunsthaus Zürich, Zurich, Switzerland **2001** Kunsthaus Bregenz; *Au-delà du spectacle*, Centre Georges Pompidou, Paris, France; *Pop and After*, Museum of Modern Art, New York (NY), USA; *Apocalypse: Beauty and Horror in Contemporary Art*, Royal Academy of Arts, London, UK; *Give & Take*, Serpentine Gallery/Victoria & Albert Museum, London, UK

SELECTED BIBLIOGRAPHY →
1992 *Jeff Koons*, Cologne **2000** *Jeff Koons: Easyfun – Ethereal*, Deutsche Guggenheim, Berlin; *Hypermental. Wahnhafte Wirklichkeit 1959–2000. Von Salvador Dalí bis Jeff Koons*, Kunsthaus Zürich, Zurich **2001** *Jeff Koons*, Kunsthaus Bregenz; *Au-delà du spectacle*, Centre Georges Pompidou, Paris

1 **Stream,** 2001, oil on canvas, 274 x 213 cm
2 **Candle,** 2001, oil on canvas, 305 x 427 cm
3 **Sheep (Yellow),** 1999, crystal glass, coloured plastic interlayer, mirrored glass, stainless steel, 180 x 150 x 5 cm

4 **Donkey,** 1999, mirror-polished stainless steel, 198 x 152 x 3 cm
5 Installation view, Royal Academy of Arts, London; left: **Balloon Dog (Red),** 1994–2000, high chromium stainless steel (with transparent colour coating), 307 x 363 x 114 cm; right: **Moon,** 1994–2000, high chromium stainless steel, 311 x 311 x 99 cm

„Ich wollte immer Kunst machen, die sich mit dem kulturellen Umfeld des Betrachters ändert. Denn dann habe ich manchmal für einen Moment das Gefühl, dass sich das Ego in der Flut der Zusammenhänge verliert."

« J'ai toujours voulu créer de l'art qui se différencie du propre environnement du public. Quelquefois, j'ai l'impression que l'ego se perd dans le flot des connexions. »

"I always wanted to create art that was different from the public's own cultural environment. There are moments when I sometimes feel that ego is swept away in the flood of connections."

2

3

4

5

Zoe Leonard

1961 born in New York (NY), lives and works in New York (NY), USA

In the New York of the late 1980s, Zoe Leonard became involved in the wide-ranging cultural activist scene as a "gay artist", a member of Act-Up and an opponent of censorship. In her art, she abstracted material from her experience of political activities and those of the AIDS campaign. Her photographs of trees, clouds and waves at sea are full of references to the history of photography, avant-garde film and the landscape paintings of former centuries. They can, however, also be viewed as allegories of the passing of time, of memory and contemplation. The triviality of her subjects – improvised shop windows and the cheap displays found in the small shops of New York's Lower East Side, the empty back yards of old brick buildings, plastic bags stuck in trees after being blown there by the wind, crumbling walls and fences – all that is ordinary and desolate has been taken by Leonard and turned into high art. Everything that is empty, banal and trivial is transformed in her photographs into the extraordinary poetry of the representational world. In her work *Mouth open, teeth showing*, 2000, she took 162 children's dolls and arranged them on the gallery floor in a threatening parade. She acquired the dolls in second-hand shops. There are aspects of collector's mania, memory, recurrence and social anthropology all overlapping with each other. The unmistakable human characteristics of the dolls' army, with their batting eyelashes and half-open mouths, are emphasised by what looks like a swinging gait. In *Mouth open, teeth showing* Leonard has designed a sort of "artistic thriller", a suggestive, spatial arrangement in which we see the unfolding of a contradictory mood of passivity and aggression.

Im New York der späten achtziger Jahre hatte Zoe Leonard sich als „gay artist", Act-Up-Mitglied und Zensurgegnerin innerhalb der damals breit gefächerten Kulturaktivismus-Szene engagiert. In ihrer Kunst abstrahierte Leonard von den Bedingungen der politischen Arbeit und den Erfahrungen der AIDS-Kampagne. Ihre Aufnahmen von Bäumen, Wolken und Meereswellen sind voller Bezüge auf die Geschichte der Fotografie, des Avantgardefilms und der Landschaftsmalerei vergangener Jahrhunderte. Sie können aber auch als Allegorien auf Vergänglichkeit, Erinnerung und Kontemplation betrachtet werden. Die Beiläufigkeit ihrer vorgefundenen Motive – improvisierte Schaufenster und billige Auslagen der kleinen Geschäfte in der New Yorker Lower East Side, leere Hinterhöfe alter Backsteinbauten, Bäume, in denen sich herumfliegende Plastiktüten verfangen, marode Mauern und Zäune –, all das gewöhnlich Desolate wird von Leonard zur hohen Kunst erhoben. Die Leere, das Banale und Nebensächliche verwandeln sich in Leonards Fotografien in eine außergewöhnliche Poetik der gegenständlichen Welt. In *Mouth open, teeth showing*, 2000, hat sie 162 Kinderpuppen auf dem Galerieboden zu einer bedrohlichen Parade aufgestellt. Die Puppen hatte Leonard in Secondhandläden erstanden. Aspekte von Sammlermanie, Erinnerung, Wiederkehr und sozialer Anthropologie überschneiden sich. Das unmittelbar Menschliche der Puppenarmee mit den klappernden Wimpern und halboffenen Mündern wurde unterstrichen durch einen scheinbar schwingenden Gang. Leonard inszenierte mit *Mouth open, teeth showing* eine Art Kunstthriller, ein suggestives räumliches Arrangement, in dem sich eine widersprüchliche Stimmung von Passivität und Aggression entfaltet.

Dans le New York de la fin des années 80, Zoe Leonard s'était engagée comme « gay artist », comme membre d'Act-Up et opposante à la censure au sein du large éventail de l'activisme culturel. Dans son art, Leonard s'abstrayait en revanche des termes du travail politique et des expériences de la campagne contre le SIDA. Ses vues d'arbres, de nuages et de vagues sont pleines de références à l'histoire de la photographie, du cinéma d'avant-garde et de la peinture de paysages des siècles passés. Mais elles peuvent aussi se lire comme des allégories de la fugacité, de la mémoire et de la contemplation. L'insignifiance de ses motifs trouvés – vitrines improvisées et présentoirs bon marché des petites boutiques de Lower East Side à New York, arrière-cours vides de vieilles bâtisses en briques, arbres où se sont accrochés des sacs en plastique soulevés par le vent, murs et grillages délabrés – bref, tout ce qui parle de la désolation ordinaire, Leonard l'élève au rang de grand art. Dans ses photographies, l'inanité, le banal et l'accessoire se transforment en une poétique inhabituelle du monde des objets. Dans une de ses dernières œuvres, *Mouth open, teeth showing*, 2000, l'artiste a organisé une parade menaçante à l'aide de 162 poupées installées au sol de la galerie, poupées achetées aux enchères chez un brocanteur. Différentes approches comme la collectionnite, la mémoire, le retour et une anthropologie sociale se superposent ici. L'aspect humain très immédiat de cette armée de poupées aux cils battants et aux lèvres entrouvertes était encore renforcé par une démarche apparemment chaloupée. Avec *Mouth open, teeth showing*, Leonard met en scène une sorte de « thriller artistique », arrangement spatial suggestif dans lequel se déploie une atmosphère contradictoire faite de passivité et d'agression.

A. K.

SELECTED EXHIBITIONS →
1997 Kunsthalle Basel, Basle, Switzerland **1998** Centre National de la Photographie, Paris, France; Philadelphia Museum of Art, Philadelphia (PA), USA; *Fast Forward (Body Check)*, Kunstverein in Hamburg, Germany **1999** Centre for Contemporary Art, Ujazdowski Castle, Warsaw, Poland; *The Museum as Muse: Artists Reflect*, Museum of Modern Art, New York (NY), USA **2000** *Die verletzte Diva*, Kunstverein München, Munich, Germany; *Voilà: Le Monde dans la tête*, Musée d'Art Moderne de la Ville de Paris, France

SELECTED BIBLIOGRAPHY →
1997 *Zoe Leonard*, Wiener Secession, Vienna **1999** *Dramatis Personae*, The Photographic Resource Center, Boston (MA); *Skin-deep: Surface and Appearance in Contemporary Art*, Israel Museum, Jerusalem; *Two by Two for AIDS and Art*, American Foundation for AIDS Research and The Dallas Museum of Art, Dallas (TX); *The Museum as Muse: Artists Reflect*, The Museum of Modern Art, New York (NY) **2001** *Double Life, Identity and Transformation in Contemporary Art*, Generali Foundation, Vienna

1 **Red & white restaurant,** 1999/2001, dye transfer print, 22 x 22 cm
2 **Mouth open, teeth showing,** 2000, 162 dolls, overall dimensions
12.84 x 11.89 m, installation view, Paula Cooper Gallery, New York (NY)

3 **Mouth open, teeth showing** (details)

„Ich interessiere mich für die Dinge, die wir hinter uns lassen, die Spuren und Zeichen unserer Benutzung; wie archäologische Fundstücke verraten sie so viel über uns."

« Je m'intéresse aux objets que nous laissons derrière nous, les marques et signes de notre utilisation ; à l'instar des trouvailles archéologiques, ils révèlent tant de choses sur nous. »

"I'm interested in the objects we leave behind, the marks and signs of our use; like archeological findings, they reveal so much about us."

2

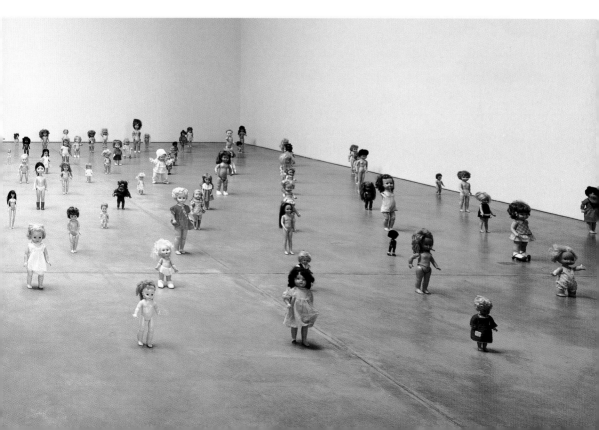

Atelier van Lieshout

Established in 1995; Joep van Lieshout 1963 born in Ravenstein, lives and works in Rotterdam, The Netherlands

Atelier van Lieshout (AVL), under the direction of Joep van Lieshout, is an artistic corporation that produces art for application in society. Apart from producing different kinds of functional items, such as living units or furniture, AVL's cross-disciplinary production also insists on an anti-authoritarian agency against state monopoly. Notions of collectivism and self-institutionalisation in AVL's production led to the construction of a self-sufficient territory for AVL's employees and production facilities in Rotterdam: the AVL Ville, which opened in 2001. Here, AVL built living units with materials they manufactured themselves. They produce their own food and have the liberty to do otherwise illegal things, such as manufacturing weapons and alcohol. As the critic Dave Hickey has emphasised about AVL, "It's the noise and fun that matter, the sex and democracy." However, the partisan ethos of AVL Ville doesn't come across as cosy hippie idealism, but rather as an implemented alternative to bureaucratic society with one foot in the art world. Instead of letting Utopia remain unrealised, AVL tests artistic autonomy against real world economies. In AVL Ville, this becomes legislation; sculpture becomes a scene for the anarchistic enactment of conviviality and the work of the individual artist assumes collective form and diffuses into the sphere of production. AVL's analysis of the expanded possibilities of the artistic profession is a direct and elementary exploration of space. The social potency and corporate professionalism of AVL propose metaphorical and concrete means for smaller power concentrations than the ones according to which we usually organise our lives.

Das Atelier van Lieshout (AVL) unter Leitung von Joep van Lieshout ist eine Künstlerkooperative, die praktisch nutzbare Kunst produziert. Das AVL entwickelt nicht nur funktionale Dinge, etwa Wohneinheiten oder Möbel, die interdisziplinären Aktivitäten der Kooperative zielen zudem darauf ab, das Herrschaftsmonopol des Staates zu brechen. Der Wunsch nach Gemeineigentum und völliger Autonomie hat zur Gründung eines autonomen Gebiets für Mitarbeiter und die Produktionsstätte in Rotterdam: AVL Ville, eröffnet 2001. Hier hat das AVL aus selbsthergestellten Materialien eine Reihe von Wohneinheiten geschaffen. Die Gruppe erzeugt ihre eigenen Lebensmittel und genießt das Vorrecht, ansonsten ungesetzliche Dinge zu tun: nämlich Waffen und alkoholische Getränke herzustellen. Der Kritiker Dave Hickey betont, dass für AVL „vor allem lautstarke Fröhlichkeit, Sex und Demokratie" zählen. Die AVL-Ville-typische Freischärlermentalität kommt nicht als anheimelndes Hippietum daher, sondern präsentiert sich als künstlerisch inspirierte konkrete Alternative zur bürokratisierten Gesellschaft. Statt auf die Verwirklichung der Utopie zu verzichten, erprobt AVL die künstlerische Autonomie im Wettstreit mit der realen Ökonomie. In AVL Ville hat man dieses Denken nachgerade zum Prinzip erhoben: So erweist sich die Skulptur als Inszenierung einer anarchischen Geselligkeit, und die Arbeit des einzelnen Künstlers nimmt eine kollektive Gestalt an und diffundiert in die Sphäre der Produktion. Die erweiterten Möglichkeiten des künstlerischen Schaffens, wie AVL sie durch seine Aktivitäten stets aufs Neue veranschaulicht, gehen auch mit einer ebenso direkten wie elementaren Erkundung des Raumes einher. Dank seiner sozialen Potenz und Gruppenprofessionalität liefert uns AVL symbolisch, aber auch ganz konkret Beispiele dafür, wie wir unser Dasein in wesentlich überschaubareren als den heute üblichen Machtstrukturen organisieren können.

L'Atelier van Lieshout (AVL), dirigé par Joep van Lieshout, est une corporation artistique qui produit de l'art à appliquer dans la société. Outre la fabrication de différents types d'articles fonctionnels, tels que des espaces habitables ou des meubles, la production interdisciplinaire d'AVL a également mis sur pied une agence anti-autoritaire contre le monopole d'Etat. Ses notions de collectivisme et d'autoinstitutionnalisation ont entraîné l'établissement d'un territoire autosuffisant pour les employés d'AVL et des locaux de production à Rotterdam : L'AVL Ville, inaugurée en 2001. Ils y produisent leur propre nourriture et ont la liberté de faire ce qui est illégal ailleurs, comme de fabriquer des armes et de l'alcool. Comme l'a souligné le critique Dave Hickey à propos d'AVL : « C'est le bruit et le plaisir qui comptent, le sexe et la démocratie. » Toutefois, l'esprit partisan d'AVL Ville n'a rien à voir avec un idéalisme hippie douillet. Il s'agit plutôt d'une alternative à la société bureaucratique avec un pied dans le monde de l'art. Au lieu de laisser l'Utopie à l'état d'idéal, AVL met l'autonomie artistique à l'épreuve de l'économie du monde réel. Dans AVL Ville, cela fait force de loi : la sculpture devient une scène pour la promulgation anarchique de la convivialité ; le travail individuel de l'artiste revêt une forme collective et se diffuse dans la sphère de production. L'analyse d'AVL des possibilités accrues de la profession artistique est une exploration directe et élémentaire de l'espace. La puissance sociale et le professionnalisme collectif d'AVL proposent des moyens métaphoriques et concrets pour des concentrations de pouvoir plus petites que celles selon lesquelles nous organisons généralement nos vies.

L. B. L.

SELECTED EXHIBITIONS →
1997 Museum Boijmans Van Beuningen, Rotterdam, The Netherlands; *Skulptur. Projekte*, Münster, Germany **1998** *The Good, the Bad and the Ugly*, Rabastens, France; *arttranspennine98*, The Henry Moore Institute, Leeds, UK **1999** *AVL Equipment*, Transmission Gallery, Glasgow, UK; *In the Midst of Things*, Bournville, Birmingham, UK **2000** *Hangover 2000, EXPO 2000*, Hanover, Germany **2001** P.S.1, Long Island City (NY), USA; *49. Biennale di Venezia*, Venice, Italy; Walker Art Center, Minneapolis **2002** Biennale of Sydney, Australia

SELECTED BIBLIOGRAPHY →
1997 Joep van Lieshout/Bart Loosma/P. Jonge, *Atelier van Lieshout – A Manual/Ein Handbuch*, Stuttgart; *Skulptur. Projekte*, Münster **1998** Atelier van Lieshout, *The Good, the Bad and the Ugly*, Rotterdam **1999** Miller/Hickey/Dellinger, *A Supplement*, Contemporary Arts Museum, Tampa (FL) **2000** Bart Loosma, *Superdutch: New Architecture in the Netherlands*, London

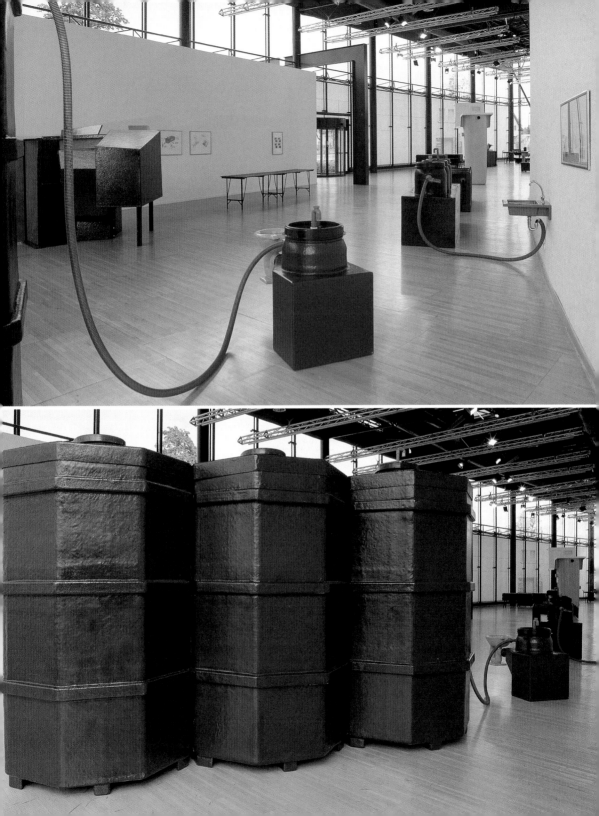

1 Installation views, *Schwarzes und graues Wasser*, Bawag Foundation, Vienna, 2001
2 Installation view, *Darkroom*, P.S.1, Long Island City (NY), 2001
3 Installation views, *Wonderland*, St. Louis (MS), 2001
4 Installation views, *Women on Waves – A Portable*, Amsterdam, 2001

„Meine Probleme mit der Regierung betreffen ihr Ausmaß: Es gibt eine Unzahl an Vorschriften und Einschränkungen. In einer kleineren Gemeinschaft kann man nach dem gesunden Menschenverstand regieren und entscheiden: Haltet euer Werkzeug in Ordnung und tötet einander nicht. Das sind die Grundlagen." (Joep van Lieshout)

« Ce qui me gêne dans un gouvernement, c'est sa taille : cela génère toutes sortes de règles et de limites. Dans une petite communauté, on peut gouverner et prendre des décisions en usant de bon sens : nettoyez vos outils, ne vous entre-tuez pas. Voilà les principes de base. » (Joep van Lieshout)

"My problem with government concerns its scale: there are all kinds of rules and limitations. If you have a smaller community, you can govern and decide things using common sense: clean your tools, don't kill each other. Those are the basics." (Joep van Lieshout)

2

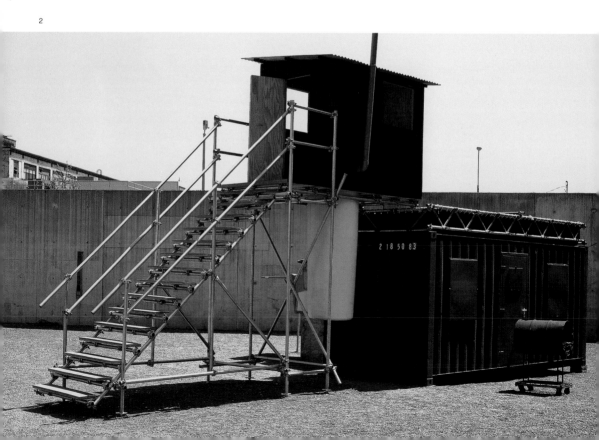

3

4

Won Ju Lim

1968 born in Kwangju, South Korea, lives and works in Los Angeles (CA), USA

Won Ju Lim is a sculptor and installation artist. Her multimedia work, consisting largely of models, focuses on the tensions between perception, space and subjectivity in the post-modern age. In order to reflect on and represent the shifting relationship between these three elements, she usually takes architectural reconstructions whose "realism" she questions, critically and poetically, through the judicious use of lighting, slide projections and video installations. Literary references crop up constantly in her concentrated, seemingly minimalist but always richly allusive work, and are abundantly clear in installations like *Proustian Bedroom*, 1996, or *Guestroom*, 1997. The latter refers to Edgar Allan Poe's story "The Fall of the House of Usher". Lim arranges furniture in a reconstruction of a mysterious room in the tale. Thus, personal experience, cultural tradition and means of communication create a disturbing connection, which confusingly melds the personal and the social. Her more recent *Horizons*, 2000, stressed the way in which perception depends on cultural perspectives. Lim blocked the four windows of an observation tower with video projection screens and also mounted four video monitors on the tower itself. The videos showed views of both the surrounding landscape and other regions of the world. Mixed into this visual cosmos were clips from famous film classics. *Horizons* provided convincing proof that our response to the world is conditioned by a wealth of media imagery that has long since become part of our own "authentic" experience.

Won Ju Lim ist Bildhauerin und Installationskünstlerin. Ihre multimedialen und meist modellhaften Arbeiten thematisieren die spannungsvolle Beziehung von Wahrnehmung, Raum und Subjektivität in der Postmoderne. Um die Wechselbeziehungen zwischen diesen drei Momenten reflektieren und präsentieren zu können, setzt Lim vor allem auf architektonische Rekonstruktionen, deren „Realistik" sie allerdings durch den sensiblen Einsatz von Beleuchtung, Dia-Projektionen und Videoinstallationen so kritisch wie poetisch hinterfragt. Immer wieder finden sich auch literarische Bezüge in ihrem konzentrierten, zunächst minimalistisch anmutenden, stets assoziationsreichen Werk. Referenzen zur Literatur sind etwa in den Installationen *Proustian Bedroom*, 1996, oder in *Guestroom*, 1997, ablesbar. Letztere bezieht sich auf die Erzählung „Der Untergang des Hauses Usher" von Edgar Allan Poe. Lim arrangierte hier eigene Möbel in der Rekonstruktion eines unheimlichen Zimmers aus besagter Erzählung. Persönliche Erfahrungen, kulturelle Tradition und mediale Vermittlung gehen so eine traumatische Verbindung ein, die Individuelles und Gesellschaftliches widerspruchsvoll miteinander verschmilzt. Die neuere Arbeit *Horizons*, 2000, betont den Aspekt der Wahrnehmung und ihrer Abhängigkeit von kultureller Perspektive. Dazu hat Lim vier Fenster eines Aussichtsturmes mit Videoprojektionsflächen verstellt und auf dem Turm zudem vier Videomonitore verteilt. Zu sehen sind auf den Videos sowohl Ansichten der umliegenden Landschaft wie Ausblicke auf andere Gebiete der Erde. Aber auch Landschaftsmalerei oder Ausschnitte aus berühmten Filmklassikern mischen sich unter diesen visuellen Kosmos. *Horizons* beweist eindrucksvoll: Unsere Rezeption von Welt ist geprägt durch einen medial vermittelten Bilderschatz, der längst unserer eigenen, „authentischen" Erfahrung vorgeschaltet ist.

Won Ju Lim est sculptrice et installatrice. Son travail multimédia se présente le plus souvent sous forme de maquette et thématise les tensions relationnelles entre perception, espace et subjectivité à l'ère post-moderne. Pour élaborer une réflexion sur ces trois aspects, Lim mise avant tout sur des reconstitutions architecturales, dont elle interroge le « réalisme » de manière aussi critique que poétique par de subtils éclairages, des projections de diapos et des installations vidéo. Dans cet œuvre dense, au premier abord minimaliste, mais toujours chargé d'associations, la référence littéraire est omniprésente, comme on peut le voir dans l'installation *Proustian Bedroom*, 1996, ou encore dans *Guestroom*, 1997, qui s'appuie sur la nouvelle d'Edgar Allan Poe « La chute de la maison Usher », et pour laquelle Lim avait installé quelques meubles dans une reconstitution de l'étrange chambre de l'histoire. Expériences personnelles, tradition culturelle et traduction dans le média entretiennent ainsi un rapport traumatique qui opère une fusion contradictoire d'aspects individuels et collectifs. Plus récemment, *Horizons*, 2000, se penche sur l'impact du fait culturel sur la perception. Les quatre fenêtres d'une tour offrant un point de vue panoramique étaient pourvues d'écrans de projection vidéo, quatre moniteurs vidéo étant par ailleurs installés sur le toit. Les vidéos montraient des vues du paysage alentour, mais aussi des images d'autres zones géographiques. Des peintures de paysages ou des extraits de classiques du cinéma venaient en outre s'insérer dans cet univers visuel. *Horizons* apporte la preuve éclatante que notre perception du monde est marquée par un fonds d'images relayées par les médias, et qui est depuis longtemps venu se superposer à notre expérience « authentique ». R. S.

SELECTED EXHIBITIONS →
1999 *Spaced Out/California Vernacular*, Russel Gallery, University of California, San Diego (CA), USA **2000** *Longing for Wilmington*, Künstlerhaus Bethanien, Berlin, Germany; *Cultural Sidewalk*, Gumpendorfer Straße, Kunst im öffentlichen Raum, Vienna, Austria **2001** Patrick Painter Inc., Santa Monica (CA), USA; *Skulptur-Biennale Münsterland*, Germany, *Snapshot: New Art From Los Angeles*, Museum of Contemporary Art, North Miami (FL), USA **2002** Galerie Max Hetzler, Berlin, Germany; *Kwangju Biennale*, Kwangju, South Korea

SELECTED BIBLIOGRAPHY →
2001 *Skulptur-Biennale Münsterland*, Münster; *Snapshot: New Art From Los Angeles*, Museum of Contemporary Art, North Miami (FL) **2002** *Kwangju Biennale 2002: Sites of Korean Diaspora*, Kwangju

1 **Schliemann's Troy,** 2001, foam core, plexiglas, still projection, lamps, 145 x 488 x 305 cm, installation view, *Snapshot,* UCLA Hammer Museum, Los Angeles (CA)
2 **Floating Suburbia,** 2001, acrylic paint on foam, 80 models, size variable, performance, *Under the Bridges,* Casino Luxembourg

3 **Displaysed – Carson,** 1998, compressed particle board, foamcore board, circuit board, mylar, still image projection, 274 x 206 x 213 cm
4 **Longing for Wilmington,** 2000, plexiglas, foamcore board, still image projection, 142 x 533 x 342 cm, installation views, Künstlerhaus Bethanien, Berlin

„Mich interessieren die von mir so genannten ‚futuristischen Ruinen',
die Art und Weise, wie Hollywood in seinen Sciencefictionfilmen
die futuristischen Stadtlandschaften dargestellt hat."

« Je m'intéresse à ce que j'appelle des ‹Ruines Futuristes›, à la manière
dont Hollywood a représenté des paysages urbains futuristes dans des films
de science-fiction. »

"I have been interested in what I refer to as 'Futuristic Ruins', how Hollywood has rendered futuristic cityscapes in science fiction films."

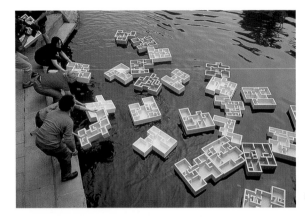

2

3

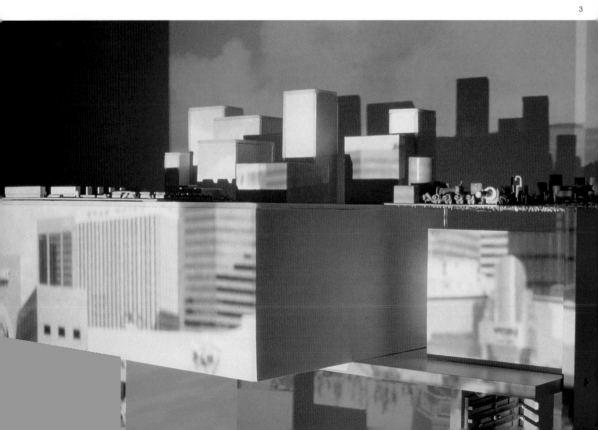

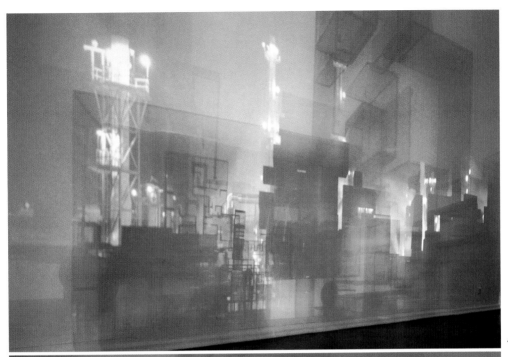

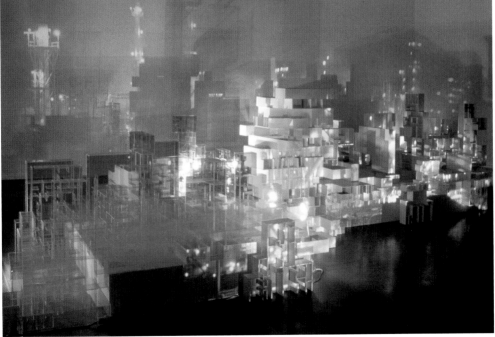

Sharon Lockhart

1964 born in Norwood (MA), lives and works in Los Angeles (CA), USA

Sharon Lockhart has become known for her meticulously choreographed film and photographic projects. She follows in the tradition of the Structuralists of the 1960s and 1970s. The production parameters of the medium itself, such as its ability to capture minute detail and the technical possibilities of the long take, form the boundaries of her aesthetic. The camera "structures" the events in their filmic or photographic setting. Lockhart works in the spaces between everyday social situations and theatrical performance. For her 1997 film *Goshogaoka*, she worked with a Japanese girls' basketball team, creating a minimalist choreography out of the players' training routine. In her portrait photography, Lockhart heightens the tension between reality and theatricality. Single subjects are posed in carefully arranged, sharply and judiciously lit interiors, creating an interplay between directness and distance. For her most recent film project *Teatro Amazonas*, 1999, Lockhart travelled to the Amazon region of Brazil and filmed in the Manaus opera house, made famous by Werner Herzog's film "Fitzcarraldo". Using strict demographic criteria, she selected an audience, which she filmed seated in the auditorium, using a stationary camera installed in the stage. The camera remains fixed on the expectant and increasingly restless spectators, while they observe what is almost a mirror image of their own behaviour. Lockhart is interested in the connection between different cultural spheres and audience interaction is a central feature of her scenario. Her work creates a kind of "aesthetic ethnography" in real time.

Sharon Lockhart ist bekannt geworden durch ihre streng choreografierten Film- und Fotoprojekte. Sie steht in der Tradition der Strukturalisten der sechziger und siebziger Jahre. Die Produktionsbedingungen des Mediums selbst, wie Bildausschnitt und die technisch mögliche Länge eines Takes, werden von ihr als die begrenzenden Mittel ihrer Ästhetik eingesetzt. Die Kamera „strukturiert" das Geschehen auf ihren filmischen und fotografischen Bühnen. Lockhart realisiert ihre Motive im Zwischenbereich von vorgefundener sozialer Situation und Inszenierung. Für den Film *Goshogaoka*, 1997, arbeitete sie mit einem japanischen Mädchen-Basketball-Team; aus den Trainingsabläufen der Mädchen entstand eine minimalistische Choreografie. Die Spannung zwischen Vorgefundenem und künstlerischer Modellierung steigert Lockhart in ihren Porträtfotografien. In intensiven Einzelaufnahmen werden Personen in präzisen Interieurs in Szene gesetzt und von sachlichen Lichtwerten scharf umrissen. Es entsteht ein Spiel von Direktheit und Distanz. Für ihr jüngstes Filmprojekt *Teatro Amazonas*, 1999, reiste Lockhart in das brasilianische Amazonasgebiet und drehte in dem Opernhaus in Manaus, das durch den Film „Fitzcarraldo" von Werner Herzog Berühmtheit erlangt hat. Sie wählte nach bestimmten demografischen Kriterien ein Publikum aus, das schließlich vor einer fest auf der Bühne installierten Kamera im Theatersaal saß. Die Kamera filmt dabei stur das auf ein Ereignis wartende, unruhig werdende Theaterpublikum, ein Verhalten, das die Kinobesucher im gleichen Maß beobachten wie sie sich darin spiegeln. Lockhart ist an den Wechselwirkungen zwischen verschiedenen kulturellen Sphären interessiert. Die Interaktion mit dem Publikum ist dabei ein zentraler Teil ihrer Inszenierung. Bei ihren Vorführungen entsteht so eine Art „ästhetischer Ethnografie" in Echtzeit.

L'artiste Sharon Lockhart s'est fait connaître par ses projets photographiques et cinématographiques rigoureusement chorégraphiés. Elle s'inscrit dans la tradition structuraliste des années 60 et 70. Les conditions de production générées par le médium – cadrage, durée possible d'une prise – sont utilisées comme des outils de délimitation de son esthétique. L'appareil photo et la caméra structurent l'événement de ses scènes photographiques ou cinématographiques. Lockhart réalise ses motifs dans le domaine intermédiaire entre une situation sociale préexistante et la mise en scène. Pour son film *Goshogaoka*, 1997, elle a travaillé avec une équipe de basket féminin japonaise, réalisant une chorégraphie minimaliste à partir des enchaînements de passes à l'entraînement. Cette tension entre situation préexistante et traitement artistique, Lockhart l'accentue encore dans ses portraits photographiques. Ces images d'une grande intensité mettent en scène des personnes dans des intérieurs en les contourant nettement par des valeurs lumineuses objectives. Il en résulte un jeu qui oscille constamment entre distance et immédiateté. Pour son dernier projet de film, *Teatro Amazonas*, 1999, Lockhart s'est rendue au Brésil, en terre amazonienne, et a tourné dans l'opéra de Manaus, rendu célèbre par le film de Werner Herzog « Fitzcarraldo ». Sur la base de certains critères démographiques, l'artiste a choisi un public qui s'est finalement trouvé assis devant une caméra fixe installée sur la scène. La caméra filme opiniâtrement le public qui attend le début de la représentation, qui s'impatiente, et ce comportement est observé par les spectateurs du film qui s'y reflètent à leur tour. Lockhart travaille sur les effets interactifs entre différentes sphères culturelles. L'interaction avec le public joue un rôle central dans des mises en scène qui génèrent une sorte d'« ethnographie esthétique » en temps réel.

A. K.

SELECTED EXHIBITIONS →
1998 *Tell Me a Story*, Magasin, Centre National d'Art Contemporain, Grenoble, France; *Sightings. New Photographic Art*, Institute of Contemporary Arts, London, UK **2000** MAK – Österreichisches Museum für angewandte Kunst, Vienna, Austria; Kunsthalle Zürich, Zurich, Switzerland; *Sharon Lockhart: Teatro Amazon*, Museum Boijmans Van Beuningen, Rotterdam, The Netherlands **2001** Museum of Contemporary Art, Chicago (IL), USA; *public offerings*, Museum of Contemporary Art, Los Angeles (CA), USA

SELECTED BIBLIOGRAPHY →
1999 *Cinéma, Cinéma, Contemporary Art and the Cinematic Experience*, Stedelijk Van Abbe Museum, Eindhoven **2000** *Elysian Fields*, Centre Georges Pompidou, Paris; *SHOOT, moving pictures by artists*, Malmö Konsthall, Malmö; *Sharon Lockhart: Teatro Amazon*, Museum Boijmans Van Beuningen, Rotterdam **2001** Museum of Contemporary Art, Chicago (IL)

1 **Untitled**, 2000, c-print, 88 x 66 cm
2 **Photo from the Collection of Antônio Noberto Bezerra 1999, Interview Location Survey of the Aripuanã River Region Regatão Boat, Comandante Bezerra, at Pastinho Community, Aripuanã River, Brazil; Interview Subject: Antônio Noberto Bezerra, Anthropologist: Ligia Simonian 1999 Interview Location Survey of the Aripuanã River Region Pastinho Community,** Aripuanã River, Brazil, Interview Subjects: Ana Lúcia das Neves Pereira; José Guerra Açaí Cardoso Anthropologist: Ligia Simonian 1999, 1999, 3 framed chrome and gelatin silver prints, overall dimensions 82 x 201 cm
3 **Untitled**, 2001, Chromogenic print, 62 x 86 cm
4 **Untitled**, 2000, c-print, 173 x 230 cm

„In letzter Zeit interessieren mich diese Situationen, in denen ein bühnenähnliches Setting schon von sich aus vorhanden ist."

« Dernièrement, je m'intéresse aux situations où un arrangement scénique est déjà préfiguré. »

"Recently I have become interested in situations where there is already a kind of theatrical setting in place."

2

3

4

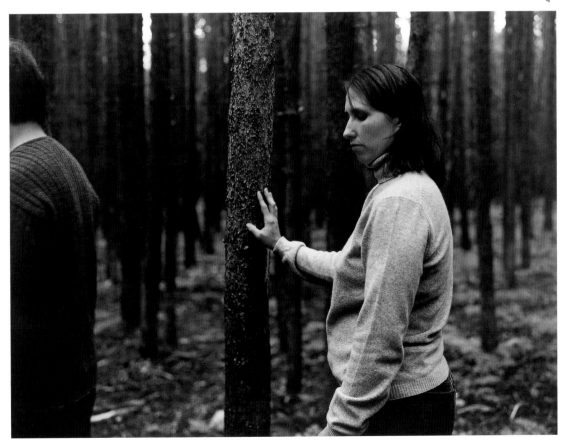

Sarah Lucas

1962 born in London, lives and works in London, UK

Sarah Lucas is one of the key figures on the new London art scene, which acquired a legendary reputation in the 1990s. In 1993, she and Tracey Emin ran a little second-hand shop that became famous as a meeting point for young artists, who swiftly made their names in the international art world while still pursuing their own independent agendas. Emin and Lucas were regarded as the strong women on the scene, unruly females who were not afraid to include obvious sexual content in their work and to portray themselves as "sluts". Lucas takes frequently autobiographical themes and transforms them into grotesque and highly artificial sculptures. Her work is filled to bursting point with provocative allusions to male and female genitalia, self-destruction, depression and death. She took her inspiration for *The Fag Show*, 2000, from her recently conquered tobacco addiction. London's Freud Museum was a particularly apt setting for Lucas' 2000 exhibition *Beyond the Pleasure Principle,* in which she used chairs to represent female bodies. A series of socially and culturally coded chairs were dressed in feminine attire. Garments with clear sexual connotations, like bras, nylons and knickers, were stretched over the furniture, while skinny, limp female legs sprouted grotesquely from the chair backs. These anthropomorphic chair sculptures were integrated into the rooms of Freud's house, the epicentre of psychoanalysis where he described illnesses such as hysteria to which, he claimed, women were especially prone. In a blend of sensitivity and aggression, Lucas' art constantly challenges the stereotypical male view of women.

Sarah Lucas ist eine der zentralen Figuren der neuen Londoner Kunstszene, die sich in den neunziger Jahren als „Young British Art" einen legendären Ruf verschafft hat. Zusammen mit Tracey Emin hatte sie 1993 einen kleinen Secondhandladen betrieben, der als Treffpunkt junger Künstler bekannt war, die neben ihrem raschen Erfolg im internationalen Kunstbetrieb weiter unabhängige Strategien verfolgten. Emin und Lucas galten als die widerspenstigen, starken Frauen der Szene, die sich nicht scheuten, sexuelle Inhalte offen in ihren Arbeiten zu demonstrieren und sich selbst als „Schlampen" zu inszenieren. Biografisches wird oft zum Thema erhoben und in grotesken Arrangements zu hochartifiziellen Skulpturen verformt. Lucas' Arbeiten sind voller provokanter Anspielungen auf männliche und weibliche Genitalien, Selbst- zerstörung, Depression und Tod. In ihrem Werkkomplex *The Fag Show*, 2000, hat Lucas ihre gerade überwundene Nikotinsucht zu einem orna- mentalen Prinzip erhoben. Als besonders geeigneter Ort für Lucas' Arbeiten erwies sich das Freud Museum in London. Für die Ausstellung *Beyond the Pleasure Principle,* 2000, benutzte Lucas Stühle, die für den weiblichen Körper stehen. Die unterschiedlich sozial und kulturell kodierten Stuhlmodelle versieht sie mit Bekleidungsstücken mit sexueller Konnotation. Büstenhalter, Nylonstrümpfe und Unterhosen werden um das Möbel gespannt, dünne, schlaffe Frauenbeine wachsen grotesk aus den Lehnen. Diese anthropomorphen Stuhlskulpturen integrierte sie in das Freud'sche Interieur, das Epizentrum der Psychoanalyse und der Beschreibung von Krankheitsbildern wie der Hysterie, die besonders Frauen attestiert wurde. In ihrem Werk tritt sie diesen männlichen Sichtweisen immer wieder so aggressiv wie sensibel entgegen.

Sarah Lucas est une des grandes figures de la nouvelle scène artistique londonienne qui a su se forger une réputation légendaire dans les années 90 sous le nom de « Young British Art ». Avec Tracey Emin, Lucas tenait en 1993 une petite boutique de nippes, point de rencontre de jeunes artistes qui continuaient de suivre des stratégies indépendantes parallèlement à leur succès fulgurant sur la scène artistique inter- nationale. Emin et Lucas étaient considérées comme les fortes têtes féminines qui n'hésitaient pas à étaler des contenus sexuels dans leurs œuvres et à se mettre elles-mêmes en scène comme des « délurées ». Dans son travail, Lucas présente souvent des éléments biographiques transformés en sculptures hautement artificielles arrangées de manière grotesque. Ses œuvres débordent d'allusions provocatrices aux organes génitaux masculins et féminins, à l'autodestruction, à la dépression et à la mort. Dans le cycle *The Fag Show*, 2000, elle a élevé au rang de principe ornemental l'addiction à nicotine dont elle vient de se défaire. Le Freud Museum de Londres est apparu comme un cadre de pré- sentation particulièrement approprié. Pour l'exposition *Beyond the Pleasure Principle,* 2000, l'artiste s'est servie de chaises ayant fonction de corps féminin. Investis de leurs codages socio-culturels respectifs, différents modèles de sièges sont affublés de vêtements présentant des connotations sexuelles. Ces éléments de mobilier sont tendus de slips, de soutiens-gorge et de bas nylon, tandis que des jambes de femmes fines et inertes sortent des dossiers de manière grotesque. Ces sculptures-chaises anthropomorphes s'insèrent dans l'appartement de Freud, épicentre de la psychanalyse et de la description des troubles de l'hystérie, considérée comme une maladie spécifiquement féminine. Dans son œuvre, Lucas s'élève de manière aussi agressive que sensible contre ce type de regard masculins.

A. K.

SELECTED EXHIBITIONS →
1996 Museum Boijmans Van Beuningen, Rotterdam, The Nether- lands **1997** *Car Park*, Museum Ludwig, Cologne, Germany; *Sensation*, Royal Academy of Arts, London, UK **2000** *The Fag Show*, Sadie Coles HQ, London, UK; *Beyond the Pleasure Principle,* The Freud Museum, London, UK; *Self Portraits and More Sex*, Tecla Sala, Barcelona, Spain; *The British Art Show 5*, Hayward Gallery, London **2001** *Public Offerings*, Museum of Contemporary Art, Los Angeles (CA), USA; *Century City*, Tate Modern, London, UK

SELECTED BIBLIOGRAPHY →
1996 *Sarah Lucas*, Museum Boijmans Van Beuningen, Rotterdam **1997** *Car Park*, Museum Ludwig, Cologne **1998** *Real/Life: New British Art*, Tochigi Prefectural Museum of Fine Arts, Utsunomiya **2000** *Sarah Lucas: Self Portraits and More Sex*, Tecla Sala, Barcelona **2001** Uta Grosenick (ed.), *Women Artists*, Cologne

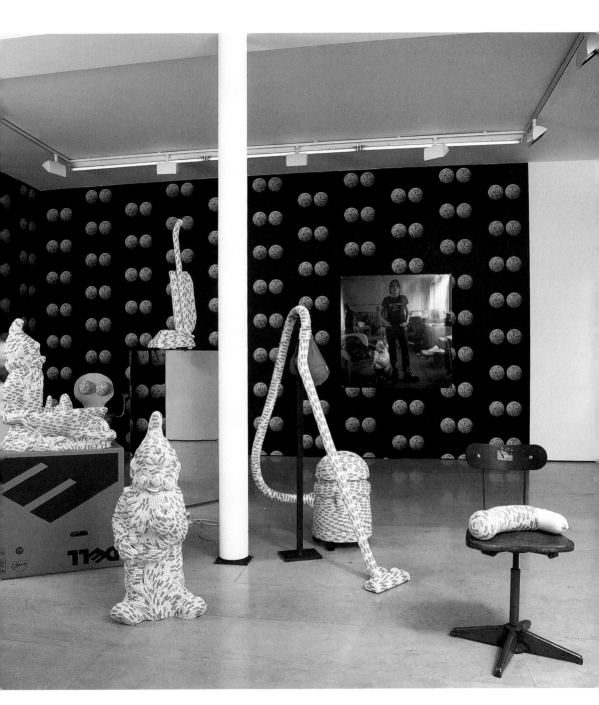

1 **The Fag Show,** 2000, installation view, Sadie Coles HQ, London
2 Installation view, *Beyond The Pleasure Principle,* Freud Museum, London, 2000; front: **Hysterical Attack,** 1999, chair and papier maché; background: **Prière de Toucher,** 2000, colour photograph

3 **Happy Families,** 1999, mixed media, 160 x 183 x 56 cm
4 **Beyond the Pleasure Principle,** 2000, futon mattress, cardboard coffin, garment rail, neon tube, light bulbs, bucket wire, 145 x 193 x 216 cm

„Ich möchte, dass meine Sachen verständlich und zugleich ein wenig respektlos sind. Die Frage ‚Ist das Kunst?' ist der Sargnagel für den Humor in meinen Arbeiten."

« J'aime que mes choses soient accessibles et en même temps légèrement irrévérencieuses. La question ‹ Est-ce de l'art ? › est au cœur de l'humour dans mon travail en général. »

"I like my things to be accessible and slightly irreverent at the same time. The 'Is it art?' question is a lynchpin of the humour in my work generally."

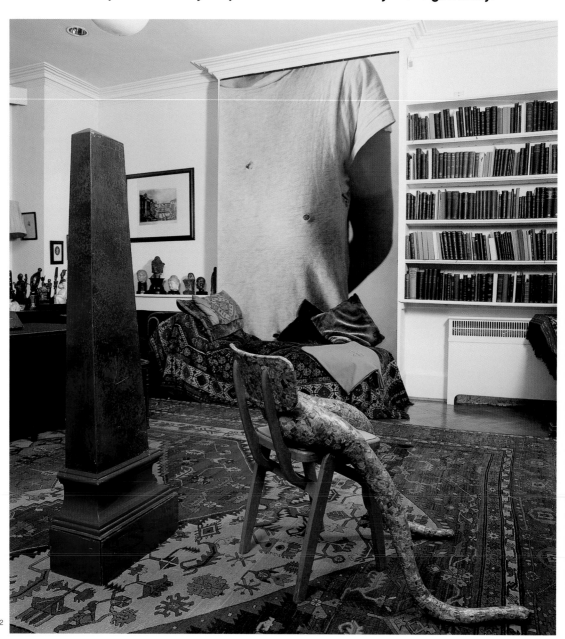

2

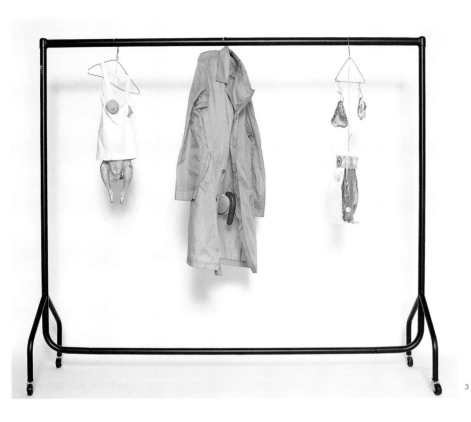

3

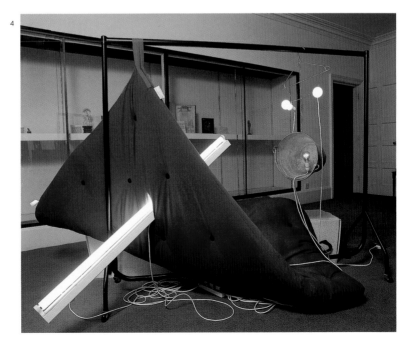

4

Michel Majerus

1967 born in Esch, Luxembourg, lives and works in Berlin, Germany

In 2000, the exhibition space at Cologne's Kunstverein was spectacularly taken over by a gigantic skateboarding half-pipe ramp. Forty-two metres long and nearly ten wide, it extended through the entire museum. On either side of the solid structure was a gallery through which visitors could wander in a hunched-forward posture. The huge ramp provided the setting for the fragments with which Michel Majerus works: logos, designer clichés, slogans and colourful bits and pieces all brought together in a vast accumulation of visual imagery. Majerus has made his name with large-scale pieces covering huge areas of space. The viewer becomes part of the picture in a world created by Majerus' painting. By carrying visitors over a distance of forty-two metres, the half-pipe ramp appears to pose the question: "How far does Majerus' art go?" Accusations of cynicism thrown at the artist's dazzlingly colourful installations miss the point. He is interested in everything that surrounds us. He only picks on things that get in his – and our – way. So he is no populist proponent of present-day values. Majerus works in accordance with economic principles. He neither pays lip service to the usual ways of seeing, nor does he indulge in wild "channel-surfing" through different styles and content. He only repeats what design has to say in other areas of art, but keeps his distance from designer forms and painterly attitudes, thus putting both phenomena under the microscope. He dissects well-known and conventional contexts by making them extend over his ever-expanding installations. The unadorned spaces in between the written elements become increasingly visible and tangible. Majerus is asking himself the very simple and determined question: how closely can painting reflect its time?

Eindrucksvoll eroberte im Kölnischen Kunstverein im Jahr 2000 eine gigantische Skateboard-Halfpipe den Raum und füllte ihn souverän. 42 Meter lang und fast 10 Meter breit erstreckte sie sich durch den gesamten Kunstverein. Eine solide Konstruktion, die an beiden Seiten eine Galerie zum gebückten Entlanggehen bot. Die gewaltige Rampenskulptur war der Bildträger für die visuellen Fragmente, mit denen Michel Majerus arbeitete – Warenzeichen, Designerklischees, Slogans, bunte Elemente in enormen visuellen Ballungen. Majerus hat sich einen Namen gemacht mit seinen großzügigen, großräumigen Bildlösungen. Der Betrachter ist im Bild, die Welten von Majerus sind aus Malerei gebaut. Die Skaterrampe trug Betrachter wie Skater 42 Meter weit und stellte die Frage, wie weit die Kunst von Majerus reicht. Der Vorwurf des Zynismus, der an Majerus' grellbunt eklektische Installationen gerichtet wird, zielt fehl. Sein Interesse gilt all dem, was uns umgibt. Majerus greift nur das auf, was sich uns und ihm entgegenstellt. Damit ist er kein Populist seiner Gegenwart. Er arbeitet nach ökonomischen Prinzipien, biedert sich nicht den Sehgewohnheiten an, betreibt also kein wildes Zapping der Stile und Inhalte. Majerus wiederholt nicht einfach, was das Design an anderer Stelle der Kunst vormacht. Er wahrt in seiner Arbeit gleichermaßen Distanz zu den Formen des Designs wie den Attitüden der Malerei und bringt dadurch beides auf den Prüfstand. Sein Werk löst uns bekannte und damit konventionelle Sinnzusammenhänge auf, indem er ihre Körperlichkeit in seinen immer größer werdenden Installationen zerdehnt. Zwischen den Sinn buchstabierenden Elementen werden die unbezeichneten Zwischenräume zunehmend fassbarer. Majerus stellt sich die sehr einfache und zielgerichtete Frage, wie nahe Malerei der Zeit sein kann.

En 2000, une gigantesque « half-pipe » de skate occupait de manière impressionnante le Kunstverein de Cologne, dont elle investissait souverainement l'espace. Sur quelque 42 mètres de long et presque 10 mètres de large, elle s'étirait à travers tout le Kunstverein, construction solide offrant de chaque côté une galerie qui permettait au spectateur de flâner, légèrement courbé. La puissante sculpture en forme de rampe servait de support aux fragments visuels sur lesquels travaille Michel Majerus – logos, clichés de designers, slogans, éléments multicolores aux développements visuels énormes. Majerus s'est fait un nom grâce à des solutions picturales amples et généreuses. Le spectateur est dans le tableau : les univers de Majerus sont construits de peinture. La rampe de skate faisait franchir 42 mètres au spectateur comme au « skater » et posait la question de savoir où s'arrête l'art de Majerus. Le reproche de cynisme dont on accable ses installations éclectiques et stridentes manque de pertinence. L'intérêt de l'artiste porte sur tout ce qui nous entoure. Majerus se contente de saisir au vol ce qui s'oppose à lui comme à nous. On ne peut voir en lui pour autant un populiste contemporain. Il travaille selon des principes économiques, refuse les habitudes visuelles, ne pratique pas le zapping sauvage des styles et des contenus et ne se borne pas à répéter les modèles que le design propose dans d'autres contextes. Dans son travail, il conserve une même distance à l'égard des formes du design et des attitudes picturales, mettant ainsi ces deux domaines à l'épreuve. Son œuvre dissout des associations de sens connues et donc conventionnelles, en étirant leur matérialité dans des installations de plus en plus grandes. Entre les éléments qui déclinent le sens, les intervalles non désignés deviennent de plus en plus palpables. Majerus pose une question très simple et ciblée, celle du rapprochement maximum entre la peinture et l'époque. F. F.

SELECTED EXHIBITIONS →
1994 neugerriemschneider, Berlin, Germany **1996** Kunsthalle Basel, Basle, Switzerland **1997** qualified, Galeria Giò Marconi, Milan, Italy **1998** Manifesta 2, Luxembourg; Tell Me a Story, Magasin, Centre National d'Art Contemporain, Grenoble, France **1999** dAPERTuttO, 48. Biennale di Venezia, Venice, Italy **2000** if we are dead, so it is, Kölnischer Kunstverein, Cologne, Germany; The space is where you'll find it, Delfina, London, UK; Taipeh Biennale, Taipeh, Korea **2001** Poetry in motion, MindBar, Lund, Sweden

SELECTED BIBLIOGRAPHY →
1999 Nach-Bild, Kunsthalle Basel, Basle; Burkhard Riemschneider/ Uta Grosenick (eds.), Art at the Turn of the Millennium, Cologne **2001** Casino 2001, S.M.A.K., Stedelijk Museum voor actuele kunst, Ghent

pure pragmatism deducing it ... ner than its o ...

pure pragmatism ...ng it

p e p ...mat

1 Installation view, *Sein Lieblingsthema war Sicherheit, seine These –*
 es gibt sie nicht, neugerriemschneider, Berlin, 1999
2 Installation view, *The space is where you'll find it,* Delfina, London, 2000

3 Installation view, *If we are dead, so it is,* Kölnischer Kunstverein,
 Cologne, 2000
4 **Gold,** 2000, acrylic on canvas, 303 x 348 cm

„Über einen Arbeitsprozess zu reden, der durch die Werkzeuge und die Farben, die man benutzt, benannt wird – das interessiert mich nicht. Genau das zu malen, was man sich vorgenommen hat, das ist das Aufregendste, was es gibt. Denn das Ergebnis ist immer so, wie es niemand anders für einen hätte machen könne."

« Parler d'un processus de travail déjà nommé par les outils et les couleurs employés ne m'intéresse pas. Peindre exactement ce qu'on a prévu de faire, c'est la chose la plus excitante qui soit. Le résultat est toujours tel que personne n'aurait jamais pu le faire à notre place. »

"I am not interested in talking about a working method and what tools and paints to use. Painting exactly what you set out to paint, that's the most exciting thing there is. Because the result is always something that no one else could have done for you."

2

3

4

Paul McCarthy

1945 born in Salt Lake City (UT), lives and works in Altadena (CA), USA

The influence Paul McCarthy has exerted on a younger generation of artists is significant, and has occasionally resulted in collaborations with other artists, for example Mike Kelley and Jason Rhoades. Since the late 1960s his performances, environments, films, installations, sculptures and drawings have taken American myths as their theme while simultaneously undermining them. Hence his sculpture *Michael Jackson white* (also *black* and *gold*), 1997–99, can be seen both as a caricature of the pop star and as an appropriation of the work of Jeff Koons. For his performances, McCarthy stages apocalypses of American daily life in which icons of the entertainment industry's illusory world are blended with images from pornography and the hidden horrors of societal ills like violence, rape and paedophilia. Children's television heroes like Heidi and Pinocchio become psychopathic players in his nursery of horrors. As in gore and porn movies, McCarthy has an obsessive preoccupation with bodily orifices and fluids. He wallows in an orgiastic deployment of such viscous foods as ketchup, mayonnaise, mustard and chocolate sauce, which he substitutes for blood, sperm, sweat and excrement. Society is understood as a social body, which finds its concentrated reproduction in each individual human body. The sets for his performances are the rooms where the videos of his performances are subsequently screened for exhibitions. McCarthy's latest works are characterised by greater sparseness and an emphasis on their architectural features – such as *Mechanized Chalet,* 1993–99, or *The Box,* 1999, a detailed reconstruction of his studio tilted by 90 degrees.

Der Einfluss von Paul McCarthy auf eine jüngere Künstlergeneration ist groß; gelegentlich kommt es auch zur Zusammenarbeit, so mit Mike Kelley oder Jason Rhoades. Seine seit den späten sechziger Jahren entstehenden Performances, Environments, Filme, Installationen, Skulpturen und Zeichnungen thematisieren und untergraben amerikanische Mythen. So karikiert er in seiner Skulptur *Michael Jackson white* (auch *black* und *gold*), 1997–99, den Popstar und appropriiert gleichzeitig die Arbeit von Jeff Koons. In seinen Performances inszeniert McCarthy Apokalypsen des amerikanischen Alltags, in denen sich Ikonen aus den Scheinwelten der Unterhaltungsindustrie mit pornografischen Posen und dem unterschwelligen Horror sozialer Dramen wie Gewaltverbrechen, Vergewaltigung und Kindesmissbrauch überlagern. Helden des Kinderfernsehens, wie Heidi und Pinocchio, werden zu psychopathischen Akteuren eines Horrorszenarios im Kinderzimmer. Wie im Splatter- oder Pornofilm thematisiert McCarthy ein obsessives Verhältnis zu Körperöffnungen und -flüssigkeiten. Er zelebriert einen orgiastischen Umgang mit dickflüssigen Nahrungsmitteln wie Ketchup, Mayonnaise, Senf oder flüssiger Schokolade, die als Ersatz für Blut, Sperma, Schweiß oder Exkremente eingesetzt werden. Gesellschaft ist als sozialer Körper aufgefasst, der sich im einzelnen menschlichen Körper konzentriert abbildet. Die Performances finden in inszenierten Räumen statt, in denen später in der Ausstellung die Videos der Performances laufen. McCarthys neuere Arbeiten fallen reduzierter aus, wobei der architektonische Aspekt weiter in den Vordergrund tritt, zum Beispiel *Mechanized Chalet,* 1993–99, oder sein detailliert nachgebautes, um 90° gekipptes Atelier in *The Box,* 1999.

Paul McCarthy a exercé une forte influence sur une jeune génération d'artistes, ce qui se traduit par des collaborations occasionnelles, notamment avec Mike Kelley ou Jason Rhoades. Ses performances, environnements, films, installations, sculptures et dessins thématisent et sapent les mythes américains. Dans la sculpture *Michael Jackson white* (et aussi *black* et *gold*), 1997–99, McCarthy caricature la star en même temps qu'il s'approprie le travail de Jeff Koons. Dans ses performances, McCarthy met en scène des apocalypses de la vie quotidienne américaine où les icônes des mondes fictifs de l'industrie du divertissement côtoient l'horreur sous-jacente de tragédies sociales comme la criminalité, le viol et la pédophilie, où les héros d'émissions de télévision infantiles comme Heidi ou Pinocchio deviennent les acteurs psychopathes de scénarios de l'horreur qui se déroulent dans la chambre d'enfant. Comme dans le film d'horreur ou le film porno, McCarthy thématise un rapport obsessionnel avec les sécrétions et les orifices corporels, célébrant le maniement orgiastique, d'aliments visqueux comme le ketchup, la mayonnaise, la moutarde ou le chocolat liquide employés comme substituts du sang, du sperme, de la sueur ou des excréments. La société est conçue comme un corps social représenté en condensé dans le corps humain. Les performances se déroulent dans des espaces soigneusement mis en scène, dans lesquels les vidéos des performances seront ensuite présentées dans l'exposition. Les œuvres récentes de McCarthy sont plus sobres, même si l'aspect architectural demeure prédominant, comme le montre *Mechanized Chalet,* 1993–99, ou *The Box,* 1999, une reproduction détaillée de l'atelier de l'artiste renversée à 90°.

N. M.

SELECTED EXHIBITIONS →
1999 *Dimensions of the Mind,* Sammlung Hauser und Wirth in der Lokremise St. Gallen, Switzerland **2000** *Au-delà du spectacle, Mike Kelley and Paul McCarthy,* Centre Georges Pompidou, Paris, France; *In Between,* EXPO 2000, Hanover, Germany **2001** *Film- und Videoretrospektive Paul McCarthy,* Kunstverein in Hamburg, Germany **2002** *Retrospective,* Moderna Museet, Stockholm, Sweden

SELECTED BIBLIOGRAPHY →
1996 Ralph Rugoff/Kristine Stiles/Giacinto Di Pietrantonio (eds.), *Paul McCarthy,* London **1999** Burkhard Riemschneider/Uta Grosenick (eds.), *Art at the Turn of the Millennium,* Cologne **2000** *Paul McCarthy,* New Museum of Contemporary Art, New York (NY)

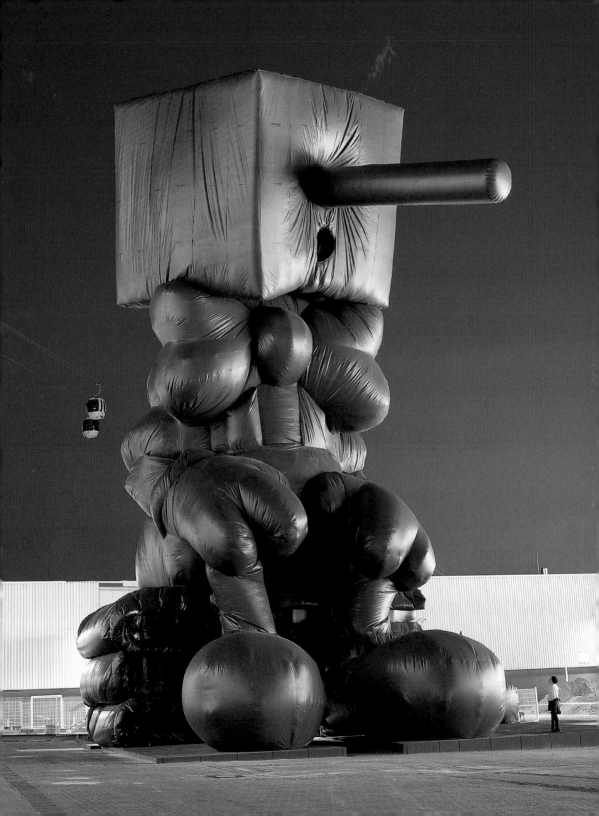

1 **Chocolate Blockhead (Nose Bar Outlet),** 2000, installation view, *In Between*, EXPO 2000, Hanover

2, 3 **The Box,** 1999, mixed media, 5.94 x 16.60 x 4.04 m, installation views, *'Dimensions of the Mind' The Denial and the Desire in the Spectacle*, Sammlung Hauser und Wirth, St. Gallen

„Die Definition von Performance als Realität – als konkretes Geschehen – beschäftigt mich immer weniger. Mein Interesse gilt vielmehr der Imitation, der Aneignung, der Fiktionalität, der Frage nach der Darstellbarkeit nach der Bedeutung."

« Pour moi, cette définition de la performance comme d'une réalité – comme de quelque chose de concret – a peu à peu perdu de son intérêt. De plus en plus, je me suis intéressé à l'imitation, à l'appropriation, à la fiction, à la représentation, et à l'interrogation du sens. »

"That definition of performance as reality – as concrete – became less interesting to me. I became more interested in mimicking, appropriation, fiction, representation and questioning meaning."

2

Jonathan Meese

1971 born in Tokyo, Japan, lives and works in Berlin, Germany

In recent years Jonathan Meese has come to public attention as a painter as well as an installation and performance artist. The artist's "miracle chambers" confront the viewer head-on, with every space filled and overflowing with chaos. However, Meese's chief objectives are not immediately apparent: despairing, occasionally aggressive attempts to develop a new German mythology in order to simultaneously destroy it with the assistance of his own internal pathos. Meese's mythological vocabulary finds nourishment in a variety of sources. His broad, frenzied spectrum ranges from Richard Wagner and Adolf Hitler to German pop groups like "Deutsch-Amerikanische-Freundschaft" (German-American Friendship) and other artists such as Anselm Kiefer. His early installation, *Die Räuber* (The Robbers), 1998, already displayed the artist's central working principles: the space is like a typical teenager's room, and its walls are wholly covered by posters, pin-ups, countless photocopies, cuttings from magazines, record sleeves and the like. Meese draws on this junk arsenal of everyday images to create a centre of cult worship. A year later the themes of Meese's room *Erzreligion Blutlazarett/Erzsöldner Richard Wagner/Privatarmee Ernte und Saat/Waffe: Erzblut der Isis/Nahrung: Bluterz* (Arch Religion Bloody Military Hospital/Arch Mercenary Richard Wagner/Private Army of Harvest and Sowing/Weapon: Arch Blood of Isis/Nourishment: Blood Ore) focus entirely on the "German delusion". The word "Erzbayreuthon" (Arch Bayreuthon) is written in black on a wall next to where gravestones have been painted. Militaria lies around, cardboard boxes, heaps of clothing, a dark table with candles: in short, a stylisation of horror – or perhaps a terrible mythogenesis taken to the realms of the absurd?

Als Maler, Installations- und Performancekünstler ist Jonathan Meese in den letzten Jahren bekannt geworden. Raumfüllend, mit überbordendem Chaos, erscheinen dem Betrachter die Angst einflößenden „Wunderkammern" des Künstlers. Erst auf den zweiten Blick erkennt man die wesentliche Intention von Meese: der verzweifelte, zuweilen aggressive Versuch, einen neuen deutschen Mythos aufzubauen, um diesen im selben Moment gerade mithilfe des ihm innewohnenden Pathos zu zerstören. Meeses mythologisches Vokabular speist sich aus unterschiedlichen Quellen. Das weite, ja wüste Spektrum reicht von Richard Wagner über Adolf Hitler bis hin zu deutschen Pop-Gruppen wie „Deutsch-Amerikanische-Freundschaft" oder anderen Künstlern wie beispielsweise Anselm Kiefer. In der frühen Installation *Die Räuber*, 1998, finden sich schon die für den Künstler zentralen Arbeitsprinzipien: Über und über ist der Raum, vergleichbar einem Jugendzimmer voller Poster und Devotionalien, mit unzähligen Fotokopien, Zeitschriftenausschnitten, Schallplattencovern und dergleichen mehr bedeckt. Meese schöpft aus den Arsenalen des alltäglichen Bildermülls, um eine wahre Kultstätte zu inszenieren. Ein Jahr später konzentriert sich Meese dann in seinem Raum *Erzreligion Blutlazarett/Erzsöldner Richard Wagner/Privatarmee Ernte und Saat/Waffe: Erzblut der Isis/Nahrung: Bluterz* thematisch ganz auf das Problem „deutscher Wahn". „Erzbayreuthon" steht da in schwarzer Schrift an der Wand, Grabsteine sind gleich daneben gemalt, Militaria liegen herum, Pappkartons, Kleiderberge, ein dunkler Tisch mit Kerzen … Eine Stilisierung des Grauens also – oder eine unheimliche Mythenbildung, die sich selbst ad absurdum führt?

Jonathan Meese s'est fait connaître ces dernières années comme peintre, performer et créateur d'installations. Ses angoissantes « chambres au trésor » occupent la totalité de l'espace et abordent le spectateur avec un déferlement chaotique. Seul un second regard révèle le propos principal de l'artiste : la tentative désespérée, parfois agressive, de reconstruire un mythe allemand, et en même temps de le détruire – précisément à l'aide du pathos qui lui est inhérent. Le vocabulaire mythologique de Meese puise à différentes sources, dont le vaste éventail va de Richard Wagner à Adolf Hitler en passant par des groupes allemands comme « Deutsch-Amerikanische Freundschaft » (Amitié germano-américaine) ou des collègues artistes comme Anselm Kiefer. Dans une installation ancienne comme *Die Räuber* (Les Voleurs), 1998, on relevait déjà les principes de travail déterminants de l'artiste : un peu comme une chambre d'adolescent pleine de posters et d'objets de dévotion, la pièce est entièrement tapissée de photocopies, de coupures de presse, de pochettes de disques etc. Meese puise dans les arsenaux de la décharge d'images quotidiennes pour mettre en scène un véritable lieu de culte. Un an plus tard, *Erzreligion Blutlazarett/Erzsöldner Richard Wagner/Privatarmee Ernte und Saat/Waffe: Erzblut der Isis/Nahrung: Bluterz* (Religion de base : Hôpital du sang/Soldat de base Richard Wagner/Armée privée Récolte et Semaille/Arme : sang de base d'Isis/Nourriture : airain de sang), est entièrement consacré au problème du « délire allemand ». En lettres noires écrites à même le mur, on y lit le mot « Erzbayreuthon » (Bayreuthon de base). Tout à côté, des pierres tombales peintes, des effets militaires disséminés, des cartons, des monceaux de vêtements, une table foncée avec des bougies … Une stylisation de l'horreur donc – ou l'effrayante construction d'un mythe qui vire par lui-même à l'absurde ?

R. S.

SELECTED EXHIBITIONS →
1998 Contemporary Fine Arts, Berlin, Germany; *1. berlin biennale*, Berlin, Germany **1999** Kunsthalle Bielefeld, Germany; Neuer Aachener Kunstverein, Aachen, Germany; *German Open*, Kunstmuseum Wolfsburg, Germany **2000** P.S.1, Long Island City (NY), USA; Museo Michetti, Francavilla al Mare, Italy **2001** Leo Koenig, New York (NY), USA; Kestner Gesellschaft, Hanover, Germany

SELECTED BIBLIOGRAPHY →
1998 *El Niño*, Städtisches Museum Abteiberg, Mönchengladbach **1999** *Gesinnung '99 – Der letzte Lichtstrahl des Jahrtausends* (with Erwin Kneihsl), Contemporary Fine Arts, Berlin **2000** *German Open*, Kunstmuseum Wolfsburg; *Wounded Time*, Städtisches Museum Abteiberg, Mönchengladbach

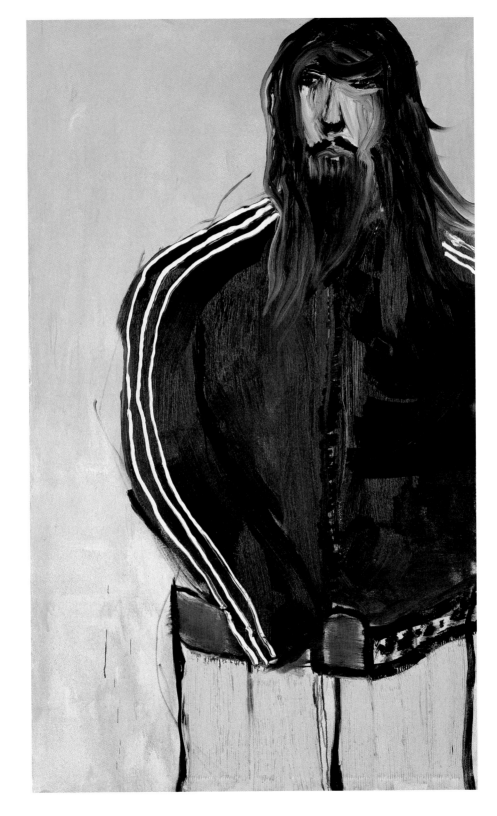

1 **Selbstgetreide – I am the walruß,** 2000, oil on canvas, 185 x 110 cm
2 **Erzreligion Blutlazarett ...,** 1999, installation view, Kunstverein Frankfurt

„Alles muss übel aufstoßen." « Tout doit méchamment défoncer. »

"Everything must be noticeable for its foulness."

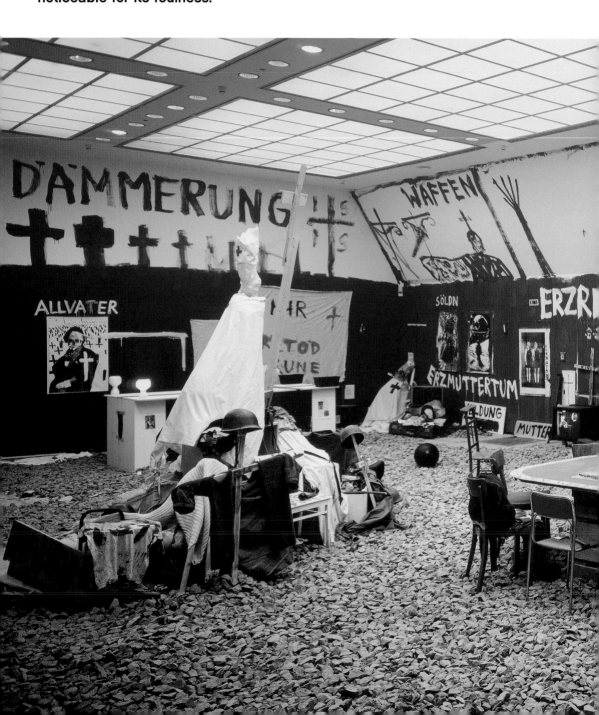

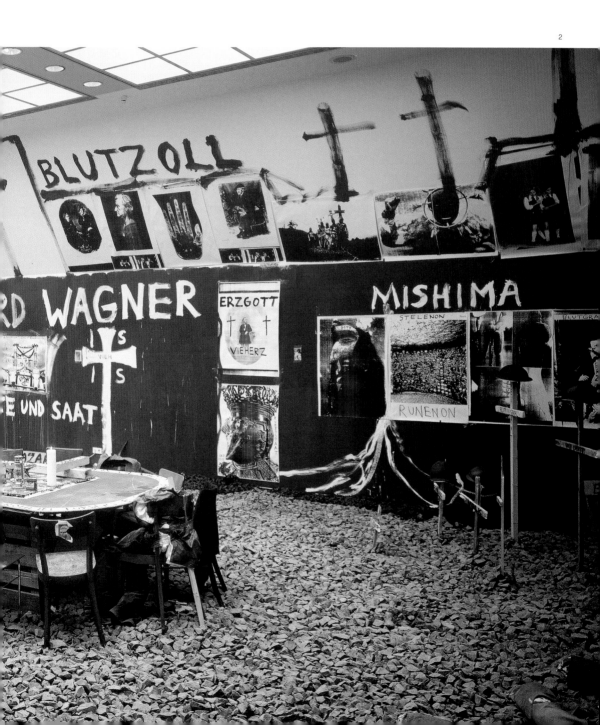

Mariko Mori

1967 born in Tokyo, Japan, lives and works in New York (NY), USA

Mariko Mori is an artist, a being with a strong hint of the extra-terrestrial, and a priestess of her own temple of dreams. Following her meteoric success in the 1990s, this most famous representative of "Tokyo Pop" can now take a step back and translate her virtual realities into three-dimensional works. Nobody else has matched the stridency with which she visualises contemporary Japan's symbiosis of tradition and innovation, nature and high technology, individual and collective dreams. Over and over again she connects the supernatural and meta-physical with the traditional and formal elements of perceptible reality. This creates a tension in her art, which is not a thousand miles away from kitsch, and has prompted its description as an *Esoteric Cosmos*. Her cocoon-like *Body Capsules*, 1995, contain the assembled energy with which she dives into the realm of mysticism. Time appears to stand still, and all is preserved in weightlessness, clarity and spiritual devotion. When Mori's *Dream Temple* construction, 1999, first made an appearance in the video and photographic work *Kumano*, 1998, it was a virtual temple for tea ceremonies, in which humanity and the cosmos were linked by ritual and spirituality. It is now physically accessible and, after passing through the traditional "stone garden of purification", visitors find themselves surrounded by traditional architectural elements based on the Yumedono Temple (AD 739) in Nara, and by transcendental images and celestial sounds. Mori relates to the idea that all the senses are connected, and makes use of high-tech to sensitise the senses and the soul. Her spirituality is a wondrous world of illusion born of the realisation that human existence is finite.

Mariko Mori – die einem Wesen vom anderen Stern gleichende Künstlerin – ist mittlerweile eine Priesterin ihres Traumtempels geworden. Nach ihrem rasanten Erfolg in den neunziger Jahren darf sich die berühmteste Vertreterin des „Tokyo Pop" zurücklehnen und ihre virtuellen Realitäten in die Dreidimensionalität umsetzen. Niemand anders visualisiert so schrill wie sie die Verbindungen von Tradition und Innovation, von Natur und Hoch-Technologie, von individuellen und kollektiven Träumen im heutigen Japan. Immer werden von ihr Beziehungen zwischen Übernatürlichkeit und Vergeistigung zur realen Ebene der traditionell-formalen Elemente geknüpft. Hieraus erhält ihre Kunst eine Spannung, die dem Kitsch nicht fern steht, sodass ihre Welt bereits als *Esoteric Cosmos* bezeichnet wurde. In ihren kokonartigen *Body Capsules*, 1995, sammelt sie Energie, mit der sie in die Welt der Mystik eintaucht. Die Zeit scheint stehen zu bleiben, und alles ist aufgehoben in einer Leichtigkeit, Klarheit und Spiritualität. Moris gebauter *Dream Temple*, 1999, war in der Video- und Fotoarbeit *Kumano*, 1998, noch ein virtueller Teezeremonie-Tempel, in dem die Welt mit dem Kosmos durch die rituelle Handlung und den Geist verbunden war. Jetzt ist er begehbar und umhüllt den Besucher – nach dem Durchschreiten des traditionellen Stein-Gartens der Reinigung – mit althergebrachten Architektur-elementen, basierend auf dem Yumedono-Tempel (von 739) in Nara, und mit transzendenten Bildern und Sphärenklängen. Mori nimmt Bezug auf die Vorstellung, dass alle Sinne zusammenhängen und nutzt die High-Tech zur Sensibilisierung der menschlichen Sinne und des Geistes. Ihre Spiritualität ist eine wunderbare Welt der Täuschung, geboren aus der Erkenntnis, dass das Menschsein endlich ist.

Mariko Mori, l'artiste qui a tout d'un être venu d'une autre planète, est devenue aujourd'hui la prêtresse de son temple du rêve. Après son succès éclatant au cours des années 90, la plus célèbre représentante du « Tokyo Pop » peut aujourd'hui se reposer et transposer ses réalités virtuelles dans les trois dimensions de l'espace. Personne d'autre ne visualise de manière aussi stridente qu'elle les rapports entre tradition et innovation, entre nature et technologie de pointe, entre rêves individuels et collectifs dans le Japon d'aujourd'hui. Elle établit sans cesse des liens entre le surnaturel et la spiritualisation, et le plan réel des éléments formels traditionnels. Son art en tire une tension qui n'est pas éloignée du kitsch, et a valu à son univers le qualificatif de *Esoteric Cosmos*. Dans ses *Body Capsules*, 1995, rappelant un cocon, elle rassemble de l'énergie grâce à laquelle elle plonge dans le monde de la mystique. Le temps semble arrêté, tout s'abolit dans la légèreté, la clarté et la spiritualité. Dans *Kumano* de 1998, le *Dream Temple* de Mori, qui fut construit l'année suivante, n'était encore qu'un temple virtuel de la cérémonie du thé, dans lequel le monde était relié au cosmos par l'acte rituel et l'esprit. Ce temple est désormais visitable et enveloppe le spectateur – une fois franchi le rituel Jardin de la purification – de ses éléments d'architecture traditionnels empruntés au temple Yumedono (de 739) à Nara, et avec des images transcendantes et des sons éthérés. Mori se réfère à l'idée que tous les sens sont liés, et se sert de la technologie de pointe aux fins de sensibilisation des sens humains et de l'esprit. Sa spiritualité est un merveilleux monde d'illusion, né de l'idée que l'existence humaine est limitée.

G. J.

SELECTED EXHIBITIONS →
1999 *Empty Dream*, Brooklyn Museum of Art, New York (NY), USA; *Dream Temple*, Fondazione Prada, Milan, Italy; *Esoteric Cosmos*, Kunstmuseum Wolfsburg, Germany; *Regarding the Beauty*, Hirshhorn Museum and Sculpture Garden, Washington D.C., USA; *Seeing Time*, San Francisco Museum of Art, San Francisco (CA), USA **2000** *Link*, Centre Georges Pompidou, Paris, France; *Sonic Boom: The Art of Sound*, Hayward Gallery, London, UK; *Apocalypse*, Royal Academy of Arts, London, UK **2001** *Miracle*, Gallery Koyanagi, Tokyo, Japan

SELECTED BIBLIOGRAPHY →
1999 *Dream Temple*, Fondazione Prada, Milan; *Esoteric Cosmos*, Kunstmuseum Wolfsburg; Burkhard Riemschneider/Uta Grosenick (eds.), *Art at the Turn of the Millennium*, Cologne **2001** Uta Grosenick (ed.), *Women Artists*, Cologne

1 **Dream Temple,** 1999, audio, metal, glass, synthetics, fibre optics, VisionDome, 3D semi-circular display, ø 10 m, height 5 m, installation view, *Apocalypse*, Royal Academy of Arts, London, 2000
2 **Kumano,** 1998, glass with photo interlayer, 5 panels, overall 305 x 610 x 2 cm

3 **Beginning of the End: Paris, La Defense,** 1996, crystal print, wood, pewter frame, 99 x 500 x 8 cm
4 **Burning Desire,** 1997/98, glass with photo interlayer, 5 panels, overall 305 x 610 x 2 cm

„Spirituelle Energie ist ewig; weder Tod noch Geburt können sie tangieren." « L'énergie spirituelle est éternelle, la mort ni la naissance ne peuvent l'atteindre. »

"Spiritual energy is eternal; no death or birth can touch it."

2

4

Sarah Morris

1967 born in London, lives and works in New York (NY), USA, and London, UK

Sarah Morris' colourful images modelled on architectural façades first brought her to public attention. Few artists have been as rigorous as this resident of New York and London in aesthetically translating the themes of "new urbanism". Her main interest is reserved for American conurbations, and in her three most recent projects – *Midtown (New York)*, 1998, *Las Vegas*, 2000, and *Capital (Washington)*, 2001 – Morris gave her attention to the special character of these exceptional cities. As a result of their particular cultural, commercial and political conditions, the cities' appearances differ markedly, and she treats each as a self-referential system. The artist creates a montage of scenes from everyday life, distinctive architectural features and media images that reflect the official image of each city, and arranges them in a rhythmically edited sequence. *Capital* features images of White House press conferences, presidential convoys and Washington airport receptions, scenes of Bill Clinton's period in office, contrasted with shots of dynamic city-dwellers jogging on Capitol Hill. The film is a visualisation of the almost imperceptible interweaving of power and daily urban routine. Morris combines film, soundtrack and photographs inside the exhibition space, thereby creating an overall atmosphere of density. Her paintings transform the structures of filmed images into sparkling, colourful grids. She creates seductive, high-gloss surfaces with foreshortened perspectives and spatial distortions. What at first glance seems like pure abstraction rapidly begins to act as a vortex. The viewer is drawn into the grids' imagined interior, and seems to become part of a digital game.

Bekannt wurde Sarah Morris durch ihre leuchtend bunten Bilder, die sie den architektonischen Konstruktionen von Fassaden nachbildet. Kaum jemand hat in den letzten Jahren die Themen „neuer Urbanität" so konsequent ästhetisch übersetzt wie die in New York und London lebende Künstlerin. Ihr Hauptinteresse gilt den amerikanischen Metropolen. In ihren drei jüngsten Projekten *Midtown (New York)*, 1998, *Las Vegas*, 2000, und *Capital (Washington)*, 2001, hat sich Morris dem speziellen Charakter dieser Ausnahmestädte gewidmet, deren Erscheinungsbild sich durch besondere kulturelle, kommerzielle und politische Gegebenheiten spektakulär unterscheidet und die sie als selbstreferenzielle Systeme behandelt. In rhythmisch geschnittener Abfolge montiert die Künstlerin Szenen aus dem täglichen Leben und architektonische Besonderheiten mit Medienbildern vom offiziellen Image dieser Metropolen. Im Film *Capital* sehen wir Bilder von Pressekonferenzen im Weißen Haus, Präsidentenkonvois, Empfangszeremonien am Washingtoner Flughafen – Szenen aus der Ära Bill Clinton, kontrastiert mit Aufnahmen dynamischer Großstädter, die auf dem Capitol Hill joggen. Der Film ist die Visualisierung des fast unmerklichen Verwobenseins von Macht und urbanem Alltag. Morris verbindet Film, Soundtrack und Bildserie im Ausstellungsraum zu einer athmosphärisch dichten Gesamtsituation. In ihren Gemälden verwandeln sich die Strukturen der Filmbilder in strahlend farbige Raster. Es entstehen verführerische Hochglanzoberflächen mit angeschnittenen Perspektiven und räumlichen Verzerrungen. Was auf den ersten Blick als reine Abstraktion erscheint, entwickelt schnell eine Sogwirkung: Wie in einem digitalen Spiel wird der Betrachter in ein imaginiertes Innenleben der Raster hineingezogen.

Sarah Morris s'est fait connaître par les tableaux lumineux et hauts en couleurs dans lesquels elle reproduit des constructions architectoniques de façades. Au cours des dernières années, cette artiste qui vit et travaille à New York et à Londres a su donner des thèmes de la « nouvelle urbanité » une traduction esthétique d'une rare cohérence en s'attachant principalement aux métropoles américaines. Dans ses trois derniers projets, *Midtown (New York)*, 1998, *Las Vegas*, 2000, et *Capital (Washington)*, 2001, elles s'est consacrée au caractère spécifique de ces villes tout à fait uniques, qui se distinguent de manière spectaculaire par leurs spécificités culturelles, commerciales et politiques, et qu'elle traite comme des systèmes autoréférentiels. Dans une séquence rythmée, l'artiste élabore des scènes de la vie quotidienne et des particularismes architectoniques à l'aide d'images tirées des médias et portant sur l'image officielle de ces métropoles. Dans le film *Capital*, nous voyons les images de conférences de presse données à la Maison Blanche, des cortèges présidentiels, des cérémonies d'accueil à l'aéroport de Washington – scènes de l'ère Clinton –, images qui contrastent avec celles de citadins dynamiques faisant leur jogging au Capitole. Ce film met en évidence l'entrelacement insensible entre le pouvoir et l'urbanité quotidienne. Dans l'espace d'exposition, la combinaison entre film, bande-son et série de tableaux, produit une situation générale d'une atmosphère extrêmement dense. Dans les peintures, les structures des images du film se transforment en radieuses trames colorées. De séduisantes surfaces ultra brillantes marquées par des perspectives coupées et de fortes distorsions spatiales apparaissent. Ce qu'un premier regard interprétait comme une pure abstraction déploie rapidement un fort pouvoir d'attraction : comme dans un jeu vidéo, le spectateur est englouti dans la vie imaginaire des trames.

A. K.

SELECTED EXHIBITIONS →
1997 *Hospital*, Galerie Max Hetzler, Berlin, Germany **1998** *djion/le consortium.coll*, Centre Georges Pompidou, Paris, France; *I love New York*, Museum Ludwig, Cologne, Germany **1999** *What if*, Moderna Museet, Stockholm, Sweden **2000** Kunsthalle Zürich, Zurich, Switzerland; *What if*, Moderna Museet, Stockholm, Sweden **2001** Friedrich Petzel Gallery, New York (NY), USA; *Correspondence*, Nationalgalerie im Hamburger Bahnhof, Museum für Gegenwart, Berlin, Germany

SELECTED BIBLIOGRAPHY →
1999 *Sarah Morris. Modern Worlds*, Oxford/Leipzig **2000** *Sarah Morris*, Kunsthalle Zürich, Zurich **2001** *Sarah Morris. Capital*, Cologne; Uta Grosenick (ed.), *Women Artists*, Cologne

1 **Federal Reserve (Capital)**, 2001, gloss household paint on canvas,
 214 x 214 cm
2 **Midtown**, 1998, 16 mm DVD, 9:36 min

3 Installation view, *Rumjungle*, White Cube², London, 2000
4 **SRHMRRS3**, 2001, gloss household paint on canvas, 257 x 198 cm

„Die Leere und die Eindimensionalität reflektierten die Dinge wie sie sind.
Es ist pervers, eine verführerische Leere zu kreieren.
Das Kunstwerk vermittelt ein verzerrtes Bild der Realität, indem es
Erfahrungen auf den Status von Kodierungen und Abbildern reduziert.
Ich vergrößere, verzerre und übertreibe. Ich trete auf's Gaspedal."

« Le vide et la planéité reflètent la manière d'être des choses.
Il est pervers de créer un vide séduisant. L'œuvre distord la réalité en
simplifiant les expériences en codes et en icônes. J'amplifie, je distords
et exagère. J'enfonce l'accélérateur. »

"The emptiness and flatness reflects the way things are.
It's perverse to create a seductive emptiness. The work distorts reality
by simplifying experiences into codes and icons. I amplify,
distort and exaggerate. I am putting a foot on the accelerator."

2

3

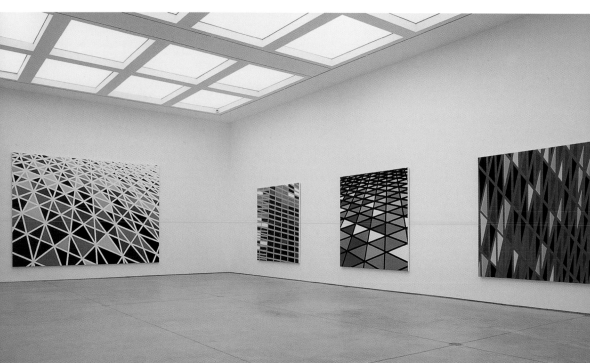

Vik Muniz

1961 born in São Paulo, Brazil, lives and works in New York (NY), USA

Vik Muniz produces witty, seductive photographic images. Their subjects are often comfortingly familiar: a well-known portrait of Sigmund Freud; a Pollock drip painting; Courbet's famous masterpiece "Origin of the World". But the satisfaction of recognition is unsettled when, on closer inspection, the Freud portrait and Pollock painting reveal themselves to be rendered in chocolate syrup, while the Courbet is crafted entirely out of dirt. The dexterity with which Muniz reconstructs these high art images contrasts with the low-brow associations of the materials he employs, creating a juncture through which their illusionism is clearly apparent. His photographs strip bare the mechanisms of representation to question the hierarchy between "original" and "reproduction" while delighting in the discrepancies that proliferate through displacement, interpretation and what he terms "the dynamic theater of visual forms". That the final photographic image is all that remains of his laboriously constructed set-ups hints at the ephemeral nature of human production. For a series entitled *Pictures of Dust*, 2001, he recreated archival images of key minimalist works entirely in dust gathered from the floor of the Whitney Museum of American Art in a succinct summation of the passing of time that can transform even the weightiest of art movements and the most reputable of institutions into dust, history and photographic souvenirs.

Vik Muniz produziert ebenso witzige wie verführerische fotografische Bilder. Die Motive seiner Arbeiten erscheinen häufig beruhigend vertraut: etwa ein bekanntes Sigmund-Freud-Porträt, ein Drip Painting von Pollock, Courbets berühmtes Meisterwerk „Der Ursprung der Welt". Bei näherem Hinsehen zeigt sich allerdings, dass das Freud-Porträt und das Pollock-Bild aus Schokoladensirup gestaltet sind und das Courbet-Werk ausschließlich aus Schmutz. Auf diese Weise wird die Freude über das Wiedererkennen aufseiten der Betrachters stets aufs Neue irritiert. Die Geschicklichkeit, mit der Muniz diese Produkte hoher Kunst rekonstruiert, kontrastiert merkwürdig mit dem „primitiven" Charakter der von ihm verwendeten Werkstoffe. Hinter der Überschneidung dieser beiden Ebenen tritt freilich der Illusionscharakter der Arbeiten umso deutlich zutage. Muniz' Fotografien machen den Mechanimus bildlicher Darstellung sichtbar und hinterfragen die hierarchische Beziehung zwischen „Original" und „Reproduktion". Sie verweisen aber auch auf die Diskrepanzen, die im Gefolge einer Delozierung oder Neuinterpretation und des von ihm so genannten „dynamischen Theaters der visuellen Formen" zu verzeichnen sind. Dass von seinen mit großem Fleiß geschaffenen „Vorlagen" nichts weiter bleibt als ein fotografisches Bild lässt sich aber auch als Verweis auf die Vergänglichkeit jeder menschlichen Produktion deuten. Für die *Pictures of Dust*, 2001, betitelte Serie hat er Archivbilder der wichtigsten Arbeiten des Minimalismus nachgeschaffen, und zwar ausschließlich aus Staub, den er auf dem Boden des Whitney Museum of American Art eingesammelt hat. Mit Hilfe dieser ungemein prägnanten Kondensation der vergehenden Zeit vermag er sogar die gewichtigsten Kunstrichtungen und die angesehensten Institutionen in nichts als Staub, Geschichte und fotografische Erinnerungen zu verwandeln.

Vik Muniz réalise des images photographiques séduisantes et spirituelles. Ses sujets nous sont souvent familiers : un célèbre portrait de Sigmund Freud, un drip painting de Pollock ou le fameux chef-d'œuvre de Courbet, « L'origine du monde ». Toutefois, la satisfaction d'avoir reconnu la source cède rapidement le pas au trouble quand, en regardant de plus près, le portrait de Freud et le tableau de Pollock s'avèrent réalisés avec du chocolat et le Courbet entièrement sculpté avec de la poussière. La dextérité avec laquelle Muniz reconstruit ces images d'art contraste avec les matériaux communs qu'il utilise, créant une jonction à travers laquelle l'illusionnisme apparaît clairement. Ses photographies mettent à nu les mécanismes de la représentation afin de contester la hiérarchie entre « l'original » et la « reproduction », tout en se délectant des divergences qui prolifèrent à travers le transfert, l'interprétation et ce qu'il qualifie de « théâtre dynamique des formes visuelles ». Le fait que l'image photographique finale soit tout ce qu'il reste de ses œuvres laborieusement construites souligne la nature éphémère de la production humaine. Pour une série intitulée *Pictures of Dust*, 2001, il a recréé des images d'archives d'œuvres phares du Minimalisme entièrement avec de la poussière recueillie sur le sol du Whitney Museum of American Art, sorte de résumé succinct du passage du temps, capable de transformer les mouvements artistiques les plus imposants et les institutions les plus respectables en poussière, en histoire et en souvenirs photographiques.

K. B.

SELECTED EXHIBITIONS →
1998 *Seeing is Believing*, International Center of Photography, New York (NY), USA; *XXIV Bienal Internacional de São Paulo*, Brazil **1999** Centre National de la Photographie, Paris, France; *Abracadabra*, Tate Gallery, London, UK **2000** *Whitney Biennial*, The Whitney Museum of American Art, New York (NY), USA **2001** Brazilian Pavilion (with Ernesto Neto), *49. Biennale di Venezia*, Venice, Italy; *Brazil: Body and Soul*, The Solomon R. Guggenheim Museum, New York (NY), USA; *Pictures of Dust*, The Whitney Museum of American Art, New York (NY), USA

SELECTED BIBLIOGRAPHY →
1993 *Vik Muniz, The Wrong Logician*, Grand Salon, New York (NY)/ Ponte Pietra, Verona **1995** *Panorama da Arte Contemporanea Brazileira*, Museu de Arte Moderna, São Paulo **1998** *Vik Muniz: Seeing is Believing*, Santa Fe (NM) **1999** *Vik Muniz*, Centre National de la Photographie and Caisse des Depots et Consignations, Paris **2001** *Vik Muniz/Ernesto Neto: Brasilconnects*, 49. Biennale di Venezia, Venice

1 **After Gerhard Richter (from pictures of Color)**, 2001, c-print, 276 x 191 cm
2 **Key**, 2002, toned gelatin silver print, 102 x 127 cm
3 **Disaster (from Pictures of Ink)**, 2000, Cibachrome, 102 x 127 cm
4 **Scissors**, 2002, toned gelatin silver print, 102 x 127 cm

„Illusionen, die so kräftig aufgetragen sind wie die von mir erzeugten, wecken im Betrachter ein Bewusstsein für den Täuschungscharakter visueller Informationen und für das Vergnügen, das solche Täuschungen gewähren."

« Les illusions aussi grossières que les miennes font prendre conscience des faux raisonnements de l'information visuelle et du plaisir que de telles erreurs peuvent procurer. »

"Illusions as bad as mine make people aware of the fallacies of visual information and the pleasure to be derived from such fallacies."

2

3

4

Takashi Murakami

1962 born in Tokyo, lives and works in Tokyo, Japan, and New York (NY), USA

Takashi Murakami plays on the originality and power of images in Japanese culture in an area between the traditional and the innovative. His version of a specifically Japanese contemporary art fuses Japanese painting, with its emphasis on surface, American Pop Art from Warhol to Koons, and the garish fantasy world of the Manga and Anime cartoons. The principle of interpenetrating the fine and applied arts is visible in the development and adaptation of stereotypical Pop paintings of popular figures, such as Mickey Mouse or Sailor Moon, and in the merchandising of ancillary objects from his production site "Hiropon Factory", created in 1995. Under his strict direction, perfectly crafted and arranged pictures and figures are created in the collective. He formulated his image of "Superflatness" with a manifesto and an exhibition, simultaneously maintaining a kind of style and avant garde thinking which up to that point had been encountered in Japanese art mostly as a Western import. Although the effect of Murakami's colourful art cosmos may seem on the surface like a Pop world of symbols and merchandise, his perceptions of the culture and identity of Japanese society are important for the national art world. They embody traumas, hopes and visions developed out of the Westernisation of Japanese culture, and aim to change the status and perception of contemporary art in Japan. On the one hand, these desires might seem childlike, but on the other they ponder the post-modern status quo of American culture in a very adult way. They are decorative and schizophrenic, while at the same time using their content to underline the originality of Japanese art.

Takashi Murakami setzt auf die Macht der Bilder und die Eigenständigkeit der japanischen Kultur zwischen Tradition und Innovation. In der Verschmelzung der japanischen flächenbetonten Malerei, der amerikanischen Pop-Art von Warhol bis Koons und den schrillen Fantasie-welten der Manga- und Anime-Kultur liegt seine Vorstellung einer spezifisch japanischen zeitgenössischen Kunst. Das Prinzip der Durchdringung von bildender und angewandter Kunst ist in der Entwicklung und Abwandlung stereotyper Pop-Malerei, von Populärfiguren wie Micky Maus oder Sailor Moon und im perfekten Merchandising von Auflagenobjekten aus seiner 1995 gegründeten Produktionsstätte „Hiropon Factory" ersichtlich. Im Kollektiv entstehen dort nach seiner Konzeption und unter seiner strengen Regie handwerklich perfekt arrangierte Bilder und Figuren. Mit einem Manifest und einer Ausstellung formulierte er seine Vorstellung der „Superflatness", gleichermaßen einem Stil- und Avantgardegedanken folgend, der der japanischen Kunst bislang zumeist als westliches Importgut begegnete. Wenngleich Murakamis bunter Kunstkosmos oberflächlich wie eine poppige Zeichen- und Warenwelt wirkt, sind seine Überlegungen zur Kultur und Identität der japanischen Gesellschaft wichtig für das nationale Betriebssystem Kunst. Sie verkörpern Traumata, Hoffnungen und Visionen, entwickelt aus der Verwestlichung der eigenen Kultur, und zielen auf die grundlegende Veränderung des Stellenwerts und der Wahrnehmung zeitgenössischer Kunst in Japan. Die kindlich anmutenden Wünsche reflektieren über ihre erwachsenen Attribute den postmodernen Status quo amerikanischer Kultur, sind dekorativ und schizophren, weisen jedoch zugleich inhaltlich weit darüber hinaus auf die Eigenständigkeit japanischer Kunst-produktion.

Takashi Murakami mise sur le pouvoir des images et l'autonomie de la culture japonaise entre tradition et innovation. Sa conception d'un art contemporain spécifiquement japonais réside dans la fusion entre la peinture nationale, qui privilégie la planéité, le Pop Art améri-cain – de Warhol à Koons – et les mondes imaginaires hauts en couleurs de la culture des mangas et des dessins animés. Le principe de l'interpénétration entre les arts plastiques et les arts appliqués apparaît clairement dans la mise au point et la déclinaison d'une peinture stéréotypée habitée de figures populaires comme Mickey ou Sailor Moon, et dans le parfait merchandising des multiples issus de sa « Hiropon Factory », site de production créé en 1995. Selon la conception et sous la direction rigoureuse de Murakami, ce collectif réalise des images et des figures d'une parfaite finition. Avec la publication d'un manifeste et une exposition, Murakami a formulé son idée de « superflatness », suivant en quelque sorte une idée stylistique d'avant-garde que l'art japonais n'a le plus souvent connu jusqu'à ce jour que comme une impor-tation occidentale. Même si l'univers artistique bigarré de Murakami est d'un effet aussi superficiel qu'un monde de signes et de produits de consommation affriolants, ses réflexions sur la culture et sur l'identité de la société japonaise jouent un rôle important dans le système de production artistique national. Elles incarnent les traumas, les espoirs et les visions développés à partir de l'occidentalisation de sa propre culture et visent à une profonde mutation dans l'appréciation et la perception de l'art contemporain au Japon. Par le biais de leurs attributs adultes, les désirs teintés d'infantilisme reflètent le statu quo postmoderne de la culture américaine. S'ils sont décoratifs et schizophrènes, leur contenu n'en va pas moins bien au-delà en tant qu'indicateur de l'autonomie de la production artistique japonaise.

G. J.

SELECTED EXHIBITIONS →
1998 *The Manga Age*, Museum of Contemporary Art, Tokyo, Japan **1999** *The Meaning of the Nonsense of the Meaning*, Center for Curatorial Studies, Bard College, Annandale-on-Hudson (NY), USA; *DOB in the Strange Forest*, Nagoya Parco Gallery, Nagoya, Japan; *Back Beat, Blum & Poe*, Santa Monica (CA), USA; *Carnegie International*, Carnegie Museum of Art, Pittsburgh (PA), USA **2000** *Marianne Boesky Gallery*, New York (NY), USA **2001** Museum of Contemporary Art, Tokyo, Japan; Museum of Contemporary Art, New York (NY), USA

SELECTED BIBLIOGRAPHY →
1996 *Tokyo Pop*, Hiratsuka Museum of Art, Kanagawa **1999** *The Meaning of the Nonsense of the Meaning*, Center for Curatorial Studies, Bard College, Annandale-on-Hudson (NY); *DOB in the Strange Forest*, Tokyo **2000** *Superflat*, Nagoya Parco Gallery, Tokyo **2001** Museum of Contemporary Art, Tokyo

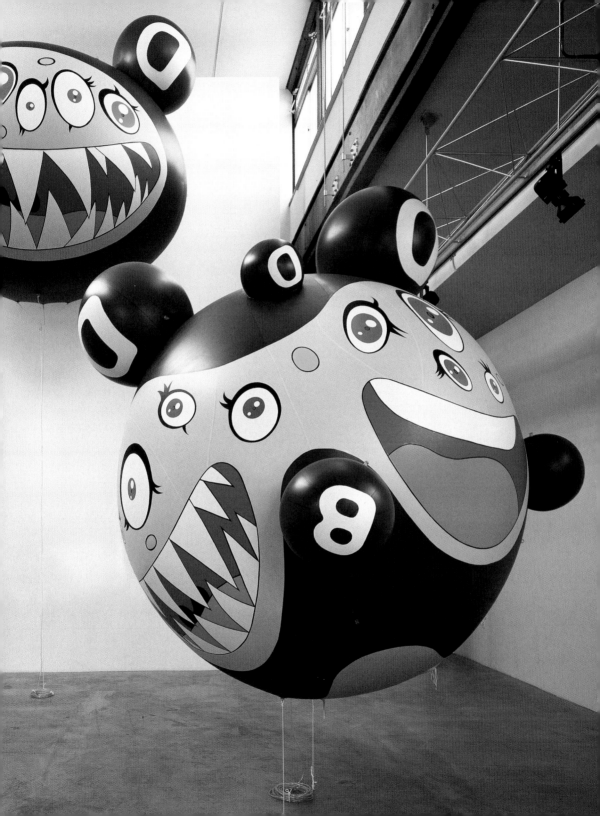

1 **Forest of DOB,** 1994, vinyl and helium, dimensions variable, installation view, Blum & Poe, Santa Monica (CA)
2 **My Lonesome Cowboy,** 1998, fibreglass, acrylic, oil paint, iron, 254 x 117 x 91 cm

3 **Hiropon,** 1997, fibreglass, acrylic, oil paint, iron, 178 x 112 x 99 cm
4 **The Castle of Tin Tin,** 1998, acrylic on canvas, 300 x 300 cm

„Für meine Generation besteht das Problem darin, ohne Rückgriff auf intellektuelle Gewissheiten originelle Produkte herzustellen, da wir uns der Unterschiede zwischen der Vorgehensweise der zeitgenössischen Kunst in den westlichen Ländern und den entsprechenden Verhältnissen in Japan bewusst sind."

« Le problème qui se pose à ma génération est de créer des produits originaux sans dépendre d'un système intellectuel, dans la mesure où nous sommes conscients des différences entre les démarches de l'art contemporain dans le monde occidental et la manière dont les choses fonctionnent au Japon. »

"The problem for my generation is to create original products without depending on an intellectual system for support, since we are aware of differences between the workings of contemporary art in the West and the way things operate in Japan."

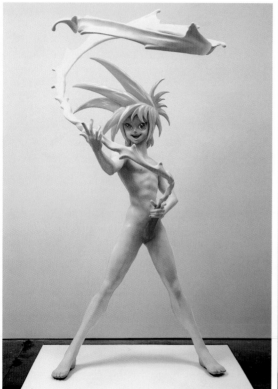

2

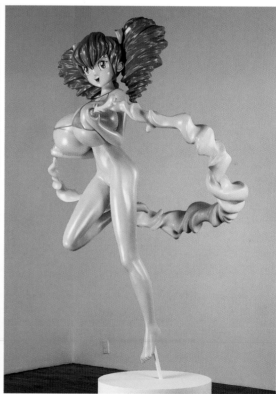

3

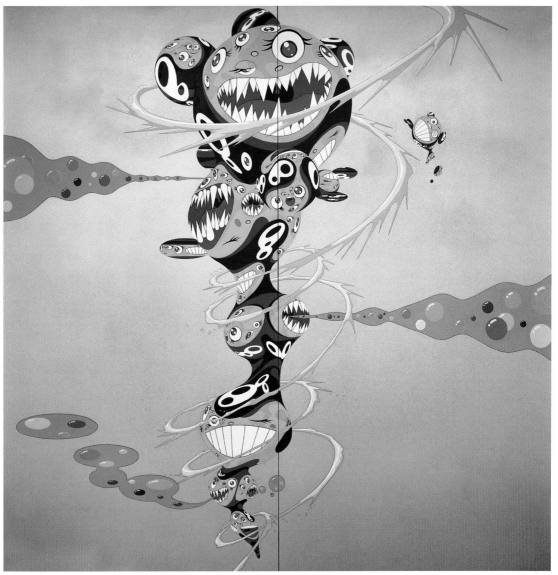

Yoshitomo Nara

1959 born in Hirosaki, lives and works in Tokyo, Japan

Rebellion is the basic principle of Yoshitomo Nara's art. As the artist himself was shaped by a carefree rural childhood and his big-city bases, Tokyo, Cologne and Los Angeles, so his work also swings between two opposite poles. His paintings, drawings and sculptures display an odd, dreamlike tension between aggressiveness and melancholy. His trademarks are children and dogs. Behind his subjects' apparent innocence is a clear potential for violence. They look shy, well brought-up and cute, their relationship to us, the viewers, defined by their great big eyes. Like sleepwalkers, they penetrate our unconscious, where the horror of daily life appears less virtual than real. Sometimes they appear sweet and loveable figures, sometimes malicious and threatening. Nara describes himself as a pop artist. Strongly influenced by rock and punk, by Japanese Manga comics and the well-ordered structure of Japanese society, his recollections of childhood happiness are traumatic portrayals of time lost for ever. His gentle paintings are shot through with the illusion of childhood and innocence, of an easy, sheltered existence. Ultimately, though, the feeling of hopefulness is one engendered by the adult world and hence emotionally loaded, so much so that we are forced to confront Nara's surreal world. But the artist, too, is growing older and his more recent work is less rebellious. Growing up also means acquiring experience and greater awareness. His highly idiosyncratic style, a cross between high and low culture, along with his enthusiasm for other areas of pop culture, have given Nara and his work cult status.

Rebellion ist das Grundprinzip der Kunst von Yoshitomo Nara. Geprägt von dem Gegensatz einer glücklichen Kindheit auf dem Land und den Großstädten Tokio, Köln und Los Angeles, wo er die meiste Zeit seines Lebens verbracht hat, pendelt sein Werk ebenfalls zwischen zwei Polen. Seine Gemälde, Zeichnungen und Skulpturen stehen unter einer seltsam entrückten Spannung von Aggressivität und Melancholie. Markenzeichen sind Kinder und Hunde, die hinter ihrer scheinbaren Unschuld ein metaphorisches Konfliktpotenzial offenlegen. Sie erscheinen isoliert und einsam, manchmal schüchtern, gut erzogen, irgendwie drollig; unser Verhältnis zur eigenen Geschichte zeigt sich in ihren großen Augen. Manchmal dringen sie schlafwandlerisch in unser Unterbewusstsein vor, in dem der alltägliche Horror weniger virtuell denn real erscheint. Mitunter sind Naras knuffige, liebenswerte Figuren aber auch böse und bedrohlich. Nara versteht sich und seine Kunst als Pop. Stark beeinflusst von Rock und Punk, von Manga-Comics und von der geordneten Struktur in der japanischen Gesellschaft, wirken die Werke wie Rückblicke auf die unbeschwerte Jugend, mitunter traumatische Schilderungen der verlorenen Zeit. Die Wirklichkeit und Illusion von Kindheit und Unschuld, von Unbeschwertheit und behütetem Glück durchschweben seine zarten Gemälde, letztlich stammen diese Erwartungshaltungen, denen wir in Naras Kosmos surreal gegenübertreten, jedoch aus einer Welt der Erwachsenen. Wenn Nara auch älter geworden ist und seine jüngeren Werke weniger rebellisch scheinen, so ist er doch seinem Reaktion fordernden Stil treu geblieben. Sein sehr eigenständiges Werk, die Vermittlung zwischen High und Low, wie seine Vorliebe zu anderen popkulturellen Bereichen – wie das Schreiben von Musikkritiken – haben die Person Nara und seinem Werk vor allem in seiner Heimat, in der er seit 2000 wieder lebt, Kultstatus erlangen lassen.

La révolte est le moteur fondamental de l'art de Yoshitomo Nara. Marqué par l'antinomie entre la campagne, où il passé une enfance heureuse et les villes de Tokyo, Cologne et de Los Angeles, où il a vécu la majeure partie de sa vie, son œuvre oscille aussientre des pôles binaires. Ses peintures, dessins et sculptures sont placés sous une tension passablement singulière entre agressivité et mélancolie. Un signe distinctif de ses œuvres apparaît avec des enfants et des chiens qui recèlent un potentiel conflictuel significatif sous une apparente innocence. Les enfants semblent bien éduqués, timides, d'une certaine manière amusants, et leurs grands yeux reflètent notre propre rapport à notre propre histoire. Ou alors ils entrent dans notre inconscient comme des somnambules, cet inconscient dans lequel l'horreur quotidienne se manifeste de manière moins virtuelle que réelle. Ils apparaissent parfois comme des êtres mignons, adorables, et ses aussi méchants et menaçants. Nara comprend sa propre personne et son art comme du pop. Fortement influencé par le rock et le punk, les mangas et la structure ordonnée de la société japonaise, ses aperçus rétrospectifs sur le bonheur de son enfance sont les descriptions traumatiques d'un temps perdu. L'illusion de l'enfance et de l'innocence, de l'insouciance et d'un bonheur protégé, tissent la trame de ses peintures délicates. Cependant, les attentes qu'elles révèlent appartiennent en définitive au monde des adultes ; et elles sont tellement chargées d'émotion que dans l'univers de Nara, elles apparaissent comme surréelles. Mais Nara a lui aussi fini par grandir, et ses œuvres récentes sont moins rebelles. Toute maturation ressort aussi de prises de conscience et d'expériences accumulées. Son style très indépendant, le lien entre haute et basse culture, ainsi que son amour pour d'autres domaines culturels populaires, ont conféré à l'œuvre et à la personne de Nara un statut culte.

G. J.

SELECTED EXHIBITIONS →
1995 SCAI The Bathhouse, Tokyo, Japan; *The Future of Paintings*, Osaka Contemporary Art Center, Osaka, Japan **1996** Tomio Koyama Gallery, Tokyo, Japan; *Tokyo Pop*, Hiratsuka Museum, Hiratsuka City, Japan **1997** Galerie Michael Zink, Regensburg, Germany **1999** Ginza Art Space, Tokyo, Japan **2000** Museum of Contemporary Art, Chicago (IL), USA; Marianne Boesky Gallery, New York (NY), USA **2001** Yokohama Museum of Art, Yokohama, Japan; *Painting at the Edge of the World*, Walker Art Center, Minneapolis (MN), USA

SELECTED BIBLIOGRAPHY →
1995 *In the deepest Puddle*, SCAI The Bathhouse, Tokyo **1998** *Slash with a Knife*, Tokyo **1999** *Ukiyo*, Tokyo **2001** *Yoshitomo Nara, Lullaby Supermarket*, Nuremberg

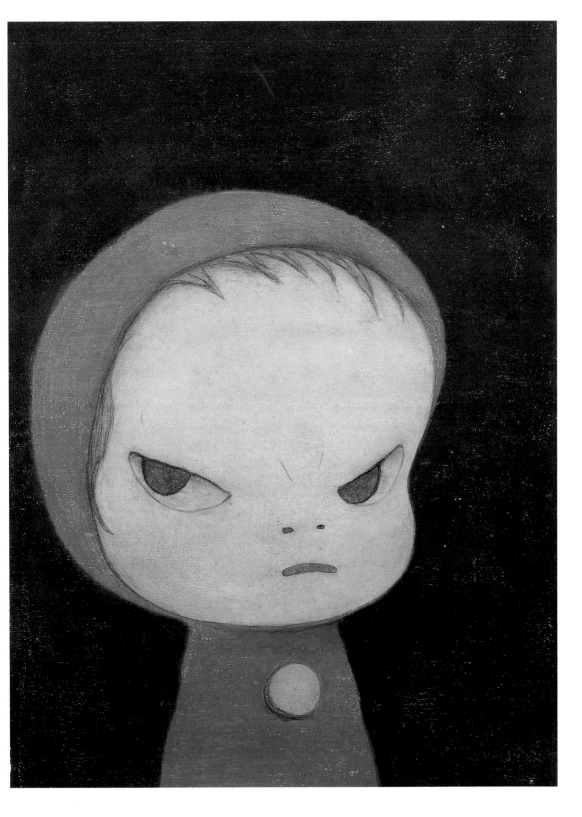

1 **Pyromaniac,** 1999, acrylic and coloured pencil on paper, 51 x 41 cm
2 **Sleepless Night-Sitting,** 1997, acrylic on cotton, 120 x 110 cm
3 **Strait Jacket,** 2000, acrylic on canvas, 234 x 208 cm

4 **Sprout the Ambassador,** 2001, acrylic on canvas, 213 x 183 cm
5 **Dogs From Your Childhood,** 1999, fibreglass, wood, fabric, acrylic paint,
 each dog 183 x 152 x 102 cm

„Ich mag Punk, aber nicht nur als Musik, sondern auch als Zeichen der
Unabhängigkeit."

« J'aime le Punk Rock, pas seulement comme musique, mais comme
manifestation d'indépendance. »

"I like punk rock, but not only as music, but as a sign of independence."

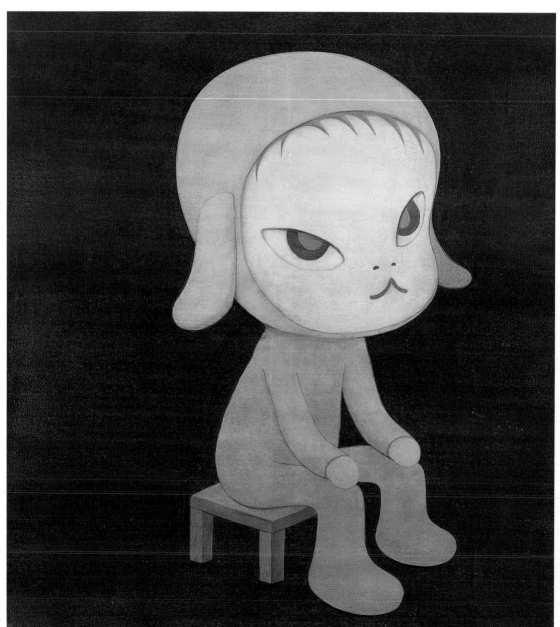

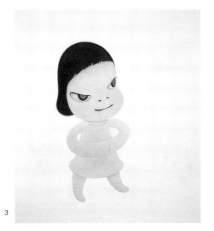

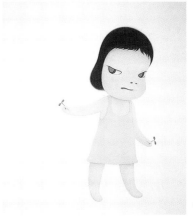

3

4

5

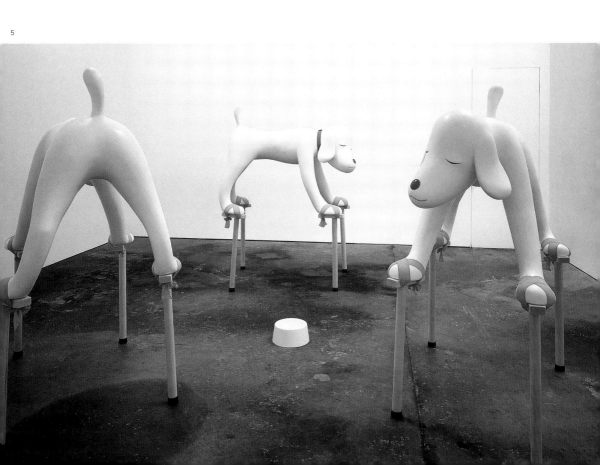

Shirin Neshat

1957 born in Qazvin, Iran, lives and works in New York (NY), USA

Islamic culture used to hold a fascination for the artistic imagination of the West, but now it has become a haunting, unruly Other. In her photographs and videos, Shirin Neshat unveils a political passion that resists the traditional representations of the "orient", especially the stereotypical images of women. What used to be considered seductive and innocent in the classical Western view of Islamic femininity, hits a counterblast in Neshat's images, with the representation of armed and violent women. In her own words, she wishes to pursue a "particular feminism rooted in Islam". *Speechless*, 1996, is a cultural confrontation conveyed by a woman's direct gaze at the viewer. In her work, Neshat uses timeless identification marks of Islamic culture – black chadors, traditional calligraphy – to localise the central conflicts of her work in a space where social law can be artistically examined. In her recent videos, Neshat focuses on emotional complexity within the discussion of identity. Her double-channel video work *Turbulent*, 1998, enacts a visual dialogue between the two screens. In the work's first half a man sings a traditional Sufi mystical poem, surrounded by other men. From the other screen a solitary woman responds, singing wordlessly, with haunting sounds, provoking shocked reactions from the male audience opposite. The duality at stake in the work, between male and female space, organised discourse and disorganised sound, is never redeemed. Isolated from each other, the two protagonists observe separate, almost antagonistic codes of culturally prescribed behaviour, each from their own side of the gallery space.

Früher einmal hat die islamische Kultur auf die künstlerische Vorstellungskraft des Abendlandes eine immense Faszination ausgeübt, während sie heute nur mehr als gespenstisches, aufsässiges Anderes vorkommt. In ihren Fotografien und Videos offenbart Shirin Neshat eine politische Leidenschaft, die sich den traditionellen Darstellungen „des" Orients widersetzt, besonders dem klischeehaften Frauenbild. Was in der klassischen westlichen Wahrnehmung islamischer Weiblichkeit einmal als verführerisch und unschuldig galt, wird durch Neshats Bilder, auf denen bewaffnete, gewaltbereite Frauen zu sehen sind, einfach hinweggefegt. Nach eigener Aussage möchte sie „einen im Islam verwurzelten speziellen Feminismus" erkunden. So handelt es sich etwa bei *Speechless*, 1996, um einen Akt der kulturellen Konfrontation, da die dort abgebildete Frau den Betrachter direkt ansieht. Neshat verwendet zeitlose Symbole der islamischen Kultur, etwa schwarze Tschadors oder traditionelle Kalligrafie, um die zentralen Konflikte ihres Schaffens in einer Dimension zu verorten, die eine künstlerische Auseinandersetzung mit der sozialen Wirklichkeit ermöglicht. In ihren neueren Videos beschäftigt sich Neshat im Kontext des aktuellen Identitätsdiskurses vor allem mit der Frage der emotionalen Komplexität. So hat sie etwa in ihrer Videoarbeit *Turbulent*, 1998, einen Dialog zwischen zwei Projektionsflächen inszeniert. Im ersten Teil der Präsentation singt ein Mann im Kreis anderer Männer ein traditionelles Sufi-Gedicht. Auf dem gegenüberliegenden Bildschirm antwortet eine einzelne Frau, indem sie – wortlos – ergreifende Klänge singt und damit beim männlichen Publikum auf dem Monitor gegenüber schockierte Reaktionen auslöst. Die Dualität zwischen männlich und weiblich besetztem Raum, zwischen organisiertem Diskurs und desorganisiertem Klang, um die es in dem Werk geht, wird nicht zum Verschwinden gebracht. Voneinander abgeschottet, folgen die Protagonisten grundverschiedenen, fast antagonistischen Verhaltensmustern und bleiben, jeder auf seiner Seite des Raums, unaufhebbar getrennt.

Autrefois, la culture islamique fascinait l'imagination artistique de l'Occident mais, aujourd'hui, elle est devenue l'Autre, hantante et indisciplinée. Dans ses photographies et ses vidéos, Shirin Neshat dévoile une passion politique qui résiste aux représentations traditionnelles de « l'Orient », et notamment aux images stéréotypées de la femme. La vision classique occidentale de la féminité islamique, présentée comme séduisante et innocente, trouve une riposte vigoureuse dans les images de Neshat montrant des femmes armées et violentes. Selon ses propres termes, elle souhaite traiter un « féminisme particulier enraciné dans l'islam ». *Speechless*, 1996, est une confrontation culturelle traduite par le regard direct d'une femme qui fixe le spectateur. Neshat utilise des repères atemporels de la culture islamique – les tchadors noirs, la calligraphie traditionnelle – pour localiser les conflits au cœur de son travail dans un espace où la loi sociale peut être examinée sur le plan artistique. Dans ces vidéos récentes, Neshat traite la complexité émotionnelle au sein du débat sur l'identité. *Turbulent*, 1998, recrée un dialogue visuel entre deux écrans vidéo. Pendant la première moitié de l'œuvre, un homme chante un poème mystique soufi traditionnel entouré de collègues masculins. Sur l'autre écran, une femme seule lui répond, chantant sans paroles, émettant des sons troublants qui provoquent des réactions choquées de la part des hommes à côté. La dualité dans son œuvre, entre l'espace féminin et masculin, entre le discours organisé et le son désorganisé, ne connaît aucune rédemption. Les deux protagonistes suivent des codes de comportement séparés, presque antagonistes, dictés par la culture, chacun isolésdans son coin de la galerie.

L. B. L.

SELECTED EXHIBITIONS →
1998 Tate Gallery, London, UK **1999** Malmö Konsthall, Malmö, Sweden; *48. Biennale di Venezia*, Venice, Italy **2000** Serpentine Gallery, London, UK; Kunsthalle Wien, Vienna, Austria; *Biennale of Sydney*, Australia; *Kwangju Biennale*, Kwangju, South Korea; *Whitney Biennial*, Whitney Museum of American Art, New York (NY), USA **2001** Barbara Gladstone Gallery, New York (NY), USA; *Biennial de Valencia*, Spain

SELECTED BIBLIOGRAPHY →
1997 *Shirin Neshat*, Marco Noire Contemporary Art, Turin **1999** *Cream. Contemporary Art in Culture*, London **2000** *Shirin Neshat*, Kunsthalle Wien, Vienna/Serpentine Gallery, London **2001** Uta Grosenick (ed.), *Women Artists*, Cologne; Farzeneh Milani, *Shirin Neshat*, Milan; Octavio Zaya/Yuko Hasegawa/Fumihiko Sumitomo, *Shirin Neshat*, Office for Contemporary Art Museum Construction, Kanazawa

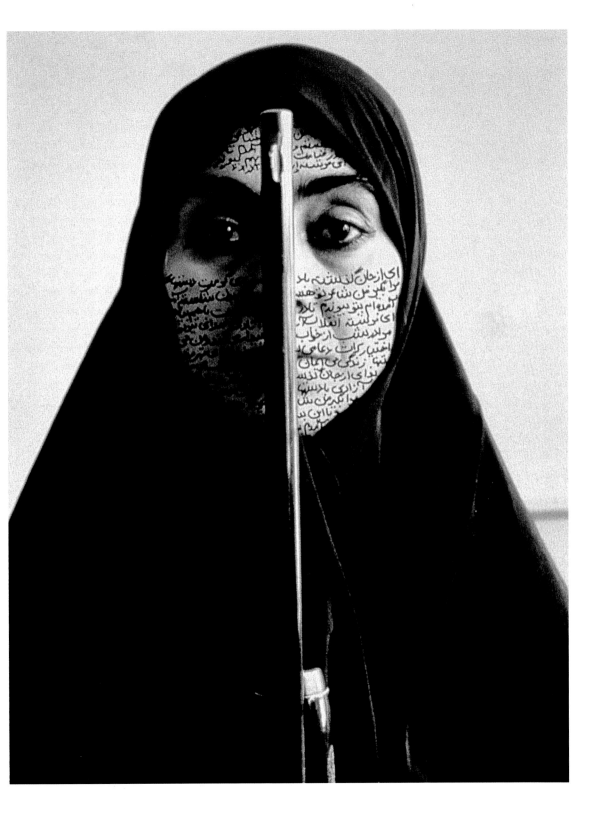

1 **Rebellious Silence,** 1994, gelatin silver print, ink, 36 x 28 cm
2 **Passage,** 2001, production still

3 **The Shadow under the Web,** 1997, video stills
4 **Pulse Series,** 2001, cibachrome print, 45 x 59 cm

„In der gesamten Geschichte haben muslimische Frauen Seite an Seite mit Männern an der Front gekämpft. Hier haben die Frauen an der Verantwortung und den Konsequenzen des Märtyrertums Anteil gehabt. Dabei lässt sich ein merkwürdiges Nebeneinander von Weiblichkeit und Gewalt beobachten."

« Tout au long de l'histoire, les femmes musulmanes ont lutté aux côtés des hommes sur la ligne de front. Elles ont partagé la responsabilité et le coût du martyre. On observe une étrange juxtaposition entre la féminité et la violence. »

"Throughout history, Islamic women have fought alongside men in the line of duty. Here women have shared the responsibility and the cost of being martyred. You can witness a strange juxtaposition between femininity and violence."

2

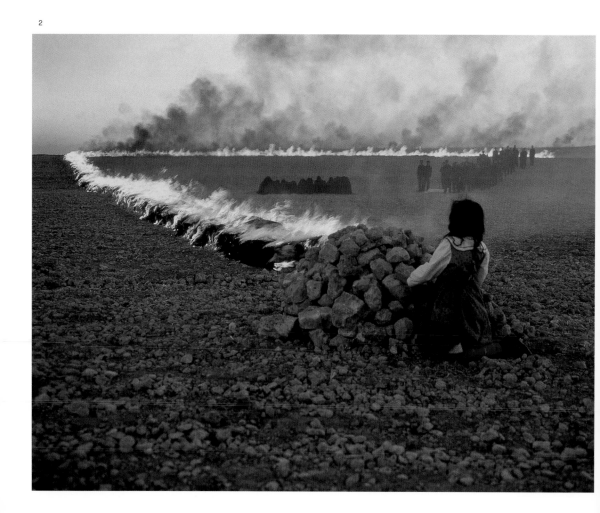

3

4

Ernesto Neto

1964 born in Rio de Janeiro, lives and works in Rio de Janeiro, Brazil

Ernesto Neto's *Naves* are tent-like structures made of lycra that envelop viewers in transparent, multi-sensory environments. The *Naves,* which means "spaceships" in Portuguese, are suspended, anchored, and balanced within the gallery space by counter-weights filled with sand and other materials. Neto also creates room-scale installations, such as *It happens on the friction of the bodies,* 1998, and *We fishing the line,* 1999, that utilise the pliable fabric to create column-like forms that are suspended from above and filled with cumin, turmeric and cloves. The spices not only add colour to the bases of the organic forms, but also suffuse the gallery with rich aromas. The fabric containers, contorted by the weight of their contents, are configured in playful arrangements that surround viewers and activate the senses. The body is at the forefront of Neto's artistic practice, and many of his pieces are womb-like. Formal, conceptual and metaphoric comparisons can be drawn between the fabric of the work, human skin and architectural membranes, all of which are barriers as much as portals. While Neto's work is sensuous and organic, it also demonstrates an attention to geometry, order and balance – an apparent opposition that has played a key role in Brazilian art since the middle of the 20th century. Working in the tradition of the Neo-Concrete movement, Neto uses modest materials to engage viewers, while connecting emotional and rational approaches to art production. Many of the classic sculptural concerns, such as mass and gravity, colour and form, are important to Neto in his exploration of the sensuality of his materials.

Die *Naves* von Ernesto Neto sind zeltartige Konstruktionen aus Lycra, die den Betrachter in eine alle Sinne ansprechende transparente Welt versetzen. Im Ausstellungsraum sind die *Naves* (portugiesisch: Raumschiffe) durch ein System von – mit Sand und anderen Materialien gefüllten – Gegengewichten aufgehängt, verankert und stabilisiert. In seinen raumfüllenden Installationen – etwa *It happens on the friction of the bodies,* 1998, und *We fishing the line,* 1999, gestaltet Neto aus dem formbaren Kunststoff säulenartige, von oben herabhängende Formen. Gefüllt mit Kreuzkümmel, Kurkuma und Nelken, leuchten die unteren Bereiche der organischen Formen farbig und durchdringen mit ihrem Duft den ganzen Galerieraum. Die unter dem Gewicht ihrer Ladung verformten Lycra-„Beutel" sind in verspielten Arrangements angeordnet, die von allen Seiten auf den Betrachter einwirken und seine Sinne aktivieren. Der Körper steht im Zentrum von Netos künstlerischem Schaffen; viele seiner Arbeiten lassen an einen Uterus denken. Konzeptuelle und metaphorische Vergleiche zwischen dem Arbeitsmaterial, der menschlichen Haut und den verschiedensten architektonischen Membranen drängen sich auf, da all diese ebenso trennen wie verbinden. Aber Netos Werk besticht nicht nur durch seine Sinnlichkeit und seinen organischen Charakter, es richtet die Aufmerksamkeit zugleich auch auf Fragen der Geometrie, der Ordnung und der Balance – ein scheinbarer Widerspruch, der bereits seit Mitte des 20. Jahrhunderts im Zentrum der brasilianischen Kunst steht. In der Tradition der neo-konkreten Kunst verwendet Neto eher unscheinbare Materialien, um den Betrachter in den Bann zu ziehen, während in seinem Kunstschaffen zugleich emotionale und rationale Kriterien eine Verbindung eingehen. In der Erkundung der sinnlichen Eigenschaften seiner Materialien setzt Neto sich auch mit den Grundfragen der klassischen Bildhauerei auseinander, etwa dem Verhältnis von Masse und Schwerkraft, Farbe und Form.

Les *Naves* d'Ernesto Neto sont des sortes de tentes en lycra qui enveloppent les spectateurs dans des environnements transparents et multisensoriels. Ces *Naves,* qui signifient « vaisseaux spatiaux » en portugais, sont suspendues, ancrées, équilibrées dans l'espace de la galerie par des contrepoids remplis de sable et d'autres matériaux. Neto crée aussi des installations à l'échelle de la pièce, tels que *It happens on the friction of the bodies,* 1998, et *We fishing the line,* 1999, qui utilisent des matières malléables pour créer des colonnes suspendues au plafond et remplies de cumin, de curcuma et clous de girofle. Outre le fait d'ajouter de la couleur à la base des colonnes, les épices diffusent de riches arômes dans la galerie. Ces contenants, déformés par le poids de leurs contenus, sont disposés d'une manière ludique de sorte à entourer les spectateurs et à activer leurs sens. Le corps est au premier plan de la pratique artistique de Neto : bon nombre de ses pièces sont comme des ventres. On peut établir des comparaisons formelles, conceptuelles et métaphoriques entre la matière de l'œuvre, la peau humaine et les membranes architecturales, toutes étant des barrières ainsi que des portes. Si le travail de Neto est sensuel et organique, il est également attentif à la géométrie, à l'ordre et à l'équilibre, une opposition apparente qui joue un rôle clef dans l'art brésilien depuis le milieu du 20ème siècle. En travaillant dans la tradition du mouvement Néoconcret, Neto utilise des matériaux humbles pour séduire le spectateur tout en associant ses démarches émotionnelles et rationnelles à la réalisation de l'œuvre d'art. Dans son exploration de la sensualité des matériaux, il attache également une grande importance aux préoccupations de la sculpture classique, telles que la masse et la gravité, la couleur et la forme. Ro. S.

SELECTED EXHIBITIONS →
1998 *XXIV Bienal Internacional de São Paulo,* Brazil **1999** Contemporary Arts Museum, Houston (TX), USA; *Carnegie International,* Carnegie Museum of Art, Pittsburgh (PA), USA **2000** Institute of Contemporary Arts, London, UK; SITE Santa Fe (NM), USA; Wexner Center for the Arts, Columbus (OH), USA; *Wonderland,* Saint Louis Art Museum, St. Louis (MS), USA **2001** *Matrix 190,* University Art Museum, Berkeley (CA), USA; Brazilian Pavilion, *49. Biennale di Venezia,* Venice, Italy

SELECTED BIBLIOGRAPHY →
1998 Carlos Basualdo, *Ernesto Neto,* São Paulo **1999** *Ernesto Neto: naves, ceus, sonhos,* Galeria Camargo Vilaça, São Paulo; *Carnegie International,* Carnegie Museum of Art, Pittsburgh (PA) **2000** *Wonderland,* Saint Louis Art Museum, St. Louis (MS) **2001** *MATRIX 190: Ernesto Neto,* University Art Museum, Berkeley (CA)

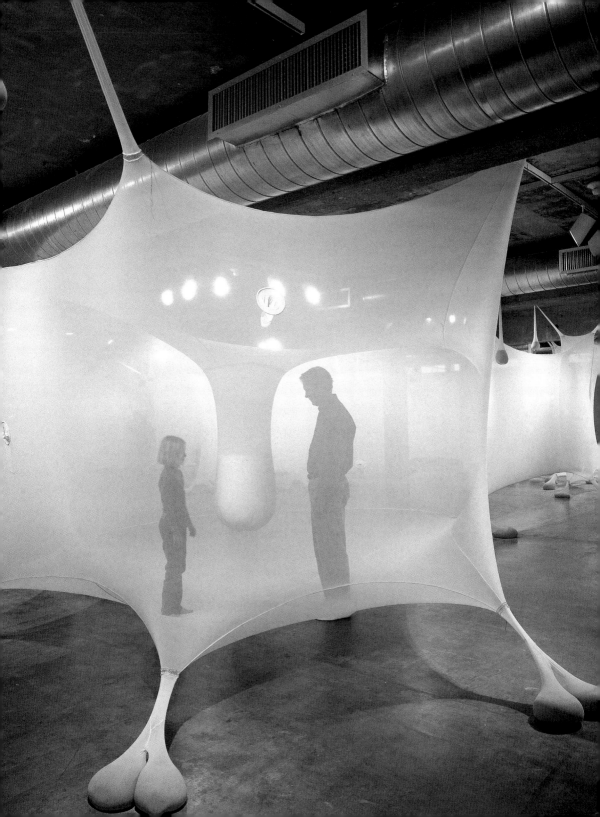

1 **Nhó Nhó Nave,** 1999, stocking, sand, installation view, Contemporary Arts Museum, Houston (TX)
2 **The Ovaloids' Meeting,** 1998, stocking, styrofoam, installation view, Tanya Bonakdar Gallery, New York (NY)

3 **O Bicho,** 2001, textile, spices, c. 5 x 12 x 12 m, installation view, Arsenale, *49. Biennale di Venezia,* Venice
4 **Walking in Venus blue cave,** 2001, stocking, styrofoam, buttons, incandescent lights, 396 x 777 x 833 cm, installation views, *Only the amoebas are happy,* Tanya Bonakdar Gallery, New York (NY)

„Ich stelle mir den Körper gerne zugleich als architektonisches Bauwerk und als Landschaft vor."

« J'aime à imaginer le corps comme étant à la fois une construction architecturale et un paysage. »

"I like to think of the body as both an architectural construction and a landscape."

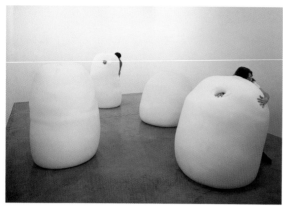

2

3

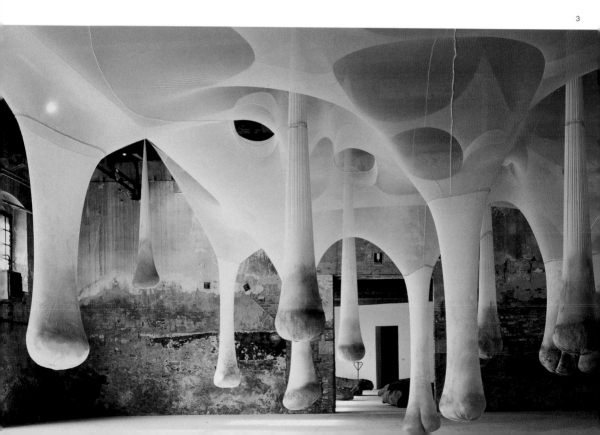

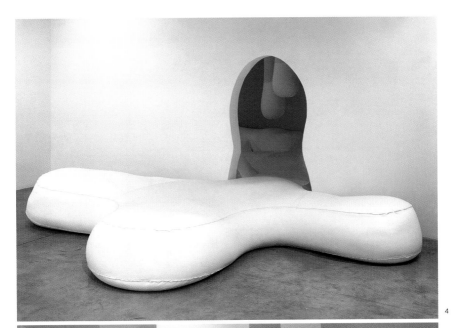

4

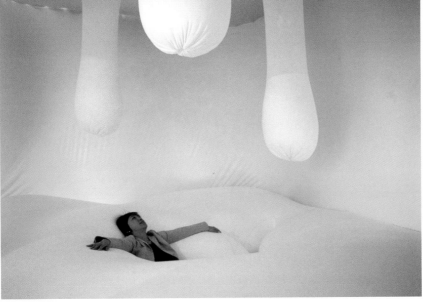

Manuel Ocampo

1965 born in Quezon, Philippines, lives and works in Berkeley (CA), USA

At first sight, Manuel Ocampo's pictures recall "alternative" political comic strips. Firstly, the similarities with the genre lie in their combination of figurative representation, typical of political and pop-cultural humour, with their pornographic and scatological references, and their religious symbolism, which all come together to create apocalyptic scenarios. Secondly, Ocampo's smoothly executed canvases share with comic strips a kind of even-handedness in the interpretation of such diverse sources of inspiration. His work is deliberately intended to provoke. He places devotional images from his native Philippines side by side with swastikas or Ku Klux Klan hoods. By contrast, his paintings are executed in distinctively brilliant colours. With their combination of imagery and lettering, they resemble the sleeves of heavy metal LPs. Rather than displaying any sense of stylistic or idiomatic continuity, Ocampo's art relies on a collage-like assembly of opposites: tradition and pop culture, innocence and horror, decoration and social critique. His allegorical juxtaposition of conflicting images produces a colonialist view of the cultures of the so-called developing countries. Through ironically introducing the historical and religious symbols of the Western world, Ocampo satirises, sometimes cynically and sometimes with black humour, their iconic status and claims to authority. For example, *God*, 1991, shows huge cockroaches in a mandorla, while bloodstained knives replace the insignia of Christ. In *Untitled (Burnt-Out Europe)*, 1992, Jesus wears both the crown of thorns and eagle's wings emblazoned with swastikas. Ocampo's painting points the finger at pain and torture as negative instruments of power in the history of colonial lands.

Die Bilder von Manuel Ocampo erinnern auf den ersten Blick an politische Comics aus dem subkulturellen Bereich. Die Ähnlichkeiten zu diesem Genre liegen zum einen in der Kombination von Figürlichem aus politischen und popkulturellen Kontexten mit pornografischen Darstellungen, Fäkalischem und sakraler Symbolik zu apokalyptischen Szenen, und zum anderen in der medialen Glättung dieser heterogenen Bildquellen, die bei Ocampo auf der gleichmäßig behandelten Leinwand stattfinden. Seine Bildthemen provozieren, so stellt er zum Beispiel Votivbilder seiner philippinischen Heimat neben Hakenkreuze oder Ku-Klux-Klan-Kapuzen. Im Kontrast dazu steht die ausgeprägte strahlende Farbigkeit seiner Bilder. In der Kombination mit Schriftzügen erinnern die Arbeiten an Plattencover, etwa aus der Heavy-Metal-Szene. Vielmehr als in einer stilistischen oder idiomatischen Kontinuität liegt das Prinzip der Kunst Ocampos in der collageartigen Zusammenführung von Gegensätzen: Tradition und Popkultur, Unschuld und Horror, Dekoration und soziale Kritik. Allegorisch verwendet, widersetzen sich Ocampos Zeichenkombinationen einem kolonialistischen Blick auf die Kulturen so genannter Entwicklungsländer. Durch Einsatz der Symbole westlicher Geschichte und Religion konterkariert Ocampo in seinen Bildern ironisch, teils zynisch oder von schwarzem Humor geleitet deren hegemonialen Anspruch. Beispielsweise sind riesige Küchenschaben in einer Mandorla dargestellt und tragen anstelle der Insignien Christi blutige Messer (*God*, 1991), oder Jesus wird mit Dornenkrone und dem Körper eines Adlers versehen, auf dessen Flügeln Hakenkreuze angebracht sind (*Untitled [Burnt-Out Europe]*, 1992). Ocampos Malerei benennt Schmerz und Qual als negative Kräfte in der Geschichte der kolonialisierten Länder.

Au premier regard, les tableaux de Manuel Ocampo rappellent les bandes dessinées politiques issues du domaine subculturel. Les rapprochements avec ce genre résident d'une part dans la combinaison de scènes figurées tirées du contexte politique et de la culture pop, d'images pornographiques, d'aspects fécaux et de symboliques sacrées en scènes apocalyptiques, et d'autre part dans le lissage médiatique de ces sources iconiques hétérogènes dans une peinture homogène. Les thèmes picturaux d'Ocampo sont provocateurs. C'est ainsi qu'il juxta-pose des images votives de sa patrie philippine et des croix gammées ou des capuches du Ku-Klux-Klan. Contrastant avec ces symboles, on trouve une polychromie franchement radieuse. Avec l'intégration d'éléments textuels, ses œuvres rappellent les créations des pochettes de disques, notamment du domaine du « heavy-metal ». Plus que dans la continuité stylistique ou idiomatique, le principe de l'art d'Ocampo réside dans un assemblage d'oppositions qui tient de la collage : tradition et culture pop, innocence et horreur, décoration et critique sociale. Utilisées allégoriquement, les combinaisons de signes d'Ocampo se dressent contre le regard colonialiste porté sur les cultures des pays dits en voie de développement. En faisant appel aux symboles de l'histoire et de la religion occidentales, Ocampo contrecarre leurs visées hégémoniques d'une manière ironique, parfois empreinte de cynisme et d'humour noir. D'immenses blattes sont représentées dans une mandorle avec des couteaux sanglants au lieu des insignes du martyre du Christ (*God*, 1991), ou bien Jésus est affublé d'une couronne d'épines et d'un aigle dont les ailes portent des croix gammées (*Untitled [Burnt-Out Europe]*, 1992). La peinture d'Ocampo dénonce la souffrance et la torture comme des forces négatives dans l'histoire des pays colonisés.

N. M.

SELECTED EXHIBITIONS →
1992 *documenta IX*, Kassel, Germany; *Helter Skelter*, The Museum of Contemporary Art, Los Angeles (CA), USA **1997** *Kwangju Biennial*, Kwangju, South Korea **1999** *Faith: The Impact of Judeo-Christian Religion on Art at the Millennium*, The Aldrich Museum of Contemporary Art, Ridgefield (CT), USA **2001** *49. Biennale di Venezia*, Venice, Italy; *2. berlin biennale*, Berlin, Germany; *Vom Eindruck zum Ausdruck – Grässlin Collection*, Deichtorhallen Hamburg, Germany; Galería OMR, Mexico City, Mexico

SELECTED BIBLIOGRAPHY →
1995 *Manuel Ocampo, Virgin Destroyer*, Honolulu (HI)
1997 *Manuel Ocampo, Heridas de la Lengua*, Santa Monica (CA)
1998 *Yo Tambien Soy Pintura*, Museo Extremeño e Iberoamericano de Arte Contemporaneo, Badajoz

1 **A Moral Exorcism Meaningless Outside a Ritualistic Sense of Artistic Heroism,** 2000, acrylic on canvas, 213 x 167 cm

2 **The Failure to Express is its Expression/the Stream of Object Making Consciously Working Towards the Goal,** 2000, 15 panels, acrylic on wood,

various sizes, 2 hammocks, 2 hubble-bubbles, porn magazine, wig, c. 7 x 8 m, installation view, Galerie Michael Neff, Frankfurt am Main

3 **The World is Full of Objects More or Less interesting,** 1998, acrylic and collage on canvas, 154 x 122 cm

„Ich möchte mit den Mitteln der Malerei buchstäblich eine Landschaft entstehen lassen, nicht nur ein Fenster, durch das man in einen imaginierten Raum blickt, sondern eine wirkliche Umgebung."

« Je cherche à créer une géographie directe à l'aide de la peinture : pas seulement une fenêtre ouverte sur un espace imaginaire, mais un environnement. »

"I want to create a literal landscape with painting, not just a window into an imagined space, but an environment."

2

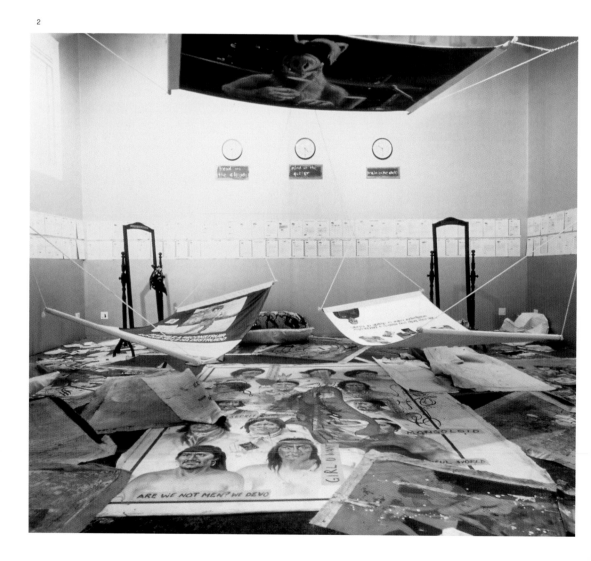

Albert Oehlen

1954 born in Krefeld, lives and works in Cologne, Germany

Albert Oehlen called his first exhibition, staged in 1982 at the Max Hetzler gallery in Stuttgart, *Bevor ihr malt, mach ich das lieber* (Before you paint, I prefer to do it myself). And that's the way he has continued. He still feels a sense of responsibility, and sets an example with every picture. It is part of Oehlen's charm that he avoids any clear meaning, but he can always offer a point of view. He presents contemporary painting and, at the same time, the clichés of contemporary painting. Oehlen is constantly exploring new ideas, whether they involve brandishing a brush or switching on the computer or laying six million tiny stones to create a floor mosaic, as he did at EXPO 2000. Along with Werner Büttner, Georg Herold and Martin Kippenberger, he was one of the enfants terribles of the 1980s art scene. Together with Albert's brother Markus Oehlen these artists carried out extremely successful experiments with Germany's image and understanding of itself as a nation. Titles of the mid-Eighties, such as *Morgenlicht fällt ins Führerhauptquartier* (Morning Light in the Führer's Headquarters) charged painting with unusual content, self-assuredly establishing new planes of visual imagery. In the 1990s, Oehlen adopted a new strategy. Motifs went by the board; now the whole concept of art was in question. Abstract painting demanded a virtuosity that he realised he would have to achieve for himself – the finest and greatest challenge for an artist like Oehlen. As a counterpoint to his oil paintings, he produced bold and simple computer-generated collages. His agenda still includes attacking art and discovering its weak points. As he said in an interview with Rainald Goetz, "one has to go joyfully berserk".

Seine erste Einzelausstellung, 1982 bei Max Hetzler in Stuttgart, nannte Albert Oehlen *Bevor ihr malt, mach ich das lieber*. Dabei ist es geblieben. Bis heute fühlt er sich verantwortlich und gibt ein Vorbild, Bild um Bild. Es gehört zu seinem Charme, dass Oehlen jede Eindeutigkeit meidet, aber immer eine Haltung anbieten kann. Er präsentiert zeitgenössische Malerei und gleichzeitig das Klischee der zeitgenössischen Malerei – ob er dafür den Pinsel schwingt oder den Computer anwirft oder sechs Millionen Steinchen zu Bodenmosaiken verlegen lässt, wie auf der EXPO 2000. In den achtziger Jahren gehörte er zusammen mit Werner Büttner, Georg Herold und Martin Kippenberger zu den Enfants terribles der Kunstszene. Zusammen mit Alberts Bruder Markus Oehlen haben diese Künstler mit dem bundesdeutschen Selbstbildnis und Selbstverständnis die gelungensten Experimente angestellt – Titel aus der Mitte der achtziger Jahre wie *Morgenlicht fällt ins Führerhaupt-quartier* luden die Malerei mit ungewohnten Botschaften auf, die selbstbewusst neue Bildebenen etablierten. In den neunziger Jahren wechselte Oehlen die Strategie. Das Motiv war ausgezählt, nun ging es der Malerei direkt an den Kragen. Die abstrakte Malerei fordert eine Virtuosität, die nach seinem Verständnis sich selbst besiegen müsste – die schönste und größte Herausforderung für einen Künstler wie Oehlen. Wie ein Kontrapunkt zu den Ölbildern erscheinen die plakative Bildsprache und klaren Formen der computergenerierten Collagen, die folgten. Die Kunst attackieren und den wunden Punkt suchen, ist immer noch sein Programm. „Man muss ein fröhlicher Berserker sein", meinte Oehlen im Gespräch mit Rainald Goetz.

A sa première exposition, présentée en 1982 à la Galerie Max Hetzler à Stuttgart, Albert Oehlen avait donné pour titre : *Bevor ihr malt, mach ich das lieber* (Avant que vous peigniez, je préfère le faire moi-même). Rien n'a changé depuis. Jusqu'à ce jour, l'artiste se sent responsable et, tableau après tableau, propose toujours un modèle. Une partie de son charme repose sur le fait qu'Oehlen évite toute évidence, tout en étant à tout moment capable d'affirmer une position. Il présente tout à la fois de la peinture contemporaine et un cliché de la peinture contemporaine. Oehlen se reconçoit donc sans cesse, qu'il manie le pinceau, qu'il se mette à l'ordinateur ou qu'il fasse arranger les six millions d'éléments d'une mosaïque de sol comme il le fit pour l'exposition universelle de Hanovre EXPO 2000. Avec Werner Büttner, Georg Herold et Martin Kippenberger, il fut l'un des enfants terribles de la scène artistique des années 80. Avec le frère d'Albert Markus Oehlen, ces artistes ont réalisé les expériences les plus pertinentes sur l'autoportrait de la RFA et la conception que celle-ci a d'elle même – certains titres du milieu des années 80 comme *Morgenlicht fällt ins Führerhauptquartier* (La Lumière matinale tombant dans le quartier général du Führer) ont investi la peinture de messages inconnus qui instauraient fièrement des niveaux inédits de l'image. Dans les années 90, Oehlen change de stratégie. Le motif ayant été épuisé, le peintre s'en prend directement à la peinture. La peinture abstraite exige une virtuosité qui, selon lui, devait se vaincre elle-même – le plus beau et le plus grand défi pour un artiste comme Oehlen. Le langage affichiste et les formes claires des collages générés par ordinateur qui suivront se présentent alors comme un contrepoint aux peintures à l'huile. Attaquer l'art et chercher le point vulnérable est resté le programme de l'artiste. « Il faut être un joyeux pourfendeur », a déclaré Oehlen dans un entretien avec Rainald Goetz. F. F.

SELECTED EXHIBITIONS →
1995 The Renaissance Society, Chicago (IL), USA; *Oehlen Williams 95* (with Christopher Williams), Wexner Center for the Arts, Columbus (OH), USA **1996** IVAM, Centre del Carme, Valencia, Spain **1997** *Albert vs. History*, Kunsthalle Basel, Basle, Switzerland **1998** INIT Kunsthalle, Berlin, Germany **2000** *Der Ritt der sieben Nutten – das war mein Jahrhundert* (with Markus Oehlen), Städtisches Museum Abteiberg, Mönchengladbach, Germany; In Between, EXPO 2000, Hanover, Germany **2001** *Terminale Erfrischung*, Kestner Gesellschaft, Hanover,

Germany; *Vom Eindruck zum Ausdruck – Grässlin Collection*, Deichtorhallen, Hamburg, Germany

SELECTED BIBLIOGRAPHY →
1997 *Albert vs. History*, Kunsthalle Basel, Basle **2000** *Inhaltsangabe*, Berlin; *Malerei*, Kunsthalle Vierseithof, Luckenwalde; *Der Ritt der sieben Nutten – das war mein Jahrhundert*, Städtisches Museum Abteiberg, Mönchengladbach **2001** *Terminale Erfrischung. Bilder und Computercollagen*, Kestner Gesellschaft, Hanover

1 **Bionic Boogie (Ich, Wasser, Technik),** 2000, mosaic, fountain, c. 2500 m², *In Between,* EXPO 2000, Hanover
2 **Taschen shop in Paris,** 2001, computer generated murals, width 18 m
3 **Name: Kevin,** 2000, oil on canvas, 240 x 240 cm
4 **Bedrohter Schwan,** 2000, ink jet plot, 209 x 309 cm

„Ich habe meine Bilder einmal postungegenständliche Malerei und später prokrustische Malerei genannt. Mit dem ersten Begriff wollte ich ausdrücken, dass ich diese Probleme gerne hinter mir hätte. Mit dem zweiten Begriff lehne ich die ganzen Malereiethiken ab. ‚Prokrustisch' steht für Biegen und Brechen und Dehnen und Stutzen. Also nicht für materialschonend."

« Il m'est arrivé de qualifier mes tableaux de post-non-figuratifs et, plus tard, de peinture ‹procroûtique›. Ce que je voulais dire avec le premier concept, c'est que j'aimerais que ces problèmes ne soient plus d'actualité pour moi. Avec le deuxième, je rejette toutes les éthiques picturales. ‹Procroûtique› renvoie au fait de tordre et de briser et d'étendre et de réduire. Autrement dit, cela ne renvoie pas au respect du matériau. »

"I once called my pictures post-non-representational painting and later I called them Procrustean painting. By the first, I meant that I was glad I had got those problems out of the way. With the second, I rejected the whole ethos of painting. Procrustean means bending and breaking and stretching and cutting to size. I mean being unmerciful with materials."

2

3

4

Chris Ofili

1968 born in Manchester, lives and works in London, UK

Chris Ofili's monumental paintings are as influenced by the complexities of late 1990s pop culture as the thought processes of postwar artists such as Picabia, Polke and Basquiat. In *Afrodizzia*, 1996, a maze of arabesques swirl around the collaged heads of afro-wearing black celebrities, in a psychedelic celebration of black sexual potency. Portraits such as *Prince Amongst Thieves*, 1999, in which the profile of a darkly handsome man emerges from a densely patterned background, are as decorative as the all-over floral design of abstract works such as *Through the Grapevine*, 1998. The paintings' shimmering surfaces result from multiple layers of pigment, acrylic and phosphorescent paint, swathes of glitter and strings of multicoloured beads of paint. A thick layer of translucent resin coats the paintings, giving them an oscillating depth and distancing the image until it becomes more imagined than real. The balls of elephant dung intertwined in the paintings' design have become something of a signature for Ofili, and add a sculptural element to the works while offering a range of associations from optimistic ideas about nature to obscenities and defecation. Captain Shit, Ofili's self-created black superhero, is the protagonist in a series of allegorical scenes, including the biblical context of *The Adoration of Captain Shit and the Legend of the Blackstars*, 1998, and an homage to Warhol in *Double Captain Shit*, 1999. Ofili's paintings exalt in the power of colour, decoration and sexuality, but also have a touch of wry humour as seen in *Monkey Magic – Sex, Money and Drugs*, 1999, in which a white monkey spirit conjures the three elements of worldly success: sex, money and drugs.

Die großen Gemälde von Chris Ofili verdanken der Pop-Kultur der späten neunziger Jahre genauso wesentliche Anregungen wie den Theorien von Künstlern wie Picabia, Polke und Basquiat. In *Afrodizzia*, 1996, wirbelt eine Fülle von Formen um die collagierten Köpfe schwarzer Berühmtheiten, die ihre Haare im Afro-Look tragen – eine psychedelische Hymne auf die sexuelle Potenz des schwarzen Menschen. Porträts wie *Prince Amongst Thieves*, 1999, das einen attraktiven dunkelhäutigen Mann im Profil zeigt, der aus einem dicht ornamentierten Hintergrund hervortritt, sind ebenso dekorativ wie abstrakte Arbeiten, etwa das vollständig aus Blumenmustern komponierte *Through the Grapevine*, 1998. Die schimmernden Bildoberflächen verdanken sich den vielfachen Schichten von Pigment, Acryl und Leuchtfarben sowie Glitzerpartikeln und vielfarbigen Perlenketten. Überzogen sind die Bilder mit einer dicken lichtdurchlässigen Harzschicht, der sie ihre oszillierende Tiefenwirkung und ihre an Traumgebilde erinnernde „Fern"-Wirkung verdanken. Die Elefantendungkugeln, die Ofili auf die Bildfläche aufbringt, gelten als eine Art Markenzeichen und verstärken die plastische Wirkung seiner Bilder. Zugleich eröffnen sie ein weites assoziatives Feld: von optimistischen Vorstellungen über die Natur bis zu Obszönitäten und Defäkation. In einem Zyklus allegorischer Szenen lässt Ofili den selbst erfundenen schwarzen Supermann Captain Shit auftreten. Eine dieser Arbeiten operiert mit biblischen Anklängen, *The Adoration of Captain Shit and the Legend of the Blackstars*, 1998, während *Double Captain Shit*, 1999, eine Hommage an Warhol ist. Ofilis Malerei feiert die Kraft der Farben, der dekorativen Prachtentfaltung und der Sexualität; sie besticht zugleich durch ihren sarkastischen Humor. Ein Beispiel dafür ist *Monkey Magic – Sex, Money and Drugs*, 1999, in dem ein weißer Affen-Geist die drei Elemente des irdischen Erfolges beschwört: Sex, Geld und Drogen.

Les toiles monumentales de Chris Ofili sont autant influencées par les complexités de la culture populaire de la fin des années 90 que par la façon de penser des artistes d'après-guerre comme Picabia, Polke et Basquiat. Dans *Afrodizzia*, 1996, un dédale d'arabesques tournoie autour d'un collage de têtes de célébrités noires coiffées à l'afro, découpées dans des magazines, forme de célébration psychédélique de la puissance sexuelle noire. Ses portraits tels que *Prince Among Thieves*, 1999, où le profil d'un séduisant ténébreux émerge d'un fond densément rempli de motifs, sont aussi décoratifs que ses œuvres abstraites entièrement couvertes de fleurs comme *Through the Grapevine*, 1998. La surface scintillante de ses toiles est due à de multiples couches de pigments, de collages, de peinture acrylique et phosphorescente, de bandes pailletées et de filets multicolores de perles de peinture. Une épaisse couche de résine translucide recouvre le tout, donnant au tableau une profondeur changeante et distançant l'image jusqu'à ce qu'elle paraisse plus imaginée que réelle. Les boules d'excréments d'éléphant insérées dans la composition sont devenues une sorte de signature de l'artiste. Elles ajoutent un élément sculptural aux œuvres tout en offrant une gamme d'associations, allant des idées optimistes sur la nature à des obscénités et à la défécation. Le Capitaine Shit, superhéros créé par Ofili, est au centre d'une série de scènes allégoriques, dont celle aux connotations bibliques, *The Adoration of Captain Shit and the Legend of the Blackstars*, 1998, et un hommage à Warhol, *Double Captain Shit*, 1999. Les peintures d'Ofili exaltent la puissance de la couleur, de la décoration et de la sexualité, mais elles dégagent également un humour noir comme dans *Monkey Magic – Sex, Money and Drugs*, 1999, où un esprit singe blanc invoque les trois éléments de la réussite sur terre : le sexe, l'argent et la drogue.　　　K. B.

SELECTED EXHIBITIONS →
1995 *Brilliant!*, Walker Art Center, Minneapolis (MN), USA **1997** *Sensation*, Royal Academy of Arts, London, UK **1998** Southampton City Art Gallery, Southampton, UK; *The Turner Prize Exhibition*, Tate Gallery, London, UK **1999** *Afrobiotics*, Gavin Brown's enterprise, New York (NY), USA; *Carnegie International*, Carnegie Museum of Art, Pittsburgh (PA), USA **2000** *Drawings*, Victoria Miro Gallery, London, UK **2001** *Public Offerings*, Museum of Contemporary Art, Los Angeles (CA), USA

SELECTED BIBLIOGRAPHY →
1995 *Brilliant! New Art from London*, Walker Art Center, Minneapolis (MN) **1998** *Chris Ofili*, Southampton City Art Gallery, Southampton/ Serpentine Gallery, London **1999** *Young British Art. The Saatchi Decade*, London; *Carnegie International*, Carnegie Museum of Art, Pittsburgh (PA) **2001** *Public Offerings*, Museum of Contemporary Art, Los Angeles (CA)

1 **Monkey Magic – Sex, Money and Drugs,** 1999, acrylic, collage, glitter, resin, pencil, map pins, elephant dung on canvas, 244 x 183 cm

2 **The Holy Virgin Mary,** 1996, mixed media on canvas, 244 x 183 cm
3 **Afrodizzia (2nd version),** 1996, mixed media on canvas, 244 x 183 cm

„Ich glaube, Kreativität hat mit Improvisation zu tun – mit dem, was um uns herum vor sich geht."

« Je pense que la créativité est liée à l'improvisation, à ce qui se passe autour de nous. »

"I think creativity's to do with improvisation – what's happening around you."

2

3

Gabriel Orozco

1962 born in Jalapa, lives and works in Mexico City, Mexico, and New York (NY), USA

Gabriel Orozco's work combines conceptual soundness and politicised practice, which in many ways is compatible with the art movements of Dada, Surrealism and Arte Povera, and with the poetic and subjective moment. In an interview Orozco stated that his cultural interventions in the public domain began in 1986, when he rearranged a joiner's offcuts that had been left on a rain-sodden street in Madrid and then photographed the result. In other works Orozco largely refrains from intervening in found situations, and uses his camera mainly to capture the tension between his own intentions and reality. A series of videos shot while strolling through urban areas, for example *From Dog Shit to Irma Vep*, 1997, condense the permanent flow of his everyday perception of objects and events. Other works take a participatory line on the production of art. For his 1993 New York Museum of Modern Art project *Home Run*, he asked the residents of surrounding buildings to place oranges on their windowsills, thus bestowing on the windows the function of exhibition spaces beyond the Museum's perimeter. The relationships between public and private spheres, everyday objects and works of art was altered and thrown into question. Similarly Orozco repeatedly stages the complex interrelationships between cultural and economic periphery and centre. His photograph *Isla dentro de la isla/ Island within an Island*, 1993, portrays – before a background of New York's skyline – a shabby replica made of garbage of the same silhouette in an empty car park.

Im Werk von Gabriel Orozco verbindet sich eine konzeptuell fundierte und politisierte Praxis – die in vielfältiger Weise mit künstlerischen Bewegungen wie Dada, Surrealismus und Arte Povera korrespondiert – mit einem Moment des Poetischen und Subjektiven. Den Beginn seiner skulpturalen Interventionen im öffentlichen Raum datierte Orozco in einem Interview auf das Jahr 1986, als er auf einer regennassen Madrider Straße die Holzabfälle einer Schreinerei arrangierte und das Resultat fotografierte. In anderen Arbeiten verzichtet Orozco weitgehend auf Eingriffe in vorgefundene Situationen und benutzt die Kamera vorwiegend, um das Spannungsverhältnis zwischen den eigenen Intentionen und der Realität festzuhalten; eine Reihe von Videofilmen wie *From Dog Shit to Irma Vep*, 1997, die während langer Spaziergänge in urbanen Umgebungen entstanden, kondensieren den permanenten Fluss seiner alltäglichen Wahrnehmungen von Objekten und Ereignissen. Andere Arbeiten Orozcos basieren auf einem partizipatorischen Prozess der Kunstproduktion. So ließ er in seinem Projekt *Home Run*, 1993, für das New Yorker Museum of Modern Art die Bewohner der umliegenden Häuser fragen, ob sie bereit seien, Orangen auf ihre Fensterbänke zu legen. Die Fenster nahmen dadurch die Funktion von Ausstellungsorten jenseits des Museums an; das Verhältnis zwischen öffentlicher und privater Sphäre, Alltagsgegenständen und Kunstobjekten wurde verschoben und in Frage gestellt. In ähnlicher Weise inszeniert Orozco immer wieder die komplexen Wechselbeziehungen zwischen kultureller und ökonomischer Peripherie und Zentrum: So zeigt seine Fotografie *Isla dentro de la Isla/Island within an Island*, 1993 – vor dem Hintergrund der New Yorker Skyline – eine ärmliche Nachbildung dieser Silhouette aus Abfällen auf einem leeren Parkplatz.

Dans l'œuvre de Gabriel Orozco se mélangent une pratique politique définie sur des bases rigoureusement conceptuelles – qui correspond par bien des aspects à des mouvements artistiques comme le dadaïsme, le surréalisme et l'Arte Povera – et un facteur poétique et subjectif. Dans une interview, Orozco a daté ses premières interventions sculpturales dans l'espace public de 1986, lorsqu'il arrangea les déchets d'une menuiserie dans une rue de Madrid mouillée de pluie avant de photographier le résultat de ce travail. Dans d'autres œuvres, Orozco renonce en grande partie à sa propre intervention et se sert de l'appareil photo avant tout pour fixer le jeu de tensions entre son propos artistique et la réalité. Toute une série de vidéos nées de longues promenades dans l'environnement urbain, par exemple *From Dog Shit to Irma Vep*, 1997, condensent le flux permanent de sa perception quotidienne des objets et des événements. D'autres œuvres d'Orozco reposent sur une démarche participative de la production artistique. Dans le projet *Home Run*, 1993, réalisé pour le Museum of Modern Art de New York, Orozco faisait demander aux habitants des immeubles environnants s'ils étaient d'accord pour disposer des oranges à leurs fenêtres. Les fenêtres prenaient ainsi la fonction de lieux d'exposition au-delà du musée ; le rapport entre sphère privée et publique, entre objet quotidien et objet d'art était décalé et remis en question. D'une façon similaire, Orozco revient constamment à la mise en scène des interrelations complexes entre les aspects périphérique et central de la culture et de l'économie : avec pour toile de fond la silhouette new-yorkaise, la photographie *Isla dentro de la Isla/Island within an Island*, 1993, montre par exemple une reconstitution maladroite de la même silhouette réalisée à partir de détritus dans un parking vide.

B. H.

SELECTED EXHIBITIONS →
1997 *documenta X*, Kassel, Germany **1998** *XXIV Biennial Internacional*, São Paulo, Brazil; Musée d'Art Moderne de la Ville de Paris, France **1999** Centre pour l'Image Contemporaine, Geneva, Switzerland; *Looking for a place*, SITE, Santa Fe (NM), USA **2000** The Museum of Contemporary Art, Los Angeles (CA), USA; *In Between*, EXPO 2000, Hanover, Germany **2001** Museo de Arte Contemporaneo de Monterrey, Mexico; Museo Internacional Rufino Tamayo, Mexico City, Mexico; *7th Istanbul Biennial*, Istanbul, Turkey

SELECTED BIBLIOGRAPHY →
1998 *Clinton is Innocent*, Musée d'Art Moderne de la Ville de Paris **1999** *Photogravity*, Philadelphia Museum of Art, Philadelphia (PA); *Chacahua*, Frankfurt am Main **2000** *Gabriel Orozco*, The Museum of Contemporary Art, Los Angeles (LA)

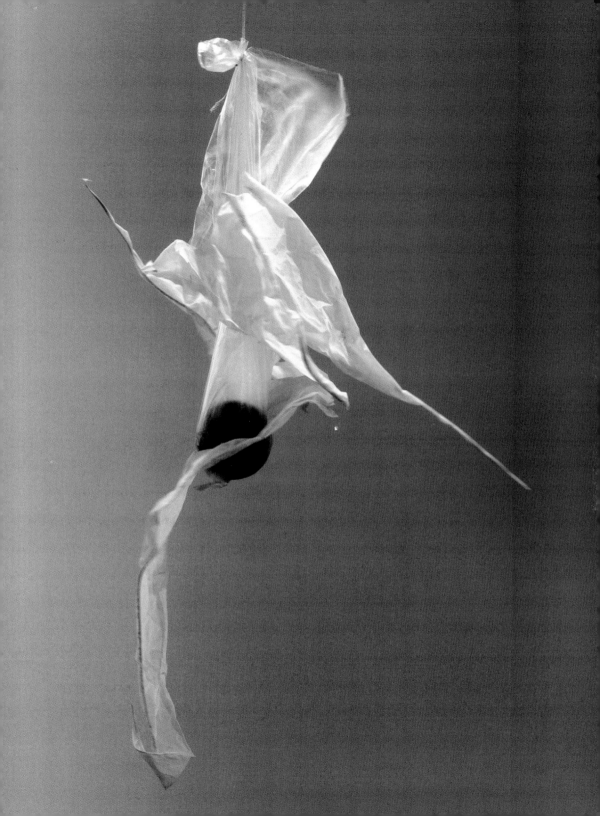

1 **Mixiotes,** 2001, cactus leaves, rubber balls, plastic bags, installation view,
Marian Goodman Gallery, New York (NY)
2 **Hoja Suspendida,** 2001, Cibachrome, 41 x 51 cm

3 **My Hands Are My Heart,** 1991, Cibachrome, 2 parts, each 41 x 51 cm
4 **Clipped Paper,** 2001, Cibachrome, 41 x 51 cm

„Ich sehe meine Arbeit gerne als das Ergebnis oder Abfallprodukt oder
Überbleibsel spezifischer Situationen."

« Il est important pour moi que mon œuvre soit un ‹ sous-produit ›,
un amoncellement de situations spécifiques. »

"I like to see my work as the result
or a by-product or a leftover of specific situations."

2

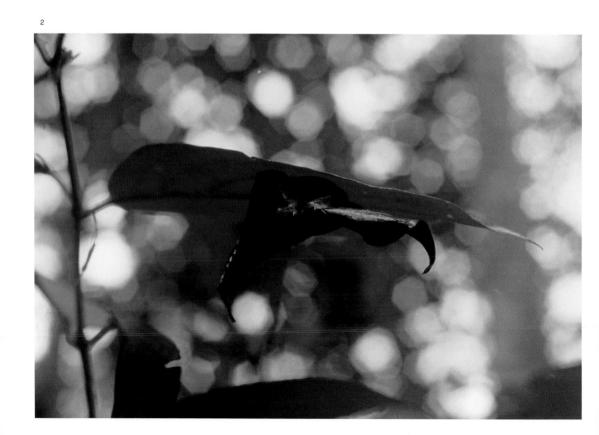

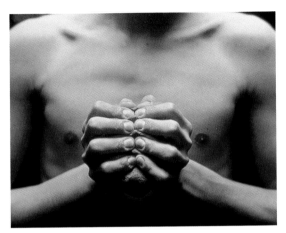

3

4

Laura Owens

1970 born in Euclid (OH), lives and works in Los Angeles (CA), USA

Laura Owens' paintings have an ephemeral quality. Her large-scale canvases are sparsely marked, the simplest lines suggesting figurative images. Three succinct blue lines indicate the sky, two black strokes provide a pattern like flying birds, and a couple of crooked lines form a high-rise apartment block or the mullion and transom of a window. The artist shows a fondness for conventional subjects such as flower arrangements and landscapes, which she often paints in a style that evokes traditional Japanese art. Some of her paintings feature cartoon elements – like little bees flying over a meadow of naïvely painted plants – which provide an impression of wallpaper patterns or folk art. At first sight some of her paintings look like abstract structures. Her upright format *Untitled*, 1999, in acrylic on canvas shows a grid of irregular lines. Crude blue blobs push their way into the picture from right to left, an immediate reminder of the Abstract Expressionists' experiments with form. But then Owens' forms and colour values meld together to suggest a landscape. Owens' paintings are untitled, suggesting that a single picture should not be seen as important, or accorded the value of uniqueness. And yet the exceptional lightness of her work is the result of long and careful preparation, and each image presents a particular painterly pose. The artist is always searching for principles of order to create inner tension in the composition. Hence, the "neurotic joviality" of her motifs encounters a formal composition of emptiness, calm, simplicity and chance. The interplay of tensions in Owens' paintings is modern and elegant, while at the same time seeming to contain humorous allusions to Zen Buddhism.

Die Malerei von Laura Owens ist von ephemerer Natur. Ihre großformatigen Leinwände sind nur spärlich mit Farben markiert, mit einfachsten Gesten wird Figuratives angedeutet. Drei lapidare blaue Linien zeigen einen Horizont an, zwei schwarze Striche stehen für Vögel am Himmel, ein paar krumme Linien bilden ein Fensterkreuz oder einen Block von Hochhäusern. Die Künstlerin hat eine Vorliebe für konventionelle Motive wie Blumenarrangements und Landschaften, die sie oft in einem auf traditionelle japanische Malerei anspielenden Stil malt. In manchen Gemälden tauchen Cartoon-Elemente auf wie die kleinen Bienen, die über eine Wiese fliegen, deren Pflanzen in einer naiv typisierten Weise gemalt sind, was den Eindruck von Tapetendekors oder Volkskunst hervorruft. Andere Bilder wirken zunächst wie abstrakte Strukturen. Auf einem hochformatigen Acrylbild von 1999 *(Untitled)* ist ein Gitter von unregelmäßigen Linien gezogen. Von rechts und links schieben sich plumpe blaue Kleckse ins Bild. Zunächst erinnern sie an die formalen Experimente des Abstrakten Expressionismus. Dann aber verbinden sich die Formen und Farbwerte und suggerieren eine Landschaft. Owens gibt ihren Werken keine Titel, so als sollte ein einzelnes Bild keine gewichtige Bedeutung oder den Wert der Einmaligkeit erhalten. Die ungemeine Leichtigkeit in ihren Bildern ist lang und präzise vorbereitet, jedes führt eine bestimmte malerische Pose vor. Zugleich ist die Künstlerin auf der Suche nach Ordnungsprinzipien, die eine innere Spannung im Bild erzeugen. So trifft diese Art „neurotischer Lustigkeit" ihrer Motive auf eine formale Komposition von Leere, Ruhe, Einfachheit und Zufall. Es ist ein modernes, elegantes Spannungsverhältnis in Owens' Malerei, das in humorvoller Weise auf zen-buddhistisches Denken anzuspielen scheint.

La peinture de Laura Owens est de nature éphémère. Ses toiles grand format ne présentent le plus souvent que des couleurs parcimonieuses avec lesquelles les gestes les plus simples esquissent des formes figuratives. Trois lignes bleues lapidaires figurent un horizon, deux traits noirs schématisent des oiseaux dans le ciel, quelques courbes dessinent une croisée de fenêtre ou un bloc d'immeubles. On y relève la prédilection de l'artiste pour les motifs conventionnels : arrangements floraux et paysages qu'elle peint souvent dans un style qui rappelle la peinture traditionnelle japonaise. Dans certaines peintures, on voit apparaître des éléments de dessins animés : petites abeilles survolant un pré dont les plantes sont traitées avec une caractérisation naïve évoquant le décor d'un papier peint ou une décoration folklorique. D'autres tableaux font en revanche d'abord l'effet de structures abstraites. Dans une acrylique verticale de 1999 *(Untitled)*, on peut voir une trame de lignes irrégulières. Des taches grossières entrent dans le tableau par la droite et par la gauche. Dans un premier temps, on songe aux recherches formelles de l'expressionnisme abstrait, mais les formes et les valeurs chromatiques s'associent ensuite pour suggérer un paysage. Owens ne donne pas de titres à ses œuvres, comme si le tableau ne devait pas recevoir de signification singulière ni prendre la valeur particulière de l'unicité. Pourtant, la légèreté inhabituelle de ces œuvres résulte d'une longue et minutieuse préparation, dans la mesure où chacune occupe une position picturale particulière. En même temps, l'artiste est à la recherche de principes d'ordre qui génèrent une tension dans le tableau, où la « volupté névrotique » des motifs est associée à une composition faite de vide, de paix, de hasard et de simplicité. Il y a dans la peinture d'Owens un rapport de tension moderne, élégant, qui semble également se référer de manière humoristique à la pensée zen-bouddhiste. A. K.

SELECTED EXHIBITIONS →
1998 *Young Americans 2*, The Saatchi Gallery, London, UK **1999** *Malerei*, INIT Kunsthalle, Berlin, Germany; Los Angeles (CA), USA; *Nach-Bild*, Kunsthalle Basel, Basle, Switzerland **2000** *Examining Pictures: Exhibiting Paintings*, Museum of Contemporary Art, Chicago (IL), USA; UCLA Hammer Museum, Los Angeles (CA), USA **2001** Isabella Steward Gardner Museum, Boston (MA), USA; *Public Offerings*, Museum of Contemporary Art, Los Angeles (CA), USA; *Painting at the Edge of the World*, Walker Art Center, Minneapolis (MN), USA

SELECTED BIBLIOGRAPHY →
1998 *Nothing left Undone. Young Americans 2*, Saatchi Gallery, London **1999** *Standing Still and Walking in Los Angeles*, Gagosian Gallery, Los Angeles (CA); *Nach-Bild*, Kunsthalle Basel; *Examinig Pictures*, Whitechapel Gallery, London/Museum of Contemporary Art, Chicago (IL) **2001** Uta Grosenick (ed.), *Women Artists*, Cologne

1 **Untitled**, 2001, oil and acrylic on canvas, 269 x 171 cm
2 **Untitled**, 2000, acrylic, oil, watercolour on canvas, 183 x 169 cm
3 **Untitled**, 1999, acrylic on canvas, 305 x 263 cm
4 **Untitled**, 2000, acrylic on canvas, 279 x 366 cm

2

3

4

Jorge Pardo

1963 born in Havana, Cuba, lives and works in Los Angeles (CA) and New York (NY), USA

Art is beauty and the promise of happiness: that is what Jorge Pardo means when he subverts existing connections while at the same time creating new ones. His objects, installations and paintings seem familiar to us; they make connections with already existing associations. His art always includes what the viewer expects. Pardo's interest in the piece of art is actually his interest in its potential to mean something to the viewer, while drawing him or her into new relationships. It is not the picture on the wall that matters, it is the way in which it affects the view of the world. The book, *Ten people, ten books*, published in 1994, contains building plans and the licence for copying a bungalow, and was described by Pardo as a sculpture. At the same time Pardo emphasises the generic frontier between design and art, turning it into a valuable tension in his works. In 1998 he transformed the ground floor of the New York Dia Center for the Arts into a colourful and exhilarating creation for the next two years: the façade was replaced by a transparent glass frontage; light, bright ceramic floor tiles conveyed a relaxed atmosphere; the new furniture drew inspiration from pragmatic, serviceable modernism. What drives Pardo is the question of how something is held in high regard for its aesthetic values. He removes the seriousness from painting by using over-dimensional formats and by silk screen printing from computer designs. A kaleidoscope of colours and shapes come together in any number of new combinations; sensitive colour matches seem to dwell in continually cheerful vibrations; the lone picture now represents only a relative size.

Kunst ist Schönheit und das Versprechen von Glück. Dies ist die Maxime von Jorge Pardo, wenn er bestehende Zusammenhänge aufnimmt und dabei neue schafft. Seine Objekte, Installationen und Gemälde erscheinen uns bekannt; sie suchen den Anschluss an schon bestehende Assoziationen. Seine Kunst bezieht die Erwartungshaltung des Betrachters immer ein. Pardos Interesse am Kunstobjekt gilt seinem Potenzial, dem Betrachter etwas zu bedeuten und ihn so in neue Beziehungen zu verwickeln. Nicht das Bild an der Wand ist entscheidend, vielmehr die Weise, wie es die Betrachtung der Welt beeinflusst. Das Buch *Ten people, ten books*, veröffentlicht 1994, beinhaltet Baupläne und die Lizenz für den Nachbau eines Bungalows und wurde von Pardo als Skulptur bezeichnet. Dabei hob Pardo die Gattungsgrenze zwischen Design und Kunst hervor und machte sie als Spannung für seine Arbeiten wertvoll. 1998 gestaltete er das Erdgeschoss des New Yorker Dia Center for the Arts für die nächsten zwei Jahre in eine farbenfrohe und heitere Angelegenheit um: Die Fassade wurde durch eine transparente Glasfront ersetzt, helle farbige Bodenfliesen verbreiteten eine lockere Atmosphäre, das neue Mobiliar orientierte sich am pragmatischen dienstfertigen Modernismus. Was Pardo antreibt ist die Frage, wie ästhetische Wertschätzungen entstehen. Er nimmt der Malerei ihre Ernsthaftigkeit mittels überdimensionaler Formate und dank der Tatsache, dass es sich um Computerentwürfe im Siebdruckverfahren handelt. Kaleidoskopisch fügen sich Farben und Formen zu immer neuen Kombinationen zusammen, sensibel abgestimmtes Kolorit scheint in beständiger heiterer Schwingung zu verweilen: Das einzelne Bild stellt nur mehr eine relative Größe dar.

L'art est beauté et promesse de bonheur. C'est aussi le but vers lequel tend Jorge Pardo lorsqu'il assimile des contextes existants et qu'il s'en sert pour en créer de nouveaux. Ses objets, installations et peintures ont un air familier, ils cherchent à se rattacher à des associations existantes. L'intérêt de Pardo pour l'objet artistique est lié à l'importance potentielle que celui-ci peut prendre pour le spectateur et, partant, à la possibilité d'investir le spectateur de nouvelles relations. Ce n'est pas le tableau accroché au mur qui est important en soi, mais la manière dont il influence le regard que nous portons sur le monde. Le livre *Ten people, ten books* publié en 1994, et qui contient les plans et la licence pour la construction d'un bungalow, a été défini par Pardo comme une sculpture. En même temps, Pardo faisait ressortir la frontière entre les genres « design » et « art », et la rendait significative pour ses œuvres en ce qu'elle est révélatrice d'un champ de tension. En 1998 et pendant deux ans, il a transformé le rez-de-chaussée du Dia Center for the Arts de New York en un événement multicolore et gai : la façade était remplacée par du verre transparent, tandis que des carrelages clairs répandaient une atmosphère décontractée, où le nouveau mobilier s'appuyait sur un modernisme utilitaire et pratique. Ce qui stimule Pardo, c'est la question de savoir comment naissent les jugements et les échelles de valeur esthétiques. Pardo libère la peinture de son sérieux par l'utilisation de formats surdimensionnés et de procédés informatiques et sérigraphiques. Les couleurs et les formes s'agencent de manière kaléidoscopique en combinaisons sans cesse nouvelles, le chromatisme aux nuances sensibles semble demeurer dans une vibration toujours joyeuse : le tableau isolé devient alors une unité très relative. F. F.

SELECTED EXHIBITIONS →
1990 Thomas Solomon's Garage, Los Angeles (CA), USA **1993** *Backstage*, Kunstverein in Hamburg, Germany **1994** neugerriemschneider, Berlin, Germany **1996** *traffic*, capcMusée d'Art Contemporain, Bordeaux, France **1997** *Lighthouse*, Museum Boijmans Van Beuningen, Rotterdam, The Netherlands; *Skulptur. Projekte*, Münster, Germany **1999** *What if*, Moderna Museet, Stockholm, Sweden **2000** Dia Art Foundation, New York (NY), USA; Kunsthalle Basel, Basle, Switzerland **2001** *public offerings*, Museum of Contemporary Art, Los Angeles (CA), USA

SELECTED BIBLIOGRAPHY →
2000 *Elysian Fields*, Centre Georges Pompidou, Paris; Kunsthalle Basel, Basle **2001** Jörn Schafaff/Barbara Steiner (ed.), *Jorge Pardo*, Ostfildern-Ruit

1 **Project, 2000,** longterm installation at Dia Center for the Arts, New York (NY)
2 Installation view, Kunsthalle Basel, Basle, 2000

3 **4166 Sea View Lane,** 1998, house and interior designed by Jorge Pardo on occasion of his solo exhibition at The Museum of Contemporary Art, Los Angeles (CA), 1998

„Allerdings hat mich nie die manuelle Tätigkeit des Malens interessiert, sondern die Zusammenhänge, in denen ein Bild entstehen kann. Ich setze mich nicht mit genuin malerischen Fragen auseinander. Vielmehr integriere ich den Alltag, das reale Leben in die Kunst. Meine Bilder entstehen aus einer großen Distanz zum Malen selbst, deshalb sind sie sehr kühl, überhaupt nicht emotional."

« Il est vrai que je n'ai jamais été intéressé par l'activité manuelle de peindre, mais par les correspondances contextuelles dans lesquelles le tableau peut être créé. Je ne travaille pas sur des problèmes fondamentalement picturaux. J'intègre plutôt le quotidien, la vie réelle dans l'art. Mes tableaux résultent d'une grande distance à l'égard de l'acte pictural en tant que tel, c'est pourquoi il sont plutôt froids et pas du tout émotionnels. »

"Mind you, the manual activity of painting has never interested me; it is has always been the connections or correlations within which a picture can be created. I don't think about the actual painting side of things. I'm more likely to integrate the day-to-day, real life into art. My pictures are created at a great distance from the actual painting aspect itself, and so they are very cool, not in the least emotional."

2

Manfred Pernice

1963 born in Hildesheim, lives and works in Berlin, Germany

Manfred Pernice's work is architectural in its references. His pieces might resemble building plans or maquettes for realizable structures, but key elements such as windows and doors are often missing or not to scale, rendering them futile. Pernice is fascinated by ships, containers and other vessels, and often includes transport and harbour references in his work. Frequently, collaged newspaper and magazine images or shipping documents are applied to his structures and integrated into his drawings. His plywood containers, such as *Bell II*, 1998, and *Sieg*, 2001, appear to be models of vessels used to transport goods, except they are non-functional in their materials and construction. Inspired by a ship in Bremerhaven, he also made reference to a boat in *Bad, Bath*, 1998, in which he erected panels with angled portions painted battleship grey at the bottom and round "portholes" at the top. Pernice's work is often linked to actual places, though his representations are conceptual rather than direct. His large-scale *Sardinien*, 1996, shares formal characteristic with the whitewashed homes and buildings perched on cliffs of Mediterranean towns. However, the shape of the sculpture itself, with rounded edges and protruding parts, is also reminiscent of recreational vehicles. The artist's inclusion of a photograph of the coast strengthens the reference to Sardinia, but its placement on the surface of the structure seems to turn the piece inside out. The photo as well as a shelf and other detailing associated with the interior of a domestic structure appear on the exterior of Pernice's sculpture and deepen the work's architectural ambiguity.

Manfred Pernice nimmt in seiner Arbeit Bezug auf architektonische Formen. Seine Werke erinnern nicht selten an Pläne oder Entwürfe, die zur baulichen Realisierung bestimmt sind, denen aber so wichtige Elemente wie Fenster und Türen fehlen oder die sämtliche Proportionen sprengen, also völlig sinnlos sind. Da Schiffe, Container und andere Transportmittel auf Pernice eine besondere Faszination ausüben, finden sich in seinen Werken vielfach Verweise auf Häfen und Transportfunktionen. Immer wieder sind collagierte Zeitungs- und Illustriertenbilder oder Frachtpapiere in seine Strukturen oder Zeichnungen integriert. Pernices Sperrholzcontainer, etwa *Bell II*, 1998, und *Sieg*, 2001, erscheinen wie Modelle für Transportbehältnisse, nur dass weder Material noch Bauweise mit einer solchen Funktion vereinbar sind. Auch seine Arbeit *Bad, bath*, 1998, zu der ihn ein Schiff in Bremerhaven inspiriert hat, erweckt solche Assoziationen. Das Werk besteht aus senkrecht aufgestellten – in dem für Schlachtschiffe typischen Grau gehaltenen – Paneelen mit abgeknickten Partien und „Bullaugen" im oberen Bereich. Pernices Werke nehmen häufig auf reale Orte Bezug, obwohl seine Darstellungen mehr konzeptuell als abbildhaft zu verstehen sind. Seine großformatige Arbeit *Sardinien*, 1996, weist zwar formale Übereinstimmungen mit den weiß getünchten, auf Fels gebauten Häusern mediterraner Dörfer auf, mit ihren abgerundeten Ecken und vorstehenden Teilen könnte es sich bei der Skulptur aber ebenso gut um einen Wohnwagen handeln. Die Fotografie einer Küstenlandschaft, die an dieser Konstruktion aufgehängt ist, unterstreicht zwar die Sardinien-Assoziation, da sie jedoch an einer Außenwand angebracht ist, scheint das Innere der Struktur nach außen gekehrt zu sein. Dies wird durch den schrankartigen Vorbau und weitere Details, die man üblicherweise mit einer zum Wohnen bestimmten Räumlichkeit in Verbindung bringt, nahegelegt. Sie verstärken damit den Eindruck der architektonischen Mehrdeutigkeit.

Le travail de Manfred Pernice est architectural par ses références. Ses pièces ressemblent tantôt à des plans de bâtiments tantôt à des modèles réduits de structures réalisables, mais les éléments clés tels que les fenêtres et les portes manquent ou ne sont pas à l'échelle, les rendant futiles. Fascinés par les bateaux, les containers et autres vaisseaux, Pernice inclut souvent des références aux ports et aux transports dans ses travaux. Des collages de papier journal, d'images de magazine ou de documents d'expédition sont appliqués sur ses structures et intégrés à ses dessins. Ses containers en contre-plaqué, tels que *Bell II*, 1998, et *Sieg*, 2001, semblent être des modèles de vaisseaux pour transporter des marchandises, sauf qu'ils ne sont pas fonctionnels par leur matériau et leur construction. Inspiré par un navire de Bremerhaven, Pernice fait également référence à un bateau dans *Bad, bath*, 1998, où il érige des panneaux avec des portions en angle. Le bas est peint en gris « navire de guerre » et le haut avec de faux hublots ronds. Le travail de Pernice est souvent lié à des lieux réels, bien que ses représentations soient conceptuelles plutôt que directes. Son grand *Sardinien*, 1996, partage des caractéristiques formelles avec les maisons et les bâtiments blanchis à la chaux perchés au bord de falaises de villes méditerranéennes. Toutefois, la forme de la sculpture, avec ses angles ronds et ses parties saillantes, rappelle également un camping-car. L'inclusion d'une photographie d'une côte renforce la référence à la Sardaigne, mais son positionnement sur la surface de la structure semble retourner la pièce comme un gant. La photo, tout comme l'étagère et d'autres détails associés à l'intérieur d'une maison apparaissent à l'extérieur de la sculpture et renforcent son ambiguïté architecturale. Ro. S.

SELECTED EXHIBITIONS →
1997 *4ème Biennale de Lyon*, France **1998** *Migrateurs*, Musée d'Art Moderne de la Ville de Paris, France; *1. berlin biennale*, Berlin, Germany **2000** Kunsthalle Zürich, Zurich, Switzerland; *Work-Raum*, Nationalgalerie im Hamburger Bahnhof, Museum für Gegenwart, Berlin, Germany; Institute of Visual Arts, University of Wisconsin, Milwaukee (WC), USA; *Manifesta 3*, Ljubljana, Slovenia **2001** Sprengel Museum, Hanover, Germany; *49. Biennale di Venezia*, Venice, Italy; *Public Offerings*, Museum of Contemporary Art, Los Angeles (CA), USA

SELECTED BIBLIOGRAPHY →
1997 Harald Szeemann, *4ème Biennale de Lyon* **1998** *Mai 98*, Josef-Haubrich-Kunsthalle, Cologne **1999** Burkhard Riemschneider/ Uta Grosenick (eds.), *Art at the Turn of the Millennium*, Cologne **2000** *Manfred Pernice*, Kunsthalle Zürich, Zurich; *Made in Berlin*, Städtische Galerie L. Kanakakis, Rethymnon

1 **Haupt/Centraldose,** 1998–2000, mixed media, 6 x Ø 2 m, installation view, Kunsthalle Zürich, Zurich
2 **Fiat** (detail), 2000, mixed media, installation view, Kunsthalle Zürich, Zurich

3 **Dosenfeld '00,** 2000, mixed media, installation view, Kunsthalle Zürich, Zurich
4 **Kümo,** 1999, mixed media, installation view, Nationalgalerie im Hamburger Bahnhof, Museum für Gegenwart, Berlin, 2000

„Im Widerspiel des Unmöglichen mit dem Möglichen erweitern wir unsere Möglichkeiten." (Ingeborg Bachmann)

« Dans l'opposition du possible avec l'impossible nous élargissons nos possibilités. » (Ingeborg Bachmann)

"In the interplay of the impossible and the possible, we extend the range of our possibilities." (Ingeborg Bachmann)

2

3

4

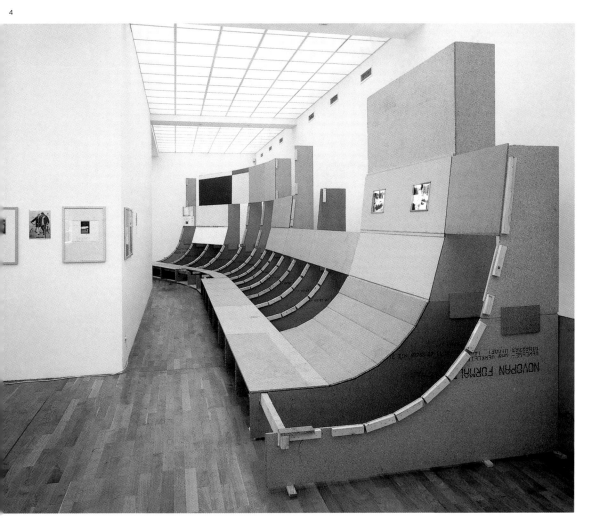

Elizabeth Peyton

1965 born in Danbury (CT), lives and works in New York (NY), USA

Elizabeth Peyton creates small, gem-like portraits of popular and historical figures, well-known musicians, fellow artists, and friends. Her visual biographies are suspended between the humanity and timelessness of traditional portraiture and the personal obsessions of an artist of her generation. She creates images that reflect her own ideas about beauty as well as beauty as it is constructed in contemporary culture. Each of the personalities she portrays – including the historic Ludwig II and Oscar Wilde, the popular Kurt Cobain from "Nirvana" and Noel Gallagher from "Oasis", and her artist-friends Craig Wadlin and Piotr Uklański – exhibits an elusive yet captivating vibrancy. Most of her subjects are men who share an androgynous quality, and she typically presents them with similar features including creamy skin and ruby lips. Working from photographs she takes or those she finds on albums and in books and magazines, Peyton surrounds herself with the people she most admires, constructing an ideal world that is filled with personal heroes and modern-day legends. But unlike the mass media which presents surface qualities, Peyton portrays the essence of her subjects with sincerity and tender admiration. She does not make distinctions in her work between people she knows personally and those she is acquainted with through their music, photos, or biographies. Rather, she chooses subjects whose spirit inspires her and influences others. Often she depicts individuals early in their lives and before they became famous, such as *Liam and Noel in the 70s*, 1997.

Elizabeth Peyton porträtiert in ihren kleinformatigen Arbeiten populäre und historische Figuren, etwa bekannte Sänger, Künstler, aber auch Freunde. Ihre visuellen Biografien sind im Spannungsfeld zwischen der Humanität und Zeitlosigkeit traditioneller Porträtkunst und den persönlichen Obsessionen einer Künstlerin ihrer Generation angesiedelt. Sie schafft Bilder, in denen sich ihr eigenes Schönheitsideal ebenso widerspiegelt wie das von der heutigen Popkultur geschaffene. Jede der von ihr porträtierten Persönlichkeiten – historische Figuren wie König Ludwig II. und Oscar Wilde, Popstars wie Kurt Cobain von "Nirvana" und Noel Gallagher von "Oasis" oder Künstlerfreunde wie Craig Wadlin und Piotr Uklański – zeichnet sich durch eine ebenso schwer fassbare wie ergreifende Lebendigkeit aus. Die meisten der von ihr Porträtierten sind androgyne Männer. Peyton gibt sie mit ähnlichen Zügen wieder, dazu gehören samtweiche Haut und rubinrote Lippen. Peyton arbeitet nach Fotografien, die sie entweder selbst aufnimmt oder auf CD-Hüllen oder in Büchern oder Zeitschriften findet, und umgibt sich auf diese Weise mit den Leuten, die sie am meisten bewundert. So entwirft sie eine Idealwelt, die von ihren persönlichen Heroen und den Legenden der Moderne bevölkert ist. Aber anders als die Massenmedien, denen es lediglich um die Oberfläche zu tun ist, stellt Peyton die von ihr porträtierten Persönlichkeiten voll Aufrichtigkeit und zärtlicher Bewunderung dar. Sie macht in ihrer Arbeit keinen Unterschied zwischen Leuten, die sie persönlich kennt, und solchen, mit denen sie lediglich durch ihre Musik, von Fotos oder aus Büchern vertraut ist. Ja, sie wählt für ihre Bildnisse Menschen aus, durch die sie sich inspiriert fühlt und die auch andere beeinflussen. Außerdem hat sie immer wieder Prominente in deren Jugend dargestellt, noch bevor sie berühmt geworden sind, etwa in der Arbeit *Liam and Noel in the 70s*, 1997.

Elizabeth Peyton réalise de petits portraits bijoux de personnages populaires et historiques, de musiciens connus, d'artistes et d'amis. Ses biographies visuelles sont suspendues entre, d'une part, l'humanité et l'intemporalité du portrait traditionnel et, de l'autre, les obsessions personnelles d'une artiste de sa génération. Elle crée des images qui reflètent ses propres critères de beauté ainsi que la beauté telle qu'elle est construite dans la culture contemporaine. Chacune des personnalités qu'elle dépeint – qu'il s'agisse de Louis II de Bavière ou d'Oscar Wilde, du chanteur de « Nirvana », Kurt Cobain, à celui d'« Oasis », Noel Gallagher, ou de ses amis artistes Craig Wadlin et Piotr Uklański – dégage des vibrations floues mais néanmoins captivantes. La plupart de ses sujets sont des hommes qui partagent une qualité androgyne. Elle les représente tous avec des traits similaires qui incluent un teint crémeux et des lèvres rouge rubis. Travaillant à partir de photographies qu'elle prend elle-même ou qu'elle trouve dans des albums, des livres ou des magazines, Peyton s'entoure des gens qu'elle admire le plus, construisant un monde idéal rempli de héros personnels et de légendes d'aujourd'hui. Mais contrairement aux médias qui présentent leurs qualités de surface, elle dépeint l'essence de ses sujets avec sincérité et une admiration teintée de tendresse. Dans son travail, elle ne fait pas de distinction entre ceux qu'elle connaît personnellement et ceux qu'elle connaît au travers de leur musique, de leurs photos ou de leur biographie. Elle choisit plutôt les sujets dont l'esprit l'inspire et influence les autres. Elle présente souvent ses personnages tôt dans leur vie, avant qu'ils ne soient devenus célèbres, comme dans le cas de *Liam and Noel in the 70s*, 1997.

Ro. S.

SELECTED EXHIBITIONS →
1998 Museum für Gegenwartskunst, Basle, Switzerland; Kunstmuseum Wolfsburg, Germany **1999** Castello di Rivoli, Turin, Italy **2000** *Tony*, Westfälischer Kunstverein, Münster, Germany; Aspen Art Museum, Aspen (CO), USA; *What if*, Moderna Museet, Stockholm, Sweden **2001** Deichtorhallen, Hamburg, Germany

SELECTED BIBLIOGRAPHY →
1998 Museum für Gegenwartskunst, Basle; Kunstmuseum Wolfsburg **2000** *Tony*, Westfälischer Kunstverein, Münster; Aspen Art Museum, Aspen (CO) **2001** Uta Grosenick (ed.), *Women Artists*, Cologne; Deichtorhallen, Hamburg

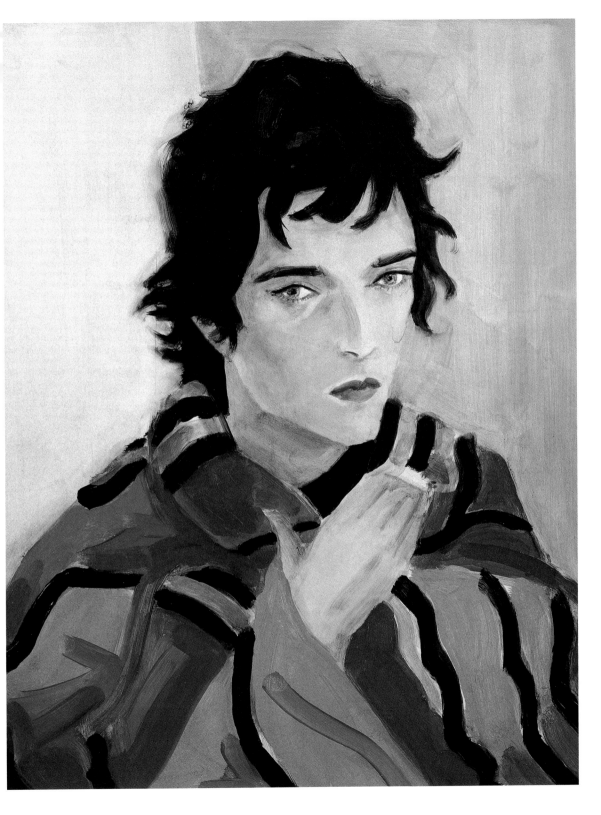

1 **Luing (Tony),** 2001, oil on MDF, 36 x 28 cm

2 **Spencer drawing,** 1999, oil on MDF, 23 x 30 cm
3 **Kirsty at Jorge's wedding,** 2001, oil on board, 36 x 28 cm

„Am meisten interessiert mich, glaube ich, die Fähigkeit der von mir
dargestellten Personen, sie selbst zu bleiben, obwohl sie in der Vorstellung
der Öffentlichkeit eine so unglaublich wichtige Rolle spielen.
Man kann ihren Willen unmittelbar erkennen, und das ist unglaublich schön."

« Je suppose que ce qui m'intéresse, c'est la faculté de mes sujets
à être eux-mêmes tout en occupant ce rôle extrême dans l'imagination
publique. On peut voir leur volonté, ce qui est incroyablement beau. »

**"I guess what I'm interested in is the quality
of my subjects' being able to be themselves while occupying
this extreme role in the public imagination.
You can see their will, and that's incredibly beautiful."**

2

Richard Phillips

1962 born in Marblehead (MA), lives and works in New York (NY), USA

Richard Phillips is known for his heroic-scale portraits copied from 1960s and 1970s fashion magazines. He adopts oil painting techniques that date back to the 19th century, though the harsh lighting and steely photo-realist surfaces of his works contradict this academic approach. His billboard-size paintings of fashion models from 1996 exhibit a cool blankness, and seem devoid of interior thought. In *Untitled (Cold Cream Woman)*, 1995, a generic beauty tilts her head in a typical pose despite the mask of thick white cream that obscures her features and provides a clear reference to the artifice involved in image-making. In a series of highly eroticised paintings from 1997, Phillips focuses his attention on the pre-Aids optimism of the 1970s soft-porn industry. *Tongue*, 1997, is a classic porn-mag shot: its low viewpoint places the model's parted lips and glistening tongue provocatively at the center of the image. Its larger-than-life proportions make it an intimidating vision of exaggerated sexuality. Phillips examines the precarious state of fame in two paintings from 1998. *Jacko (after Jeff Koons)*, is a portrait of Michael Jackson modelled on a sculpture by Jeff Koons, and *Portrait of God (after Richard Bernstein)* is a portrait of Rob Lowe at the height of his stardom, based on an "Interview" magazine cover. Both celebrities' reputations were tarnished by highly publicised sex scandals and Phillips' heroic paintings seem to reclaim the fallen heroes. Yet the titles' explicit reference to their intermediate source spells out Phillips' ironic distance and subordinates the star's identity to the power of his constructed image.

Richard Phillips ist für seine großformatigen Bildnisse bekannt, die von Modezeitschriften der sechziger und siebziger Jahre kopiert sind. Er verwendet Techniken der Ölmalerei des 19. Jahrhunderts, wenngleich die harte Ausleuchtung und die in fotorealistischer Nüchternheit gestalteten Oberflächen seiner Bilder dieser akademischen Vorgehensweise widersprechen. Seine plakatgroßen Gemälde von Supermodels (1996) stellen ihre kühle Glattheit und einen vollständigen Mangel an Emotionalität aus. *Untitled (Cold Cream Woman)*, 1995, zeigt eine typische Schönheit, die ihren Kopf in Pose wirft, trotz der dicken Feuchtigkeitsmaske, die ihre Züge fast unkenntlich macht und auf die Künstlichkeit jeder Bildkreation verweist. In einer Serie hocherotischer Gemälde von 1997 beschäftigt sich Phillips mit dem Optimismus der Softporno-Industrie der siebziger Jahre vor dem Auftreten von AIDS. *Tongue*, 1997, bietet die klassische Einstellung aus einem Pornomagazin: In der Untersicht rücken die geöffneten Lippen und die feucht glänzende Zunge des Models provokativ in den Mittelpunkt des Bildes. Das überlebensgroße Format macht es zur Angst erregenden Vision einer aus den Fugen geratenen Sexualität. In zwei Arbeiten von 1998 hat Phillips sich mit den Wechselfällen der Popularität auseinandergesetzt. *Jacko (after Jeff Koons)* ist ein – nach einer Skulptur von Jeff Koons modelliertes – Michael-Jackson-Porträt, während *Portrait of God (after Richard Bernstein)* Rob Lowe auf der Höhe seines Erfolgs zeigt; dieses Bildnis ist nach einem Titelfoto des „Interview"-Magazins entstanden. Auf die Popularität beider Stars ist ein dunkler Schatten gefallen, seit sie wegen angeblicher sexueller Verfehlungen in die Schusslinie der Medien geraten sind. Mit seiner heroischen Darstellung scheint Phillips die beiden gestürzten Helden wieder auf ihre Sockel stellen zu wollen. Durch den expliziten Verweis der Titel auf die Vorlagen der beiden Bilder demonstriert Phillips zugleich seine ironische Distanz und zeigt, dass die Identität eines Stars der Macht seines von den Medien geschaffenen Images unterworfen ist.

Richard Phillips est connu pour ses portraits grand format inspirés des magasines de mode des années 60 et 70. Il utilise des techniques de peinture à l'huile qui remontent au 19ème siècle, même si la lumière crue et les surfaces brillantes photo-réalistes de ses œuvres contredisent cette démarche académique. Ses tableaux de la taille de panneaux publicitaires géants représentent des mannequins et datant 1996 font preuve d'une neutralité froide et paraissent dépourvus d'intériorité. Dans *Untitled (Cold Cream Woman)*, 1995, une beauté générique renverse la tête en arrière dans une pose typique malgré l'épais masque de crème blanche qui dissimule ses traits et renvoie clairement aux artifices impliqués dans la fabrication des images. Dans une série de tableaux très érotiques de 1997, Phillips concentre son attention sur l'optimisme de l'industrie du porno soft des années 1970 avant l'apparition du sida. *Tongue*, 1997, est un cliché classique de revue X. Sa perspective provocante vers le haut place les lèvres entrouvertes et la langue luisante du modèle au centre de l'image. Toutefois, les proportions plus grandes que nature en font une vision intimidante de sexualité exagérée. Phillips se penche sur l'état précaire de la célébrité dans deux peintures de 1998 : *Jacko (after Jeff Koons)* est un portrait de Michael Jackson réalisé d'après une sculpture de Jeff Koons, et *Portrait of God (after Richard Bernstein)* celui de Rob Lowe au sommet de sa gloire, basé sur une couverture du magazine « Interview ». Ces deux célébrités ayant vu leur réputation salie par des scandales sexuels fortement médiatisés, ces toiles grand format semblent réhabiliter les héros déchus. Pourtant, les références explicites dans les titres à des sources intermédiaires trahissent la distance ironique de Phillips et subordonnent l'identité de la star à la puissance de son image construite. K. B.

SELECTED EXHIBITIONS →
1994 White Columns, New York (NY), USA **1997** Shoshana Wayne Gallery, Santa Monica (CA), USA; *Whitney Biennial*, The Whitney Museum of American Art, New York (NY), USA **1998** Friedrich Petzel Gallery, New York (NY), USA **1999** *Das XX Century*, INIT Kunsthalle Berlin, Germany **2000** Kunsthalle Zürich, Zurich, Switzerland; *Greater New York*, P.S.1, Long Island City (NY), USA **2001** Galerie Max Hetzler, Berlin, Germany; *The Contemporary Face: From Picasso to Alex Katz*, Deichtorhallen, Hamburg, Germany

SELECTED BIBLIOGRAPHY →
1999 Marcia Fortes, *ArtLovers*, Liverpool Biennial, Liverpool **2000** Mendes Burgi/Ronald Jones, *Richard Phillips*, Munich; *Greater New York*, P.S.1, Long Island City (NY); *The Figure: Another Side of Modernism. Paintings from 1950 to the Present*, Newhouse Center for Contemporary Art, Snug Harbour Cultural Center, Staten Island (NY)

1 **Scout,** 1999, oil on linen, 259 x 178 cm
2 **The President of the United States of America,** 2001, oil on linen,
 263 x 396 cm

3 Installation view, Kunsthalle Zürich, Zurich, 2000
4 **Blessed Mother,** 2000, oil on linen, 213 x 183 cm

„In meinen Bildern geht es um verschwendete Schönheit –
das ist von jeher das Grundthema meiner Arbeit gewesen."

« Mes images évoquent une sorte de beauté gaspillée,
le fil conducteur de tout mon travail. »

"My pictures involve a kind of wasted beauty – that's always been a thread in my work."

2

3

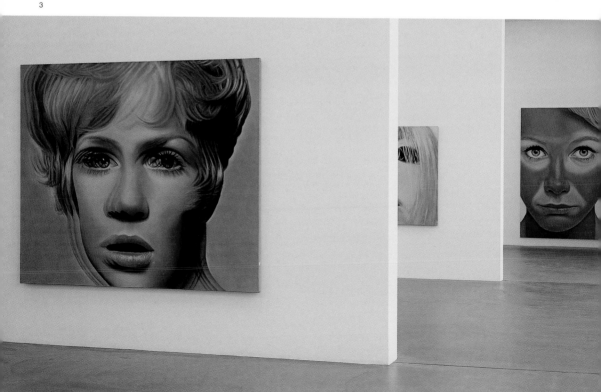

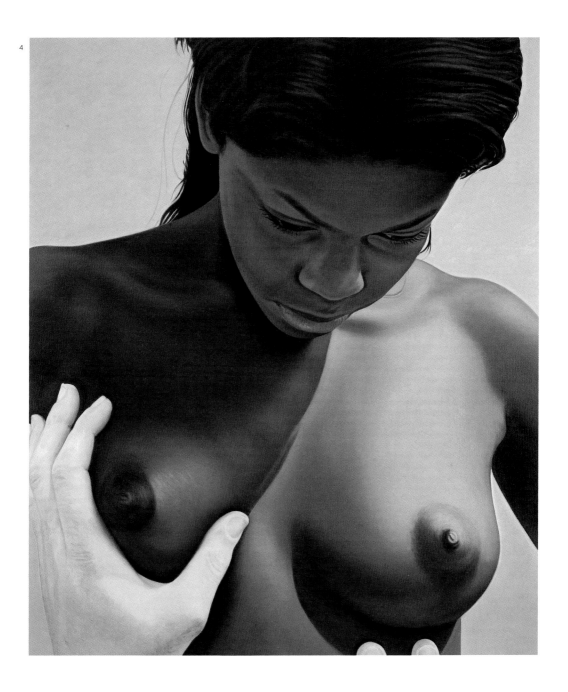

Neo Rauch

1960 born in Leipzig, lives and works in Leipzig, Germany

The colours, figures and forms in Neo Rauch's paintings are those of a bygone era. His personal background lies in the figurative East German paintings of the GDR's Leipzig School, with artists such as Wolfgang Mattheuer and Werner Tübke, but he is also influenced by the model of socialist perfection and the conventional graphic art of the period between 1940 and 1960. Comparable to montages, Rauch's paintings combine quotations and historical fragments to create designs full of narrative that exhibit his own clear viewpoint. He provides the trappings for a world of creation and change, a symbolic realism that dramaturgically traces life as it is arranged and mechanised. He fuses cartoons and print media with photography and film to serve his painting, and, ultimately, to produce an imagery of power. Rauch's ideas are based on the dissecting tension of the single frame, picked out like a film still, which he inserts in a structure somewhere between the aesthetic ideology of power and the political forces of socialism and capitalism. The titles of his works – *Werkschutz* (Factory Security), 1997, *Nachtarbeit* (Nightshift), 1997, *Arbeiter* (Worker), 1998, or *Form,* 1999 – refer to an associative construction of productive forces. Rauch is a producer and a creator – the inventor of idealistic characters whose hopes have failed or become meaningless. He is an alchemist who uses his tools and materials as if they were the pieces in a bewitched jigsaw puzzle. The moment of painting is always primary, and the power of painting within the structural canon of the 1960s remains present as a contemporary story, which he brings to our attention not as a linear narrative but as an irritation created by breaking open the surface, inserting new objects, interfacings, transferences and terms.

In den Gemälden von Neo Rauch sind Farben, Figuren und Formen einer vergangenen Epoche zugegen. Sein persönlicher Hintergrund ist die figurative ostdeutsche Malerei der Leipziger Schule in der DDR, Wolfgang Mattheuer und Werner Tübke, aber auch das Musterbild sozialistischer Vollkommenheit oder der Gebrauchsgrafik der vierziger bis sechziger Jahre. Rauch kombiniert wie in einer Montage Zitate und historische Fragmente zu einem Entwurf eines eigenen klaren Horizonts voller Erzählungen. Er richtet eine Welt des Schaffens und Werdens ein, einen symbolischen Realismus, der dramaturgisch dem arrangierten, mechanisierten Leben folgt. Die der Malerei dienende Verschränkung von Comic oder Printmedien und Fotografie oder Film ist letztlich eine Metaphorik der Kräfte. Rauchs Idee fußt auf der sezierenden Spannung eines Einzelbildes, herausgelöst wie ein Filmstill. Er legt es unter ein Raster zwischen der ästhetischen Ideologie der Macht und politischen Kräften wie Sozialismus und Kapitalismus. Titel seiner Arbeiten lauten *Werkschutz,* 1997, *Nachtarbeit,* 1997, *Arbeiter,* 1998, oder *Form,* 1999, und verweisen auf ein assoziatives Gefüge von Produktivkräften. Rauch ist produzierender Gestalter – Erfinder von Figuren voller Ideale, aber auch sinnentleerter, gescheiterter Hoffnungen. Er ist ein puzzelnder Alchimist, der die Apparaturen als prozessuale Materialien nutzt. Das malerische Moment bleibt immer vorrangig, und die Macht der Malerei im Formenkanon der sechziger Jahre ist als gegenwärtige Erzählung anwesend. Diese wird durch Aufbrechen der Fläche, Einschübe, Geflechte, Versätze oder Begriffe nicht narrativ und linear, sondern irritierend simultan vor Augen geführt.

Dans les peintures de Neo Rauch, on assiste à la résurgence de couleurs, de personnages et de formes issus d'époques passées. L'arrière-plan biographique de l'artiste est celui de la peinture figurative de l'école de Leipzig en RDA, avec Wolfgang Mattheuer ou Werner Tübke, mais aussi le modèle de la perfection socialiste ou le graphisme utilitaire des années 40 à 60. A partir de citations et de fragments historiques, Rauch concrétise le projet d'un horizon personnel limpide et plein d'anecdotes, un peu comme dans un montage, arrangeant un monde de création et de devenir, un réalisme symbolique dont la dramaturgie se calque sur la vie arrangée et mécanisée. En définitive, la combinaison entre bande dessinée et médias imprimés, ou entre photographie et cinéma mise au service de la peinture, est une grande métaphore filée des forces en présence. L'idée de Rauch repose sur l'énergie disséquante de l'image unique isolée comme une photographie de plateau, soumise à une trame mêlant idéologie esthétique du pouvoir et forces politiques telles que le socialisme et le capitalisme. Les titres de ses œuvres – *Werkschutz* (Sécurité de l'entreprise), 1997, *Nachtarbeit* (Travail de nuit), 1997, *Arbeiter* (Travailleur), 1998, ou *Form* (Forme), 1999 – renvoient à la synergie des forces de production. Rauch est créateur et producteur – inventeur de figures chargées d'idéaux, mais aussi d'espoirs échoués et vidés de sens. Il est un alchimiste composant un puzzle, et qui se sert de son appareillage comme d'un matériau processuel. L'élément pictural demeure toujours prédominant, et le pouvoir de la peinture réalisée dans le canon formel des années 60 est présent sous la forme d'un récit contemporain que les ruptures de plans, les inserts, les trames, les décalages ou les concepts ne présentent jamais de façon narrative ou linéaire, mais dans une irritante simultanéité.

G. J.

SELECTED EXHIBITIONS →
1995 Dresdner Bank, Leipzig, Germany **1999** *After the Wall,* Moderna Museet, Stockholm, Sweden; *Malerei,* INIT Kunsthalle, Berlin, Germany **2000** Galerie Eigen+Art, Leipzig, Germany; David Zwirner Gallery, New York (NY), USA; *German Open,* Kunstmuseum Wolfsburg, Germany **2001** Galerie für Zeitgenössische Kunst Leipzig, Germany; *Contemporary German Art/The Last Thirty Years/Thirty Artists from Germany,* Goethe-Institut, Bombay, India; *49. Biennale di Venezia,* Venice, Italy

SELECTED BIBLIOGRAPHY →
2000 *Randgebiet,* Galerie für Zeitgenössische Kunst Leipzig; *Neo Rauch – Sammlung Deutsche Bank,* Leipzig

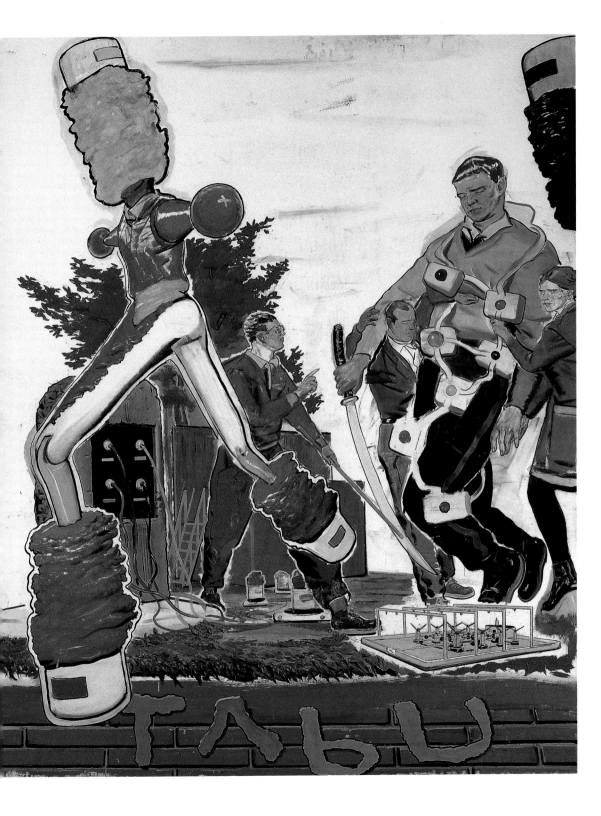

1 **Tabu,** 2001, oil on paper, 243 x 198 cm
2 **Grat,** 2000, oil on canvas, 200 x 300 cm

3 Installation view, Italian Pavilion, *49. Biennale di Venezia,* Venice, 2001
4 **Märznacht,** 2000, oil on paper, 265 x 200 cm

„Ich versuche, die Dinge im Zaum zu halten und die Aspekte
des Unbewussten sehr bewusst zu inszenieren."

« Je tente de tenir la bride aux choses et de mettre en scène de
manière très consciente les aspects de l'inconscient. »

"I try to keep things under control
and to stage aspects of the subconscious in a very conscious way."

2

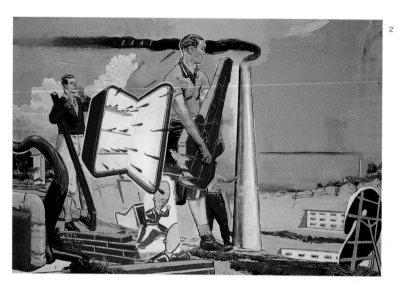

3

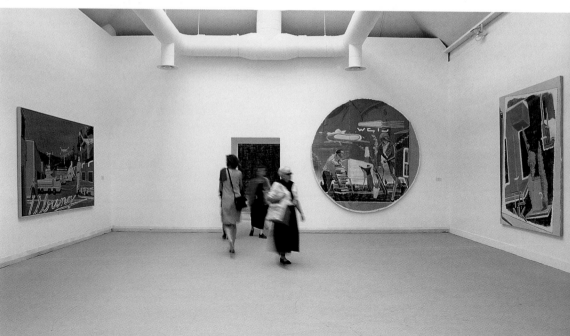

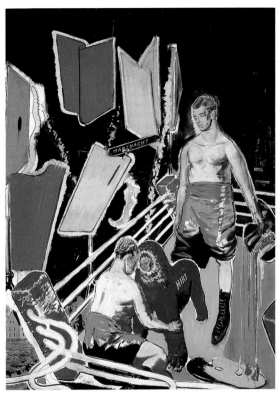

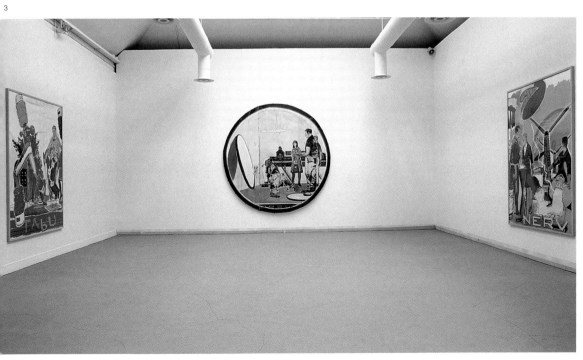

Tobias Rehberger

1966 born in Esslingen, lives and works in Frankfurt am Main, Germany

Tobias Rehberger's inclusive approach to his art involves museum staff, curators, gallery owners and friends in the process of artistic creation. Some of his works are designed simply to fulfill the physical requirements of a gallery's staff members, such as *vorschlag für die decke eines gemeinschaftsraums [frau sievert und frau eckhardt-salaemae]* (suggestion for the ceiling of a common room), 1997. Others result from proposals for comfortable furnishings. As a result of a survey held in the changing exhibition space at Frankfurt's Portikus, he ordered new door handles to be fitted, placed newspapers in toilets, gave instructions for the exhibition space to be fitted with a colourful, sprung timber floor, and designed a 1970s-style seating arrangement. His comfort displays (*Lying around lazy. Not even moving for TV, sweets, Coke and vaseline*, 1996) have links with the clubbing scene, where the design of lounges and chill-out zones is often inspired by 1970s interiors. Rehberger's inclusive working method often involves delegating the actual production of his works, and so he commissioned the construction of two cars of the type men dream of – a Porsche 911 and a MacLaren. The vehicles were built cheaply in Thailand using sketches he had drawn from memory. Rehberger appropriates the mechanisms of the service industry by treating galleries as "customers", and by confirming and including the "productive force of consumers" (Michel de Certeau). His *Bindan GmbH & Co.*, 2000, shown at the Kunsthalle in Hamburg, creates a direct link between the work of museums and that of business. The installation consists of hand-blown lamps, which switch on automatically as soon as people enter the meeting room of a temp agency in the office building across the street.

Der partizipatorische Ansatz von Tobias Rehberger beteiligt Museumsmitarbeiter, Kuratoren, Galeristen und Freunde am Entstehungsprozess seiner Werke. Einige Arbeiten sind lediglich nach den Körpermaßen von Institutionsmitarbeitern ausgerichtet (*vorschlag für die decke eines gemeinschaftsraums [frau sievert und frau eckhardt-salaemae]*, 1997), andere folgen den Vorschlägen für eine besonders angenehme Inneneinrichtung. So ließ er nach einer Befragung im Frankfurter Portikus neue Türklinken anbringen, deponierte Zeitungen in den Toiletten, ließ den Ausstellungsraum mit einem farbigen, federnden Holzboden auslegen und entwarf eine Sitzgruppe im Siebziger-Jahre-Design. Die Gestaltung seiner Wohlfühldisplays (*Lying around lazy. Not even moving for TV, sweets, Coke and vaseline*, 1996) stellt Beziehungen zum Clubkontext her, wo Siebziger-Jahre-Design den Einrichtungsstandard von Lounges und Chill-Out-Zonen bestimmt. Zu Rehbergers integrativem Arbeitsprozess gehört auch, dass er die Produktion der Arbeiten delegiert. So ließ er zwei Autos, von denen Jungen häufig träumen, einen Porsche 911 und einen MacLaren, im Billigproduktionsland Thailand nach Skizzen anfertigen, die er aus der Erinnerung gezeichnet hatte. Rehberger übernimmt Mechanismen der Dienstleistungsökonomie, indem er die Ausstellungsinstitution als eine Art „Kunden" betrachtet, und die „Produktivkraft der Konsumenten" (Michel de Certeau) konstatiert und miteinbezieht. In seiner Arbeit *Bindan GmbH & Co.*, 2000, in der Hamburger Kunsthalle, verknüpft Rehberger die Arbeit im Museum unmittelbar mit derjenigen eines Wirtschaftsbetriebs. Die Installation aus mundgeblasenen Lampen schaltet sich ein, wenn in einer Zeitarbeitsfirma im gegenüber liegenden Bürohaus der Konferenzraum genutzt wird.

La démarche de Tobias Rehberger est ouverture à l'intervention du personnel des musées, des conservateurs, des galeristes et des amis dans la genèse des œuvres. Certaines s'appuient simplement sur les mensurations des employés de certaines institutions (*vorschlag für die decke eines gemeinschaftsraums [frau sievert und frau eckhardt-salaemae]*/proposition pour le plafond d'une salle commune, 1997), d'autres répondent à des propositions pour tel ou tel aménagement intérieur particulièrement agréable. Ainsi, après avoir procédé à un sondage, l'artiste faisait installer au Portikus de Francfort de nouvelles poignées de porte, disposait des journaux dans les toilettes, faisait installer au sol de la salle d'exposition un plancher de bois souple et coloré, et concevait un ensemble de sièges dans le style des années 70. La création de ces éléments de bien-être (*Lying around lazy. Not even moving for TV, sweets, Coke and vaseline*, 1996) se réfère au contexte des clubs, dans lesquels le design des années 1970 a posé le standard des aménagements des salons et des zones de transit. Un facteur du processus de travail intégratif de Rehberger consiste à déléguer la production des œuvres. Ainsi, dans un pays de production rentable comme la Thaïlande, l'artiste a fait fabriquer sur la base d'esquisses réalisées de mémoire, deux voitures dont les jeunes rêvent souvent : une Porsche 911 et une MacLaren. Rehberger adopte les mécanismes du secteur tertiaire en considérant l'institution exposante comme une sorte de « client », enregistrant et intégrant la « force de production du consommateur » (Michel de Certeau). Dans *Bindan GmbH & Co.*, 2000, une œuvre exposée à la Kunsthalle de Hambourg, Rehberger lie le travail du musée à celui de l'entreprise : l'installation de lampes soufflées à la main s'allume lorsqu'une salle de conférence est utilisée dans l'agence d'intérim de l'immeuble de bureaux qui fait face au musée. N. M.

SELECTED EXHIBITIONS →
1996 *Heetz, Nowak, Rehberger*, Städtisches Museum Abteiberg, Mönchengladbach, Germany **1997** *Home Sweet Home*, Deichtorhallen Hamburg, Germany **1998** Kunsthalle Basel, Basle, Switzerland; *Manifesta 2*, Luxembourg **1999** *The Secret Bulb in Barry L.*, Galerie für Zeitgenössische Kunst, Leipzig, Germany **2000** *The Sun from Above*, Museum of Contemporary Art, Chicago (IL), USA; *In Between*, EXPO 2000, Hanover, Germany; *What if*, Moderna Museet, Stockholm, Sweden **2001** *Plug In*, Westfälisches Landesmuseum, Münster, Germany

SELECTED BIBLIOGRAPHY →
1998 *Tobias Rehberger*, Moderna Museet, Stockholm; *Tobias Rehberger*, Kunsthalle Basel, Basle **1999** Burkhard Riemschneider/ Uta Grosenick (eds.), *Art at the Turn of the Millennium*, Cologne **2001** *(whenever you need me)*, Westfälischer Kunstverein, Münster

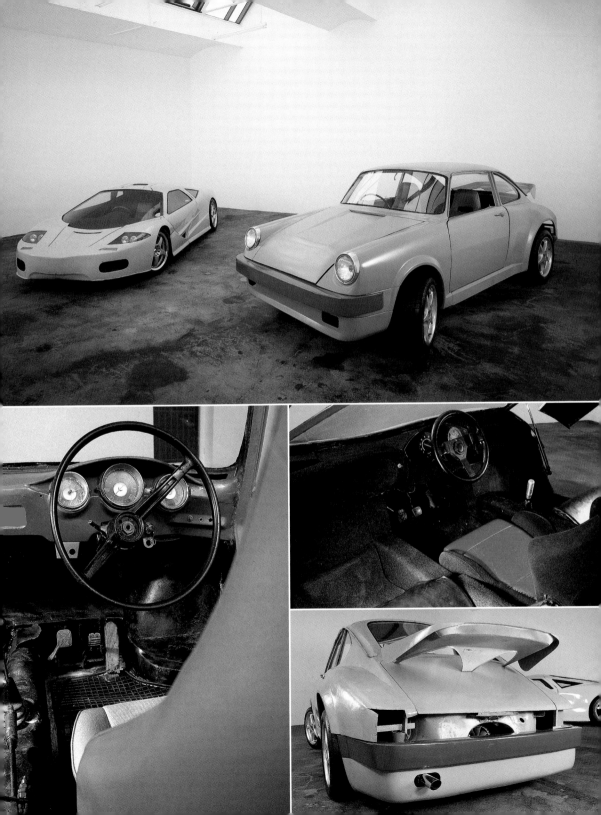

„Das, was mir angenehm ist, ist das ‚Außer-Kontrolle-Geraten'.
Mich interessiert die Differenz zwischen dem, was ich gewollt habe und
dem, was einer draus gemacht hat."

« Ce qui me plaît, c'est la perte de contrôle. Ce qui m'intéresse,
c'est la différence entre ce que j'ai voulu et ce que d'autres en ont fait. »

"I enjoy the aspect of 'losing control'. I'm interested in the difference between my intention and what someone else has done with it."

2

3

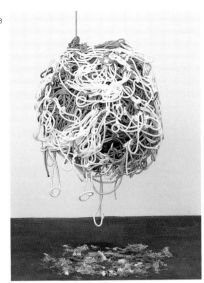

4

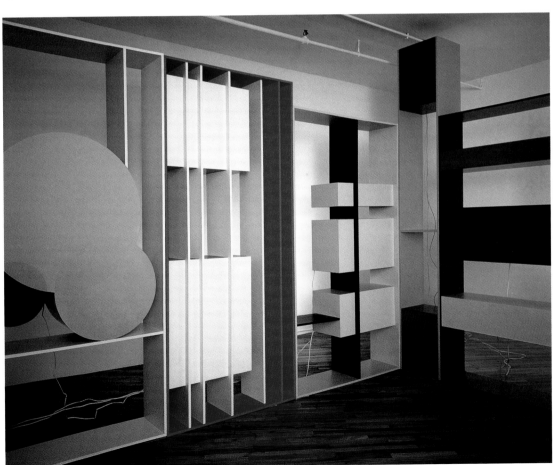

Jason Rhoades

1965 born in Newcastle (CA), lives and works in Los Angeles (CA), USA

Male obsessions determine Jason Rhoades' urge for accumulation: large, fast sports cars, car races, weapons, phallic constructions and ejaculations, machinery, tools, engines. Masses of materials are acquired, organised, purchased, owned, collected, constructed. Everything is connected with everything else and it is all part of the scupltural process. The formation of an idea in space is a precise combination of ordinary materials, which are subjected by Rhoades to a new interrelation of meaning and a new order. The personal cosmos and private context is frequently a background for his subjective interpretations. This can be seen in the world's largest sculpture, *Perfect World*, 1999, displayed in the Deichtorhallen in Hamburg. Reinterpreted as a secular Garden of Eden, the parent garden in California was lifted from the soil and placed onto a second level. With this colossal construction of polished aluminium pipes and wooden boards, Rhoades constructed an airy, biblical Paradise. Whether they are experiences in space or moments of physical danger on crossing from the public to the private space via a hydraulic ramp, all this is part of the work, a personal system within an artificial system. All of Rhoades' artistic thought is focused on the imagined, not the real space. It is apparent that the physical principle, indeed a principle of physics, is of far more importance than the masculine. After spending a year as a guest lecturer in Frankfurt, he installed the *Costner Complex (Perfect Process)* in the Portikus in Frankfurt, where he created a totally uninhibited mixture of Hollywood kitsch, gastronomic culture and sculptural concept. The moment of conviction lies in the overwhelming power of his creativity and perception.

Männliche Obsessionen bestimmen den Akkumulationsdrang von Jason Rhoades: schnelle, große Autos, Autorennen, Waffen, phallische Konstruktionen und Ejakulationen, Maschinen, Werkzeug, Motoren. Massen von Material werden beschafft, organisiert, gekauft, besessen, gesammelt, zusammengestellt. Alles hängt mit allem zusammen und ist skulptural prozess. Die Formbildung ist eine präzise Kombination handelsüblicher Materialien, die von Rhoades einem neuen Sinnzusammenhang und einer neuen Ordnung unterworfen werden. Der persönliche Kosmos ist häufig Hintergrund der Interpretationen wie auch bei der größten Skulptur der Welt in den Hamburger Deichtorhallen, *Perfect World*, 1999. Zum weltlichen Paradiesgarten Eden umgedeutet, war der väterliche Garten in Kalifornien dem Boden enthoben und erhielt auf einer zweiten Ebene Raum. Mit einer gewaltigen Konstruktion aus polierten Alu-Rohren, Holzplatten und Computerprints der fotografierten Pflanzen errichtete Rhoades die luftige, biblische Paradieszone. In ihr fanden Raumerfahrungen, physische Gefahrenmomente wie das Durchfahren vom öffentlichen in den privaten Raum mit einer Hebebühne statt – all das ist Teil der Arbeit, ein eigenes System im Kunstsystem. Dem imaginären, nicht dem realen Raum gilt die künstlerische Hoffnung Rhoades'. Deutlich wird hierbei, dass das physikalische, mithin physische Prinzip weitaus wesentlicher als das männliche ist. Für den Frankfurter Portikus brachte er nach einer einjährigen Gastprofessur ebendort den *Costner Complex (Perfect Process)* in den Kunstbetrieb und mixte ungeniert Hollywood-Glamour, Esskultur und Skulpturbegriff zusammen. In der Überforderung der Schaffenskraft und der Wahrnehmung liegt das überzeugende Moment.

Les obsessions masculines sont à l'origine du besoin d'accumulation de Jason Rhoades : voitures de sport rapides et imposantes, courses automobiles, armes, constructions phalliques et éjaculations, machines, outils, moteurs. Des masses de matériau sont commandées, organisées, achetées, habitées, collectionnées, agencées. Tout est lié à tout et devient processus sculptural. La mise en forme de l'idée d'espace est une combinaison précise de matériaux courants que Rhoades soumet à un ordre et à une cohérence sémantique nouveaux. L'univers personnel et le contexte privé servent souvent de toile de fond à ces interprétations subjectives, comme l'a montré la plus grande sculpture du monde exposée dans les Deichtorhallen de Hamburg, *Perfect World*, 1999. Réinterprété en Eden terrestre, le jardin californien du père de l'artiste fut surélevé et installé sur un deuxième niveau. Avec sa gigantesque structure de tubes d'aluminium poli et de planches de bois, Rhoades édifiait la zone aérienne, biblique, du paradis. Les perceptions spatiales et les menaces physiques au moment du passage de la sphère privée à la sphère publique – à l'aide d'un plateau hydraulique – tout ceci fait partie de l'œuvre et constitue un système particulier au sein du système « art ». En fait, l'espoir artistique de Rhoades porte sur l'espace neutre, pas sur l'espace réel. Ici manifestement, le principe physique, par conséquent physiologique, est de loin plus essentiel que le principe masculin. Après avoir été professeur invité pendant un an à Francfort, l'artiste installait au Portikus de Francfort son *Costner Complex (Perfect Process)*, qui mêlait insolement Kitsch hollywoodien, culture gastronomique et concept sculptural. Ce travail emporte l'adhésion par l'exacerbation de la force créatrice et de la perception. G. J.

SELECTED EXHIBITIONS →
1996 Kunsthalle Basel, Basle, Switzerland **1997** *Whitney Biennial*, The Whitney Museum of American Art, New York (NY), USA **1998** *The Purple Penis and the Venus*, Kunsthalle Nürnberg, Nuremberg, Germany **1999** Danish Pavilion (with Peter Bonde), *48. Biennale di Venezia*, Venice, Italy; *dAPERTuttO*, *49. Biennale di Venezia*, Venice, Italy; *A Perfect World*, Deichtorhallen, Hamburg, Germany **2001** *Costner Complex (Perfect Process)*, Portikus, Frankfurt am Main, Germany; *Public Offerings*, Museum of Contemporary Art, Los Angeles (CA), USA

SELECTED BIBLIOGRAPHY →
1998 *The Purple Penis and the Venus*, Kunsthalle Nürnberg, Nuremberg; *The Purple Penis and the Venus in Eindhoven – A Spiral with Flaps and Two useless Appendages. After the Seven Stomachs of Nurnberg as Part of the Creation Myth*, Van Abbemuseum, Eindhoven **1999** Burkhard Riemschneider/Uta Grosenick (eds.), *Art at the Turn of the Millennium*, Cologne; *A Perfect World*, Deichtorhallen, Hamburg

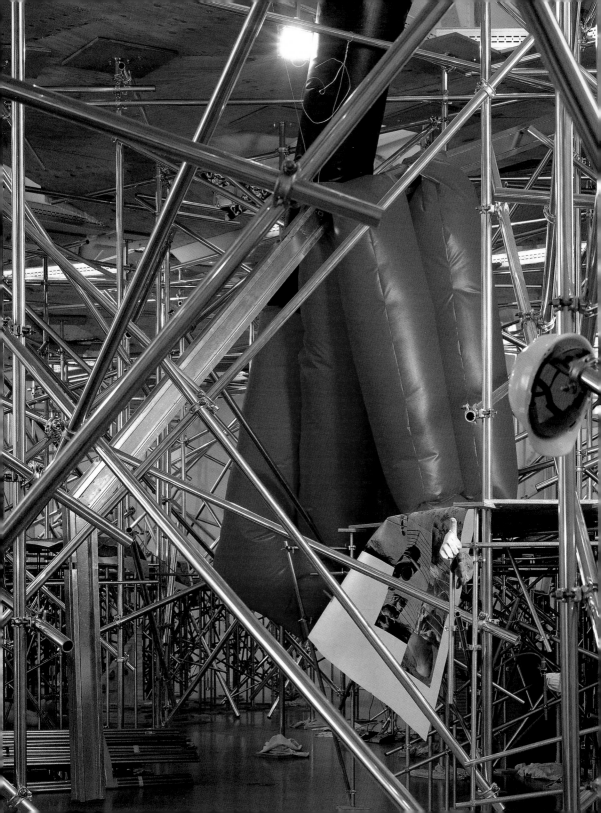

266

1, 2, 3 **Perfect World,** 1999, installation views, Deichtorhallen Hamburg
4 **Costner Complex (Perfect Process),** 2001, installation view, Portikus,
Frankfurt am Main

5 **A Few Free Years,** 1998, 18 gaming machines, installation view,
Kunsthalle Bremen, 1999

„Es gibt nichts Beliebiges in meiner Arbeit, weil es immer eine Reaktion
auf die Beliebigkeit gibt, die sie dann wieder präzise macht."

« Il n'y a rien d'arbitraire dans mon travail, car il existe toujours une
réaction qui rend l'arbitraire précis. »

"There's nothing arbitrary about anything in my work because there's always a reaction to the arbitrariness which make it precise."

2

3

4

5

Daniel Richter

1962 born in Eutin, lives and works in Berlin, Germany

At the beginning of his artistic career the graphic artist and painter Daniel Richter worked as an illustrator for popular music magazines. This affinity with music is reflected in his early paintings: like a DJ with his mixing desks, he feverishly sampled a variety of painting styles and traditions. The canvases contain references to other artists, including Asger Jorn, Gerhard Richter and Philip Guston. His extraordinary imagery is also infiltrated by ornamentation and abstract figures from popular culture. These paintings, such as *Babylon Disco vs. Disco Babylon*, 1999, are full to bursting point, and test the limits of painting as a storage medium and the receptiveness of the almost overloaded viewer. Richter has expanded the stylistic repertoire of his more recent pictures by integrating representational elements. Virtually naturalistic representations enter into an intense dialogue with a psychedelic expressiveness of colour. Again Richter refers to the painterly positions of others, including James Ensor and Peter Doig, while at the same time dealing with overtly political subjects like violence and emigration. The painting *Tarifa*, 2001, for instance, depicts refugees in a stormy sea, helplessly crowded together in a small inflatable dinghy. The sea is painted an expressive black, while the figures seem irradiated by garish colour. This work can be viewed as an aesthetic testing ground for the autonomy of painting, its historicity and its scope for political application.

Der Maler und Zeichner Daniel Richter war zu Beginn seiner künstlerischen Karriere auch als Illustrator für populäre Musikmagazine tätig. Die Verwandtschaft zur Musik findet sich in seinen frühen Gemälden wieder: Diverse malerische Stile und Traditionen werden wie auf dem Mixpult eines DJs furios gesampelt. Referenzen an Maler wie Asger Jorn, Gerhard Richter oder Philip Guston etwa sind auf der Leinwand auszumachen. Aber auch Ornamente und abstrakte Figuren aus der Populärkultur werden eingeschleust in diese fantastische Bilderwelt. Zum Bersten voll sind diese Gemälde, zum Beispiel sein *Babylon Disco vs. Disco Babylon*, 1999, und testen so die Grenzen der Aufnahmefähigkeit – der Aufnahmefähigkeit des Speichermediums Gemälde, aber auch die des fast schon überforderten Rezipienten. In neueren Bildern hat Richter sein stilistisches Repertoire erweitert, indem er auch gegenständliche Formen in seine Malerei integriert. Beinahe naturalistische Abbildungen und eine psychedelisch-expressive Farbigkeit treten in einen spannungsvollen Dialog. Wieder bezieht sich Richter dabei auf andere malerische Positionen, zum Beispiel auf James Ensor oder Peter Doig. Gleichzeitig behandelt der Künstler in diesen Arbeiten dezidiert politische Themen wie Gewalt oder Emigration. In dem Bild *Tarifa*, 2001, etwa sind Flüchtlinge auf schwerer See zu sehen, hilflos in einem kleinen Schlauchboot eingepfercht. Das Meer ist in expressivem Schwarz gemalt, die Figuren dagegen scheinen in greller Farbigkeit gleichsam durchleuchtet worden zu sein. Hier stehen die Autonomie des Genres Malerei, seine Geschichtlichkeit und die Möglichkeiten auch für politische Anwendungen auf dem ästhetischen Prüfstand.

Au début de sa carrière artistique, le peintre et dessinateur Daniel Richter a notamment travaillé comme illustrateur pour des revues de musique pop. Le parallèle avec la musique se retrouve dans ses premières peintures : différents styles et traditions picturaux sont furieusement samplés comme sur la table de mixage d'un DJ. Dans ces toiles, on relève toutes sortes de références picturales, notamment à Asger Jorn, Gerhard Richter ou Philip Guston. Mais cet univers visuel fantastique intègre aussi des ornements et des figures abstraites issues de la culture populaire. Ces peintures sont pleines à craquer, comme par exemple *Babylon Disco vs. Disco Babylon*, 1999, et sondent ainsi les limites de l'assimilation, à savoir la capacité d'accueil du support de données qu'est le « tableau », mais aussi la réceptivité d'un spectateur presque dépassé par cette profusion. Dans ses œuvres récentes, Richter a étendu son répertoire stylistique en intégrant aussi dans sa peinture des formes figuratives. Des représentations quasi naturalistes et un chromatisme psychédélique-expressif y entretiennent un passionnant dialogue. Dans ces œuvres, Richter fait également référence à d'autres positions artistiques comme James Ensor ou Peter Doig. En même temps, il y aborde des thèmes résolument politiques, tels que la violence et l'immigration. Dans *Tarifa*, 2001, il nous montre des réfugiés en haute mer entassés sans défense dans un zodiaque. La mer est peinte dans un noir expressif, tandis qu'avec leurs couleurs stridentes, les figures semblent en quelque sorte irradiées. Ici, l'autonomie du genre « peinture », son historicité et ses possibilités sont aussi mises à l'épreuve de leur utilisation politique.

R. S.

SELECTED EXHIBITIONS →
1997 *punch in out*, Kunsthaus Hamburg, Germany **1998** *Organisierte Kriminalität*, Contemporary Fine Arts, Berlin, Germany; *Otto-Dix-Preis*, Kunstsammlung Gera, Germany **1999** *Fool on a Hill*, Galerie Johnen + Schöttle, Cologne, Germany; *Malerei*, INIT Kunsthalle, Berlin, Germany; *German Open*, Kunstmuseum Wolfsburg, Germany **2001** *Billard um halbzehn*, Kunsthalle zu Kiel, Germany; *Painting*, Victoria Miró Gallery, London, UK; *La cause du peuple*, Patrick Painter Inc., Santa Monica (CA), USA

SELECTED BIBLIOGRAPHY →
1997 *Daniel Richter, 17 Jahre Nasenbluten*, Berlin **2000** *German Open*, Kunstmuseum Wolfsburg **2001** *Daniel Richter, Billard um halbzehn*, Kunsthalle zu Kiel

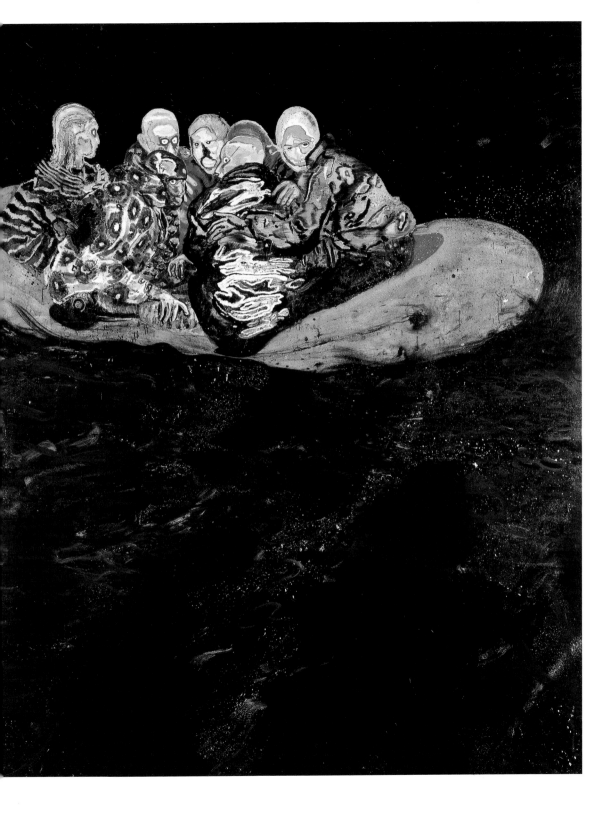

1 **Tarifa,** 2001, oil on canvas, 350 x 280 cm

2 **Fool on a Hill,** 1999, oil, gloss paint on canvas, 255 x 405 cm
3 **King Kong,** 1999, oil, gloss paint on canvas, 225 x 180 cm

„Malerei ist das trägste, langsamste und traditionsbewussteste Medium, das am schwersten zu erweitern ist."

« La peinture est le médium le plus figé, le plus lent et le plus conscient de la tradition, et donc le plus difficile à élargir. »

"Painting is the most sluggish, unhurried and tradition-conscious medium, and the most difficult to broaden."

2

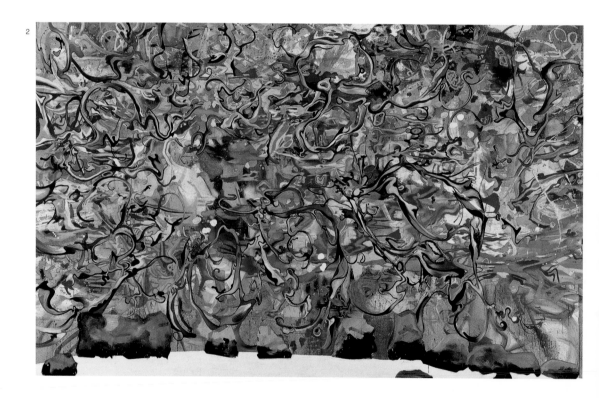

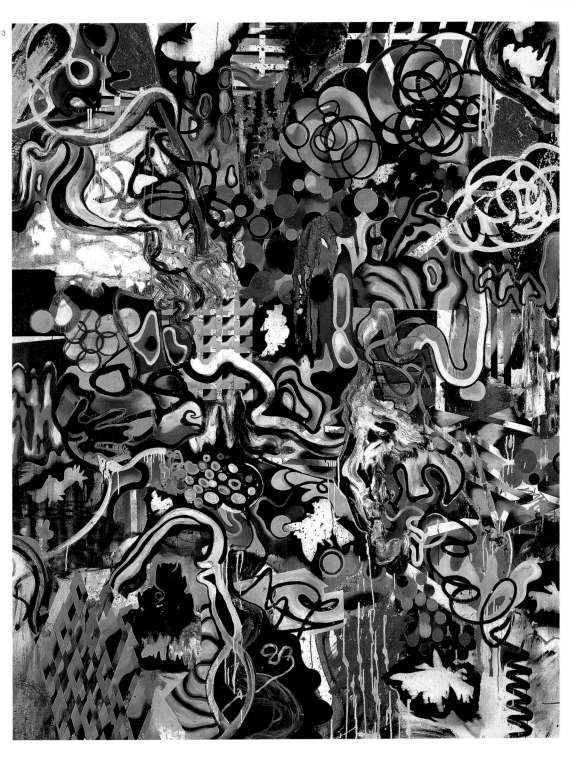

Pipilotti Rist

1962 born in Rheintal, lives and works in Zurich, Switzerland

Pipilotti Rist is best known for her double video projection *Ever Is Over All*, 1997, which is set to mesmerizing music composed by Anders Guggisberg. One image features a young woman wearing a light blue dress and red shoes; she carries a flower called a red-hot poker that has been cast in metal and uses it to smash the windows of cars parked along her path. That image is juxtaposed with a video featuring a garden of red-hot pokers, a swirling abstraction of enlarged stalks and colourful blossoms. Rist's combinations of strong soundtracks and vibrant moving images has led to her work being compared with music videos. Many of her video pieces, including *Sip My Ocean*, 1996, and *I'm Not The Girl Who Misses Much*, 1986, make direct references to popular music and the genre of music videos, recasting songs by Chris Isaak and John Lennon respectively. In addition to making videos, Rist constructs spaces in which to view them. *Das Zimmer* (The Room), 1994, includes an oversized red leather sofa and a television featuring a selection of her videos. A large-scale remote control labelled "Pipi TV" allows viewers to choose the videos they watch. *Himalaya Goldsteins Stube* (H. G.'s Room), 1997–99, approximates the playful ambience of a young woman's apartment. Monitors and projectors are inset into walls and furniture so that moving images appear on the sofas, chairs, lampshades and tables. Like the pervasive tune in *Ever Is Over All*, the piece's haunting melody adds to the overall ambience and engaging experience of the installation. Viewers are invited to make themselves at home, sit on the furniture, wander around the rooms and watch her videos.

Am bekanntesten ist Pipilotti Rist für ihre doppelte Videoprojektion *Ever Is Over All*, 1997, die von Anders Guggisbergs faszinierender Musik untermalt wird. Auf einer der Bildfolgen ist eine junge Frau in einem hellblauen Kleid und mit roten Schuhen zu sehen. Sie hält eine in Metall gegossene Fackellilie in der Hand und zertrümmert damit die Scheiben der Autos am Straßenrand. Parallel dazu läuft ein Video, das einen Garten mit Fackellilien zeigt, der wie eine wirbelnde Abstraktion aus vergrößerten Stengeln und farbenprächtigen Blüten erscheint. Wegen der Kombination eindrucksvoller Musik mit pulsierend bewegten Bildern werden Rists Arbeiten immer wieder mit Musikvideos verglichen. Viele ihrer Videostücke, etwa *Sip My Ocean*, 1996, und *I'm Not The Girl Who Misses Much*, 1986, enthalten direkte Verweise auf die Popmusik sowie das Genre des Musikvideos und präsentieren Lieder von Chris Isaak und John Lennon in ganz neuen Kontexten. Rist produziert nicht nur Videos, sondern entwirft auch die Räume, in denen sie gezeigt werden. In der Installation *Das Zimmer*, 1994, hat sie ein überdimensioniertes Sofa und einen Fernseher aufgestellt, auf dem eine Auswahl ihrer Videos gezeigt wird. Eine großformatige Fernbedienung mit der Aufschrift „Pipi TV" gestattet es dem Betrachter, selbst zu entscheiden, welches Video er sehen möchte. *Himalaya Goldsteins Stube*, 1997–99, erinnert mit seinem verspielten Interieur an die Wohnung einer jungen Frau. In die Wände und Möbel sind Monitore und Projektoren eingebaut, so dass in den Oberflächen der Sofas, Stühle, Lampenschirme und Tische bewegte Bilder erscheinen. Genau wie in *Ever Is Over All* verstärkt auch hier die ungemein eindrucksvolle musikalische „Untermalung" die atmosphärische Gesamtwirkung der Installation. Der Betrachter ist eingeladen, es sich bequem zu machen, die Möbel zu benutzen, durch die Räume zu schlendern und sich Rists Videos anzuschauen.

Pipilotti Rist est surtout connue pour sa double projection vidéo, *Ever Is Over All*, 1997, qui s'accompagne d'une musique envoûtante composée par Anders Guggisberg. Sur un écran, une jeune femme, vêtue d'une légère robe bleue et de souliers rouges, porte une fleur en métal appelée un « fer rouge » avec laquelle elle fracasse les vitres des voitures garées le long de son chemin. Cette image est juxtaposée à une seconde projection présentant un jardin de « fers rouges », une abstraction tourbillonnante d'agrandissements de tiges et de fleurs colorées. Les associations de bandes son marquantes et d'images vibrantes ont souvent fait comparer son travail à des clips vidéos. De fait, un grand nombre de ses œuvres vidéos, dont *Sip My Ocean*, 1996, et *I'm Not The Girl Who Misses Much*, 1986, font directement référence à la musique populaire et au monde du clip, recourant à des chansons de, respectivement, Chris Isaak et John Lennon. Outre ses vidéos, Rist construit des espaces dans lesquels les visionner. *Das Zimmer* (La Chambre), 1994, inclut un canapé géant en cuir rouge et un poste de télévision dans lequel passe une sélection de ses vidéos. Une grande télécommande, baptisée « Pipi TV » permet aux spectateurs de choisir leur programme. *Himalaya Goldsteins Stube* (chambre de H. G.) 1997–99, recrée l'atmosphère ludique de l'appartement d'une jeune femme. Des écrans et des projecteurs sont encastrés dans les murs et les meubles de sorte que des images animées apparaissent sur les canapés, les fauteuils, les abat-jour et les tables. Comme l'air entêtant de *Ever Is Over All*, une mélodie envoûtante en fond sonore ajoute à l'atmosphère d'ensemble et à l'expérience conviviale de l'installation. Les spectateurs sont invités à prendre leurs aises, à s'asseoir sur les meubles, à se promener dans les pièces et à regarder ses vidéos.

Ro. S.

SELECTED EXHIBITIONS →
1996 *Sip My Ocean*, Museum of Contemporary Art, Chicago (IL), USA **1997** *Future Past Present*, *47. Biennale di Venezia*, Venice, Italy **1998** *Remake of the Weekend*, Musée d'Art Moderne de la Ville de Paris, France; *1. berlin biennale*, Germany **1999** *Regarding Beauty*, Hirshhorn Museum and Sculpture Garden, Washington D.C., USA; *6th Istanbul Biennial*, Istanbul, Turkey **2000** *Wonderland*, Saint Louis Art Museum, St. Louis (MS), USA **2001** Museo Nacional de Arte Reina-Sofía, Madrid, Spain

SELECTED BIBLIOGRAPHY →
1995 Pipilotti Rist, *I'm Not The Girl Who Misses Much*, Stuttgart **1996** *Sip My Ocean*, Museum of Contemporary Art, Chicago (IL) **1998** Pipilotti Rist, *Himalaya: Pipilotti Rist: 50 kg*, Cologne; Pipilotti Rist, *Remake of the Weekend*, Cologne **2000** *Wonderland*, Saint Louis Art Museum, St. Louis (MS)

1 **Open My Glade,** 2000, 16 different 1 min videos for the NBC Astrovision by Panasonic Video Screen at Times Square, New York City commissioned by Public Art Fund, running every quarter past the hour from April 6 through May 20

2 **Extremitäten (weich, weich),** 1999, video installation, installation view, Kunsthalle Zürich, Zurich

3 **Extremitäten (weich, weich),** 1999, video stills

4 **Himalaya Goldsteins Stube (Remake of the Weekend),** 1998/99, video installation, installation view, Kunsthalle Zürich, Zurich, 1999

„Wir versuchen Visionen zu schaffen, die die Leute mit dem ganzen Körper erfahren können. Denn virtuelle Welten vermögen das Bedürfnis nach Sinneswahrnehmungen nicht zu ersetzen."

« Nous essayons de construire des visions que les gens peuvent vivre avec l'ensemble de leur corps, car les mondes virtuels ne peuvent remplacer le besoin de perceptions sensuelles. »

"We are trying to build visions that people can experience with their whole bodies, because virtual worlds cannot replace the need for sensual perceptions."

2

4

3

Ugo Rondinone

1964 born in Brunnen, lives and works in Zurich, Switzerland, and New York (NY), USA

This enigmatic statement ("I never sleep …", p. 278) is the title of a 1999 installation by Ugo Rondinone. A small orchard of eight trees, their branches bandaged with black electrical tape, is planted in a field of black rubber on the floor of the gallery. The gallery windows are covered with acid green gel, infusing the room with green light while giving the landscape outside an unnatural, nauseating fluorescence. The boundaries between nature and artifice blur until both states seem elusive and unreliable. Tiny speakers dangling from the trees inside whisper a melancholy monologue (from which the title is taken), further complicating the perceptual process by lulling the viewer into a dreamlike state. Sleep itself is literally manifest in *Where Do We Go From Here*, 1996, a filmed performance in which four costumed clowns lie sleeping fitfully on the gallery floor, ignoring their task of entertainment in an illustration of affected ennui. Rondinone's work is riddled with unsettling effects, not least due to the proliferation of media he chooses to work with. He produces small "diaries" filled with ink drawings and wistful texts; large circular paintings in day-glo colours whose concentric rings merge into each other like intoxicated targets; photographs borrowed from high-fashion magazines with his facial features digitally grafted onto the supermodel's own. Rondinone disassembles the forms of contemporary mass media and uses their flimsy structures to rebuild a separate hazy world where reality is hesitant, activity is circular, identity is transitory and melancholy is the overriding emotional force.

Das rätselhafte Statement ("I never sleep …", S. 278) ist der Titel einer Installation von Ugo Rondinone aus dem Jahr 1999: Er pflanzte einen kleinen Hain aus acht Bäumen, deren Äste mit schwarzem Isolierband umwickelt waren, In einem mit schwarzem Gummi ausgelegtem Ausstellungsraum. Die Galeriefenster waren mit einem giftgrünen Gel verkleistert, so dass der Raum von grünem Licht durchflutet wurde, während die Landschaft draußen auf eine unnatürliche, Übelkeit erregende Weise zu leuchten schien. Die Grenzen zwischen Natur und Kunst verschwammen so weit, dass beide Ebenen sich als flüchtig und ungreifbar erwiesen. Kleine Lautsprecher, die von den Bäumen baumelten, flüsterten einen melancholischen Monolog (dem auch der Titel entnommen ist), der den Betrachter in seinen Wahrnehmungen noch mehr verwirrte und in eine Art Traumzustand versetzte. Ausdrücklich behandelt wird das Thema Schlaf in *Where Do We Go From Here*, 1996, einer gefilmten Performance, in der vier kostümierte Clowns unruhig auf dem Boden der Galerie schlafend sich demonstrativ ihrer eigentlichen Aufgabe zu unterhalten verweigern. Rondinones Werk gibt durch seine verstörenden Effekte immer neue Rätsel auf, nicht zuletzt wegen der Vielfalt der Medien, in denen er arbeitet. So kreiert er mit Tuschezeichnungen und sehnsuchtsvollen Texten angefüllte kleine „Tagebücher"; mit fluoreszierenden Day-Glo-Farben ausgeführte großformatige kreisrunde Gemälde, deren konzentrische Ringe wie auf einer benebelten Zielscheibe ineinander fließen. Oder aber er nimmt Fotografien aus Modemagazinen und kopiert sein Gesicht digital über die Züge eines Supermodels. Rondinone zerlegt die zeitgenössischen Massenmedien in ihre Bestandteile und baut ihre zerbrechlichen Elemente zu einer ganz eigenen schemenhaften Welt neu zusammen – einer Welt, deren Wirklichkeit sich nur zögernd offenbart, in der alles Tun im Kreis verläuft und in der sich Identität als ein höchst flüchtiges Gebilde und Melancholie als die Grundbefindlichkeit erweisen.

Cette déclaration énigmatique (« I never sleep … », p. 278) est le titre d'une installation d'Ugo Rondinone de 1999. Un petit verger de huit arbres, leurs branches bandées de ruban isolant noir, est planté dans un champ de caoutchouc noir sur le plancher de la galerie. Les fenêtres sont enduites d'un gel vert acidulé, diffusant dans la pièce une lumière verte tout en conférant au paysage extérieur une fluorescence irréelle et écœurante. Les frontières entre la nature et l'artifice se fondent jusqu'à ce que les deux états paraissent également fuyants et trompeurs. De minuscules haut-parleurs suspendus aux arbres chuchotent un monologue mélancolique (d'où est extrait le titre), compliquant encore le processus perceptif en berçant le spectateur dans un état proche du rêve. Le sommeil est littéralement présent dans *Where Do We Go From Here*, 1996, une performance filmée où quatre clowns en costume dorment d'un sommeil agité sur le sol de la galerie, négligeant leur mission d'amuseurs dans une illustration d'ennui affecté. Le travail de Rondinone fourmille d'effets déstabilisateurs, dus notamment à la prolifération des techniques avec lesquelles il choisit de s'exprimer. Il réalise de petits « journaux intimes » remplis de dessins à l'encre et de textes nostalgiques ; de grandes peintures circulaires aux couleurs fluorescentes dont les anneaux concentriques se télescopent et fusionnent comme des cibles ivres ; des photographies empruntées à des revues de haute couture avec de nouveaux visages greffés numériquement sur ceux des top models. Rondinone démonte les formes des médias contemporains et utilise leurs structures fragiles pour reconstruire un autre univers brumeux où la réalité est hésitante, l'activité circulaire, l'identité transitoire et la mélancolie la force émotionnelle directrice. K. B.

SELECTED EXHIBITIONS →
1994 *Oh boy, it's a girl*, Kunstverein München, Munich, Germany **1996** *XXIII Bienal Internacional de São Paulo*, Brazil; *Dog days are over*, Museum für Gegenwartskunst, Zürich, Switzerland **1998** *From the corner of the eye*, Stedelijk Museum, Amsterdam, The Netherlands **1999** Kunsthaus Glarus, Switzerland; *6th Istanbul Biennial*, Istanbul, Turkey **2000** P.S.1, Long Island City (NY), USA; *Let's Entertain*, Walker Art Center, Minneapolis (MN), USA

SELECTED BIBLIOGRAPHY →
1993 *Die Sprache der Kunst*, Kunsthalle Wien, Vienna/Frankfurter Kunstverein, Frankfurt am Main **1996** *Where do we go from here?*, XXIII Bienal Internacional de São Paulo; *heyday*, Museum für Gegenwartskunst, Zurich **2000** *Guided by Voices*, Kunsthaus Glarus

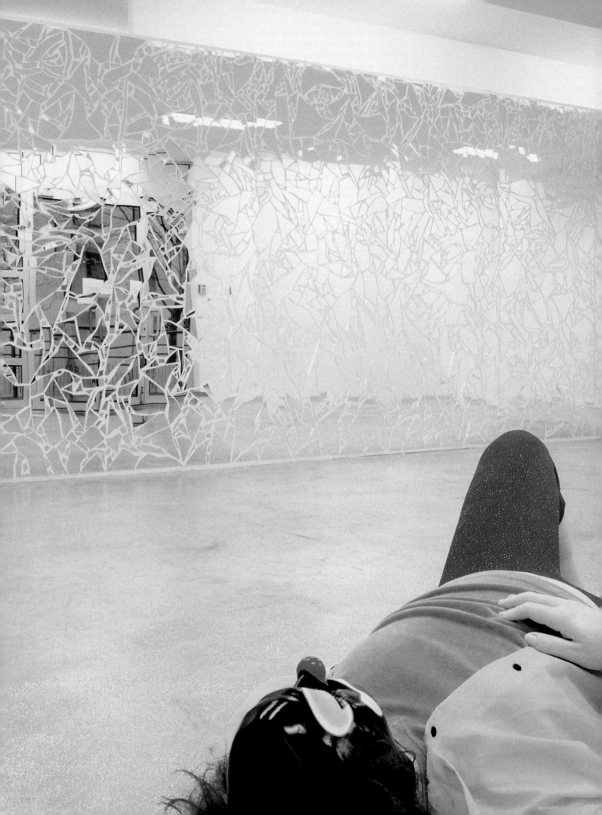

1 **If There Were Anywhere But Desert (1),** 2000, 1 Clown (cotton, polyester), glitter, dimensions of the artist, installation view, Galerie Almine Rech, Paris, 2001
2 **Love Invents Us,** 1999, acrylic glass, neon, 3.10 x 7.20 m, installation view, *Moonlighting,* Galerie Hauser & Wirth & Presenhuber, Zurich

3 **Grand Central Station,** 1999, wood, plaster, 2 trees, 2 x 20 loudspeakers, CD-player, amplifier, sound, installation view, *Moonlighting,* Galerie Hauser & Wirth & Presenhuber, Zurich
4 **Where Do We Go From Here?,** 1996, wall painting in Indian ink, wood, yellow neon light, 4 video projectors, sound, dimensions variable, installation view, Le Consortium – Centre d'Art Contemporain, Dijon

„Ich schlafe nie. Ich habe noch nie geschlafen. Ich habe noch nie einen Traum gehabt. Das alles könnte wahr sein."

« Je ne dors jamais. Je n'ai jamais dormi. Je n'ai jamais rêvé. Tout ceci pourrait être vrai. »

"I never sleep. I've never slept at all. I've never had a dream. All of that could be true."

2

3

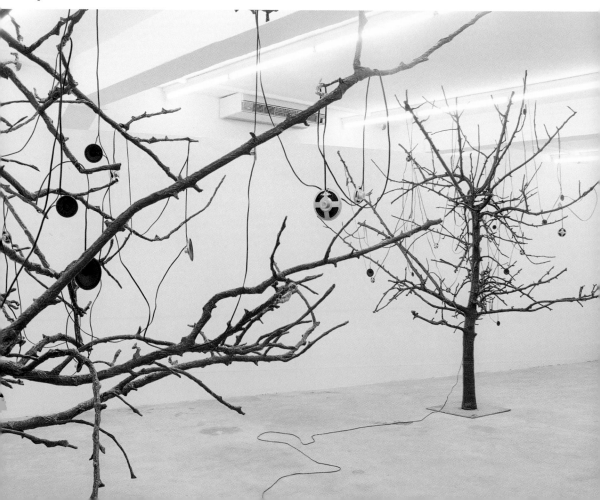

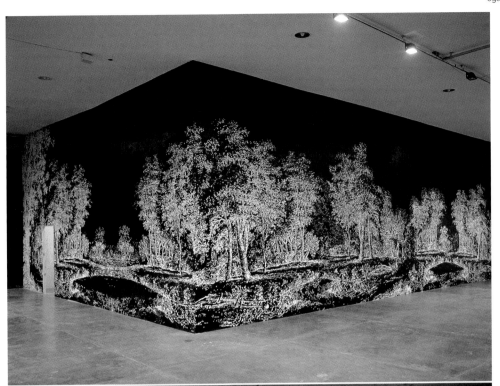

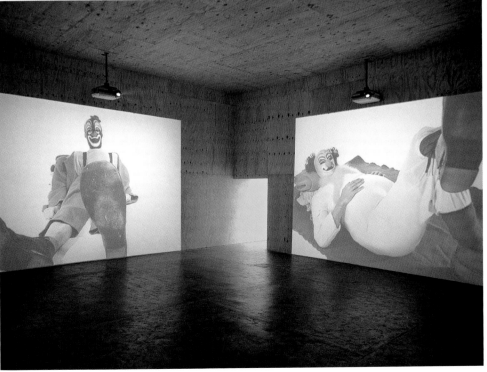

Thomas Ruff

1958 born in Zell am Hammersbach, lives and works in Düsseldorf, Germany

Thomas Ruff's approach to the production of images could be described as a sceptical examination of the conventions of various genres such as portraiture, political posters and the photography of architecture. Although Ruff is grouped with Düsseldorf's "Becher School", and his output therefore associated with the medium of photography, his work reaches beyond the boundaries of conventional photography. Ruff commonly refers to ready-made visual material and makes use of the computer's ability to retrieve and manipulate images. For his *nudes* series (begun in 1999), he downloaded pornographic images from the Internet and then modified them by altering colours, blurring the pictures and adding a "painterly" touch by softening the focus. The visible structures of pixels on the hugely enlarged *nudes* guide the viewer to the pictures' surfaces; they remove the pornographic gaze from the depicted reality and offer themselves up for perception in a more aestheticised form. Hence photographic considerations – with regard to reproduction, mass reception and relation to reality – are developed further using visual techniques. Ruff uses all of his extensive series to test the resistance and transformational capacity of omnipresent (imaginary) images. The points of reference for his *l. m. v. d. r.* series (1999–2001) are famous works by the architect Ludwig Mies van der Rohe: icons of modernism whose perception has to a high degree been shaped by photographs. Again, Ruff asks whether it is possible to remove or add a dimension to material that is all too familiar – be it through the spatial effects of stereo photography or by virtually "accelerating" the viewer's gaze with horizontally blurred motifs.

Die Herangehensweise von Thomas Ruff an die Produktion von Bildern lässt sich beschreiben als skeptische Beschäftigung mit den Konventionen verschiedener Genres, wie etwa Porträt, politisches Plakat oder Architekturfotografie. Auch wenn man Ruff der Düsseldorfer „Becher-Schule" zurechnet und sein Werk daher mit dem Medium Fotografie assoziiert, geht seine Arbeit über das konventionell Fotografische hinaus. Häufig greift Ruff auf bereits vorhandenes visuelles Material zurück und bedient sich der Möglichkeiten der Bildrecherche und -bearbeitung am Computer. Für die Serie der *nudes* (1999 begonnen) verwendete er pornografische Darstellungen aus dem Internet, die er durch Farbveränderungen, Bewegungsunschärfen und „malerische" Weichzeichner modifizierte. Die erkennbare Pixelstruktur der stark vergrößerten *nudes* verweist den Betrachter auf die Oberfläche der Bilder; sie entziehen die dargestellten Tatsachen dem pornografischen Blick und bieten sich für eine stärker ästhetisierende Wahrnehmung an. So werden fotografische Überlegungen – zu Reproduzierbarkeit, massenhafter Rezeption und zum Wirklichkeitsbezug – mittels neuer Techniken des Visuellen weitergeführt. In umfangreichen Serien testet Ruff allgegenwärtige (Vorstellungs-)Bilder auf ihre Resistenz oder Wandlungsfähigkeit. Bezugspunkt seiner Serie *l. m. v. d. r.* (1999–2001) sind berühmte Werke des Architekten Ludwig Mies van der Rohe, Ikonen der Moderne, deren Wahrnehmung in hohem Maß durch Fotografien geprägt wurde. Auch hier geht Ruff der Frage nach, ob es möglich ist, einem allzu bekannt erscheinenden Ausgangsmaterial eine Dimension zu nehmen oder hinzuzufügen – sei es durch räumlich wirkende Stereofotografien oder eine virtuelle „Beschleunigung" des Blicks durch horizontale Verwischungen der Motive.

La manière dont Thomas Ruff aborde la production d'images pourrait se décrire comme un travail sceptique sur les conventions de genres comme le portrait, l'affiche politique ou la photographie d'architecture. Même s'il peut être classé dans « l'école de Becher » et que son œuvre est associée de ce fait au médium photographique, le travail de Ruff va au-delà de la photographie au sens conventionnel. Ruff fait appel à un matériau visuel préexistant et se sert des outils de recherche et de traitement informatiques de l'image. Pour sa série *nudes* (commencée en 1999), l'artiste s'est servi de représentations pornographiques tirées de l'Internet, modifiées par altération des couleurs, par des flous dynamiques et par l'utilisation de l'outil « artistique ». La structure pixellisée des *nudes* fortement agrandis renvoie le spectateur à la surface des images, qui soustraient la représentation au regard pornographique et proposent une perception plus fortement esthétique. Ainsi, l'emploi de nouvelles techniques visuelles permet de développer la réflexion photographique sur la reproductibilité, la réception massive et le rapport au réel. Dans ses vastes séries, Ruff teste des images (fantasmatiques) omniprésentes quant à leur résistance ou à leur évolutivité potentielle. La série *l. m. v. d. r.* (1999–2001) a pour référence les célèbres réalisations de l'architecte Ludwig Mies van der Rohe, icônes de la modernité dont la perception a été fortement marquée par la photographie. Ici encore, Ruff se penche sur la question de savoir s'il est possible de tirer ou d'ajouter une dimension à un matériau initial à première vue trop connu – que ce soit par les effets tridimensionnels de la stéréographie ou par une « accélération » virtuelle du regard produite par des traînées horizontales appliquées aux motifs. B. H.

SELECTED EXHIBITIONS →
2000 *l. m. v. d. r.*, Haus Lange/Haus Esters, Krefeld, Germany; *How you look at it*, Sprengel Museum, Hanover, Germany **2001** Chabot Museum, Rotterdam, The Netherlands; *ex(o)DUS*, Haifa Museum of Art, Haifa, Israel; *Mies in Berlin*, The Museum of Modern Art, New York (NY), USA **2002** Folkwang Museum, Essen, Germany; Lenbachhaus, Munich, Germany

SELECTED BIBLIOGRAPHY →
1997 *Œuvres 1979–97*, Centre National de la Photographie, Paris **1999** Burkhard Riemschneider/Uta Grosenick (eds.), *Art at the Turn of the Millennium*, Cologne **2000** *l. m. v. d. r./l. m. v. d. r*, Haus Lange/Haus Esters, Krefeld

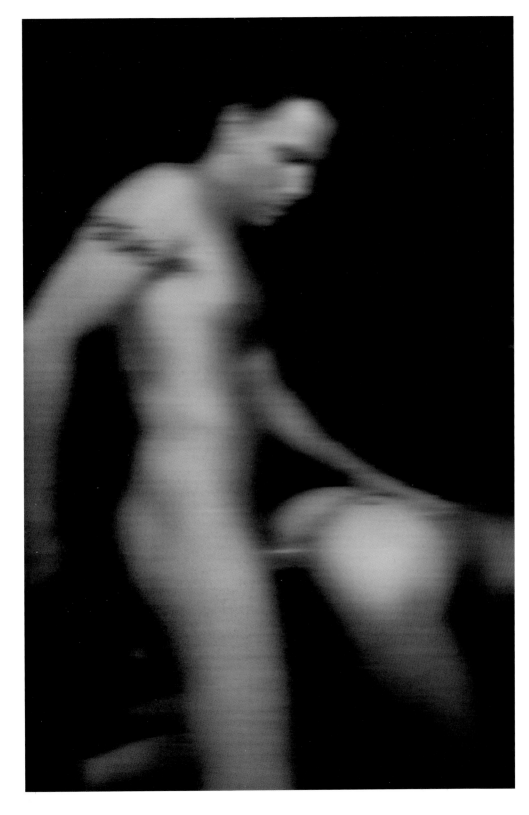

1 **nudes mn23,** 1999, c-print, 160 x 110 cm
2 **d. p. b. 02,** 1999, c-print, 185 x 285 cm

3 **h. l. k. 01,** 2000, c-print, 185 x 285 cm
4 **h. l. k. 02,** 2000, c-print, 185 x 270 cm

„Aktfotos müssen schön sein."

« Les photos de nus doivent être belles. »

"Photographs of the nude have to be beautiful."

2

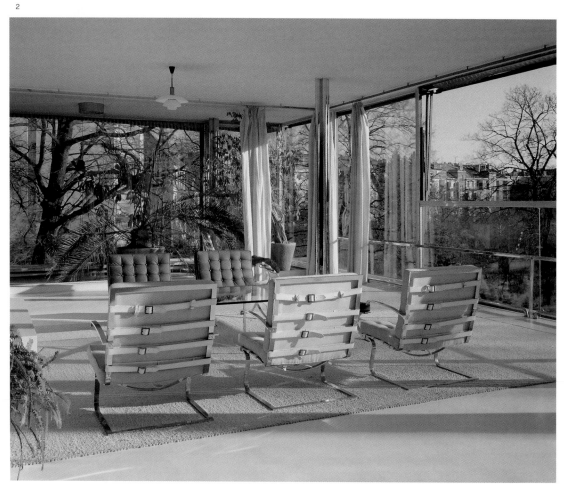

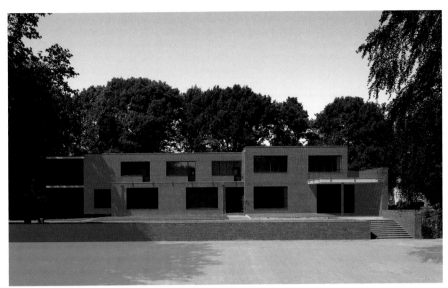

3

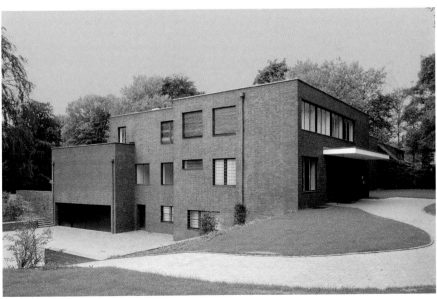

4

Gregor Schneider

1969 born in Rheydt, lives and works in Rheydt, Germany

Art circles obsessively around the home, wishing either to flee or to return. In times of homelessness, when the familiar suddenly becomes alien and the distant and strange make up for the lack of privacy, Gregor Schneider chooses to stay at home. His house in Rheydt has become the scene of one of the most radical projects at the turn of the century. While its unassuming bourgeois façade would seem to indicate stability, the *House ur* (as the artist calls it) is being continually remodelled. In most of the rooms Schneider has erected additional walls, installed extra windows and soundproof panels, and enveloped living space within a cocoon of lead. He builds inwards, closing certain rooms off for good; the phantasm of perfect isolation is a leitmotif of his work. A web of conjecture hangs around the house. Schneider makes no concessions to the inquisitive, merely mentions having "relatives in the cellar" and provides proof of his fascination with the dark, the hidden and the perverse. Having worked inside the house since the late 1980s, the artist faced the issue of letting his work be seen. Using the same material that the room in the *House ur* was made of, he recreates his innocent white spaces and the mysterious stains on the carpet. Rooms disappear from the house as Schneider puts them on display. After the exhibition the rooms fall back into place. The *House ur* absorbs them like a mother in reverse.

Die Kunst kreist wie besessen um das traute Heim, möchte entweder davor fliehen oder dorthin zurückkehren. In Zeiten der Heimatlosigkeit, da das Vertraute plötzlich fremd erscheint und das Ferne und Fremde den Verlust an Geborgenheit kompensieren soll, ent-scheidet sich Gregor Schneider dafür, zu Hause zu bleiben. Sein Haus im niederrheinischen Rheydt ist zum Schauplatz eines der radikalsten Projekte der Jahrhundertwende geworden. Mag auch die unprätentiöse Fassade des *Haus ur* (wie der Künstler seine Heimstatt nennt) auf den ersten Blick Stabilität verheißen, das Innere des Gebäudes ist gleichwohl einem Prozess der permanenten Umgestaltung unterworfen. Schneider hat in den meisten Räumen zusätzliche Wände gesetzt, Extrafenster und schalldämpfende Platten eingebaut und den Wohnraum mit einer Bleischicht umkleidet. Der Umbau schreitet immer weiter nach innen fort; einige Räume sind versiegelt. Das Phantasma der perfekten Isolation ist ein Leitmotiv seiner Arbeit. Sein Haus ist in ein ganzes Gewebe von Mutmaßungen eingesponnen. Doch Schneider quittiert die Neugier mit Schweigen und erwähnt lediglich, dass er „Verwandte im Keller" hat. Dies alles belegt die Faszination, die das Dunkle, das Verborgene und Perverse auf ihn ausüben. Bereits Ende der achtziger Jahre hat der Künstler mit der Umgestaltung seines Hauses begonnen und stand schließlich vor dem Problem, sein Werk zu zeigen. Unter Verwendung der Materialien aus *Haus ur* entstehen seither andernorts unschuldig weiße Nachbauten der betreffenden Zimmer – mitsamt den mysteriösen Flecken auf dem Teppichboden. So verschwinden nach und nach ganze Räume aus seinem Haus, die Schneider anderswo wieder aufbaut. Nach dem Ende einer Ausstellung lässt Schneider die betreffenden Räume an ihrem Ursprungsort neu erstehen. Das *Haus ur* nimmt sie wie eine Mutter wieder in sich auf.

L'art gravite de manière obsessionnelle autour du foyer, qu'il tente de le fuir ou d'y pénétrer. En ces temps d'errance, alors que le familier devient étranger et que le distant et l'étrange compensent l'absence d'intimité, Gregor Schneider a choisi de rester chez lui. Sa maison à Rheydt est devenue la scène de l'un des projets les plus radicaux du tournant du siècle. En dépit de sa façade bourgeoise sans prétention qui semble suggérer une certaine stabilité, la *Haus ur* (Maison ur, comme l'appelle l'artiste) est continuellement en train d'être remodelée. Dans la plupart des pièces, Schneider a érigé des murs supplémentaires, rajoutant des fenêtres et des panneaux insonorisants, avant d'envelopper l'espace habitable d'un cocon en plomb. Il construit vers l'intérieur, condamnant définitivement certaines pièces. Le fantasme d'un isolement parfait est un leitmotiv dans son travail. Un réseau de conjectures plane sur la maison. Schneider ne fait aucune concession à la curiosité des autres, mentionnant vaguement qu'il a des « parents dans la cave ». En outre, il apporte les preuves de sa fascination pour les ténèbres, le caché et le pervers. Ayant travaillé dans sa maison depuis la fin des années 80, l'artiste a été confronté à la question de laisser voir son travail. Utilisant les mêmes matériaux que dans la *Haus ur*, il recrée ses espaces blancs innocents et les taches mystérieuses sur le tapis. Les pièces disparaissent de la maison à mesure que Schneider les expose. Après l'exposition, les pièces retrouvent leur place. La *Haus ur* les absorbe comme une mère à l'envers.

A. S.

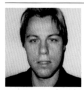

SELECTED EXHIBITIONS →
1996 Kunsthalle Bern, Berne, Switzerland **1997** Portikus, Frankfurt am Main, Germany; *Niemandsland*, Museum Haus Lange/Haus Esters, Krefeld, Germany **1998** *Performing Buildings*, Tate Gallery, London, UK **1999** Kabinett für aktuelle Kunst, Bremerhaven, Germany; *Anarchitecture*, Stichting De Appel, Amsterdam, The Netherlands; *Carnegie International*, Carnegie Museum of Art, Pittsburgh (PA), USA **2001** Wiener Secession, Vienna, Austria; German Pavilion, *49. Biennale di Venezia*, Venice, Italy

SELECTED BIBLIOGRAPHY →
1996 *Gregor Schneider*, Kunsthalle Bern, Berne **1997** *Totes Haus ur/ Dead House ur/Martwy Dom ur 1985–1997*, Frankfurt am Main/ Warsaw/Mönchengladbach/Paris **1999** *Gregor Schneider. Keller*, Wiener Secession, Vienna; Burkhard Riemschneider/Uta Grosenick (eds.), *Art at the Turn of the Millennium*, Cologne **2001** *Gregor Schneider, Totes Haus ur, 49. Biennale di Venezia*, Venice

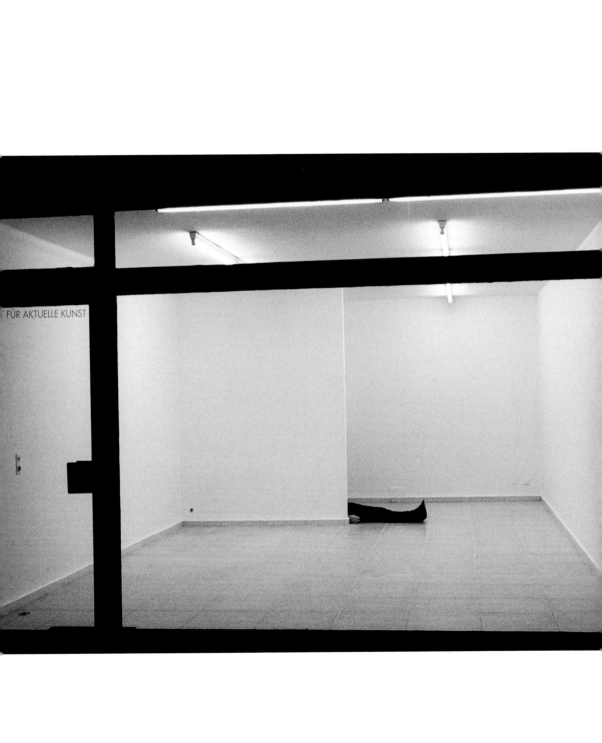

1 Installation view, *N. Schmidt*, Kabinett für Aktuelle Kunst, Bremerhaven, 2001

2 Installation view, *Hannelore Reuen, alte Hausschlampe*, Galeria Foksal, Warsaw, 1999
3 Installation view, *ur36, Hardcore*, Haus Esters, Krefeld, 2000

„Wenn ein Werk ausgestellt wird, verliert es seine Schärfe."

« Quand une œuvre est exposée, elle perd de son tranchant. »

"When a work is exhibited it loses its edge."

2

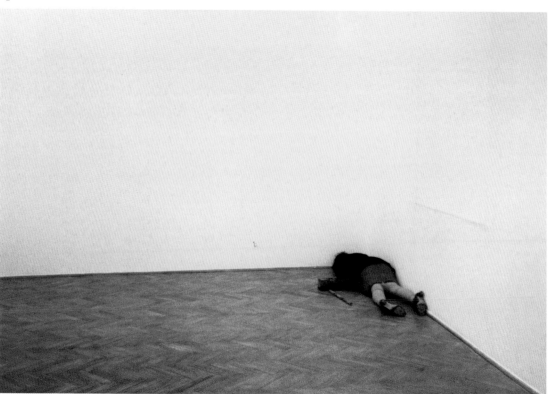

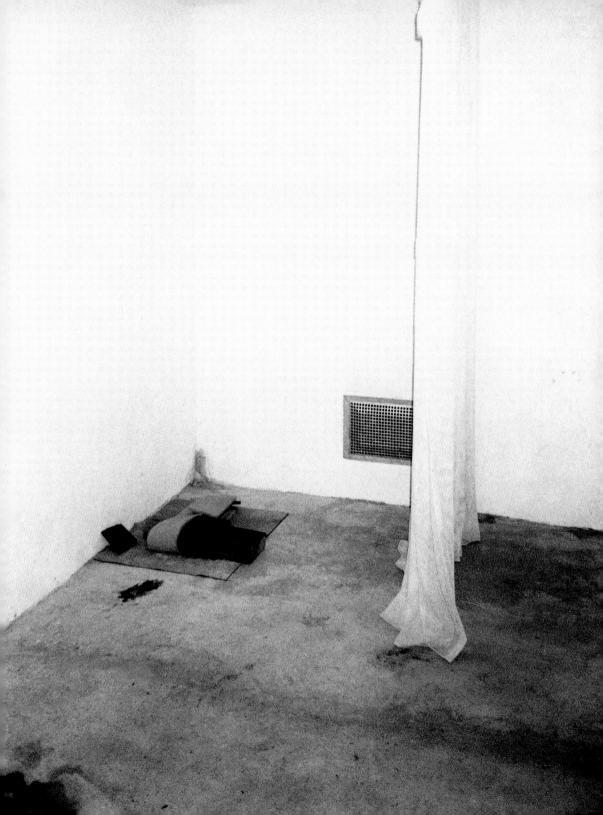

Cindy Sherman

1954 born in Glen Ridge (NJ), lives and works in New York (NY), USA

In 1978, at the age of 23, Cindy Sherman began her landmark photographic series *Untitled Film Stills*. In each small-format black and white image, Sherman plays a different role – prim office worker, suburban housewife, glamorous femme fatale – in a minutely staged psychologically intense drama. Although she is the only character in shot, her transformation in each image is so complete that her personal identity disappears and instead of a series of self-portraits, we have a comprehensive repertoire of 20th-century female stereotypes. For most of the 1980s, Sherman continued to use her body as her central prop, working with colour photography to explore aspects of horror, violence and the grotesque. The *Fairy Tales*, 1984–86, *Disaster Series*, 1987–89, and *Sex Pictures*, 1992, employed an array of prosthetic teeth, snouts and breasts, mysterious liquids, rotting food and anatomically rearranged mannequin limbs to portray nightmarish visions of deformity and scenes of sexual violence, half seen, half imagined. A palpable tension exists between the pictures' seductive, vividly coloured surfaces and their disgusting, anxiety-inducing subject matter. This sense of anxiety is apparent throughout Sherman's work. Her most recent series *Untitled* features twelve new fictional characters – all over-tanned, over-dressed, heavily made-up women "of a certain age". Occupying the narrow terrain between pathos and parody, these large-format colour portraits examine women's attempts to defy, deny or at least slow down old age, while suggesting the small disappointments and minor tragedies embedded in each character's personal history.

Im Alter von 23 Jahren hat Cindy Sherman 1978 ihre bahnbrechende Fotoserie *Untitled Film Stills* begonnen. Auf jedem der kleinformatigen Schwarzweißbilder spielt Sherman eine andere Rolle – pedantische Büroangestellte, Vorstadt-Hausfrau, glamouröse Femme fatale – in einem detailliert inszenierten Drama von hoher Intensität. Obwohl Sherman selbst abgebildet ist, erscheint ihre Verwandlung von Bild zu Bild so komplett, dass ihre Identität dahinter verschwindet. Statt einer Serie von Selbstporträts sehen wir ein umfassendes Repertoire weiblicher Stereotype des 20. Jahrhunderts. In den achtziger Jahren hat Sherman ihren Körper weiter als Requisit eingesetzt, als sie in Farbfotografien verschiedene Aspekte des Horrors, der Gewalt und des Grotesken erkundete. Für die Serien *Fairy Tales*, 1984–86, *Disasters*, 1987–89, und *Sex Pictures*, 1992, griff sie auf ein Arsenal von künstlichen Zähnen, Nasen und Brüsten zurück, auf mysteriöse Flüssigkeiten, verrottende Lebensmittel und anatomisch neu arrangierte Glieder von Schaufensterpuppen, um albtraumhafte Visionen der Deformation und der sexuellen Gewalt zu inszenieren, die nur ansatzweise zu erkennen sind und in der Fantasie des Betrachters ergänzt werden. Zwischen der verführerischen Oberfläche und den lebhaften Farben der Bilder und ihren abstoßenden, Angst erregenden Motiven besteht ein spürbares Spannungsverhältnis. Dieses Gefühl der Angst ist für Shermans gesamtes Werk bestimmend. In ihrer neuesten Serie *Untitled* zeigt sie zwölf tief gebräunte, aufgetakelte, stark geschminkte Frauen „in den besten Jahren". Auf dem schmalen Grat zwischen Pathos und Parodie setzen sich diese großformatigen Farbporträts mit dem Wunsch der Frauen auseinander, dem Verfall zu trotzen, ihn zu verleugnen oder wenigstens zu verlangsamen. Zugleich werden auf den Bildern die kleinen Enttäuschungen und Tragödien sichtbar, von denen die Geschichte jeder Figur gezeichnet ist.

Cindy Sherman a commencé sa célèbre série photographique *Untitled Film Stills* en 1978, à l'âge de 23 ans. Sur chacune de ses images petit format en noir et blanc, elle joue un nouveau rôle – employée de bureau guindée, ménagère de banlieue, femme fatale glamour – dans une mise en scène minutieuse et psychologiquement intense. Bien qu'elle soit le seul personnage dans le plan, sa transformation est à chaque fois si complète que sa propre personnalité s'efface. Au lieu d'une série d'autoportraits, cela donne un répertoire complet des stéréotypes féminins du 20ème siècle. Pendant presque toutes les années 80, Sherman a continué à utiliser son corps comme accessoire principal, travaillant avec la photo couleur pour explorer divers aspects de l'horreur, de la violence et du grotesque. Dans ses séries *Fairy Tales*, 1984–86, *Disasters*, 1987–89, et *Sex Pictures*, 1992, elle a recours à tout un assortiment de prothèses dentaires, de groins en plastique, de faux seins, de liquides mystérieux, d'aliments pourris et de membres de mannequins anatomiquement modifiés pour dépeindre des visions cauchemardesques de difformité et des scènes d'une violence sexuelle, mi montrée mi suggérée. Il existe une tension palpable entre les surfaces séduisantes vivement colorées de ses photos et leur sujet répugnant et angoissant. Cette angoisse se retrouve dans toute l'œuvre de Sherman. Sa toute dernière série *Untitled* présente douze nouveaux personnages de fiction – des femmes « d'un certain âge » au bronzage intégral, trop habillées, exagérément maquillées. Se situant dans l'espace étroit entre le pathos et la parodie, ces portraits en couleurs grand format examinent les tentatives des femmes pour défier, nier ou du moins ralentir le vieillissement, tout en suggérant les petites désillusions et les tragédies mineures enchâssées dans l'histoire personnelle de chacune d'elles.

K. B.

SELECTED EXHIBITIONS →
1995 *Photographien 1975–1995*, Deichtorhallen Hamburg, Germany; *46. Biennale di Venezia*, Venice, Italy **1997** Museum Ludwig, Cologne, Germany; *The Complete Untitled Film Stills*, Museum of Modern Art, New York (NY), USA; *Retrospective*, Museum of Contemporary Art, Los Angeles (CA), USA **1998** *Mirror Images: Women, Surrealism and Self-Representation*, MIT-List Visual Arts Center, Cambridge (MA), USA **2000** *Die verletzte Diva*, Kunstverein München/Städtische Galerie im Lenbachhaus, Munich, Germany

SELECTED BIBLIOGRAPHY →
1995 *Cindy Sherman: Photoarbeiten 1975–1995*, Deichtorhallen, Hamburg/Malmö Konsthall, Malmö/Kunstmuseum Luzern, Lucerne **1996** *Cindy Sherman*, Museum of Modern Art, Shiga **1997** *Cindy Sherman: Retrospective*, Museum of Contemporary Art, Los Angeles (CA); *Cindy Sherman*, Museum Ludwig, Cologne **2000** *Cindy Sherman*, Hasselblad Center, Göteborg **2001** Uta Grosenick (ed.), *Women Artists*, Cologne

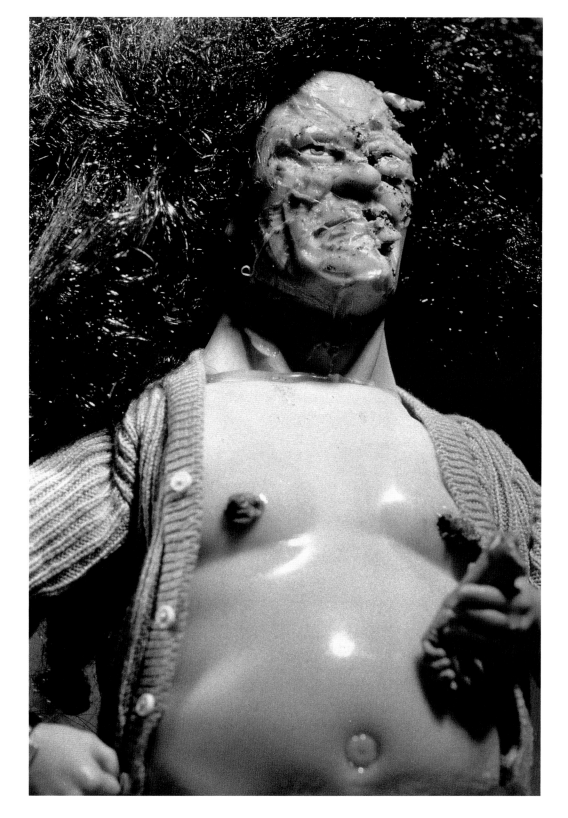

1 **Untitled,** 1999, black and white photograph, 119 x 86 cm
2 **Untitled,** 2000, colour print, 91 x 61 cm
3 **Untitled,** 2000, colour print, 69 x 46 cm
4 **Untitled,** 1976/2000, black and white photograph, 18 x 13 cm

5 **Untitled (The Press),** 1976/2000, black and white photograph, 18 x 13 cm
6 **Untitled,** 2000, colour print, 76 x 51 cm
7 **Untitled,** 2000, colour print, 76 x 51 cm

„Es geht unter anderem darum, das Publikum so weit zu bringen,
dass es anfängt, seine vorgefassten Meinungen über Frauen, Sex
und solche Sachen zu hinterfragen."

« Il s'agit en partie de faire en sorte que le public remette en
question ses idées préconçues sur les femmes, le sexe,
ce genre de choses. »

"Part of the idea is to get the audience to question their preconceived ideas about women, sex – things like that."

2

3

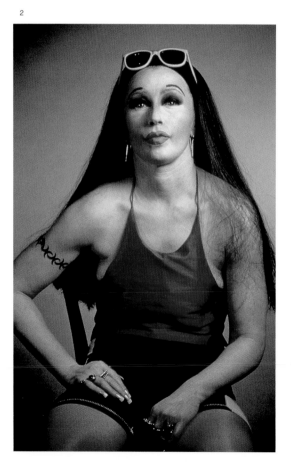

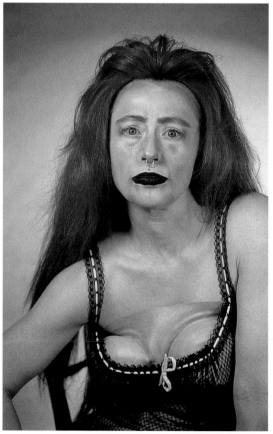

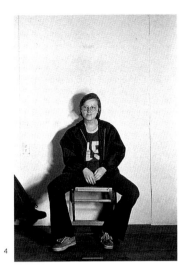

4

5

6 7

Andreas Slominski

1959 born in Meppen, lives and works in Hamburg, Germany

Andreas Slominski is a sculptor. He is also a maker of traps, with a sly sense of humour, whose art requires closer examination to discover its hidden meaning. The materials Slominski puts together to create his cunning works of art are mostly drawn from everyday life. Only the slightest shift of perspective is enough to reveal the darkness, cynicism and absurd complexities behind familiar façades. His *Schrank für Liebhaber im Rollstuhl* (Wardrobe for lovers in wheelchairs), 2000, is based on the cliché of the adulterer caught in flagrante hiding in the wardrobe. In Slominski's version, the lover is a less nimble wheelchair user. So the artist supplies a perfectly ordinary wardrobe with a wheelchair-friendly ramp arrangement to ensure escape from the irate husband. In recent years, Slominski's work has become more complex with stronger narrative content. Where once they used simple means to question the illusory nature of art, his sometimes large installations play masterfully with the different levels of fictionality. In his *Vogelfangstation* (Bird Trap), executed 1998/99, various fully functioning traps are arranged around a fenced-in hut. Who does the viewer identify with while contemplating this representation of violence? The hidden trappers or the supposed victims? Is it about sadism or compassion, the thrill of the hunt or animal protection? It is the multiplicity of allusions that creates the tension of the work.

Andreas Slominski ist Bildhauer. Und er ist ein hintersinniger Fallensteller, dessen Kunst erst auf den zweiten Blick ihren doppelten Boden offenbart. Das Material, aus dem sich Slominskis tückische Kunst zusammensetzt, ist meist unserer alltäglichen Lebenswelt entnommen – nur eine kleine Verschiebung genügt und schon tun sich hinter der Fassade des Gewöhnlichen zynische Abgründe und absurde Verwicklungen auf. Der *Schrank für Liebhaber im Rollstuhl*, 2000, etwa basiert auf dem Klischee, dass sich in flagranti ertappte Ehebrecher flugs im Schlafzimmerschrank verstecken. Bei Slominski allerdings ist dieser Liebhaber ein normalerweise nicht so flinker Rollstuhlfahrer. Also versieht der Künstler einen handelsüblichen Schrank mit einer Schienenkonstruktion, die ein Rollstuhl leicht hinauffahren kann – die Rettung vor dem erbosten Ehegatten scheint nun gesichert. Slominskis Arbeiten sind in den letzten Jahren aufwendiger und erzählerischer geworden. Befragten sie früher eher mit sparsamen Mitteln den Schein-Charakter von Kunst, so spielen jetzt die zum Teil raumfüllenden Installationen virtuos mit verschiedenen Ebenen von Fiktionalität: So etwa die *Vogelfangstation*, 1998/99, in der diverse funktionstüchtige Fallen um eine verrammelte Hütte arrangiert sind, die den Mittelpunkt der imaginären Jagd darstellen. Mit wem identifiziert sich der Kunstfreund angesichts dieser beeindruckenden Inszenierung von Gewalt: mit den im Verborgenen bleibenden Tätern oder mit den vermeintlichen Opfern dieser Vogelfangstation? Sadismus oder Mitleid, Jagdfieber oder Tierschutz heißen die Schlagwörter, die diese Arbeit anspielungsreich unter Spannung setzen.

Andreas Slominski est sculpteur. Il est aussi un profond poseur de pièges dont l'art ne dévoile son double fond qu'au second regard. Le matériau dont se compose l'art malicieux de Slominski est emprunté le plus souvent à notre univers quotidien ; souvent, un décalage minime suffit pour que des abîmes cyniques et des trames d'interrelations absurdes s'ouvrent derrière la façade de l'habitude. Le *Schrank für Liebhaber im Rollstuhl* (Armoire pour amant en fauteuil roulant), 2000, par exemple, repose sur le schéma classique dans lequel les amants adultères pris sur le fait se cachent dans l'armoire de la chambre à coucher. Chez Slominski, l'amant est assis dans un fauteuil roulant qui n'est pas aussi leste. L'artiste a donc prévu une armoire courante du commerce munie de glissières permettant de hisser aisément un fauteuil roulant – la fuite devant le mari en colère semble dès lors assurée. Au cours des dernières années, les œuvres de Slominski sont devenues plus complexes et plus narratives. Si des moyens parcimonieux remettaient naguère en cause le caractère fictif de l'art, les installations parfois intégrales jouent aujourd'hui avec une indéniable virtuosité sur différents niveaux de fiction. La *Vogelfangstation* (Station ornithologique) 1998/99, dans laquelle différents pièges armés sont disposés autour d'une cabane soigneusement barricadée représentent le centre d'une chasse imaginaire, en est un bon exemple. Avec qui s'identifie l'amateur d'art au regard de cette impressionnante mise en scène de la violence : avec les acteurs cachés ou avec les soi-disant victimes de cette station ? Sadisme ou pitié, fièvre de la chasse ou protection des animaux, tels sont les slogans qui placent cette œuvre dans un champ de tension hautement allusif.

R. S.

SELECTED EXHIBITIONS →
1998 Kunsthalle Zürich, Zurich, Switzerland **1999** Deutsche Guggenheim, Berlin, Germany; *collection 99*, Galerie für Zeitgenössische Kunst, Leipzig, Germany **2000** Jablonka Galerie, Cologne, Germany; *Orbis Terrarum*, Museum Plantin-Moretus, Antwerp, Belgium; *Tout le temps*, *La Biennale de Montréal*, Centre international d'art contemporain de Montréal, Canada; *Let's Entertain*, Walker Art Center, Minneapolis (MN), USA **2001** Wako Works of Art, Tokyo, Japan; *The Big Show 2*, New International Cultural Center, Antwerp, Belgium

SELECTED BIBLIOGRAPHY →
1999 *Andreas Slominski*, Berlin; Burkhard Riemschneider/ Uta Grosenick (eds), *Art at the Turn of the Millennium*, Cologne **2000** *Let's Entertain*, Walker Art Center, Minneapolis (MN)

1 Gerät zum Knicken von Antennen, 2001, metal, 65 x 6 x 21 cm

2 Die Hose des Einbeinigen trocknen (Drying the trousers of the one-legged man), 2000, kunstwegen, Städtische Galerie Nordhorn

„Wo sind die Skier?"

« Où sont les skis ? »

"Where are the skiers?"

2

Simon Starling

1967 born in Epsom, lives and works in Glasgow, UK

When did modernism end? It hasn't yet, as demonstrated by the strength with which modernistic ideas are still projected. They are exemplified in design, architecture and art works, which provoke artists to invest new meanings in the worn but destruction-resistant project of our culture. Simon Starling's works are strolls in time and space. He starts with an object. It can be an empty crate for a piece of art from Edinburgh that the artist reworks into a fishing boat in Marseille. Or a can of Eichenbaum Pils beer found somewhere in the Bauhaus complex in Dessau. Each object triggers a process of translocation, circular returns and violent leaps in time and space, in which our perception of the meaning of objects is ruthlessly revised. Starling weaves a web of incredible links between distant facts and places. His works result from the processes of reflection that reveal the psychology of objects and the psychology of our understanding of culture. In Starling's installation *burn-time*, 2000/01, the Bauhaus designed egg-coddlers were confronted with a model of the Neo-classical prison building, made into a functioning hen-house. However improbable such combination might appear, in the end the mesh of interlocking links between seemingly disparate objects and facts proved far more convincing than the chance coincidences praised by surrealists. History is everywhere and its center is nowhere. Starling undermines our knowledge in order to reintroduce us to the adventure of knowing.

Wann ist die Moderne zu Ende gegangen? Noch gar nicht – wie der Einfluss bezeugt, den die Ideen der Moderne bis heute aus-üben. Sie prägen noch immer das Design, die Architektur und jene Werke, in denen Künstler sich bemühen, das ebenso verbrauchte wie zerstörungsresistente Projekt unserer Kultur mit neuen Bedeutungen zu füllen. Bei den Werken von Simon Starling handelt es sich um Wanderungen durch Zeit und Raum. Er beginnt mit einem Objekt. Das kann eine leere Kiste sein, in der zuvor ein Kunstwerk aus Edinburgh untergebracht war, die er in Marseille zu einem Fischerboot umgestaltet. Sein Ausgangsmaterial kann aber genauso gut eine Eichenbaum-Pils-Bierdose sein, die er irgendwo auf dem Bauhaus-Gelände in Dessau gefunden hat. Jedes dieser Objekte ist Anlass für eine ganze Abfolge von Translokationen, Kreisbewegungen und gewaltsamen Sprüngen in Raum und Zeit – ein Prozess, der uns die Objekte in einem völlig neuen Licht erscheinen lässt. Starling spinnt ein Netzwerk völlig unwahrscheinlicher Verbindungen zwischen weit auseinander liegenden Fakten und Orten. Seine Arbeit ist das Ergebnis eines Reflexionsprozesses, in dem die Mechanismen unserer Erfahrung der Objektwelt und die Gesetze zutage treten, denen unser Kulturverständnis unterliegt. In Starlings Installation *burn-time*, 2000/01, konfrontiertr er Bauhaus-Eierpochierer mit dem neo-klassizistischen Modell eines Gefängnisses, das zu einem Hühnerhaus umfunktioniert wurde. So unwahrscheinlich diese Kombination auch scheinen mag, am Ende erweist sie sich im Verknüpfen scheinbar verschiedener Objekte und Fakten als weitaus überzeugender als der von den Surrealisten gepriesene Zufall. Die – historische – Geschichte ist überall zugleich und hat nirgends ein Zentrum. Starling entzieht unserem Wissen den Boden, um uns aufs Neue mit dem Abenteuer des Wissens zu konfrontieren.

Quand le modernisme s'est-il éteint ? Pas encore, comme le démontre la puissance avec laquelle des idées modernistes sont encore projetées. Elles sont illustrées dans le design, l'architecture et l'art, incitant les artistes à investir de nouveaux sens dans le projet usé mais indestructible de notre culture. Les travaux de Simon Starling sont des promenades dans le temps et l'espace. Il part d'un objet. Il peut s'agir d'une caisse vide ayant contenu une œuvre d'art à Edimbourg qu'il retravaille en barque de pêcheur à Marseille. Ou d'une canette de bière Eichenbaum Pils trouvée quelque part dans le complexe Bauhaus de Dessau. Chaque objet déclenche un processus de translocation, des retours circulaires et des bonds violents dans le temps et l'espace, où notre perception du sens de l'objet est impitoyablement remise en question. Starling tisse une toile de liens incroyables entre des faits et des lieux éloignés. Ses travaux sont le résultat de réflexions qui révèlent la psychologie des objets et celle de notre compréhension de la culture. Dans l'installation de Starling *burn-time*, 2000/01, les pocheuses des-sinées par le Bauhaus étaient confrontées à une maquette de bâtiment pénitentiaire néoclassique, transformé en poulailler fonctionnel. Aussi improbable que puisse paraître une telle combinaison, à la fin le réseau de liens entre des objets et des faits qui semblent disparates était plus convaincant que les coïncidences fortuites louées par les surréalistes. L'histoire est partout et son centre n'est nulle part. Starling sape nos connaissances pour mieux nous réapprendre l'aventure du savoir.

A. S.

SELECTED EXHIBITIONS →
1996 *An Eichenbaum Pils beer can...*, The Showroom, London, UK
1997 *Blue Boat Black*, Transmission Gallery, Glasgow, UK, *Glasgow*, Kunsthalle Bern, Berne, Switzerland **1999** *Blinky Palermo Preis*, Galerie für Zeitgenössische Kunst, Leipzig, Germany; The Living Art Museum, Reykjavik, Iceland **2000** Camden Arts Centre, London, UK; *Manifesta 3*, Ljubljana, Slovenia; *The British Art Show 5*, Hayward Gallery, London, UK; *What if*, Moderna Museet, Stockholm **2001** *Squatters*, Museu Serralves, Oporto, Portugal

SELECTED BIBLIOGRAPHY →
1995 *An Eichenbaum Pils beer can...*, The Showroom, London **1997** *Blue Boat Black*, Transmission Gallery, Glasgow **1998** *Simon Starling*, Moderna Museet Project Room, Stockholm **2001** *back to front*, Camden Art Centre, London/John Hansard Gallery, Southampton

1

1 Work, made ready, Kunsthalle Bern, 1997, a Marin "Sausalito" bicycle remade using the metal from one Charles Eames "Aluminium Group Chair", a Charles Eames "Aluminium Group Chair" remade using the metal from one Marin "Sausalito" bicycle, 1997, bicycle, chair, 2 plinths, glass, vinyl text, dimensions variable, installation view, Kunsthalle Bern, Berne
2 Burn-time, 2001, C-type print, 78 x 101 cm
3 Burn-time, 2000/01, installation views, neugerriemschneider, Berlin

„Ich möchte Dinge zusammenzwingen, die sonst unverbunden nebeneinander stünden."

« Etablir de force des relations entre des choses qui autrement n'auraient probablement aucun lien entre elles. »

"Forcing things to relate that would probably otherwise be unrelated."

2

Thomas Struth

1954 born in Geldern, lives and works in Düsseldorf, Germany

Paradise – the idea of a joyful place from which our search for knowledge made us outcasts – has been a source of fascination since time immemorial. Many have travelled to supposedly "promised lands" in search of their own paradise. In this respect, visual representations have been the easiest to understand and the most enduring. Thomas Struth has made use of this sense of yearning for his latest photographs: several series of landscape images depicting the great forests of the world and the western deserts of the USA. Whereas his earlier works dealt principally with buildings, museums and portraits, the photographs taken since 1999 and entitled *Paradise* provide us with observations of unspoiled nature. As the opposite of the differentiated urban space that shapes our perception, nature and wilderness can only be experienced as distance and, in this respect, as both intellectual and physical. His interest in anthropology always shines through in his precise "portraits of conditions" (Struth). What is astonishing about his pictures is their sublime aesthetic, and the magnificence with which their ambivalent effect is achieved. In contrast to the terse *Unbewußte Orte* (unconscious places) that characterised his early photographs, there is now a metaphoric, emotional aspect, which brings to mind the description "remarkable places". Experiences are organised, although neither the paradises nor the American sequence provide many clues; their details flicker between sensitive composition and fleeting moment. Reminiscences and collective memories bestow the raised position of the camera with a far-sightedness in which glimmers the retrospective vision of a dialectic relationship between loss and gain, nature and culture. Ultimately, photographs are always reminders of actions left undone.

Das Paradies – seit Menschengedenken fasziniert die Vorstellung über den glücklichen Ort, aus dem wir vertrieben wurden, weil wir Erkenntnis suchten. Oft schon zogen Menschen in ein vermeintlich „gelobtes Land", auf der verheißungsvollen Suche nach einem Paradies. Hierbei scheint die visuelle Vorstellung die sinnfälligste, nachhaltigste. Mit dieser Sehnsucht arbeiten auch die neuen Fotografien von Thomas Struth: Landschaftsserien aus den großen Wäldern der Welt und den Wüsten Westamerikas. Waren es vorrangig Gebäude, Museumsräume und Porträts, die seine Arbeiten bisher bestimmten, sind es seit 1999 die *Paradiese (Paradise)* betitelten Fotografien, in denen Einblicke in unberührte Natur gewährt werden. Natur, Wildnis als Gegensatz zum differenzierten Stadtraum, der die Wahrnehmung prägend bestimmt, ist immer als Distanz und insoweit mental wie physisch zu erfahren. Sein soziologisches Interesse an Kulturen ist immer präsent, er zeigt präzise „Porträts von Bedingungen" (Struth). Erstaunlich ist bei der Betrachtung der Bilder, wie ästhetisch erhaben, wie grandios ihre ambivalente Wirkung erzeugt wird. Im Gegensatz zu den lapidaren *Unbewußten Orten* des Beginns seiner fotografischen Tätigkeit kommt eine metaphorische, emotionale Sphäre hinzu, die als „bemerkenswerte Orte" indiziert werden könnte. Erfahrungen werden sortiert, obwohl die *Paradiese* oder die amerikanische Folge kaum Anhaltspunkt bieten – ihre Ausschnitte changieren zwischen sensibler Komposition und flüchtigem Moment. Und es sind Reminiszenzen, kollektive Erinnerungen, denen die erhöhte Stellung des Aufnahmeapparates ihre Weitsicht verleiht. Hierin glimmt eine rückblickende Vision auf, das dialektische Verhältnis von Verlust und Gewinn von Natur und Kultur auf. Eine Fotografie erinnert letztlich immer auch an unerledigte Taten.

Le paradis – de tout temps, l'homme a été fasciné par l'idée d'un lieu heureux dont il fut chassé pour avoir cherché la connaissance. Souvent des hommes sont partis pour une terre « promise » dans l'espoir d'y trouver un paradis. Dans ce domaine, c'est la représentation visuelle qui s'avère la plus marquante et la plus durable. Les nouvelles photographies de Thomas Struth, séries de paysages des grandes forêts de la planète et des déserts de l'Ouest américain, travaillent aujourd'hui sur ce même désir. Si l'œuvre de Struth a été dominée jusqu'ici par des vues d'immeubles, de salles de musées et des portraits, la série *Paradise*, sur laquelle l'artiste travaille depuis 1999, propose les aperçus d'une nature encore vierge. La nature – l'état sauvage comme pôle opposé de l'espace urbain différencié qui conditionne notre regard – est toujours vécue sous le signe de la distance et donc de manière mentale tout autant que physique. L'intérêt sociologique pour les cultures du monde y est toujours opérant et produit des « portraits de conditions » (Struth) précis. Ce qui surprend dans ces images, c'est l'élévation esthétique et la grandeur avec laquelle est générée leur ambivalence. A l'inverse des lapidaires *Unbewußte Orte* (lieux inconscients) qui ont marqué les débuts de Struth, on assiste à l'intervention d'une dimension métaphorique et émotionnelle qu'on pourrait désigner sous l'appellation « lieux remarquables ». Les expériences sont triées, bien que les Paradis ou le cycle américain ne proposent guère de points de repères – leurs cadrages évoluent entre composition sensible et fugacité de l'instant. Ce sont des réminiscences, des souvenirs collectifs auxquels la position surélevée de l'appareil photo confère toute leur vastitude. Une vision rétrospective entonne ici son rapport dialectique entre perte et gain de la nature et de la culture : en définitive, toute photographie draine avec elle l'évocation de certains actes manqués.

G. J.

SELECTED EXHIBITIONS →
1999 Centre National de la Photographie, Paris, France; *The Museum as Muse: Artists reflect*, The Museum of Modern Art, New York (NY), USA; *Biennale of Sydney*, Sidney, Australia **2000** *Mein Porträt – Thomas Struth*, Galleri K, Oslo, Norway; National Museum of Modern Art, Tokyo; *How you look at it*, Sprengel Museum, Hanover, Germany; *5ème Biennale de Lyon*, France; *Architecture Hot and Cold*, Museum of Modern Art, New York (NY), USA; *Vision and Reality*, Louisiana Museum of Modern Art, Humlebæk, Denmark **2001** *Instant City*, Museum Pecci, Prato, Milan, Italy; *Open City: Aspects of Street Photography*, Museum of Modern Art, Oxford, UK

SELECTED BIBLIOGRAPHY →
1987 *Unbewußte Orte/Unconscious Places*, Kunsthalle Bern, Berne **1992** *Portraits*, Museum Haus Lange, Krefeld **1995** *Thomas Struth. Straßen. Fotografie 1976 bis 1995*, Kunstmuseum Bonn **1997** *Thomas Struth. Portraits*, Sprengel Museum, Hanover **1998** *Thomas Struth. Still*, Carré d'Art, Nîmes **2001** Galerie Max Hetzler Berlin, München

1 **Paradise 22 – São Francisco de Xavier,** 2001, print, 177 x 135 cm
2 **Drammen 1 – Drammen/Oslo,** 2001, print, 130 x 170 cm

3 **Paradise 5 – Daintree/Australien,** 1998, print, 134 x 174 cm

„Ein Bild der leeren Landschaft kommt insofern dem fotografischen Medium entgegen, als es trotz seiner geschichtlichen Referenzialität stets auch das Jetzt einbezieht."

« L'image du paysage vide se prête au médium photographique dans la mesure où elle intègre aussi l'instant présent malgré le référentiel historique. »

"The image of an empty landscape accommodates the medium of photography in so far as it always involves the present, despite being historically referential."

2

Fiona Tan

1966 born in Pekan Baru, Indonesia, lives and works in Berlin, Germany, and Amsterdam, The Netherlands

Fiona Tan works with video and film, with moments in time and outcomes. While the technical reproduction of images is linked to media and space, she regards content as equally bound to questions of cultural character and identity. Working in the context of globalisation and migration, she devoted three years to investigating her identity for the documentary *May You Live in Interesting Times,* 1997. Tan travelled the world to find and visit members of her Indonesian family, who were scattered as a result of the turmoil of the 1960s. The daughter of a Chinese-Indonesian father and an Australian mother, she grew up in Australia and moved to Europe to study. The result of her social and cultural background is a migrant trans-identity. Tan's own history is bound to the understanding that our knowledge of the world is informed by the mass media, which is not always free of the suspicion of manipulation. Documentaries from distant countries are particularly important in shaping our opinions and understanding of the big wide world – and this includes exoticism. By formally combining, contrasting and sounding the depth of spaces, and by carefully selecting her found material, Tan alerts the viewer to the exploratory authenticity of the viewed work's function, which is to search for a position. She consciously manipulates the narrative by inserting her own film and video sequences, thereby ensuring that the film is perceived as a structural presence. Tan has set up a two-screen car-wreck cinema (*Car Wreck Cinema,* 2000), in which visitors can watch her films through the windscreen or in the rear-view mirror. The use of filmed fiction and world citizenship as identity can be light and humorous, yet always remains part of the complex system of social reality contained in implements and appliances, whether they are art, culture or cinema.

Fiona Tan arbeitet mit Video und Film, mit Augenblick und Wirkung. Die technische Reproduzierbarkeit von Bildern beschäftigt sie ebenso wie die Frage nach kultureller Prägung und Identität. Im Kontext von Globalisierung und Migration widmete sie sich drei Jahre lang in dem Dokumentarfilm *May You Live in Interesting Times* von 1997 ihrer Herkunft. Sie (be)suchte ihre nach dem Aufruhr der sechziger Jahre über die ganze Welt verstreute indonesische Familie. Als Tochter eines chinesisch-indonesischen Vaters und einer australischen Mutter – aufgewachsen in Australien und zum Studium nach Europa aufgebrochen – ist Tans sozio-kultureller Hintergrund der einer migrantischen Transidentität. Ihre Geschichte ist verbunden mit der Erfahrung, dass unser Wissen über die Welt aus den Massenmedien stammt, die nicht immer frei von einem Manipulationsverdacht sind. Insbesondere Dokumentarfilme aus fernen Ländern bestimmen maßgeblich unsere Auffassung und Erkenntnis von der weiten Welt – und mithin unsere Exotismen. Im Kombinieren, Gegenüberstellen, räumlichen Ausloten auf formaler Ebene und in der Auswahl des gefundenen Materials macht Tan dem Betrachter die forschende Authentizität des Gesehenen als Standortsuche bewusst. Durch den Einbau eigener Film- und Videosequenzen wird die Erzählung gezielt manipuliert, so dass Film als strukturelle Präsenz wahrgenommen wird. Tan hat ein Schrottwagen-Autokino mit zwei Leinwänden installiert (*Car Wreck Cinema,* 2000), bei dem die Besucher die Filme durch die Windschutzscheibe und im Rückspiegel betrachten konnten. Die Thematisierung von filmischer Fiktion und Weltbürgeridentität kann sehr leicht und humorvoll sein, aber immer ist sie Teil des komplexen Systems von gesellschaftlicher Realität in Geräten und Apparaturen, seien sie Kunst, Kultur oder Kino.

Fiona Tan travaille avec la vidéo et le cinéma, avec l'instant et l'effet. La reproductibilité technique des images est liée aux médias, à l'espace et, en termes de contenu, tout aussi étroitement à l'empreinte et à l'identité culturelle. Dans le contexte de la globalisation et des flux migratoires, Tan s'est consacrée pendant trois ans au problème de sa propre identité dans le documentaire *May You Live in Interesting Times,* 1997, partant sur les traces de sa famille disséminée dans le monde entier après les événements des années 60. La toile de fond culturelle de Tan est celle d'une trans-identité migrante : fille d'un père sino-indochinois et d'une mère australienne, elle a grandi en Australie et a fait ses études en Europe. Son expérience personnelle est liée au fait que notre idée et notre connaissance du monde sont modelées par les mass media, qui ne sont pas toujours au-dessus de tout soupçon du point de vue de la manipulation. En particulier, les documentaires qui nous informent sur des pays lointains conditionnent de manière déterminante notre manière de connaître et d'appréhender le vaste monde – et aussi nos propres exotismes. En combinant, en comparant, en sondant l'espace au niveau formel, mais aussi dans le choix des sujets, Tan fait vivre l'authenticité de ce qu'elle a filmé sous la forme d'une recherche de points de repères. En y intégrant des séquences personnelles, elle manipule délibérément le récit de manière à faire percevoir le film dans sa qualité structurelle. Tan a aussi installé un cinéma de plein air dans une casse automobile (*Car Wreck Cinema,* 2000), avec deux écrans où passaient des films que les spectateurs pouvaient regarder à travers le pare-brise et dans le rétroviseur. L'illustration de la fiction filmique et de l'identité de citoyen du monde peut être tout à fait légère et humoristique, mais elle participe toujours du système complexe de la réalité sociale à travers les différents outils et appareils, que ceux-ci soient art, culture ou cinéma.

G. J.

SELECTED EXHIBITIONS →
1997 *2nd Johannesburg Biennale,* Johannesburg, South Africa
1998 *Traces of Science in Art,* Het Trippenhuis KNAW, Amsterdam, The Netherlands **1999** *Roll I & II,* Museum De Pont, Tilburg, The Netherlands; *Cradle,* Galerie Paul Andriesse, Amsterdam, The Netherlands; *Life Cycles,* Galerie für Zeitgenössische Kunst, Leipzig, Germany; *Go Away,* Royal College of Art, London, UK **2000** *Scenario,* Kunstverein Hamburg, Germany; ‹hers› *Video as a Female Terrain,* Steirischer Herbst, Graz, Austria; *5ème Biennale de Lyon,* Institut d'art contemporain Villeurbanne, France **2001** *Matrix 145,* Wadsworth Atheneum, Hartford (CT), USA; *Yokohama Triennale,* Japan; *49. Biennale di Venezia,* Venice, Italy; *2. berlin biennale,* Berlin, Germany

SELECTED BIBLIOGRAPHY →
2000 *Fiona Tan, Scenario,* Rotterdam

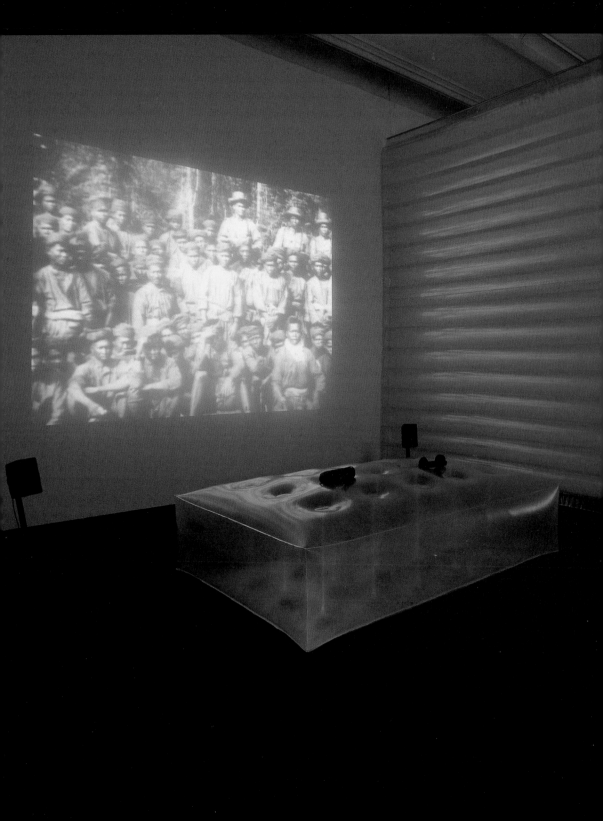

1 **Facing Forward,** 1998/99, video projection, installation view, *<hers> – Video as a Female Terrain,* Steirischer Herbst, Graz 2000
2 **Car Wreck Cinema,** 2000, installation view, *Außendienst, Kunstprojekte in öffentlichen Räumen,* Hamburg
3 **Thin Cities,** 1999/2000, video installation, installation view, *Scenario,* Kunstverein in Hamburg, 2000

„Das Konzept von Vergangenheit, von Geschichte ist Menschenwerk. Ein vergängliches Konzept. Wie das Museum ist es eine Institution des 19. Jahrhunderts. Konzepte, die mich schwindlig machen, die ich noch nicht ausloten kann."

« Même l'idée de passé, d'histoire, est un concept créé par l'homme. Un concept éphémère. C'est comme un musée, une institution du 19ème siècle. Des concepts qui donnent le vertige, que je ne puis encore sonder. »

"Even the idea of the past, of history, is a man-made concept. A temporary one. Like the museum, it is a 19th-century institution. Concepts which make me dizzy, I cannot yet fathom."

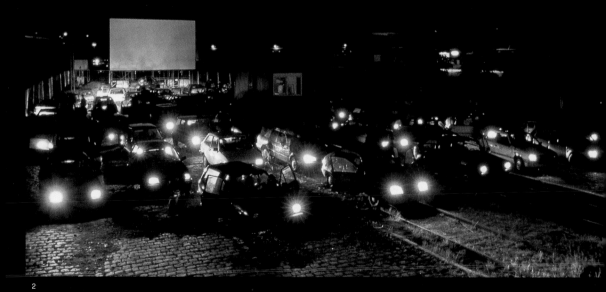

2

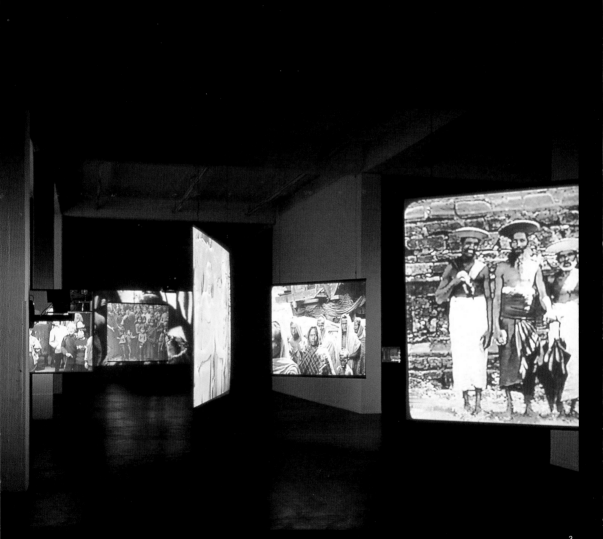

Wolfgang Tillmans

1968 born in Remscheid, Germany, lives and works in London, UK

Wolfgang Tillmans' pictures make us believe in their truthfulness, because he captures private moments in close-up. Not only do we see the people depicted as friends, the images also transmit a relaxed, sometimes even an intimate and playful openness. At the same time, his still lifes of fruit and pieces of clothing are more than purely objective representations. While his pornographic motifs are clearly voyeuristic, they also communicate the chilliness of an apartment or the scent of the forest. The photographs record instances of how people relate to one another and to objects. They narrate personal experience but also a kind of wishful thinking about an ideal, self-determined living space. Many of his pictures have a sensual surface texture, especially obvious in those depicting folds in fabric and the new *Blushes* series. These c-type prints are the result of playing and experimenting with light sources in the darkroom. Best known for his *Vintage Fashion People* portraits, with his *Concorde* series, 1997, and *Total Solar Eclipse* photos, 1999, since the early 1990s, the 2001 Turner Prize winner has moved into a new phase. Decisions about classic photographic issues, such as lighting, colour, "picking the moment", cutting and enlargement, are approached from the point of view of producing polished works of art. Tillmans moves with complete ease between creating works of art and fulfilling assignments for magazines. The inseparability of these different fields shows in the configuration of his exhibitions, which he himself hangs. The displays are clearly influenced by magazine layouts.

Die Bilder von Wolfgang Tillmans verleiten dazu, das Dargestellte für wahrhaftig zu halten, weil sein Blick ohne Distanz private Momente einfängt. Nicht nur die dargestellten Personen, die man unmittelbar als seine Freunde ansieht, vermitteln eine entspannte, manchmal auch vertraute und verspielte Offenheit, sondern auch die Fruchtstillleben und Kleidungsstücke unterscheiden sich von einer sachlichen Dokumentation. Seine pornografischen Motive vermitteln neben dem voyeuristischen Erlebnis die Kälte einer Wohnung oder den Geruch des Waldes. Die Aufnahmen zeigen Momente von Beziehungen zu Personen, zwischen Personen und zu Objekten, eine Art persönlichen Erlebens, das auch mit einem Wunschdenken an einen idealen selbstbestimmten Lebensraum verbunden ist. Viele seiner Bilder geben eine sinnliche Oberflächentextur wieder, besonders offensichtlich in der Faltenwurfserie und in der neuen *Blushes*-Serie. Diese c-type-prints entstehen in der Dunkelkammer durch ein experimentelles Spiel mit Lichteinflüssen. Seit den frühen neunziger Jahren vor allem für seine Porträts *Vintage Fashion People* bekannt, führte der Turner-Preisträger von 2001 mit der *Concorde*-Serie, 1997, und den *Total-Solar-Eclipse*-Fotos, 1999, ein neues Moment ein, bei dem alle Style-Elemente eliminiert sind. Tillmans trifft die Entscheidungen über klassische fotografische Fragen wie Belichtung, Farben, Wahl des Moments, Ausschnitt oder Vergrößerung ganz im Sinn perfektionierter künstlerischer Fotografie. Dabei bewegt sich Tillmans ganz selbstverständlich in den unterschiedlichen Kontexten zwischen Kunst und Auftragsarbeit für Zeitschriften. Die Untrennbarkeit dieser Bereiche in seiner Arbeit zeigt sich auch in der von ihm selbst vorgenommenen Hängung seiner Ausstellungen, in die die Sehgewohnheit eines Zeitschriften-Layouts einfließt.

Les images de Wolfgang Tillmans font considérer ce qui est représenté comme réel dans la mesure où son regard capte des moments privés sans prendre aucune distance. Les personnes représentées, qu'on considère d'emblée comme ses propres amis, ne sont pas seules à communiquer un esprit d'ouverture, de détente parfois familière et ludique ; les natures mortes de fruits ou de vêtements se démarquent également de toute objectivation documentaire. Au-delà de l'aspect voyeuriste, les motifs pornographiques font percevoir au spectateur la froideur d'un appartement ou les odeurs d'une forêt. Le choix de la prise de vue illustre des moments précis du rapport aux objets, aux personnes, des personnes entre elles, expérience personnelle liée notamment au fantasme d'un espace de vie idéal, entièrement défini par l'individu. Beaucoup de photos présentent une texture de surface sensuelle, comme on le remarque tout particulièrement dans la nouvelle série des *Blushes*. Ces tirages «c-type» sont produits en chambre noire par un jeu expérimental sur les incidences de la lumière. Avec ses séries *Concorde*, 1997, et *Total Solar Eclipse*, 1999, le lauréat du Prix Turner (2001), connu surtout depuis le début des années 90 pour ses portraits des *Vintage Fashion People*, instaurait une vision nouvelle exempte de tout option stylistique. Tillmans résout les questions classiques de la photographie – éclairage, couleurs, choix du moment, cadrage, agrandissement – au sens de la photographie d'art la plus perfectionnée. Tillmans est parfaitement à l'aise dans des contextes aussi différents que l'art libre et les travaux de commande réalisés pour des revues. Chez Tillmans, le caractère indissociable de ces domaines apparaît également dans les accrochages de ses expositions, que l'artiste réalise lui-même, et dans lesquels il fait entrer les habitudes visuelles de la mise en page des magazines.

N. M.

SELECTED EXHIBITIONS →
1999 *Eins ist sicher: Es kommt immer ganz anders als man denkt*, Städtische Galerie Remscheid, Germany; *Soldiers – The Nineties*, Neuer Aachener Kunstverein, Aachen, Germany **2000** *Apocalypse, Beauty and Horror in Contemporary Art*, Royal Academy of Arts, London, UK; *The Turner Prize Exhibition*, Tate Britain, London, UK **2001** *Aufsicht*, Deichtorhallen, Hamburg, Germany

SELECTED BIBLIOGRAPHY →
1995 Kunsthalle Zürich, Zurich; Portikus, Frankfurt am Main; *Wolfgang Tillmans*, Cologne **1996** *Wer Liebe wagt lebt morgen*, Kunstmuseum Wolfsburg **1997** *Concorde*, Cologne **1998** *Burg*, Cologne **1999** *Soldiers – The Nineties*, Cologne; *Portraits*, Cologne **2001** *Aufsicht*, Deichtorhallen, Hamburg

1 **Blushes #2,** 2000, c-print, unique piece, 61 x 51 cm
2 Installation view, *The Turner Prize Exhibition,* Tate Britain, London, 2000

3 **Blushes #66,** 2000, ink jet print, 304 x 242 cm

„Meine Arbeit zielt darauf ab, eine Welt zu schaffen, in der ich leben möchte. Also geht es um die Erzeugung eines Ideals mit der Hilfe realistischer Technik. Meine Motivation ist der Wunsch nach Einheit, Verschmelzen und Gemeinschaftssinn."

« Mon travail est destiné à créer un monde dans lequel je souhaite vivre. Par conséquent, il s'agit de créer des idéaux à l'aide de techniques réalistes. Ma motivation essentielle est un désir d'unité, de fusion et de sens de la communauté. »

"My work is aimed at creating a world in which I wish to live. Consequently, it is about creating ideals with the aid of realistic techniques. My most fundamental motivation is a desire for unity, fusion and sense of community."

2

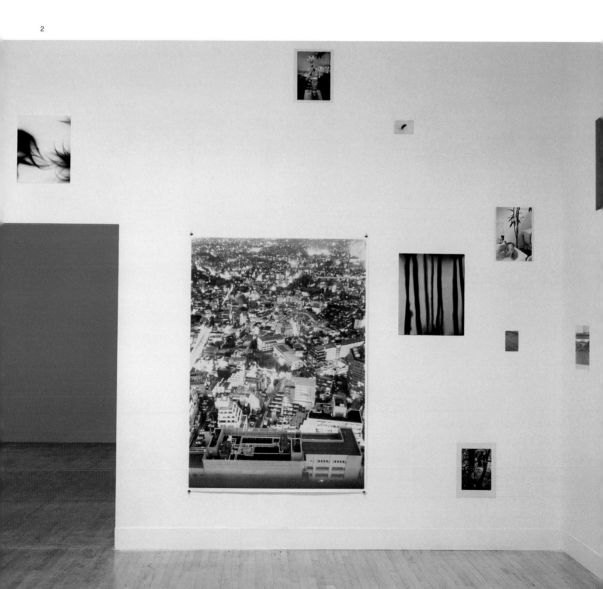

Rirkrit Tiravanija

1961 born in Buenos Aires, Argentina, lives and works in New York (NY), USA, and Berlin, Germany

During the 1990s, Rirkrit Tiravanija helped shape an aesthetic that broke radically with classic methods like painting and sculpture. In his live acts he cooked for exhibition visitors, and faithfully recreated his apartment in an institution then opened it to the public for 24 hours. The bringing together of art and life, as practised by the Fluxus group and applied in conceptual art, has found a contemporary successor in Tiravanija. The artist, who was brought up in Argentina, Thailand and Canada, links the positive, communicative energy of such actions with contemporary issues like cultural transfer and the translation of specific acts from one geographic and economic sphere into another. Tiravanija's cookery projects in particular confronted his enthusiastic public with the "exotic cuisine" cliché, which is often the only form of inter-cultural encounter many people experience in their everyday lives, and the only expression of other cultures they are able to "digest". In his latest projects, Tiravanija has pursued the themes of cultural nomadism and global art by exhibiting his actions live on the Internet. He has also been working for some time on the idea of an art magazine in which all kinds of contributions can be published across the world without editorial input. This newspaper would become an almost impossible network of spontaneous, democratic communication, subject to new inter-media conditions. Tiravanija has homes in many parts of the globe, and pays great attention to integrating the conditions pertaining to his surroundings, wherever they may be, into his artistic thought. Hence his approach to the work is always processual, and his installations are stationary with fluid transitions to future projects.

Rirkrit Tiravanija prägte in den neunziger Jahren eine Ästhetik, die mit den klassischen Medien wie Malerei und Skulptur radikal gebrochen hat. In seinen Live-Acts kochte er für die Besucher seiner Ausstellungen oder baute sein Apartment originalgetreu in einer Institution auf und stellte es 24 Stunden lang der Öffentlichkeit zur Verfügung. Die Verknüpfung von Kunst und Leben, wie sie besonders im Fluxus und in der Konzeptkunst ausgelebt wurde, findet so in Tiravanija einen zeitgenössischen Nachfolger. Dabei verbindet der in Argentinien, Thailand und Kanada aufgewachsene Künstler die positive, kommunikative Energie solcher Aktionen mit neuen Themen wie dem kulturellen Transfer, der Übersetzung spezifischer Handlungen von einer geografischen und ökonomischen Sphäre in eine andere. Gerade Tiravanijas Koch-Projekte konfrontierten das begeisterte Publikum mit dem Klischee von „exotischer Küche" als die oft einzige Form interkultureller Begegnung, die viele im Alltag erleben und als Ausdruck einer anderen Kultur „verdauen" können. Das Thema des kulturellen Nomadentums und einer globalen Kunst verfolgt Tiravanija in seinen jüngsten Projekten, indem er seine Aktionen live ins Internet stellt. Daneben realisiert er seit einiger Zeit die Idee eines Kunstmagazins, in dem Beiträge aller Art weltweit unlektoriert veröffentlicht werden können. Die Zeitung wird somit zu einem Netzwerk spontaner, demokratischer Kommunikation unter neuen intermedialen Bedingungen. Tiravanija lebt an mehreren Orten auf der Welt und integriert mit höchster Aufmerksamkeit die Bedingungen der jeweiligen Umgebung in sein künstlerisches Denken. Sein Arbeitsansatz bleibt so immer prozessual, seine Installationen sind stationär und haben fließende Übergänge zu künftigen Projekten.

Dans les années 90, Rirkrit Tiravanija a marqué de son empreinte une esthétique qui rompait radicalement avec les médiums classiques de la peinture et de la sculpture. Dans ses live-acts, il faisait la cuisine pour les visiteurs de ses expositions ou reconstituait fidèlement son appartement pour le mettre à la disposition du public pendant 24 heures. Ainsi, la mise en relation de l'art et de la vie, telle qu'elle a été pratiquée en particulier au sein du mouvement Fluxus et de l'art conceptuel, trouve aujourd'hui son successeur en la personne de Tiravanija. Cet artiste qui a grandi en Argentine, en Thaïlande et au Canada, combine l'énergie positive et communicative de ce type d'actions avec des thèmes actuels comme le transfert culturel, la transposition d'actions spécifiques d'une zone géographique et économique vers une autre. Ce sont précisément les projets culinaires de Tiravanija qui confrontent le public enthousiaste avec le cliché de la « cuisine exotique » comme la seule forme de rencontre interculturelle que beaucoup vivent dans le quotidien et sont capables de « digérer » comme expression d'une autre culture. Dans ses derniers projets, Tiravanija poursuit le thème du nomadisme culturel et d'un art global en mettant ses actions en live sur Internet. Parallèlement, Tiravanija réalise depuis quelque temps l'idée d'un magazine d'art dans lequel toutes sortes de contributions peuvent être publiées à l'échelle planétaire sans relecture éditoriale. Ce magazine devient ainsi un réseau foisonnant de communication spontanée et démocratique dans les nouvelles conditions intermédiatiques. Tiravanija vit à plusieurs endroits de par le monde et met une attention extrême à intégrer dans sa pensée artistique les conditions de chaque environnement. Sa démarche artistique demeure donc toujours processuelle, ses installations sont stationnaires et contiennent des transitions fluides vers ses projets futurs.

A. K.

SELECTED EXHIBITIONS →
1996 *Untitled 1996 (Tomorrow is another day)*, Kölnischer Kunstverein, Cologne, Germany **1997** *Untitled, 1997 (playtime)*, Projects 58, Museum of Modern Art, New York (NY), USA **1998** *Untitled, 1998 (das soziale Kapital)*, Migros Museum für Gegenwartskunst, Zurich, Switzerland **1999** *Community Cinema for a Quit Intersection (Against Oldenburg)*, The Modern Institute, Glasgow, UK; *Untitled, 1999 (Mobile Home)*, Fundacio „la caixa", Barcelona, Spain **2001** *DemoStation*, Portikus, Frankfurt am Main, Germany; Kunstverein Wolfsburg, Germany

SELECTED BIBLIOGRAPHY →
1996 *Untitled 1996 (Tomorrow is another day)*, Kölnischer Kunstverein, Cologne; *Real Time*, Institute of Contemporary Arts, London **1997** Biennale of Sydney; *Cities on the Move*, Wiener Secession/capcMusée d'Art Contemporain, Vienna/Bordeaux **1998** *Untitled, 1998 (das soziale Kapital)*, Migros Museum für Gegenwartskunst, Zurich; Franz Ackermann/Rirkrit Tiravanija, *RE public*, Grazer Kunstverein **1999** *dAPERTutto*, 48. Biennale di Venezia, Venice; *Untitled, 1999 (Mobile Home)*, Fundació „la caixa", Barcelona

1 **Untitled 1999 (Thai Pavilion),** installation view, dAPERTuttO,
 48. Biennale di Venezia, Venice, 1999
2 **Untitled 1999 (Community for a quiet intersection) (After Oldenburg),**

installation view, The Modern Institute, Glasgow, 1999
3 **Untitled 2001 (DemoStation),** 2001, installation view, Portikus,
 Frankfurt am Main

„Ich mag positive Ironie.
Ironie kann neue Metaphern schaffen, und das finde ich interessant."

« J'aime l'ironie positive.
L'ironie peut générer de nouvelles métaphores, et c'est ce qui m'intéresse. »

"I like positive irony.
Irony can create new metaphors, and I find that interesting."

2

3

3

3

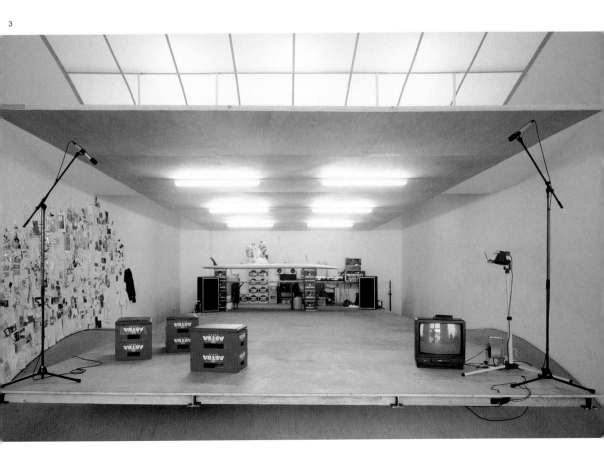

Luc Tuymans

1958 born in Mortsel, lives and works in Antwerp, Belgium

Indifference, anxiety and an atmosphere of suppressed violence seep from Luc Tuymans' small haunting paintings. He derives his imagery from other pictures or films, considering the only possible form of originality to be the "authentic forgery", and uses an anemic palette of dirty greys and yellows that recall bleached out photographs or faded newspaper clippings. The paintings seem old from the start, creating a temporal distance between the work and its producer while stimulating the memory of the viewer. Memory, or its failure, is a central concern, whether childhood recollections of fear and sickness or the collective trauma of the most horrendous episodes of recent history. The paintings in his 1992 exhibition *Disenchantment* refer to Nazi concentration camps, although the specific horror of images such as a flatly painted cellar interior is made explicit only in the painting's title, *Gas Chamber*. His subjects are often blank or evasive: a portrait painted with closed eyes (*Secrets*, 1990); a detail of a body so enlarged as to be unrecognisable (*Nose*, 1993); or a series of paintings of shadows. This apparent incompleteness signifies the failure of the painted image to adequately represent the horror or guilt of history, or the complexity of personal identity. A recent group of works, *Mwana Kitoko*, 2000, looks at the murky end of Belgian colonialism in the Congo. These seemingly unconnected images: a portrait of an assassinated revolutionary, a tower block hanging the Belgian and Congolese flags, an anonymous bunker-like whitewashed church, piece together a fragmentary narrative that reflects the complexity of their subject while suggesting the selective nature of his nation's memory.

Die kleinformatigen Bilder von Luc Tuymans vermitteln einen diffusen Eindruck der Indifferenz, der Angst und der unterdrückten Gewalt. Seine Motive entnimmt er anderen Bildvorlagen oder Filmen, da er die „authentische Fälschung" ohnehin für die einzig mögliche Form von Originalität hält. Dabei verwendet er eine anämische Palette schmutziger Grau- und Gelbtöne, die an vergilbte Fotografien oder Zeitungsausschnitte erinnern. Die von Anfang an erscheinenden Gemälde evozieren den Eindruck einer zeitlichen Distanz zwischen dem Werk und seinem Produzenten und rufen beim Betrachter Erinnerungen hervor. Das Gelingen oder Scheitern von Erinnerung ist ein zentrales Thema, ob es sich nun um Kindheitserinnerungen an Angstzustände oder Krankheiten oder um das kollektive Trauma der grauenhaftesten Geschehnisse der jüngeren Vergangenheit handelt. Die Bilder seiner Ausstellung *Disenchantment* (1992) nehmen auf die Konzentrationslager der Nationalsozialisten Bezug, auch wenn der spezifische Horror bestimmter Bilder, etwa eines schlicht gemalten Kellers, nur im Werktitel *Gas Chamber* ausgedrück wird. Seine Sujets sind häufig kaum identifizierbar oder erscheinen ungreifbar: etwa ein Porträt, gemalt mit geschlossenen Augen (*Secrets*, 1990), ein bis zur Unkenntlichkeit vergrößertes Detail eines Körpers (*Nose*, 1993) oder eine Serie von Schattenbildern. Diese offenkundige Unvollständigkeit verweist auf das Unvermögen des gemalten Bildes, das Grauen und die Schuld der Geschichte oder die Komplexität personaler Identität angemessen darzustellen. In der neueren Werkgruppe *Mwana Kitoko*, 2000, beschäftigt sich Tuymans mit dem finsteren Ende des belgischen Kolonialismus im Kongo. Diese Bilder scheinen kaum etwas gemein zu haben: das Porträt eines ermordeten Revolutionärs, ein Gebäude, an dem die belgische und die kongolesische Flagge wehen, eine anonyme bunkerartige weiße Kirche. Aus ihnen setzt sich eine fragmentarische Erzählung zusammen, die die Komplexität der Thematik spiegelt und von der selektiven Erinnerung der vormaligen Kolonialmacht kündet.

L'indifférence, l'angoisse et une atmosphère de violence retenue se dégagent des petits tableaux troublants de Luc Tuymans. Il puise son iconographie dans d'autres peintures ou films, considérant que la seule forme d'originalité possible est « l'authentique contrefaçon ». Il utilise une palette anémique de gris et de jaunes sales qui rappellent des photos décolorées ou des coupures de presse jaunies. Ses tableaux semblent vieux d'emblée, créant une distance temporelle entre l'œuvre et son créateur tout en stimulant la mémoire du spectateur. La mémoire, ou son échec, est une préoccupation centrale de l'artiste, qu'il s'agisse de souvenirs d'enfance marqués par la peur et la maladie aux traumatismes collectifs des épisodes les plus monstrueux de notre histoire récente. Les peintures de son exposition de 1992, *Disenchantment*, renvoient aux camps de concentration nazis, bien que l'horreur spécifique d'images telles que les murs ternes d'une cave ne soit explicite que par le titre du tableau, *Gas Chamber*. Ses sujets sont souvent neutres ou fuyants : un visage aux yeux fermés (*Secrets*, 1990), le détail d'un corps agrandi au point de devenir méconnaissable (*Nose*, 1993) ; ou une série de peintures d'ombres. Cette absence apparente d'achèvement signifie l'échec de l'image peinte à représenter de manière adéquate l'horreur ou la culpabilité de l'histoire, ou encore la complexité de l'identité d'un être. Un groupe d'œuvres récentes, *Mwana Kitoko*, 2000, traite des derniers jours glauques du colonialisme belge au Congo. Ces images apparemment sans liens – le portrait d'un révolutionnaire assassiné, une tour d'appartements où sont accrochés les drapeaux belges et congolais, une église blanche anonyme qui ressemble à un bunker – tissent un récit fragmentaire qui reflète la complexité de leur sujet tout en suggérant la nature sélective de la mémoire collective belge.

K. B.

SELECTED EXHIBITIONS →
1997 *John Currin, Elizabeth Peyton, Luc Tuymans*, Museum of Modern Art, New York (NY), USA **1999** *The Passion*, Douglas Hyde Gallery, Dublin, Ireland; *The Purge, Paintings 1991–1998*, Kunstmuseum Wolfsburg, Germany; *Carnegie International*, Carnegie Museum of Art, Pittsburgh (PA), USA **2000** *Luc Tuymans Sincerely*, Tokyo Opera City Art Gallery, Tokyo, Japan; *Biennale of Sydney*, Australia; *Apocalypse*, Royal Academy of Arts, London, UK **2001** Nationalgalerie im Hamburger Bahnhof, Museum für Gegenwart, Berlin, Germany; Belgian Pavilion, *49. Biennale di Venezia*, Venice, Italy; *The Beauty of Intimacy*, Gemeentemuseum Den Haag, The Netherlands

SELECTED BIBLIOGRAPHY →
1996 *Luc Tuymans*, London **1999** *The Purge*, Kunstmuseum Wolfsburg; Bonnefantenmuseum, Maastricht **2001** *Signal*, Nationalgalerie im Hamburger Bahnhof, Museum für Gegenwart, Berlin **2002** *Luc Tuymans: Mwana Kitoko (Beautiful White Man)*, S.M.A.K., Stedelijk Museum voor Actuele Kunst, Ghent

1 **Der Architekt,** 1997, oil on canvas, 113 x 145 cm
2 **Himmler,** 1998, oil on canvas, 52 x 36 cm

3 **Soldier,** 1999, oil on canvas, 60 x 50 cm
4 Installation view, Belgian Pavilion, *49. Biennale di Venezia*, Venice, 2001

„Meine Gemälde zeichnen sich durch eine Art Indifferenz aus, die sie fast gewalttätig erscheinen lässt, da in ihnen die Objekte gewissermaßen ausradiert, annuliert erscheinen."

« Il y a dans mes peintures une sorte d'indifférence qui les rend plus violentes, car tous les objets représentés sont comme effacés, annulés. »

"There is a sort of indifference in my paintings which makes them more violent, because any objects in them are as if erased, cancelled."

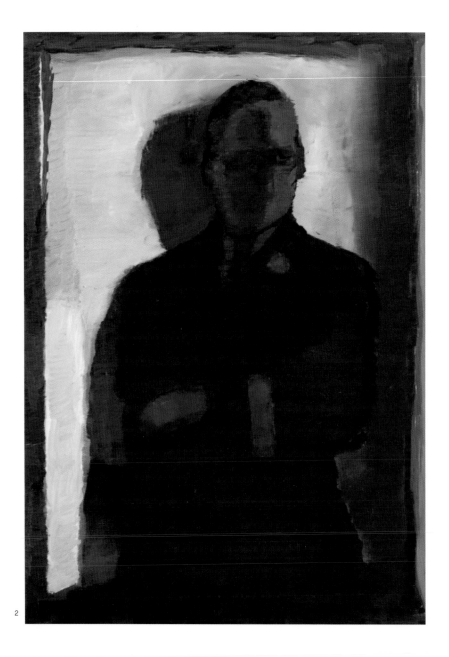

2

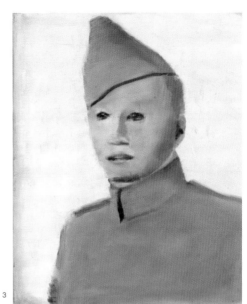

3

4

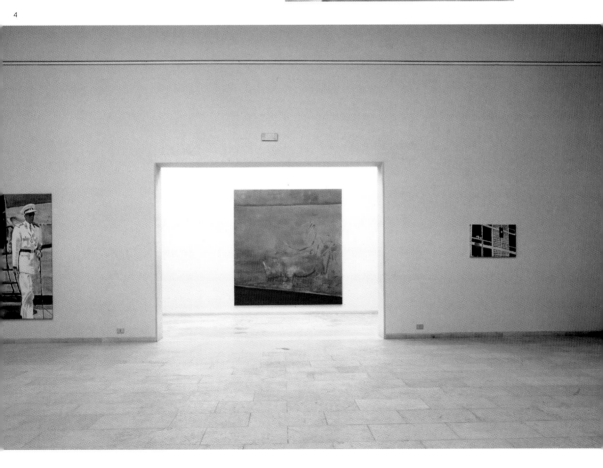

Jeff Wall

1946 born in Vancouver, lives and works in Vancouver, Canada

Although Jeff Wall's medium is photography, his large-scale transparencies in fluorescent lightboxes speak more about traditions of historical narrative painting than those of classical photography. Although some works such as *A Sudden Gust of Wind (After Hokusai)*, 1993, refer directly to existing paintings, Wall is mainly interested in the formal qualities associated with painting: the sense of scale in relation to the human body, the procedure of composing an image piece by piece, and the use of colour. He counteracts the spontaneity fundamental to the nature of photography by planning each image precisely, constructing elaborate stage sets in his studio and taking multiple shots while his cast enact the same isolated moment again and again. For works such as *The Flooded Grave*, 1998–2000, he shoots each element independently and uses a computer to montage them seamlessly together. A freshly dug grave occupies the foreground of this ordinary-looking cemetery landscape, but instead of just an empty hole, the grave is host to an ocean rock pool, filled with vividly coloured starfish, sea urchins and anemones. To make the image as plausible as possible, Wall spent two years researching every detail, from the cemetery's topography, soil and light to the exact rock formations and sea creatures local to the area. The documentary straight-forwardness of the finished image collides with the immense artifice involved in its production. Throughout his work, Wall seeks to remove the evidence of cause and effect while packing each picture with clues to possible allegorical or socio-political meanings.

Mag auch die Fotografie das Medium von Jeff Wall sein: Seine großformatigen, in Leuchtkästen präsentierten Diapositive sind den Traditionen der narrativen Malerei stärker verpflichtet als denen der klassischen Fotografie. Obwohl manche seiner Werke, etwa *A Sudden Gust of Wind (After Hokusai)*, 1993, direkt auf ein bestimmtes Gemälde verweisen, interessiert sich Wall vor allem für die formalen Möglichkeiten der Malerei: die Größenverhältnisse in Bezug zum menschlichen Körper, die Technik, ein Bild Stück für Stück zu komponieren, und die Verwendung der Farbe. Die dem fotografischen Verfahren zutiefst eigene Spontaneität konterkariert er, indem er jedes einzelne Bild sorgfältig plant, in seinem Atelier kunstvolle Bühnenaufbauten vornimmt und zahllose Aufnahmen macht, während die Mitwirkenden dieselbe ganz für sich stehende Szene ein ums andere Mal aufführen. Für Werke wie *The Flooded Grave*, 1998–2000, montiert er viele jeweils für sich fotografierte Elemente am Computer nahtlos zusammen. Im Vordergrund dieser völlig unspektakulär erscheinenden Friedhofslandschaft ist ein frisch ausgehobenes Grab zu sehen. Es handelt sich nicht lediglich um ein leeres Loch, das Grab beherbergt vielmehr einen Teil des Ozeans, in dem allerlei farbenprächtige Seesterne, Seeigel und Seeanemonen dahintreiben. Um das Bild so plausibel wie möglich erscheinen zu lassen, hat Wall zwei Jahre lang sämtliche Details recherchiert – von der Topografie und dem Boden des Friedhofs bis hin zu den Lichtverhältnissen, der Beschaffenheit der Felsformationen und den Meerestieren der Region. Die dokumentarische Direktheit des fertigen Bildes kollidiert mit den zahllosen Kunstgriffen, denen es seine Entstehung verdankt. In seinem Œuvre ist Wall darum bemüht, sämtliche Belege, aus denen sich auf Ursachen und Wirkungen schließen ließe, verschwinden zu lassen. Zugleich enthält jedes seiner Bilder zahllose Hinweise auf mögliche allegorische und sozio-politische Bedeutungen.

Bien que le médium de Jeff Wall soit la photographie, ses diapositives grand format dans des boîtes de lumière fluorescentes rappellent davantage les traditions de la peinture narrative historique que celles de la photographie classique. Néanmoins, si certaines œuvres telles que *A Sudden Gust of Wind (After Hokusai)*, 1993, renvoient directement à des tableaux existants, ce sont surtout les qualités formelles de la peinture qui intéressent Wall : son sens de l'échelle par rapport au corps humain, la composition d'une image élément par élément et l'utilisation de la couleur. Il contrecarre la spontanéité fondamentale de la photographie en planifiant chaque image avec minutie, construisant des décors sophistiqués et prenant des clichés multiples pendant que ses acteurs rejouent les mêmes moments isolés encore et encore. Pour des œuvres telles que *The Flooded Grave*, 1998–2000, il photographie chaque élément séparément puis utilise un ordinateur pour les assembler de manière invisible. Une tombe qui vient d'être creusée occupe le premier plan de ce cimetière d'apparence banale mais, au lieu d'un simple trou vide, la tombe accueille une mare retenue entre des rochers au bord d'un océan. Elle est remplie d'étoiles de mer, d'oursins et d'anémones de mer. Pour rendre l'image plus plausible possible, Wall a passé deux ans à en étudier les moindres détails, de la topographie, du sol et de la lumière du cimetière, aux formations rocheuses exactes et à la faune marine locale. La simplicité documentaire de l'image finale se heurte à l'immense artifice impliqué dans son élaboration. Dans l'ensemble de ses œuvres, Wall cherche à effacer les traces de causalités tout en saturant chaque image d'indices menant à d'éventuelles significations allégoriques ou socio-politiques.

K. B.

SELECTED EXHIBITIONS →
1990 The Carnegie Museum of Art, Pittsburgh (PA), USA
1995 Galerie Nationale du Jeu de Paume, Paris, France; *Whitney Biennial*, The Whitney Museum of American Art, New York (NY), USA
1996 Whitechapel Art Gallery, London, UK **1997** *documenta X*, Kassel, Germany **1999** *Œuvres 1990–1998*, Musée d'Art Contemporain, Montreal, Canada; *Carnegie International*, Carnegie Museum of Art, Pittsburgh (PA), USA **2000** *Biennale of Sydney*, Australia **2001** *Elusive Paradise*, National Gallery of Canada, Ottawa, Canada

SELECTED BIBLIOGRAPHY →
1995 *Jeff Wall*, The Museum of Contemporary Art, Chicago (IL)
1996 *Jeff Wall: Landscapes and Other Pictures*, Kunstmuseum Wolfsburg; *Jeff Wall*, London **1997** *Jeff Wall*, The Museum of Contemporary Art, Los Angeles (CA) **1999** Burkhard Riemschneider/ Uta Grosenick (eds), *Art at the Turn of the Millennium*, Cologne; *Jeff Wall: Œuvres 1990–1998*, Musée d'Art Contemporain de Montréal

1 **The Flooded Grave,** 1998–2000, transparency in lightbox, 246 x 299 cm

2 **Morning Cleaning, Mies van der Rohe Foundation, Barcelona,** 1999, transparency in lightbox, 187 x 352 cm

3 **Tattoos and Shadows,** 2000, transparency in lightbox, 196 x 255 cm

„Ein Bild ist etwas, das sein Vorher und Nachher unsichtbar macht."

« Une image est une chose qui rend invisible son avant et son après. »

"A picture is something that makes invisible its before and after."

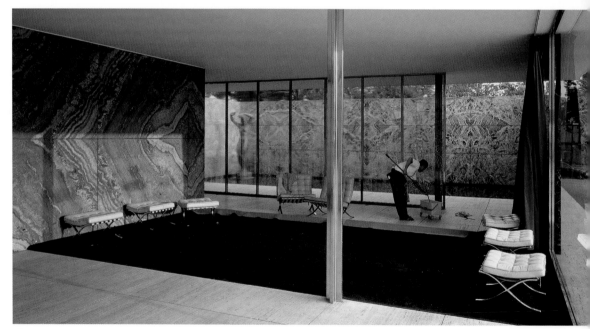

2

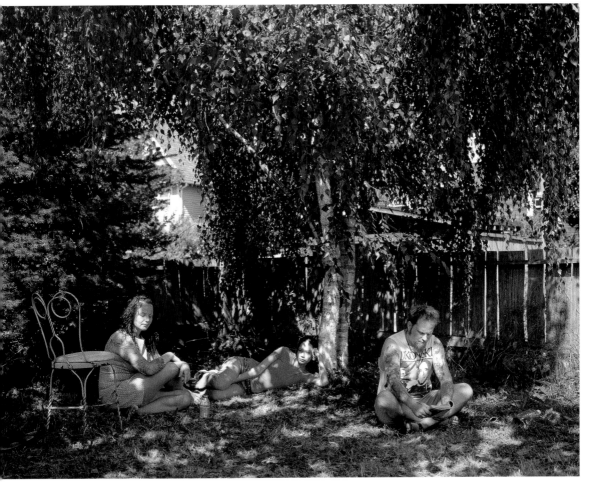

Franz West

1947 born in Vienna, lives and works in Vienna, Austria

Do symbolic forms of interpretation necessarily precede physical and material ones? In the work of Franz West, one can't be so sure about the primacy of intellect vis-à-vis the challenges of a visceral understanding of objects and environments. The notion of sculpture in West's version is tactile and sensual, as well as having metaphorical relations to the body of the beholder. When the beholder lounges on a piece of West furniture he or she often has to work his or her body through hitherto unknown positions, while taking possession of the furniture and in a sense co-authoring it. His *Passstücke* (Fitting Pieces), for example, are unwieldy objects the beholder is expected to take and parade in the exhibition space; a use has to be invented for them as if they were prostheses of negative space. West's works are hybrids between pure form and pure function, art-object and use-object. The way we use our bodies in the world is something that has to be worked through and reinvented, as if the body itself were the interpretation of a cryptic dream surrendered on the couch of a psychoanalyst. The rusticated surfaces and crude materiality of West's work, with all the traces of its manufacture, suggest how the labour of contemplation is extroverted into space. West is at once raw materiality and ephemeral poetry; carnality, spirituality and sociability. West's amorphous plastic formulations are a kind of idealist sculptural slapstick that uses as well as opens up the art work's self-referentiality. A West is exactly that – a Franz West – with its own indelible craftmanship and unique "thingliness". But at the same time it issues an open invitation to events in the space outside itself.

Gehen symbolische Formen der Interpretation notwendig physischen oder materiellen voraus? Im Werk von Franz West kann man über den Primat des Intellekts gegenüber einer instinktgeleiteten Aneignung seiner Objekte und Environments nicht sicher sein. Die Vorstellung von Skulptur bei West ist taktil und sinnlich, gleichzeitig hat sie metaphorische Beziehungen zum Körper des Betrachters. Wenn der Nutzer es sich auf einem West-Möbel bequem machen möchte, sieht er oder sie sich des Öfteren gezwungen, den eigenen Körper in bis dato unbekannte Positionen zu bringen und dabei das Möbel zugleich in Besitz zu nehmen und gewissermaßen mitzukreieren. Seine *Passstücke* zum Beispiel sind unhandliche Objekte, die der Besucher im Galerieraum umhertragen soll. Dabei gilt es, ihren Verwendungszweck erst noch zu entdecken, als ob man es mit Prothesen des negativen Raumes zu tun hätte. Wests Arbeiten sind Zwitterwesen aus reiner Form und reiner Funktion, Kunstobjekt und Gebrauchsgegenstand. Sie verlangen, dass wir uns über die Bewegung unseres Körpers in der Welt Klarheit verschaffen und uns dann neu erfinden, als ob der Körper selbst die Deutung eines auf der Analytikercouch preisgegebenen rätselhaften Traumes wäre. Die handfesten Oberflächen und krude bearbeiteten Materialien von Wests Arbeiten, mit sämtlichen Spuren ihrer Herstellung, vermitteln einen Eindruck davon, wie die Arbeit der Kontemplation sich in den Raum entäußert. West ist zugleich rohe Materialität und ephemere Poesie; Fleischlichkeit, Spiritualität und Geselligkeit. Bei seinen amorphen plastischen Formulierungen haben wir es mit einer Art idealistischem skulpturalem Slapstick zu tun, der die Selbstbezüglichkeit des Kunstwerks zugleich ausschlachtet und für neue Möglichkeiten öffnet. Ein West ist genau das: ein Franz West – mit seiner unauslöschlichen materiellen Handschrift und seiner einzigartigen „Dinglichkeit". Doch zugleich spricht seine Arbeit eine Einladung an all jene Ereignisse aus, die in dem Raum außerhalb seiner selbst stattfinden.

Les formes symboliques de l'interprétation précèdent-elles nécessairement les formes physiques et matérielles ? Dans l'œuvre de Franz West, on ne peut jamais être tout à fait sûr de la primauté de l'intellect sur les défis d'une compréhension viscérale des objets et des environnements. Chez lui, la notion de sculpture est tactile et sensuelle. Elle est métaphoriquement liée au corps du spectateur. Lorsque ce dernier s'installe sur un meuble de West, il doit souvent adopter des positions qui lui étaient jusque-là inconnues, tout en prenant possession du meuble et, dans un sens, en devenant le coauteur. Ses *Passstücke* (Accolements), par exemple, sont des objets encombrants que le spectateur est censé prendre et transporter dans l'espace de la galerie. Il est contraint de leur inventer un usage comme s'il s'agissait des prothèses d'un espace négatif. Les travaux de West sont des hybrides entre la forme pure et la fonction pure, entre des objets-art et des objets-utilisation. La manière dont nous utilisons notre corps dans le monde doit être retravaillée et réinventée, comme si le corps lui-même était l'interprétation d'un rêve énigmatique éructé sur le canapé d'un psychanalyste. Les surfaces vieillies et la matérialité grossière des œuvres de West, toutes portant les traces de fabrication, suggèrent comment le travail de contemplation est extraverti en espace. West est à la fois matérialité brute et poésie éphémère ; corporalité, spiritualité et sociabilité. Ses formulations plastiques amorphes sont une sorte de burlesque sculptural idéaliste qui exploite et élargit l'auto-référentialité de l'œuvre d'art. Un West est exactement cela : un Franz West, avec sa propre dextérité indélébile et son « état d'objet » unique. Mais parallèlement, il lance une invitation à des événements se déroulant dans l'espace en dehors de lui-même.

L. B. L.

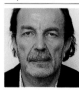

SELECTED EXHIBITIONS →
1997 *Skulptur. Projekte*, Münster, Germany; *documenta X*, Kassel, Germany **1998** *São Paulo Biennale*, São Paulo, Brazil **1999** Rooseum Center for Contemporary Art, Malmö, Sweden **2000** The Renaissance Society, Chicago (IL), USA; *Biennale of Sydney*, Australia; *In Between*, EXPO 2000, Hanover, Germany **2001** Wexner Centre of the Arts, Columbus (OH), USA; Museum für Angewandte Kunst, Vienna, Austria; *Yokohama Triennial*, Yokohama, Japan

SELECTED BIBLIOGRAPHY →
1998 *Franz West*, Rooseum, Malmö **1999** *Limited, Franz West*, London **2000** *Franz West – In & Out*, Museum für Neue Kunst, Zentrum für Kunst und Medientechnologie, Karlsruhe; *Franz West*, Fundaçao de Serralves, Oporto

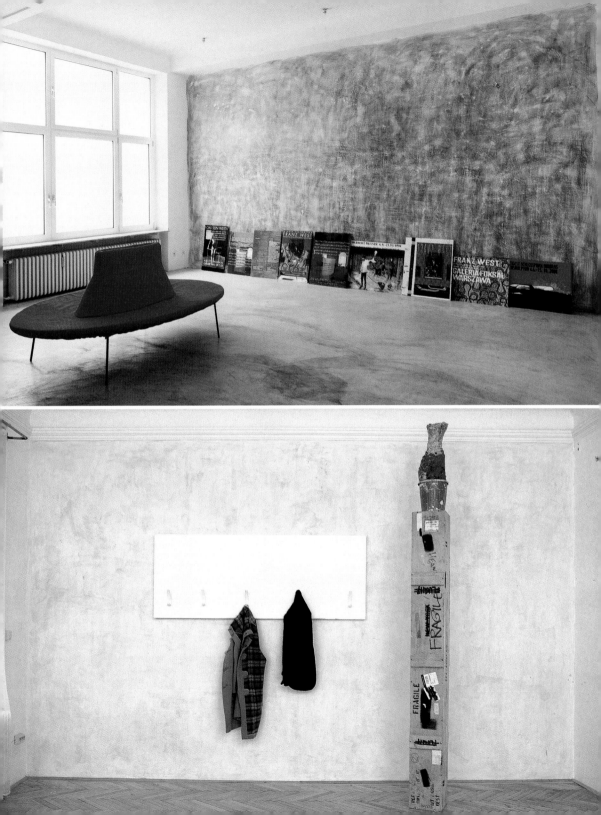

1 **Pouf,** 2000, metal, foam material, linen, cotton piqué, 220 x 150 x 80 cm, poster designs, installation view, *Plakatentwürfe*, Galerie Gisela Capitain, Cologne
2 **Oh Oklahoma,** 1999, wall piece: wood, plastic, paint, 80 x 206 x 15 cm, sculpture: papier maché, 77 x 30 x 30 cm, pedestal: wood, 241 x 34 x 28 cm
3 **3 Sitzwuste,** 2000, aluminium, painted, each c. 484 x 55 x 75 cm, installation view, Schlosspark Ambras, Innsbruck, 2000
4 In collaboration with Heimo Zobernig:
 Auto Sex, 1999, 2 chairs, metal, wood, foam material, cotton, each

45 x 54 x 84 cm, transparent reflector foil, 150 x 150 cm, rubber floor covering, 141 x 320 cm
5 **Blickle,** 1999, Passstück: epoxy resin, emulsion paint, metal, 46 x 44 x 25 cm, plinth: wood, emulsion paint, video monitor, video
6 **Vorschein und Alltag (Pre-Semblance and the Everyday)** (detail), 1999/2000, installation with 15 sculptures on plinths, 2 divans, 2 club armchairs and 11 collages, installation view, Renaissance Society, Chicago (IL), 2000

„Nimm einen Stuhl aus dem Regal, verwende ihn für seinen Zweck und stelle ihn dann zurück."

« Prenez une chaise sur l'étagère, utilisez-la pour ce pour quoi elle a été conçue, puis remettez-la à sa place. »

"Take a chair off the shelf, use it for its purpose and then put it back again."

3

4

5

6

Pae White

1963 born in Pasadena (CA), lives and works in Los Angeles (CA), USA

The Californian artist Pae White works on the borderlines between art, design and graphics. While working on numerous advertising projects, with colleagues such as Jorge Pardo, she has developed her own idiosyncratic style of layout, which could be described as "modernist mannerism". White's sculptures share the same fragility and sense of colour as her graphic designs. She creates mobiles from fine slips of paper on nylon thread, forming a dense, shimmering, ornamental network. Sometimes she offsets these delicate compositions with solid masses, as in *Birds and Ships*, 2000, with layers of opaque orange Plexiglas laid on the floor. The unevenly applied laminate glue between the layers creates visible patterns, giving an impression both of solidity and flowing movement. *Clocks*, 2000, is a series of twelve cardboard wall clocks in different colours, made using the simple techniques of cutting out and folding. The clocks do not tell the time in the usual way, but have their own quirky mechanism, and each one stands for a sign of the zodiac. They may appear to be naively charming private fetishes, but their form is far removed from and even stubbornly opposed to the surreal. White's abstract, handcrafted constructions, which serve no function at all, cannot be classified as "design". They also dispense with the ideological and theoretical precepts of classic minimalism and are relatively self-sufficient and independent of the context in which they appear. Their power to communicate lies in the hallucinatory effect of their impenetrable surfaces. White's designs reflect the typically Californian tradition of décor as a permanent interplay between beauty and inscrutability.

Pae White arbeitet an den Grenzlinien von Kunst, Design und Grafik. In zahlreichen publizistischen Kooperationen, etwa mit Jorge Pardo, hat sie einen eigenwilligen Stil des Layouts entwickelt, den man als modernistischen Manierismus beschreiben könnte. Das Filigrane und die Farbigkeit dieser grafischen Entwürfe hat sie in ihre Skulpturen überführt. Ihre Mobiles sind dichte Netze aus Nylonfäden und feinen Papierstücken, die einen ornamentalen, optisch flirrenden Charakter haben. Die Leichtigkeit dieser Objekte kontrastiert sie gelegentlich mit einem skulpturalen Gegenstück, wie in der Arbeit *Birds and Ships*, 2000, mit Plexiglasplatten, deren opakes Orange durch die Spuren des unregelmäßig aufgetragenen Laminatklebers zwischen den Plexiglasschichten ein Muster erhält. Es entsteht ein zugleich solider wie fließender Eindruck. Ein Zyklus von zwölf Wandobjekten, *Clocks* (Uhren), 2000, besteht aus modellierten Pappen in verschiedenen Farben. Die Uhren zeigen nicht im gewöhnlichen Sinne die Zeit an, sondern haben einen absurden Mechanismus. Jede Uhr steht für ein astrologisches Tierkreiszeichen. Diese Objekte haben den naiven Charme des privaten Fetisches. Zugleich sind sie aber auch distanziert und widerspenstig in ihrem Zustand des Surrealen. Die abstrakten Gestaltungen von White sind gänzlich funktionslos, wie vom Design unterscheidet, ebenso der einfache, „bastelige" Materialgebrauch. Sie entbehren aber auch der ideologischen oder theoretischen Postulate der klassischen Minimal-Art. Sie sind relativ selbstgenügsam und unabhängig vom Kontext, in dem sie auftreten. Whites Objekte kommunizieren vor allem über den halluzinatorischen Effekt ihrer undurchdringlichen Oberflächen. In Whites Entwürfen spiegelt sich eine typisch kalifornische Geschichte des Dekors als einem permanenten Spiel von Schönheit und Abgründigkeit.

Pae White travaille au carrefour entre l'art, le design et le graphisme. Dans de nombreuses collaborations éditoriales – notamment avec Jorge Pardo –, elle a développé un style très personnel de la mise en page, qu'on pourrait qualifier de maniérisme moderniste. De ces projets graphiques, elle a repris dans ses sculptures l'aspect filigrane et le chromatisme. Dans ses mobiles réalisés à partir de fines découpes de papier accrochées à des fils de nylon, White confectionne de foisonnants réseaux de couleurs dont la vibration optique possède un caractère ornemental. La légèreté de ces objets est parfois contrecarrée par des contrepoints sculpturaux tels que la sculpture *Birds and Ships*, 2000, réalisée à partir de plaques de plexiglas, et dont la couleur orange opaque dessine des motifs résultant des traces d'encollage entre les strates du matériau, l'ensemble produisant une impression aussi fluide que solide. Un cycle de douze objets muraux, les *Clocks* (Horloges), 2000, consiste en cartons modelés de différentes couleurs. Les horloges n'indiquent pas l'heure au sens conventionnel, mais présentent un mécanisme absurde. Chacune est liée à un signe astrologique. Ces objets ont le charme naïf du fétiche privé, mais leur aspect surréaliste leur confère en même temps un caractère distancé et revêche. Les réalisations abstraites de White sont totalement dénuées de fonction, ce qui le distingue du design, tout comme l'utilisation « bricolée » et simple des matériaux. Mais elles manquent aussi de tous les postulats idéologiques et théoriques qui sont ceux du Minimal Art classique. Elles sont relativement autonomes et indépendantes du contexte dans lequel elles apparaissent. Les objets de White communiquent essentiellement par l'intermédiaire de l'effet hallucinatoire de leur surfaces impénétrables. Avec leur jeu permanent entre beauté et profondeur, les projets de l'artiste rendent compte d'une histoire typiquement californienne du décor.

A. K.

SELECTED EXHIBITIONS →
1995 *Hawaii* (with Jorge Pardo), Friedrich Petzel Gallery, New York (NY), USA **1998** greengrassi, London, UK; *Abstract Painting, Once Removed,* Contemporary Arts Museum, Houston (TX), USA **2000** China Art Objects Galleries, Los Angeles (CA), USA; *What if,* Moderna Museet, Stockholm, Sweden; *Against Design,* Institute of Contemporary Art, Philadelphia (PA), USA; *Made in California: Art, Image, and Identity, 1900–2000,* Los Angeles County Museum of Art, Los Angeles (CA), USA **2001** neugerriemschneider, Berlin, Germany

SELECTED BIBLIOGRAPHY →
1994 *Plane Structures,* The Renaissance Society, Chicago (IL)/ Pittsburgh Center for the Arts, Pittsburgh (PA) **2000** *Made in California: Art, Image, and Identity, 1900–2000,* Los Angeles County Museum of Art, Los Angeles (CA) **2001** Uta Grosenick (ed.), *Women Artists,* Cologne

1 **Tawny + Scatter,** 1997, film gels, adhesive, thread
2 **Web sampler 2000 (#69),** 2001, spiderweb on perfect paper, 59 x 44 cm

3 **Web sampler 2000 (#63),** 2001, spiderweb on perfect paper, 59 x 44 cm
4 Installation view, *Birds and Ships*, neugerriemschneider, Berlin, 2001

„Die von mir bevorzugte Kunst ist die, die ich nicht verstehe."

« Mon art péféré est l'art que je ne comprends pas. »

"My favorite art is the art I don't understand."

2

3

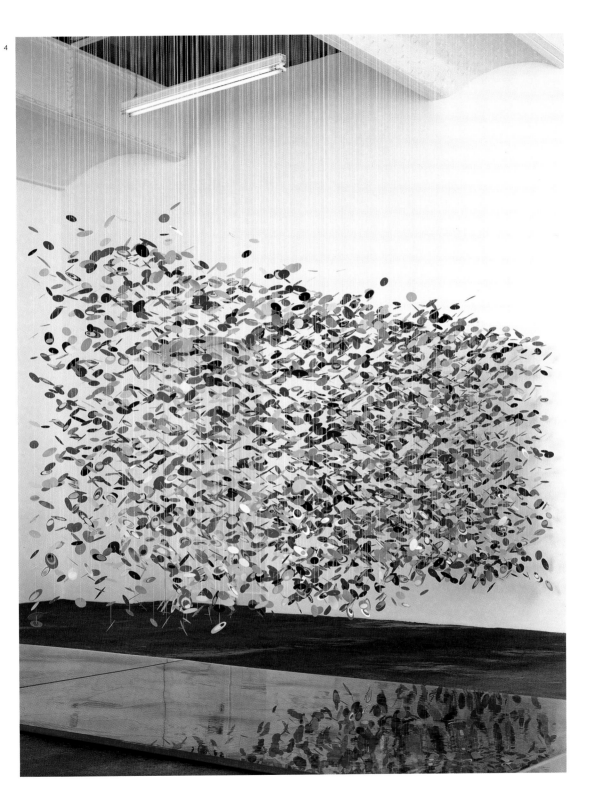

Andrea Zittel

1965 born in Escondido (CA), lives and works in New York (NY) and Altadena (CA), USA

Since 1992 Andrea Zittel has made domestic products under the company name "A–Z Administrative Services". She has designed collapsible *Living Units*, 1993/94, all-in-one structures with spaces for cooking, eating, washing and sleeping. She has also created clothes, food and other personal items to streamline users' daily routine. The *A–Z Comfort Units*, 1994, which allow individuals to perform tasks without getting out of bed, and *A–Z Ottoman Furniture*, 1994, which combines storage solutions with flexible seating and sleeping surfaces, demonstrate the dual nature of Zittel's work as idealistic yet practical. Zittel's inspiration is truly American. She is interested in American mass production and, perhaps paradoxically, the growing demand for customisation. The *A–Z Escape Vehicles*, 1996, and *A–Z Travel Trailer Units*, 1995, demonstrate this commitment to unique products: the pod-like "Escape Vehicles" and "Travel Trailers", which resemble recreational vehicles, have uniform metal exteriors, but Zittel encourages their owners to customise the interiors to reflect their personal needs and individual styles. Both of these projects highlight the nomadic quality of Zittel's work, whether it is an escape inside the hermetic environment of the "Escape Vehicles" or a journey into the landscape with the "Travel Trailer Units". Recently Zittel has branched out to create a new line of products under the label "Raugh", that strives to accommodate rather than control daily activities. These products, which include large-scale foam seating units that resemble rock formations, are meant to be comfortable and practical in their use and wear.

Seit 1992 stellen die von Andrea Zittel gegründeten „A–Z Adminstrative Services" Haushaltsgegenstände her. So hat Zittel etwa zusammenfaltbare *Living Units*, 1993/94, entworfen, bei denen es sich um kompakte Wohneinheiten handelt, in denen die Funktionen Kochen, Essen, Waschen und Schlafen auf engstem Raum zusammengefasst sind. Sie hat aber auch Kleider, Lebensmittel und sonstige persönliche Utensilien gestaltet, die den Alltag erleichtern. Beispiele für die doppelte – idealistische und zugleich praktische – Zielrichtung von Zittels Arbeit sind auch Werke wie *A–Z Comfort Units*, 1994, die es dem Benutzer gestatten, allfällige Aufgaben vom Bett aus zu erledigen, sowie *A–Z Ottoman Furniture*, 1994, eine Kombination aus Stauraum und flexiblen Sitz- und Schlafelementen. Dabei lässt sich Zittel von einem wahrhaft amerikanischen Pragmatismus leiten. So interessiert sie sich etwa für Massenproduktion und, paradoxerweise, den damit einhergehenden Wunsch nach individuellen Lösungen. Beispielhaft für derart einzigartige Produkte sind die *A–Z Escape Vehicles*, 1996, und die *A–Z Travel Trailer Units*, 1995. Die fast kugelförmigen „Escape Vehicles" und „Travel Trailers" erinnern an Wohnwagen. Sie sind zwar außen mit einer einheitlichen Metallverkleidung ausgestattet, aber Zittel ermutigt die Besitzer der Wohnmobile dazu, diese so einzurichten, wie es ihren persönlichen Bedürfnissen und ästhetischen Vorlieben entspricht. Beide Projekte betonen das nomadische Element in Zittels Arbeit, ob es sich dabei nun um eine Flucht in das hermetisch abgeschlossene Innere der „Escape Vehicles" handelt oder um eine Reise durch die offene Landschaft in einer „Travel Trailer Unit". Erst unlängst hat Zittel ihr Tätigkeitsfeld erweitert und kreiert jetzt unter dem Namen „Raugh" eine neue Produktlinie, die tägliche Aufgaben erleichtern, nicht kontrollieren soll. Diese Produkte, zu denen auch großformatige Sitzgelegenheiten aus Schaumstoff gehören, sollen sich ebenso bequem und praktisch am Körper tragen lassen wie – je nach Funktion – für andere Zwecke eignen.

Depuis 1992, Andrea Zittel fabrique des produits domestiques sous le nom de compagnie « A–Z Administrative Services ». Elle a conçu des *Living Units* (Unités habitables, 1993/94) pliables, des structures intégrées comprenant des espaces pour cuisiner, manger, laver et dormir. Elle a également créé des vêtements, de la nourriture et d'autres articles personnels pour rationaliser sa vie quotidienne. Les *A–Z Comfort Units*, 1994, qui permettent d'effectuer des tâches sans quitter son lit, et les *A–Z Ottoman Furniture*, 1994, qui associent des solutions de rangement à des sièges souples et des surfaces de couchage, démontrent la dualité du travail de Zittel, idéaliste tout en étant pratique. Son inspiration est profondément américaine. Elle s'intéresse à la fabrication de masse associée à la production américaine et, peut-être paradoxalement, au désir croissant de customisation. Les *A–Z Escape Vehicles*, 1996, et *A–Z Travel Trailer Units*, 1995, attestent de cet attachement à des produits uniques : ses « véhicules d'évasion » en forme de cosse et ses « caravanes » ont des extérieurs métalliques uniformes, mais Zittel encourage leurs propriétaires à aménager leur intérieur de sorte à refléter leurs besoins personnels et leurs styles individuels. Ces deux projets soulignent la qualité nomade du travail de Zittel, qu'il s'agisse d'une fuite à l'intérieur de l'environnement hermétique des « Escape Vehicles » ou d'un voyage dans le paysage avec les « Travel Trailers Units ». Récemment, Zittel s'est diversifiée pour créer une nouvelle ligne de produits sous la marque « Raugh » qui visent à accommoder plutôt qu'à contrôler les activités quotidiennes. Ces produits, qui incluent de grands sièges en mousse qui ressemblent à des rochers, sont censés être confortables et pratiques dans leur utilisation tout en vieillissant bien. Ro. S.

1

SELECTED EXHIBITIONS →
1995 San Francisco Museum of Modern Art, San Francisco (CA), USA **1996** Museum für Gegenwartskunst, Basel, Basle, Switzerland **1997** *documenta X*, Kassel, Germany; *Skulptur. Projekte*, Münster, Germany **1999** Deichtorhallen, Hamburg, Germany **2000** *Made In California*, Los Angeles County Museum of Art, Los Angeles (CA), USA; *Against Design*, Institute of Contemporary Art, Philadelphia (PA), USA **2000** *What If*, Moderna Museet, Stockholm, Sweden **2001** IKON Gallery, Birmingham, UK; *International Communities*, Rooseum, Malmö, Sweden

SELECTED BIBLIOGRAPHY →
1997 Klaus Bußmann/Kasper König/Florian Matzner (eds.), *Skulptur. Projekte*, Münster **1999** *Andrea Zittel*, Deichtorhallen, Hamburg **2001** Uta Grosenick (ed.), *Women Artists*, Cologne

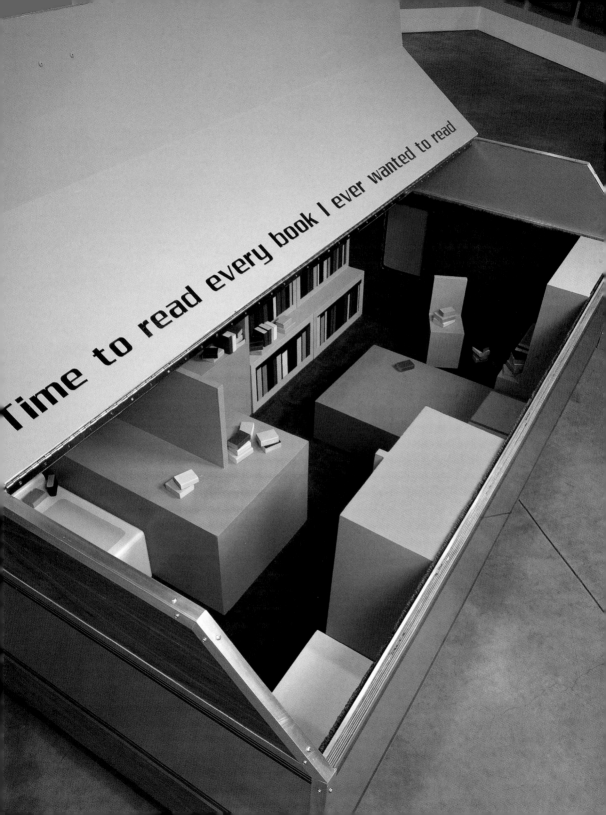

1 **A–Z Time Tunnel: Time To Read Every Book I Ever Wanted to Read,** 2000, aluminium, walnut wood, steel, carpet, paint, vinyl, adhesive, MDF, electrical lighting, sound machine, 119 x 123 x 239 cm (open with ladder), installation view, Andrea Rosen Gallery, New York (NY)

2 **A–Z Cellular Compartment Units,** 2001, stainless steel, plywood, glass, mixed media, 10 Units, each 244 x 122 x 122 cm, installation view, IKON Gallery, Birmingham

3 **A–Z 2001 Homestead Unit** (detail), 2001, steel, wood, glass, objects, 305 x 396 x 305 cm, installation view, Sadie Coles HQ, London

„Früher wollte ich mal Designerin werden, aber als Designer steht man vor der Aufgabe, Produkte zu gestalten, die der Mehrzahl der Leute gefallen müssen, und das finde ich nun auch wieder nicht sonderlich befreiend."

« J'ai envisagé de devenir designer, mais le designer a la responsabilité de concevoir des objets qui servent le plus grand nombre, et je ne pense pas que ce soit si libératoire. »

"I thought about becoming a designer but designers are responsible for making products that best serve the greatest number of people, and I don't think that's so liberating."

2

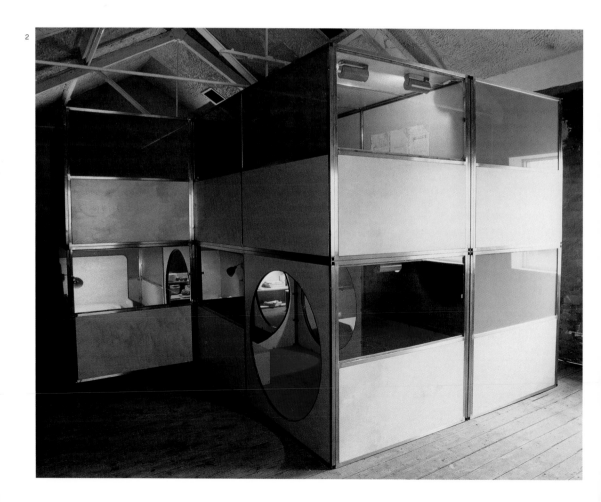

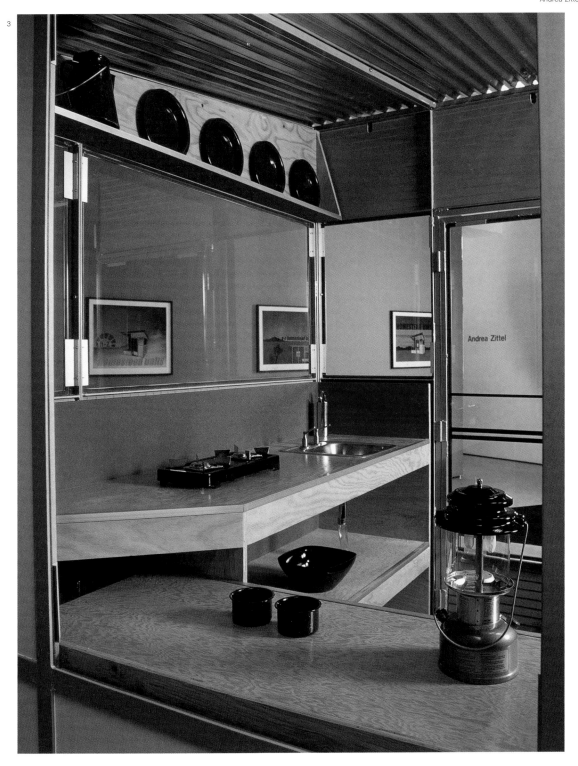

Glossary

ANIME → Japanese cartoon films, whose simply drawn figures and straightforward plots are based on Japanese manga comics. In the 1990s, anime and their extravagant soundtracks became famous outside Japan.

APPROPRIATION ART → In Appropriation Art, objects, images and texts are lifted from their cultural context and placed unchanged in a new one. They thus become charged with a new significance.

ARTE POVERA → Art movement which began in Italy in the 1960s. Artists used "humble" materials and the simplest design principles to reduce artworks to their barest essentials.

ASSEMBLAGE → A three-dimensional picture made of different materials, usually of everyday use.

AURA → The radiance that renders a person or work of art subject to veneration. People or works of art possessing an aura are at once remote and approachable. They fascinate by their precious uniqueness.

AUTONOMY → Condition of self-reliance and independence. In art, autonomy means freedom from any conditioning by non-artistic objectives.

BODY ART → Art that takes the body for its subject and makes it the object of performances, sculptures or videos.

CAMP → Persons or objects whose appearance is exaggeratedly stylised are called camp. Admiration for them generates a mocking and at the same time emotion-laden cult of artificiality.

CATALOGUE RAISONNÉ → Annotated catalogue of an artist's work, with a claim to completeness.

CIBACHROME → A colour print (usually large format) made from a slide.

CLUB CULTURE → The 1990s' club culture was shaped by the aesthetics of techno-music. However, it was not confined to dance-floor activities but also found expression through a whole lifestyle, influencing fashion, design and typography.

CODE → Sign system providing the basis for communication and conveying information.

COLLAGE → Work of art made up of a variety of unconnected objects or fragments that were not created by the artist.

COMPUTER ANIMATION → Apparently three-dimensional models produced on a computer which can be "walked through" or seen from different perspectives by the user; or virtual figures which move on the screen.

COMPUTER-GENERATED → Produced by computer.

CONCEPTUAL ART → Conceptual Art emerged in the 1960s. It gives primacy to the basic idea of a work's content. This is often revealed in language alone, i. e. texts or notes. The actual execution of the work is considered secondary and may be totally lacking.

CONSTRUCTIVISM → Early 20th-century art movement that coined a mostly abstract formal language and made everyday use of modern art.

CONTEXT ART → Criticises the art business and its institutions. Power structures are disclosed, distribution mechanisms and exhibition forms are investigated for their political function. Various artistic means of expression are adopted to present this criticism, such as performances, installations and Object Art.

C-PRINT → A colour print from a photographic negative.

CROSSOVER → Crossover refers to crossing the boundaries between art and popular culture and between different cultures; also to the inclusion of music, design and folklore etc in artistic work.

CULTURAL STUDIES → A new trend in Anglo-American quasi-academic studies that is concerned with the examination of popular culture. Cultural studies pay particular attention to the influence of racial, class or gender factors on cultural expression.

CURATOR → A curator decides what exhibitions are about, and selects the participating artists.

DADA → Revolutionary art movement at its peak in the 1920s, whose collages, performances and public readings of nonsense poetry called all existing cultural values into question.

DECONSTRUCTION → A means of interpretation that regards a work not as closed entity but as an open and many-layered network of the most varied elements in form and content. These elements, their functions and contradictions, are revealed by deconstruction.

DIGITAL ART → Art that makes use of new digital media such as computers and the Internet.

ECLECTICISM → A common resort of postmodernism, characterised by extensive quotation from largely historical styles and other artists' works.

ENTROPY → A concept derived from heat theory signifying the degree of disorder in closed systems. Total entropy would be reached when a system collapsed in chaos. By analogy, entropy indicates the informational value of news. The ultimate here would be a meaningless rushing noise.

ENVIRONMENT → An interior or exterior space entirely put together by the artist which integrates the viewer in the aesthetic experience.

FICTION → A picture or a story is a fiction when it is based on free invention.

FLUXUS → Radical experimental art movement embracing a variety of forms, including happenings, poetry, music and the plastic arts, whose ephemeral nature removed art from its accepted museum context.

FOLK ART → Traditional arts and crafts connected to particular regions – especially rural areas – or ways of life, which remain relatively unaffected by changes of style.

FUTURISM → Founded in Italy around 1910 by a group of writers and artists, the Futurist movement made a radical break with the past. It promoted a type of art reflecting life in the modern age, characterised by simultaneity, dynamism and speed.

GENDER SURFING → The confusing game with sexual roles whose point is to mix them up, to humorous effect.

GLOBALISATION → Globalisation means that economic or cultural processes increasingly have worldwide implications.

HAPPENING → An artistic action in front of a public that normally becomes involved in what happens.

HETEROGENEITY → Basic difference in kind or species.

HIGH AND LOW CULTURE (HI 'N' LO) → A complex of themes concerning the influence of trivial culture (low art) on modern art (high art). The concept derives from an exhibition assembled by Kirk Varnedoe in 1990 at the New York Museum of Modern Art.

HYBRID → Of many forms, mixed, incapable of single classification.

ICON → Image or person venerated by a cult.

ICONOGRAPHY → The language of images or forms that is typical of a particular cultural context; for example, the iconography of advertising, the western, postmodern architecture etc.

ICONOLOGY → The interpretation of the content of a work of art, based on its iconography.

INSTALLATION → A work of art that integrates the exhibition space as an aesthetic component.

INTERACTIVE ART → Works of art intended for the viewer's direct participation. Normally this participation is made possible by computer technology.

LOCATION → Site of an event or exhibition etc.

MAINSTREAM → Predominant style reflecting the taste of the general public.

MANGA → Comics and cartoon films, the most popular type of reading matter in Japan, where manga is produced and consumed in large quantities.

MEMENTO MORI → An event or object reminding one of death.

MICROPOLITICS → Political strategy based on interventions involving small social groups rather than overall social change.

MINIMAL ART → Art trend of the 1960s that traces sculptures and pictures back to clear basic geometric forms and places them in a concrete relation to the space and the viewer.

MIXED MEDIA → Combination of different media, materials and techniques in the production of a work of art.

MONTAGE → Joining together pictorial elements or sequences in photography, film and video.

MULTIPLE → In the 1960's, the classical concept of a work of art came under fire. Instead of a single original, works of art were produced in longer runs, i. e. as "multiples". The idea was to take art out of museums and galleries and make it more available.

NARRATION → Telling a story in art, film or literature.

NEO-CONCRETE ART → A movement in the tradition of Concrete Art. Since the 1950s, Concrete Art, like Abstract Art, has emphasised the material, "concrete" properties of aesthetic means.

NEO-GEO → 1980s style of painting that operates highly objectively with geometric patterns and colour compositions.

NEW AGE → A form of alternative culture that believes in the beginning of a new age.

OBJECT ART → All works of art that contain already existing objects or materials, or are entirely composed of them. (cf. readymade)

OP ART → A type of 1960s Abstract Art that played with optical effects on the eye.

PERFORMANCE → Artistic work performed in public as a (quasi-theatrical) action. The first performances took place during the 1960s in the context of the Fluxus movement, which tried to widen the concept of art.

PHENOMENOLOGY → A branch of philosophy which examines the way external reality appears to humans.

Glossary

PHOTOREALISM → Hyper-realistic painting and sculpture using exaggerated photographic sharpness to take a critical look at the details of reality.

POLITICAL CORRECTNESS → A socio-political attitude particularly influential in the USA. The purpose of Political Correctness is to change public language. The principal requirement is to refer to social "minorities" in a non-judgmental way.

POP ART → Artistic strategy of the 1960s which transformed the popular iconography of film, music and commerce into art.

POP CULTURE → Pop culture finds its expression in the mass circulation of items from areas such as fashion, music, sport and film. The world of pop culture entered art in the early 60s, through Pop Art.

POST HUMAN → A complex of themes centering on the influence of new technologies – such as computers, genetic engineering etc. – and the influence of a media-based society on the human body. "Post human" was the title of an exhibition put together by Jeffrey Deitch in 1992.

POST-CONCEPTUALISM → Aesthetic approach that, like 1960s Concept Art, concentrates more on the idea and concept of art than on its visual and perceptible form.

POST-MINIMALISM → Following on from Minimal Art, post-minimalist art uses simple forms and structures, functioning within clearly defined limits.

POSTMODERNISM → Unlike modernism, Postmodernism starts from the assumption that grand utopias are impossible. It accepts that reality is fragmented and that personal identity is an unstable quantity transmitted by a variety of cultural factors. Postmodernism advocates an irreverent, playful treatment of one's own identity, and a liberal society.

POST-STRUCTURALISM → Whereas structuralism considers sign systems to be closed, post-structuralism assumes that sign systems are always dynamic and open to change. (cf. structuralism)

PROCESS ART → Since the 1960s, Process Art has replaced the concept of a work as a definitive and self-contained entity with the ideas of changeability of form, collaboration and incompleteness within the creative process.

PRODUCTION STILL → Photo of a scene from a film or of an actor in a film, taken on the set by a specialist photographer and used for publicity or documentary purposes.

READYMADE → A readymade is an everyday article which the artist declares to be an artwork and exhibits without major alterations. The idea derives from French artist Marcel Duchamp, who displayed the first readymades in New York in 1913, e. g. an ordinary urinal ("Fountain") or a bottle drier.

SAMPLING → Arrangement of existing visual or audio material with the main intention of playing with the material's formal characteristics. Rather than quoting from the material, whose sources are often unclear, sampling aims to reformulate it.

SCATTER ART → Installation art consisting of everyday objects, including objets trouvés and junk, scattered seemingly at random around exhibition spaces.

SELF-REFERENTIAL ART → Art that refers exclusively to its own formal qualities and so rejects any idea of portrayal.

SEMANTICS → The study of the significance of linguistic signs, i. e. the meaning of words.

SETTING → An existing or specially created environment surrounding a work of art.

SIMULACRUM → An illusionary image which is so seductive that it can supplant reality.

SITUATIONISM → The International Situationists are a group of artists who introduced the concept of "situation" in art in the mid-20th century. According to its practitioners, situationism means constructing temporary situations and transforming them to produce a higher level of passionate intensity.

SOCIAL WORK → Art here is understood as a service that quite deliberately accepts socio-political functions.

STEREOTYPE → A standardised, non-individual image that has become generally accepted.

STRUCTURAL FILM → Expression commonly used since the 1960s in the USA to describe experimental films that reveal the material composition and the physical processes of film making.

STRUCTURALISM → Structuralism systematically examines the meaning of signs. The purpose of structuralism is to explore the rules of different sign systems. Languages and even cultural connections are seen and interpreted by structuralism as sign systems.

SURREALISM → Art movement formed in the 1920s around the writer André Breton and his followers, whose main interest was Automatism, or the suspension of conscious control in creating art.

TRANSCENDENCE → In philosophy and religion, transcendence is what is beyond normal human perception. In the extraordinary experience of transcendence, therefore, the boundaries of consciousness are crossed.

TRASH → The US word for "rubbish" aims at a level below accepted aesthetic and qualitative norms, with ironic intent.

URBANISM → The subject of town construction and living together in towns.

VIDEO STILL → Still image taken by stopping a running videotape on screen or scanning a videotape.

VIENNESE ACTIONISM → Artform based around happenings of a ritualistic, bloodthirsty and apparently painful nature. Actionists often used sadomasochism and orgies for their systematic attack on the apparent moral and religious hypocrisy of Austrian society in the early 1960s.

VIRTUAL REALITY → An artificial world created on computer. (cf. computer-generated, computer animation)

WHITE CUBE → The neutral white exhibition room which in modern times has succeeded older forms of presenting art, e. g. hanging of pictures close to each other on coloured wallpaper. The white cube is supposed to facilitate the concentrated and undisturbed perception of the work of art.

WORK-IN-PROGRESS → Work which the artist does not attempt to complete, focusing instead on the actual creative process.

YOUNG BRITISH ARTISTS (YBA) → Group of young British artists who since the beginning of the 1990s have created a furore with object and video art inspired by pop culture.

Ariane Beyn and Raimar Stange

Glossar

ANIME → Japanische Zeichentrickfilme, deren einfach gezeichnete Figuren und schlichte Handlungen auf den japanischen Manga-Comics basieren. In den neunziger Jahren wurden diese Filme und ihre aufwendigen Soundtracks auch über Japan hinaus bekannt.

APPROPRIATION ART → Bei der Appropriation Art werden Objekte, Bilder und Texte aus ihrem kulturellen Zusammenhang genommen und unverändert in einen neuen gestellt. Dadurch laden sie sich mit neuer Bedeutung auf.

ARTE POVERA → In den sechziger Jahren in Italien entstandene Kunstrichtung, die vor allem „ärmliche" Materialien und einfachste Gestaltungs-prinzipien nutzte, um die Werke auf ihre ureigensten Qualitäten zu reduzieren.

ASSEMBLAGE → Dreidimensionales Bild aus verschiedenen, meist dem Alltag entnommenen Materialien.

AURA → Die Aura bezeichnet die Ausstrahlung, die eine Person oder ein Kunstwerk verehrungswürdig macht. Auratische Personen oder Kunstwerke sind entrückt und nahbar zugleich, sie faszinieren durch ihre kostbare Einzigartigkeit.

AUTONOMIE → Zustand der Selbstständigkeit und Unabhängigkeit. Für die Kunst bedeutet Autonomie die Freiheit von jeder Bestimmung durch außerkünstlerische Zwecke.

BODY ART → Kunst, die den Körper thematisiert und zum Gegenstand von Performances, Skulpturen oder Videoarbeiten macht.

CAMP → Personen oder Objekte, deren Erscheinungsbild übertrieben stilisiert ist, sind camp. Ihre Verehrung mündet in einen ironischen und zugleich emotionsgeladenen Kult der Künstlichkeit.

CATALOGUE RAISONNÉ → Kommentiertes Werkverzeichnis eines Künstlers, mit dem Anspruch auf Vollständigkeit.

CIBACHROME → Ein meist großformatiger Farbpapierabzug von einem Dia.

CLUBKULTUR → Die Clubkultur der neunziger Jahre wurde wesentlich von der Ästhetik der Techno-Musik geprägt. Sie beschränkt sich aber nicht auf das reine Tanzen auf dem „Dancefloor", sondern drückt sich als umfassende Lebenshaltung auch in Mode, Design und Typografie aus.

CODE → Zeichensystem als Grundlage für Kommunikation und Informationsübermittlung.

COLLAGE → Ein künstlerisches Werk, das aus aneinandergefügten, vom Künstler nicht selbst angefertigten zusammenhanglosen Objekten bzw. Objektteilen besteht.

COMPUTERANIMATION → Im Computer erzeugte, scheinbar dreidimensionale Modelle, die vom Benutzer „durchwandert" beziehungsweise von verschiedenen Perspektiven aus gesehen werden können; virtuelle Figuren, die sich auf dem Bildschirm bewegen.

COMPUTERGENERIERT → Durch Computereinsatz erzeugt.

C-PRINT → Ein „colour-print", der Farbpapierabzug eines Fotonegativs.

CROSSOVER → Beim Crossover werden die Grenzen zwischen Kunst und Populärkultur sowie zwischen verschiedenen Kulturen überschritten und Musik, Design, Folklore etc. in die künstlerische Arbeit einbezogen.

CULTURAL STUDIES → Neuere Strömung in der angloamerikanischen Kulturwissenschaft, die sich der Untersuchung der Populärkultur widmet. Die Cultural Studies legen ein besonderes Augenmerk darauf, inwieweit kulturelle Äußerungen durch Rasse, Klassenzugehörigkeit und Geschlecht bedingt sind.

DADA → Revolutionäre Künstlerbewegung, die in den zwanziger Jahren des 20. Jahrhunderts vor allem mit ihren Collagen, Lautdichtungen und Performances sämtliche kulturellen Werte infrage stellte.

DEKONSTRUKTION → Eine Interpretationsweise, die ein Werk nicht als geschlossene Einheit betrachtet, sondern als offenes und vielschichtiges Geflecht aus unterschiedlichsten formalen und inhaltlichen Elementen. Diese Elemente, ihre Funktionen und Widersprüche werden in der Dekonstruktion aufgedeckt.

DIGITALE KUNST → Kunst, die mit neuen Medien wie Computer oder Internet arbeitet.

EKLEKTIZISMUS → In der Postmoderne übliches Verfahren, das durch das ausgiebige Zitieren von (historischen) Stilen und Werken anderer Künstler charakterisiert ist.

ENTROPIE → Der aus der Wärmelehre stammende Begriff benennt dort den Grad der Unordnung in geschlossenen Systemen. Vollständige Entropie wäre dann erreicht, wenn ein System sich im Chaos auflöst. Analog dazu zeigt die Entropie die Größe des Informationswertes einer Nachricht an. Der Endpunkt hier: ein bedeutungsloses Rauschen.

ENVIRONMENT → Ein von dem Künstler komplett durchgestalteter Innen- oder Außenraum, der den Betrachter in das ästhetische Geschehen integriert.

FIKTION → Ein Bild oder eine Geschichte ist dann eine Fiktion, wenn sie auf freier Erfindung beruht.

FLUXUS → Radikal experimentelle Kunstströmung, die unterschiedliche Formen wie Happening, Poesie, Musik und bildende Kunst zusammen-

bringt. Das Flüchtige dieser Aktionen tritt an die Stelle von auratischer Musealität.

FOLK ART → Kunsthandwerkliche und volkstümliche Ästhetik, die an bestimmte Regionen oder Berufsstände, zum Beispiel das bäuerliche Milieu, gebunden ist und von Stilwandlungen relativ unberührt bleibt.

FOTOREALISMUS → Hyperrealistische Malerei und Skulptur, die mit überzogener fotografischer Schärfe Ausschnitte der Realität kritisch beleuchtet.

FUTURISMUS → Die um 1910 von Dichtern und bildenden Künstlern in Italien ausgerufene futuristische Bewegung vollzog einen radikalen Bruch mit der Vergangenheit. Sie forderte stattdessen eine den Lebensbedingungen der Moderne angemessene Kunst der Simultaneität, Dynamik und Geschwindigkeit.

GENDER SURFING → Das verwirrende Spiel mit den Geschlechterrollen, das auf die lustvolle Überschreitung ihrer Grenzen abzielt.

GLOBALISIERUNG → Globalisierung bedeutet, dass wirtschaftliche oder kulturelle Prozesse zunehmend weltweite Auswirkungen haben.

HAPPENING → Künstlerische Aktion in Anwesenheit des Publikums, das zumeist in das Geschehen einbezogen wird.

HETEROGENITÄT → Unvereinbare Gegensätzlichkeit.

HIGH AND LOW CULTURE (HI 'N' LO) → Themenkomplex, der den Einfluss der Trivialkultur (Low Art) auf die moderne Kunst (High Art) beleuchtet. Der Begriff geht zurück auf eine von Kirk Varnedoe 1990 im New Yorker Museum of Modern Art konzipierte Ausstellung.

HYBRID → Vielgestaltig, gemischt, nicht eindeutig zuzuordnen.

IKONE → Bilder oder Personen, die kultisch verehrt werden.

IKONOGRAFIE → Bild- oder Formensprache, die für einen bestimmten kulturellen Zusammenhang typisch ist, zum Beispiel die Ikonografie der Werbung, des Westerns, der postmodernen Architektur etc.

IKONOLOGIE → Wissenschaft von der inhaltlichen Interpretation eines Kunstwerks, die auf seiner Ikonografie basiert.

INSTALLATION → Ein Kunstwerk, das den Ausstellungsraum als ästhetische Komponente mit einbezieht.

INTERAKTIVE KUNST → Kunstwerke, die die direkte Einflussnahme des Betrachters – meist durch computergestützte Technik – vorsehen.

KONSTRUKTIVISMUS → Künstlerische Richtung zu Beginn des 20. Jahrhunderts, die in Anlehnung an die moderne Technik eine zumeist abstrakte Formensprache und die alltägliche Anwendung moderner Kunst suchte.

KONTEXTKUNST → Kritisiert den Kunstbetrieb und seine Institutionen: Machtstrukturen werden offengelegt, Verteilungsmechanismen und Ausstellungsformen auf ihre politische Funktion hin befragt. Unterschiedliche künstlerische Ausdrucksmittel wie Performance, Installation oder Objektkunst werden eingesetzt, um diese Kritik vorzutragen.

KONZEPTKUNST → Die Konzeptkunst entstand in den sechziger Jahren und stellt die inhaltliche Konzeption eines Werkes in den Vordergrund. Diese wird oft nur durch Texte oder Notizen präsentiert, die tatsächliche Umsetzung eines Werkes wird für zweitrangig erklärt und bleibt manchmal auch aus.

KURATOR → Ein Kurator legt die inhaltlichen Schwerpunkte einer Ausstellung fest und trifft die Auswahl der beteiligten Künstler.

LOCATION → Ort einer Veranstaltung, Ausstellung etc.

MAINSTREAM → Bereits etablierte, dem Geschmack der breiten Masse entsprechende Stilrichtung.

MANGA → Comics und Zeichentrickfilme, die bevorzugte Populärliteratur Japans, die dort in großen Mengen produziert und konsumiert wird.

MEMENTO MORI → Ereignis oder Objekt, das an den Tod erinnert.

MIKROPOLITIK → Politische Strategie, die statt auf gesamtgesellschaftliche Veränderung auf Interventionen in kleineren Lebenseinheiten setzt.

MINIMAL ART → Kunstströmung der sechziger Jahre, die Skulpturen und Bilder auf klare geometrische Grundformen zurückführte und in eine konkrete Beziehung zu Raum und Betrachter setzte.

MIXED MEDIA → Verbindung verschiedener Medien, Materialien und Techniken bei der Produktion eines Kunstwerks.

MONTAGE → Zusammenfügen von Bildelementen oder Bildfolgen in Fotografie, Film und Video.

MULTIPLE → In den sechziger Jahren entwickelte sich eine kritische Haltung gegenüber dem klassischen Werkbegriff: Anstelle eines einzelnen Originals wurden Kunstwerke in höherer Auflage, d. h. als Multiples, produziert. Kunst sollte auf diese Weise die Museen und Galerien verlassen können und mehr Menschen zugänglich gemacht werden.

NARRATION → Erzählung in Kunst, Film und Literatur.

Glossar

NEO-GEO → Tendenz in der Malerei der achtziger Jahre, die überaus sachlich mit geometrischen Mustern und Farbkompositionen operiert.

NEOKONKRETE KUNST → Kunstrichtung in der Tradition der „Konkreten Kunst". Seit den fünfziger Jahre betont diese, ähnlich wie die abstrakte Kunst, die materiellen, also „konkreten" Eigenschaften der ästhetischen Mittel.

NEW AGE → Esoterische Bewegung, die an den Beginn eines neuen Zeitalters glaubt.

OBJEKTKUNST → Ihr sind alle Kunstwerke zuzuordnen, die bereits existierende Gegenstände oder Materialien beinhalten oder ganz aus ihnen bestehen. (vgl. Readymade)

OP-ART → Kunstströmung der sechziger Jahre, deren Vertreter mit der visuellen Wirkung von Linien, Flächen und Farben experimentieren.

PERFORMANCE → Künstlerische Arbeit, die in Form einer (theatralischen) Aktion einem Publikum vorgeführt wird. Erste Performances fanden während der sechziger Jahre im Rahmen der Fluxus-Bewegung statt, die auf die Erweiterung des Kunstbegriffs abzielte.

PHÄNOMENOLOGIE → Bereich der Philosophie, in dem untersucht wird, wie die äußere Wirklichkeit dem Menschen erscheint.

POLITICAL CORRECTNESS → Eine engagierte Haltung, die besonders einflussreich in den USA vertreten wird. Ziel der Political correctness ist es, die moralischen Standards des öffentlichen Lebens zu erhöhen. Gefordert wird vor allem ein gerechter Umgang mit sozialen Minderheiten.

POP-ART → Eine künstlerische Strategie der sechziger Jahre, die populäre Ikonografien aus Film, Musik und Kommerz in die Kunst überführte.

POPKULTUR → Die Popkultur findet ihren Ausdruck in massenhaft verbreiteten Kulturgütern aus Bereichen wie Mode, Musik, Sport oder Film. Anfang der sechziger Jahre fand die Welt der Popkultur durch die Pop-Art Eingang in die Kunst.

POST HUMAN → Themenkomplex, bei dem der Einfluss neuer Technologien – wie Computer-, Gentechnologie etc. – und der Einfluss der Mediengesellschaft auf den menschlichen Körper im Mittelpunkt steht. „Post human" war der Titel einer 1992 von Jeffrey Deitch organisierten Ausstellung.

POSTKONZEPTUALISMUS → Ästhetischer Ansatz, der sich, wie die Konzeptkunst in den sechziger Jahren, mehr auf die Idee und das Konzept der Kunst als auf ihre visuell wahrnehmbare Form konzentriert.

POSTMINIMALISMUS → Kunst, die in der Tradition der Minimal Art mithilfe einfacher Formen und Strukturen ihr Funktionieren innerhalb präzise abgesteckter Rahmenbedingungen untersucht.

POSTMODERNE → Die Postmoderne geht, im Gegensatz zur Moderne, von der Unmöglichkeit großer Utopien aus. Sie akzeptiert die Wirklichkeit als eine zersplitterte und die persönliche Identität als eine unstabile Größe, die durch eine Vielzahl kultureller Faktoren vermittelt wird. Die Postmoderne plädiert für einen ironisch-spielerischen Umgang mit der eigenen Identität sowie für eine liberale Gesellschaft.

POSTSTRUKTURALISMUS → Während der Strukturalismus Zeichensysteme als geschlossen begreift, nimmt der Poststrukturalismus an, dass Zeichensysteme immer dynamisch und offen für Veränderungen sind. (vgl. Strukturalismus)

PROCESS ART → Die Veränderbarkeit der Form, Zusammenarbeit und der unvollendete kreative Prozess ersetzen in der Process Art seit den sechziger Jahren einen definitiven und abgeschlossenen Werkbegriff.

PRODUCTION STILL → Foto von einer Filmszene oder von den Protagonisten eines Films, das am Filmset von einem speziellen Fotografen für die Werbung oder zu dokumentarischen Zwecken aufgenommen wird.

READYMADE → Ein Alltagsgegenstand, der ohne größere Veränderung durch den Künstler von diesem zum Kunstwerk erklärt und ausgestellt wird. Der Begriff geht auf den französischen Künstler Marcel Duchamp zurück, der 1913 in New York die ersten Readymades, zum Beispiel ein handelsübliches Pissoir („Fountain") oder einen Flaschentrockner, präsentierte.

SAMPLING → Arrangement von vorhandenem Bild- oder Tonmaterial, das vor allem mit den formalen Eigenschaften des verarbeiteten Materials spielt. Anders als das Zitieren zielt das Sampling dabei auf neue Formulierungen ab und lässt seine Quellen häufig im Unklaren.

SCATTER ART → Raumfüllende Installationskunst, bei der alltägliche, oftmals gefundene und trashige Objekte scheinbar chaotisch angeordnet am Ausstellungsort verteilt sind.

SELBSTREFERENZIELLE KUNST → Kunst, die sich ausschließlich auf ihre eigenen formalen Eigenschaften bezieht und somit jeden Abbildcharakter zurückweist.

SEMANTIK → Lehre von der Bedeutung sprachlicher Zeichen.

SETTING → Eine vorgefundene oder inszenierte Umgebung, in die ein Werk kompositorisch eingebettet ist.

SIMULAKRUM → Ein „Trugbild", das so verführerisch ist, dass es die Wirklichkeit zu ersetzen vermag.

SITUATIONISMUS → Die Künstlergruppe der Internationalen Situationisten führte Mitte des 20. Jahrhunderts den Begriff der „Situation" in die Kunst ein. Die Situation ist demnach eine Konstruktion temporärer Lebensumgebungen und ihre Umgestaltung in eine höhere Qualität der Leidenschaft.

SOZIALARBEIT → Kunst wird hier als Dienstleistung begriffen, die sich ganz konkret sozialpolitischen Aufgaben stellt.

STEREOTYP → Klischeehafte Vorstellung, die sich allgemein eingebürgert hat.

STRUKTURALISMUS → Der Strukturalismus untersucht systematisch die Bedeutung von Zeichen. Ziel des Strukturalismus ist es, die Regeln verschiedener Zeichensysteme zu erforschen. Sprachen und auch kulturelle Zusammenhänge werden vom Strukturalismus als Zeichensysteme verstanden und interpretiert.

STRUKTURELLER FILM → In den USA geläufige Bezeichnung für Experimentalfilme seit den sechziger Jahren, die die materielle Beschaffenheit und die Wahrnehmungsbedingungen des Films offen legen.

SURREALISMUS → Kunstbewegung, die sich Mitte der zwanziger Jahren des 20. Jahrhunderts um den Literaten André Breton und seine Anhänger formierte und psychische Automatismen in den Mittelpunkt ihres Interesses stellte.

TRANSZENDENZ → In Philosophie und Religion der Begriff für das, was außerhalb der normalen menschlichen Wahrnehmung liegt. In der Erfahrung der Transzendenz werden also die Grenzen des Bewusstseins überschritten.

TRASH → Trash – ursprünglich: „Abfall" – ist die ironische Unterbietung ästhetischer und qualitativer Normen.

URBANISMUS → Reflexionen über Städtebau und das Zusammenleben in Städten.

VIDEO STILL → Durch Anhalten des laufenden Videobandes auf dem Bildschirm erscheinendes oder aus den Zeilen eines Videobandes herausgerechnetes (Stand-)Bild.

VIRTUAL REALITY → Im Computer erzeugte künstliche Welt. (vgl. computergeneriert, Computeranimation)

WHITE CUBE → Begriff für den neutralen weißen Ausstellungsraum, der in der Moderne ältere Formen der Präsentation von Kunst, zum Beispiel die dichte Hängung von Bildern auf farbigen Tapeten, ablöste. Der White Cube soll die konzentrierte und ungestörte Wahrnehmung eines Kunstwerks ermöglichen.

WIENER AKTIONISMUS → Blutig und schmerzhaft erscheinende Happening-Kunst rituellen Charakters, die mit oftmals sadomasochistischen Handlungen und Orgien systematisch die moralisch-religiöse Scheinheiligkeit der österreichischen Gesellschaft der frühen sechziger Jahre angreift.

WORK-IN-PROGRESS → Werk, das keine Abgeschlossenheit anstrebt, sondern seinen prozessualen Charakter betont.

YOUNG BRITISH ARTISTS (YBA) → Gruppe junger englischer Künstler, die seit Anfang der neunziger Jahre mit ihrer von der Popkultur inspirierten Objekt- und Videokunst Furore macht.

Ariane Beyn und Raimar Stange

Glossaire

ACTIONNISME VIENNOIS → Art d'un happening à caractère rituel, dont les manifestations sanglantes et douloureuses s'attaquent à la bigoterie morale et religieuse de la société autrichienne du début des années 1960, dans des actions et des orgies ayant souvent un caractère sadomasochiste.

ANIMATION → Module d'apparence tridimensionelle produit par ordinateur et pouvant être « parcouru » par la spectateur – en fait : pouvant être vu sous des points de vue changeants ; figures virtuelles qui se meuvent sur un écran.

ANIME → Dessins animés japonais dans lesquels le graphisme simple des figures et l'action sobre sont issus des mangas, les bandes dessinées japonaises. Depuis les années 90, ces films et leurs bandes-son très élaborées se sont aussi fait connaître au-delà des frontières japonaises.

APPROPRIATION ART → Des objets, des images, des textes sont extraits de leur contexte cultureI pour être transplantés tels quels dans un nouveau contexte, où ils se chargent d'une nouvelle signification.

ART CONCEPTUEL → L'art conceptuel, qui a vu le jour dans les années 60, met au premier plan le contenu de l'œuvre, dont la conception n'est souvent présentée que par des textes ou des notes, la réalisation concrète étant déclarée secondaire, voire éludée.

ART CONTEXTUEL → Il critique le marché de l'art et ses institutions : les structures du pouvoir sont mises en évidence, les mécanismes de distribution et les formes d'exposition remises en cause sous l'angle de leur fonction politique. Des moyens d'expression aussi différents que la performance, l'installation ou l'art de l'objet y sont employés pour présenter cette critique.

ART DE L'OBJET → On peut y classer toutes les œuvres d'art entièrement composées ou comportant des objets ou des matériaux préexistants. (cf. Ready-made)

ART DIGITAL → Art s'appuyant sur les moyens offerts par les nouveaux médias tels que l'informatique ou l'internet.

ART INTERACTIF → Art qui prévoit une intervention directe du spectateur dans l'œuvre. Le plus souvent, cette intervention est rendue possible par des techniques s'appuyant sur l'informatique.

ART NEO-CONCRET → Courant artistique dans la tradition de l'« Art concret ». Depuis les années 50, celle-ci souligne, de manière similaire à l'art abstrait, les qualités matérielles, donc « concrètes » des moyens esthéthiques.

ARTE POVERA → Mouvement artistique né en Italie dans les années 1960, qui se servit surtout de matériaux et de principes de création « pauvres », en vue de réduire les œuvres à leurs qualités intrinsèques.

ASSEMBLAGE → Image en trois dimensions composée de matériaux divers issus le plus souvent de la vie courante.

AURA → L'aura désigne le rayonnement qui rend une personne ou une œuvre d'art digne d'admiration. Les personnes ou les œuvres d'art douées d'une aura sont à la fois distantes et accessibles, elles fascinent par leur incomparable unicité.

AUTONOMIE → Etat d'indépendance. Dans le contexte de l'art, l'autonomie signifie la liberté à l'égard de tout conditionnement par un propos extra-artistique.

AUTO-REFERENCE → Se dit d'un art qui se réfère exclusivement à ses propres propriétés formelles et qui rejette ainsi tout caractère représentatif.

BODY ART → Art qui prend le corps pour thème et qui en fait l'objet central de performances, de sculptures ou d'œuvres vidéo.

CAMP → Personnes ou objets dont la manifestation visuelle est exagérément stylisée. L'admiration dont ils bénéficient débouche sur un culte de l'artificiel à la fois ironique et chargé d'émotion.

CATALOGUE RAISONNE → Liste commentée des œuvres d'un artiste, avec une recherche d'exhaustivité.

CIBACHROME → Tirage papier d'une diapositive, le plus souvent en grand format.

CLUBCULTURE → La clubculture des années 1990 a été fortement marquée par l'esthétique de la musique techno. Elle ne se limite cependant pas à la danse sur le « dancefloor », mais traduit aussi une attitude de vie globale dans les domaines de la mode, du design et de la typographie.

CODE → Système de signes qui sous-tend la communication et la transmission d'informations.

COLLAGE → Œuvre d'art constituée d'objets ou de parties d'objets juxtaposés qui ne sont pas des productions personnelles de l'artiste.

COMMISSAIRE → Le commissaire d'une exposition fixe le contenu d'une présentation et procède au choix des artistes participants.

CONSTRUCTIVISME → Courant artistique du début du siècle dernier dont la recherche formelle, le plus souvent abstraite, s'appuie sur la technique moderne et vise à l'application de l'art dans la vie quotidienne.

COURANT DOMINANT → Tendance stylistique qui s'est imposée et qui correspond au goût de la masse.

C-PRINT → « Colour-print », tirage papier en couleurs à partir d'un négatif.

CROSSOVER → Dans le Crossover, les limites entre l'art et la culture populaire, ainsi qu'entre les différentes cultures, sont rendues perméables. La musique, le design, le folklore etc. sont intégrés dans le travail artistique.

CULTURAL STUDIES → Dans les sciences humaines anglo-saxonnes, courant récent qui étudie la culture populaire. Un domaine de recherches particulier des Cultural Studies consiste à déterminer jusqu'à quel point les manifestations culturelles sont conditionnées par la race, l'appartenance à une classe sociale et à un sexe.

CULTURE POP → La culture pop trouve son expression dans des biens culturels répandus en masse et issus de domaines tels que la mode, la musique, le sport ou le cinéma. Au début des années 60, le monde de la culture pop devait entrer dans l'art par le biais du Pop Art.

DADA → Mouvement artistique révolutionnaire des années 20 qui remit en question l'ensemble des valeurs culturelles, surtout dans des collages, des poèmes phonétiques et des performances.
DECONSTRUCTION → Mode d'interprétation qui ne considère pas l'œuvre comme une unité finie, mais comme un ensemble d'éléments formels et signifiants les plus divers, et qui met en évidence leurs fonctions et leurs contradictions.

ECLECTISME → Procédé courant dans l'art postmoderne et qui se caractérise par la citation généreuse d'œuvres et de styles (historiques) d'autres artistes.
ENTROPIE → Concept issu de la thermodynamique, où il désigne l'état de désordre dans les systèmes clos. L'entropie totale serait ainsi atteinte lorsqu'un système se dissout en chaos. Par analogie, l'entropie indique la valeur informative d'une nouvelle. L'entropie totale serait atteinte par un bruit de fond vide de sens.
ENVIRONNEMENT → Espace intérieur ou extérieur entièrement formé par l'artiste et intégrant le spectateur dans l'événement esthétique.

FICTION → Une image ou une histoire est une fiction lorsqu'elle repose sur l'invention libre.
FLUXUS → Courant artistique expérimental et radical qui réunit différentes formes d'art comme le happening, la poésie, la musique et les arts plastiques. Le caractère fugace de ces actions y remplace l'aura de la muséalité.
FOLK ART → Esthétique artisanale et folklorique liée à certaines régions ou à certains métiers – par exemple le monde rural –, et qui reste relativement à l'écart des évolutions stylistiques.
FUTURISME → Le mouvement futuriste, proclamé vers 1910 par des poètes et des plasticiens italiens, accomplit une rupture radicale avec le passé, dont il exigeait le remplacement par un art rendant compte des conditions de vie modernes, avec des moyens nouveaux comme la simultanéité, la dynamique et la vitesse.

GENDER SURFING → Jeu troublant sur les rôles des sexes, et qui vise à la voluptueuse transgression de leurs limites.
GENERE PAR ORDINATEUR → Produit à l'aide de l'ordinateur.
GLOBALISATION → La globalisation renvoie au fait que certains processus économiques ou culturels ont de plus en plus fréquemment des répercussions au niveau mondial.

HAPPENING → Action artistique menée en présence du public, qui est le plus souvent intégré à l'événement.
HETEROGENEITE → Opposition inconciliable.
HIGH AND LOW CULTURE (HI 'N' LO) → Complexe thématique dans lequel l'influence de la culture triviale (Low Art) éclaire l'art moderne (High Art). Ce concept remonte à une exposition organisée par Kirk Varnedoe en 1990 au Museum of Modern Art de New York.
HYBRIDE → Multiforme, mixte, qui ne peut être classé clairement.

ICONE → Image ou personne faisant l'objet d'une vénération ou d'un culte.
ICONOLOGIE → Science de l'interprétation du contenu d'une œuvre sur la base de son iconographie.
ICONOGRAPHIE → Vocabulaire d'images ou de formes caractéristiques d'un contexte culturel déterminé. Ex.: l'iconographie de la publicité, du western, de l'architecture postmoderne ...
INSTALLATION → Œuvre d'art qui intègre l'espace d'exposition comme une composante esthétique.

LOCATION → Site of an event or exhibition etc.

MANGA →Bandes dessinées et dessins animés, littérature populaire privilégiée du Japon, où elle est produite et consommée en grande quantité.
MEMENTO MORI → Evénement ou objet qui rappelle la mort.
MICROPOLITIQUE → Stratégie politique qui mise sur une action dans des domaines particuliers de la vie, plutôt que sur des changements sociaux globaux.

Glossaire

MINIMAL ART → Courant artistique des années 60 qui réduit les sculptures et les tableaux à des formes géométriques clairement définies et qui les place dans un rapport concret avec l'espace et le spectateur.

MIXED MEDIA → Mélange de différents médias, matériaux et techniques dans la production d'une œuvre d'art.

MONTAGE → Agencement d'éléments visuels ou de séquences d'images dans la photographie, le cinéma et la vidéo.

MULTIPLE → Au cours des années 60 est apparue une attitude critique à l'égard de la notion classique d'œuvre : au lieu d'un original unique, les œuvres furent produites en tirages plus élevés (comme « multiples » précisément), ce qui devait permettre à l'art de quitter les musées et les galeries et d'être accessible à un plus grand nombre.

NARRATION → Récit dans l'art, le cinéma et la littérature.

NEO-GEO → Tendance de la peinture des années 80 qui travaille d'une façon extrêmement concrète avec les motifs géométriques et les compositions chromatiques.

NEW AGE → Mouvement ésotérique qui croit à l'avènement d'une ère nouvelle.

OP ART → Courant artistique des années 60 dont les représentants travaillent sur le jeu visuel des lignes, des surfaces et des couleurs. Ces artistes composent des motifs déterminés visant à produire des effets d'optique.

PERFORMANCE → Travail artistique présenté à un public sous la forme d'une action (théâtrale). Les premières performances furent présentées pendant les années 60 dans le cadre du mouvement Fluxus, qui visait à l'élargissement du concept d'art.

PHENOMENOLOGIE → Domaine de la philosophie qui étudie la manière dont la réalité extérieure apparaît à l'homme.

PHOTO DE PLATEAU → Photo d'une scène de cinéma ou de protagonistes d'un film, prise pendant le tournage, à des fins publicitaires, par un photographe spécialisé. Les photos d'une documentation prises durant le tournage sont également appelées stills.

PHOTOREALISME → Peinture et sculpture hyperréaliste qui porte un regard critique sur des morceaux de réalité à travers une amplification extrême de la vision photographique.

POLITICAL CORRECTNESS → Attitude engagée particulièrement influente aux Etats-Unis, et qui se fixe pour but de relever les standards moraux de la vie publique. Une revendication majeure en est le traitement plus juste des minorités sociales.

POP ART → Stratégie artistique des années 1960 qui fit entrer dans l'art l'iconographie populaire du cinéma, de la musique et du commerce.

POST HUMAN → Complexe thématique dans lequel l'influence des nouvelles technologies – informatique, manipulation génétique, etc. – et de la société médiatique sur le corps humain, est au centre du propos artistique. Ce concept remonte au titre d'une exposition organisée en 1992 par Jeffrey Deitch.

POST-CONCEPTUALISME → A l'instar de l'art conceptuel des années 60, démarche esthétique qui repose davantage sur l'idée et le concept artistique que sur la forme perceptible visuellement.

POST-MINIMALISME → Dans le sillage du Minimal Art, art qui analyse son propre fonctionnement à l'aide de formes et de structures simples, dans le cadre de conditions définies avec précision.

POSTMODERNISME → Par opposition à l'art moderne, le postmodernisme postule l'impossibilité des grandes utopies. Il accepte la réalité comme étant éclatée et l'identité personnelle comme une valeur instable fondée par un grand nombre de facteurs culturels. Le postmodernisme plaide en faveur d'un maniement ironique et ludique de l'identité personnelle et pour une société libérale.

POST-STRUCTURALISME → Tandis que le structuralisme conçoit les systèmes de signes comme des systèmes clos, le post-structuralisme suppose que les systèmes de signes sont toujours dynamiques et sujets à modification. (cf. Structuralisme)

PROCESS ART → Dans le Process Art, la modifiabilité de la forme, de la collaboration et du processus créateur se substituent depuis les années 60 à une conception définitive et figée de l'œuvre.

READY-MADE → Un objet quotidien déclaré œuvre d'art par l'artiste et exposé comme tel sans changement notoire. Le terme remonte à l'artiste français Marcel Duchamp, qui présente les premiers ready-mades – par exemple un urinoir du commerce (« Fountain ») ou un porte-bouteilles – en 1913 à New York.

REALITE VIRTUELLE → Monde artificiel généré par ordinateur. (cf. Généré par ordinateur, Animation)

SAMPLING → Arrangement de matériaux visuels ou sonores jouant essentiellement des caractéristiques formelles du matériau utilisé. Contrairement à la citation, le sampling vise à des formulations nouvelles et ne cite généralement pas ses sources.

SCATTER ART → Art producteur d'installations globales dans lesquelles des objets quotidiens, souvent trouvés et trash, semblent disposés de manière chaotique sur le lieu d'exposition.

SEMANTIQUE → Etude de la signification des signes linguistiques.

SETTING → Environnement existant ou mis en scène qui vient s'insérer dans la composition d'une œuvre.

SIMULACRE → « Mirage » que sa séduction met à même de se substituer à la réalité.

SITUATIONNISME → Au milieu du siècle dernier, le groupe d'artistes de l'Internationale situationniste a introduit dans l'art le concept de situation, construction temporaire d'environnements de la vie et leur transformation en une intensité de passion.

STEREOTYPE → Idée qui a acquis droit de cité sous forme de cliché.

STRUCTURAL FILM → Depuis les années 1960, terme couramment employé aux Etats-Unis pour désigner des films d'art et d'essai qui mettent en évidence la conformation matérielle et les conditions de perception du cinéma.

STRUCTURALISME → Le structuralisme étudie systématiquement la signification des signes. Il a pour but d'étudier les facteurs qui régissent différents systèmes de signes. Les langues, mais aussi les contextes sociaux y sont compris et interprétés comme des systèmes de signes.

SURREALISME → Mouvement artistique formé au milieu des années 1920 autour du littérateur André Breton et de ses partisans, et qui plaça l'automatisme psychique au centre de ses préoccupations.

TRANSCENDANCE → En philosophie et en religion, terme employé pour désigner l'au-delà de la perception humaine ordinaire. Dans l'expérience inhabituelle de la transcendance, les limites de la conscience sont donc transgressées.

TRASH → Trash – à l'origine : « ordure, déchet » – est l'abaissement ironique des normes esthétiques et qualitatives.

TRAVAIL SOCIAL → L'art y est compris comme une prestation de service qui se propose de remplir très concrètement des tâches socio-politiques.

URBANISME → Réflexions sur la construction des villes et la vie urbaine.

VIDEO STILL → Image (fixe) obtenue à l'écran par arrêt d'une bande vidéo ou calculée à partir des lignes d'une bande vidéo.

WHITE CUBE → Terme désignant la salle d'exposition blanche, neutre, qui dans l'art moderne remplace des formes plus anciennes de présentation, par exemple l'accrochage dense de tableaux sur des papiers peints de couleur. Le White Cube propose une perception concentrée et non troublée de l'œuvre d'art.

WORK-IN-PROGRESS → Œuvre qui ne recherche pas son achèvement, mais qui souligne au contraire son caractère processuel.

YOUNG BRITISH ARTISTS (YBA) → Groupe de jeunes artistes anglais qui, depuis les années 90, fait parler de lui avec son art de l'objet et ses vidéos inspirés du Pop Art.

Ariane Beyn et Raimar Stange

Photo Credits — Fotonachweis — Crédits photographiques

We would like to thank all the individual people, galleries and institutions who placed photographs and information at our disposal for ART NOW.
Unser Dank gilt allen Personen, Galerien und Institutionen, die großzügig Bildmaterial und Informationen für ART NOW zur Verfügung gestellt haben.
Nous remercions toutes les personnes, galeries et institutions qui ont mis gracieusement à la disposition de ART NOW leurs documentations, images et informations.

Biographical notes on the authors — Kurzbiografien der Autoren — Les auteurs en bref

K. B. — KIRSTY BELL (born 1971)

Studied Literature and History of Art in Cambridge (UK). Worked in galleries in London and New York and now lives in Berlin as a writer and curator.

Studierte Literatur und Kunstgeschichte in Cambridge (UK). Arbeitete in Galerien in London und New York, lebt derzeit als Autorin und Kuratorin in Berlin.

Etudes de littérature et d'histoire de l'art à Cambridge (UK). A travaillé dans plusieurs galeries à Londres et à New York, vit aujourd'hui à Berlin comme auteur et commissaire d'expositions.

F. F. — FRANK FRANGENBERG (born 1963)

Lives with his sons Jonathan, Konrad and Jesse in Cologne. He writes on contemporary art for magazines, including Kunst-Bulletin, Kunstforum, Parkett, springerin and starship. Since 2001, he has worked for the hospitality centre motelhanoi.

Lebt mit seinen Söhnen Jonathan, Konrad und Jesse in Köln. Veröffentlichungen zur Kunst der Gegenwart in den Magazinen Kunst-Bulletin, Kunstforum, Parkett, springerin und starship. Seit 2001 tätig für das motelhanoi, einen Ort der Gastfreundschaft.

Vit à Cologne avec ses fils Jonathan, Konrad et Jesse. Publications sur l'art contemporain dans les revues Kunst-Bulletin, Kunstforum, Parkett, springerin et starship. Travaille depuis 2001 pour motelhanoi, un lieu convivial.

B. H. — BARBARA HESS (born 1964)

Studied Art History and Romance Languages in Cologne and Florence. Based in Cologne, she is a freelance author and translator and has written extensively on modern and contemporary art for magazines, including Camera Austria, Flash Art and Texte zur Kunst.

Studium der Kunstgeschichte und Romanistik in Köln und Florenz, lebt als freie Autorin und Übersetzerin in Köln. Zahlreiche Veröffentlichungen zur modernen und zeitgenössischen Kunst, u. a. in Camera Austria, Flash Art und Texte zur Kunst.

Etudes d'histoire de l'art et de langues romanes à Cologne et à Florence. Vit et travaille à Cologne comme auteur et traducteur en free-lance ; nombreuses publications sur l'art moderne et sur l'art contemporain, notamment dans Camera Austria, Flash Art et Texte zur Kunst.

G. J. — GREGOR JANSEN (born 1965)

Aachen-based art historian, critic, curator and lecturer in media studies at Aachen University of Applied Sciences. Currently organiser of the interdisciplinary exhibition "iconoclash" at the Zentrum für Kunst und Medientechnologie, Karlsruhe. Contributor to publications including Blitzreview, Kunst-Bulletin and springerin.

Lebt als Kunstwissenschaftler, Kritiker, Kurator und Lehrbeauftragter (Medientheorie an der FH Aachen) in Aachen. Derzeit tätig am Zentrum für Kunst und Medientechnologie, Karlsruhe, als Projektleiter der interdispiäneren Ausstellung „iconoclash". Schreibt u. a. in Blitzreview, Kunst-Bulletin und springerin.

Vit et travaille à Aix-la-Chapelle comme chercheur, critique d'art, conservateur et chargé de cours (théorie des médias à la Fachhochschule d'Aix-la-Chapelle). Travaille actuellement au Zentrum für Kunst und Medientechnologie Karlsruhe comme directeur de projet pour l'exposition interdisciplinaire « iconoclash ». Ecrit notamment dans Blitzreview, Kunst-Bulletin et springerin.

A. K. — ANKE KEMPKES (born 1968)

Art historian, freelance author and curator, living and working in Berlin. Has been published in the magazines frieze, Texte zur Kunst and Camera Austria.

Kunsthistorikerin, freie Publizistin und Kuratorin, lebt und arbeitet in Berlin. Veröffentlichungen u. a. in frieze, Texte zur Kunst und Camera Austria.

Historienne de l'art, auteur et commissaire d'expositions en free-lance. Vit et travaille à Berlin. Publications notamment dans frieze, Texte zur Kunst et Camera Austria.

L. B. L. — LARS BANG LARSEN (born 1972)
Copenhagen-based writer and curator. He writes on contemporary art and culture for various art journals and is currently researching psychedelic art since the 1960s.
In Kopenhagen ansässiger Kunstpublizist und Kurator. Er schreibt über zeitgenössische Kunst und Kultur für verschiedene Kunstzeitschriften und forscht über psychedelische Kunst seit den sechziger Jahren.
Critique d'art et commissaire d'expositions. Vit et travaille à Copenhague. Ecrit dans plusieurs revues sur l'art et la culture d'aujourd'hui. Recherches sur l'art psychédélique des années 1960.

N. M. — NINA MÖNTMANN (born 1969)
Has a doctorate in Art History from Hamburg University. An author and critic living in Hamburg, she has curated a range of exhibitions, including "minimalisms" at the Akademie der Künste, Berlin (1998), "Sound aka Space", part of "Außendienst", Hamburg (2000), and "04131 Town Projects", in Lüneburg (2001).
Promotion in Kunstgeschichte an der Universität Hamburg, lebt als Kritikerin und Autorin in Hamburg. Kuratierte zahlreiche Ausstellungen (u. a. „minimalisms", Akademie der Künste, Berlin, 1998, „Sound aka Space" im Rahmen von „Außendienst", Hamburg, 2000, „04131 Town Projects", im Stadtraum von Lüneburg, 2001).
Doctorat en histoire de l'art à l'université de Hambourg, vit et travaille à Hambourg comm critique d'art, auteur et commissaire d'expositions (notamment « minimalisms », Akademie der Künste, Berlin 1998 ; « Sound aka Space » dans le cadre de « Außendienst », Hambourg 2000 ; « 04131 Town Projects », espace urbain de Lüneburg 2001).

R. S. — RAIMAR STANGE (born 1960)
A graduate in German Studies and Philosophy, living and working in Berlin as a freelance art writer and curator. Regular contributor to Flash Art, Kunst-Bulletin, Frankfurter Rundschau and Artist.
Studium der Germanistik und Philosophie, lebt und arbeitet in Berlin als freier Kunstpublizist und Kurator. Veröffentlicht regelmäßig in Flash Art, Kunst-Bulletin, Frankfurter Rundschau und Artist.
Etudes de lettres allemandes et de philosophie, vit et travaille à Berlin comme auteur et commissaire d'expositions en free-lance. Publie régulièrement dans Flash Art, Kunst-Bulletin, Frankfurter Rundschau et Artist.

RO. S. — ROCHELLE STEINER (born 1965)
Chief Curator at the Serpentine Gallery in London. She was previously Associate Curator of Contemporary Art at the Saint Louis Art Museum in St. Louis, Missouri (1996–2001) and NEA Curatorial Intern at the Walker Art Center in Minneapolis, Minnesota (1994–1996).
Chief Curator an der Serpentine Gallery in London. Zuvor war sie Associate Curator für Zeitgenössische Kunst am Saint Louis Art Museum in St. Louis, Missouri (1996–2001) und National Endowment of Arts Curatorial Intern am Walker Art Center in Minneapolis, Minnesota (1994–1996).
Conservateur en chef à la Serpentine Gallery de Londres. Auparavant, conservatrice adjointe pour l'art contemporain au Saint Louis Art Museum à St. Louis, Missouri (1996–2001) et National Endowment of Arts Curatorial Intern au Walker Art Center à Minneapolis, Minnesota (1994–1996).

A. S. — ADAM SZYMCZYK (born 1970)
Studied Art History at Warsaw University. Freelance curator and writer based in Warsaw. Co-founder of the Foksal Gallery Foundation in 1997.
Studierte Kunstgeschichte an der Universität Warschau. Lebt als freier Kurator und Publizist in Warschau. 1997 Mitgründer der Foksal Gallery Foundation.
Etudes d'histoire de l'art à l'Université de Varsovie. Commissaire d'expositions et auteur en free-lance. Vit à Varsovie. Cofondateur de la Foksal Gallery Foundation en 1997.

Imprint — Impressum — Imprint

To stay informed about upcoming TASCHEN titles, please request our magazine at www.taschen.com
or write to TASCHEN, Hohenzollernring 53, D-50672 Cologne, Germany, Fax: +49-221-254919. We will
be happy to send you a free copy of our magazine which is filled with information about all of our books.

Original edition: © 2002 Benedikt Taschen Verlag GmbH

© for the illustrations by Thomas Demand, Andreas Gursky, Carsten Höller,
Neo Rauch, Thomas Ruff, Gregor Schneider: 2005 VG Bild-Kunst, Bonn

Texts by Kirsty Bell, Ariane Beyn, Frank Frangenberg, Barbara Hess, Gregor Jansen, Anke Kempkes,
Lars Bang Larsen, Nina Möntmann, Raimar Stange, Rochelle Steiner, Adam Szymczyk

English translation by Monica Bloxam, Isabel Varea, Karen Waloschek
for Grapevine Publishing Service Ltd., London
German translation by Christian Quatmann, Munich
French translation by Gunter Fruhtrunk, Philippe Safavi, Paris

Editorial coordination and copy-editing by Uta Grosenick, Sabine Bleßmann, Cologne
Co-editorial coordination by Anne Sauvadet, Cologne
Design by Sense/Net, Andy Disl & Birgit Reber, Cologne
Production by Ute Wachendorf, Cologne

Printed in Singapore
ISBN 3–8228–4093–9